Visions and Images

Visions and Images

American Photographers on Photography

Barbaralee Diamonstein

with

Harry Callahan
Cornell Capa
Alfred Eisenstaedt
Elliot Erwitt
Horst P. Horst
André Kertész
Ray Metzker
Joel Meyerowitz
Duane Michals
Barbara Morgan
Arnold Newman
Aaron Siskind
Frederick Sommer
Burk Uzzle
Garry Winogrand

RIZZOLI
NEW YORK

Published in the United States of America in 1981 by
RIZZOLI INTERNATIONAL PUBLICATIONS, INC
712 Fifth Avenue, New York, NY 10019

pages 11-22 © Harry Callahan
pages 23-31 © Cornell Capa
pages 39-54 © Alfred Eisenstaedt
pages 55-66 © Elliot Erwitt
pages 67-80 © Horst P. Horst
pages 81-92 © André Kertész
pages 93-102 © Ray Metzker
pages 103-116 © Joel Meyerowitz
pages 117-130 © Duane Michals
pages 131-142 © Barbara Morgan
pages 143-158 © Arnold Newman
pages 159-166 © Aaron Siskind
pages 167-178 © Frederick Sommer
pages 32-38 © Burk Uzzle
pages 179-191 © Garry Winogrand

LC 81-51236
ISBN Hardcover 0-8478-0417-8 Paperback 0-8478-0399-6

The book *Visions and Images* is based on a series of edited interviews conducted
by Barbaralee Diamonstein at the New School for Social Research/Parsons
School of Design in New York

Designed by Arnold Skolnick
Composition by Interstate Graphics Inc, Arlington, Vermont
Printed and bound by Interstate Book Manufacturers, Inc, Olathe, Kansas

For Carl and Tim

Contents

Introduction

Alfred Stieglitz once said that the camera perceives that which is invisible to the literal eye. Perhaps that is why he described some of his photographs as "equivalents"—by which he meant that they were the external analogues of interior experiences. In a similar vein, Aaron Siskind once told an admirer of his nature photographs that he cared less about how well the camera recorded sweeping vistas than about what it showed of internal panoramas, the geography of the soul: "I'm really not interested in rocks. I'm really interested in myself."

For some photographers, the camera is a courtly sycophant, flattering and beautifying whatever it looks at; for others, it is a means of indictment, used to distort, to abstract, to extract an ugly truth; for still others, it is every bit as versatile and expressive as the palette and brushes of a master painter. But for no photographer is the camera a noncommittal tool. At this stage in its development, we are witnessing ever-increasing experimentation with its identity and ever more imaginative efforts to test its power.

For a century and more—just think of Matthew Brady's Civil War reporting going back some one hundred and twenty years—photography has been central to the evolution of the American self-image: to our culture, commerce and history. The significance of these printed images to daily American life is indisputable when one considers television, film, newspapers, glossy magazines, advertising. Since the mid-nineteenth century, with the emergence of the word *photographie,* and with the evolution of the first cameras from the *camera obscura*—an aid to drawing employed by Renaissaince and later European landscape painters—photography has been used for an astonishing variety of purposes and has exerted a powerful pull on the imagination.

Even so, it was little more than forty years ago that the first curatorial department devoted exclusively to photography was founded, in a museum—the Museum of Modern Art, in New York. At that point, photography was barely a century old, and a sharp debate still raged over the question: Is it art? Who can forget Baudelaire's condemnation of the medium as "art's most mortal enemy"? Indeed, we continue to hear, even today, the argument that because it contains elements that are chemical, duplicatable and mechanical, it cannot possibly be art—an argument enhanced by photography's enormous popularity and its accessibility to millions of owners of Instamatics, Polaroids and assorted miniature cameras requiring neither focusing nor light/speed settings.

If the Museum of Modern Art was being bold in launching its photography department, it was also being terribly pre-

scient. For over these past four decades, there has been a substantial growth of interest in the making, viewing and collecting of photographs, and a parallel acceptance of it as an art form. Photography has, in fact, become the visual art with the broadest public appeal of all. It now not only complements but actually competes with television and the printed word as our prime vehicle for the dissemination of information. Its possibilities seem to keep expanding, as its cumulative impact makes itself felt. New myths, new landscapes, new definitions and parameters of the art concern contemporary photographers and continue to influence the direction of this still-emerging discipline. And along with all else has come a new photographic historicism about it.

If all art reflects the culture out of which it grows, photography mirrors our society literally as well as metaphorically. In recent years, photographers have continued to record our private visions, whether as independently created masterworks, or as commissions by the government, the media, the business sector or the patron. The assassination of John F. Kennedy, the Civil Rights Movement, the war in Viet Nam, the moon landing, the Bicentennial Celebration, the release of the American hostages from Iran and now the attempted assassination of Ronald Reagan—vivid images of these historic events remain imprinted on our collective memories and preserve for us events that have dramatically touched our lives.

It is only in the contemporary period that books about the history of photography as a distinct and respected field of study have been published. But this literary documentation has rarely been made in the words of the men and women who worked to create that history. It may be that photographers, and some of their publics, have been all too well persuaded that one picture *is* worth more than ten thousand words. Perhaps it is because this old Chinese proverb has become so universal a cliché that the creators of intense visual images are assumed to lack the ability, or interest, to express themselves in mere words.

We were convinced that this need not be the case, and this conviction led to a series of videotaped conversations, "Visions and Images: American Photographers on Photography." In examining the evolving careers, techniques and philosophies of fifteen great photographers, in their own words, we think we have proved otherwise. Listen to their direct and carefully considered observations on their work as an art form—with or without reference to painting or any other medium. Hear them on the subject of photography as a documentary tool. Note their reflections on many of the formal and thematic issues that characterize photography. Inarticulate? Far from it. These photographers, some of the most distinguished and celebrated in the brief history of the medium, provide a rich and consistently fascinating commentary.

The fifteen photographers interviewed represent the spectrum of "schools," movements and styles current in the medium. Initially, to be sure, some of our photographers were distinctly uncomfortable about articulating their opinions in a public forum. There is some comparison between this reaction and the manner in which American artists in the 1950s responded to their sudden, though long overdue, public acclaim. The artists were unprepared to be celebrated personally, or to have their work aesthetically proclaimed and economically rewarded. Photographers today, I think, share that bewilderment, and they are still somewhat cautious about giving voice to their views.

For me, "Visions and Images" developed naturally, almost inevitably, from the videotaped conversations I have been conducting for nearly a decade. The interviewees have included visual, performing and literary artists, historians, diplomats and educators, architects, preservationists and designers, appointed and elected officials. Most recently, the focus has been on those who affect the visual and built environment by creating works of art that range from individual objects to entire buildings.

Two books that grew out of those talks are *Inside New York's Art World* (conversations with leading artists, critics, museum directors and gallery owners) and *American Architecture Now* (conversations with widely known architects). As with the interviews that led to those books, the talks with photographers were videotaped at New York's New School/Parsons School of Design as the Van Day Truex lecture series (four audiotapes were later included). The tapes have been made available to students and the larger public by being placed with the Columbia University Oral History Archives.

In transition from oral to written form, the transcripts have necessarily been condensed and edited for clarity. But the spirit of the individual conversations, if not each letter, has been respected. I hope you will agree that, taken together, the honesty and vitality of the photographers' words reproduced here will help to document the importance of their controversial art.

For all involved in "Visions and Images," especially the photographers, my thanks. And thanks, too, to Alexandra Kahn, Jean Zimmerman, Jill Shaffer, David Gordon and ABC Video Enterprises ARTS network, who helped to transform the idea into a reality. All were committed to the notion which animated the entire project: that photography is central to our culture—and that these accounts will help to illuminate its increasingly important position.

Barbaralee Diamonstein
27 June, 1981
New York City

Harry Callahan

Harry Callahan is one of the world's great living photographers. He has been a photographer for more than forty years, during which time he has explored a diverse range of picture making ideas and concerns. A fine teacher, he was the head of the photography department at the Instutite of Design in Chicago, and then a professor at the Rhode Island School of Design in Providence, where he established the Department of Photography.

Barbaralee Diamonstein: In 1936, as a young man, you left school after three semesters at Michigan State, found a job and married Eleanor Knapp. You had no artistic amibitions then and very little formal art training. By 1941, however, you had become a photographer. What occurred in those intervening five years that prompted the change in your career? How and where did you discover photography?

Harry Callahan: That's a pretty profound question. I think it had something to do with my growing up and not being able to do anything that I felt good about. I found photography as a hobby, and then finally realized that it was something I really believed in. I had believed in the hope of believing in something. But I hadn't had anything to believe in, and photography was it.

D: You joined a photography club in 1941. While you were there, you attended a number of workshops, and met someone who was an important and early influence.

C: Ansel Adams came to Detroit and gave a talk, and then he took us on a weekend. There was something about what he did that hit me just right. He talked with great reverence about music, and about Alfred Steiglitz, whom I'd never heard of. And he had pictures which I felt were photography. Beautiful

tone and texture. I don't think the great pictures that are considered his best were the ones that really excited me. It was the close-up pictures near the ground. From then on, I felt I could photograph anything. I didn't have to go to Yellowstone or Grand Canyon. I could photograph a footprint in the sand, and it would be like a sand dune. This was probably the most freeing thing that could ever have happened to me. From then on even though I hadn't made a picture, I thought I was a great artist.

D: What did Ansel Adams show you at that time? Was there a surf sequence? A five part series?

C: Oh, yes, and this is really a strange thing, I think. About a year after he left, I started making sequences, and I thought this was quite unique. I didn't realize that I had seen his. I think this is something that happens to all of us. You think you invent something yourself, and you have seen it someplace before. I think probably those surf pictures moved me very strongly, but unconsciously.

D: So the serial nature of his work did influence you. What would you say was his strongest influence on you?

C: I didn't feel like I had to go and photograph the great landscape. He'd done it. I could photograph with anything around me.

D: You mentioned that he spoke with great passion about Steiglitz. You had never heard of Steiglitz, but you were then determined to meet him. How did that meeting come about? Do you recall the circumstances?

C: Well, I don't know; I was so overwhelmed. I have to explain that I didn't have any formal education; I'm a very naive person. My dream was to go and see Steiglitz. And I went there, and it wasn't all that pleasant. He was sitting all by himself in his room, and I didn't know what to say to him. He didn't particularly care to say anything to me, so I asked him if I could see some of his pictures. And he said, "I don't show any of my pictures anymore."

D: Where did this meeting take place?

C: In Steiglitz's New York Gallery, An American Place. He finally got one of his people to go show me his pictures. One of the ridiculous things is that after I'd seen some of the pictures, I asked him if he'd been influenced by Ansel Adams. That's just proof of my naivité.

D: How did Steiglitz respond?

C: Beautifully. He could have laughed and treated me like an idiot, but he didn't. He just said, "No, I don't think I was."

D: Before you came to New York, you were working in the photography laboratories of the General Motors Corporation, in one of their darkrooms. As I recall, you awarded yourself a four month fellowship to come to New York. Was it during that time that you met Steiglitz?

C: No, I met him earlier, in 1942. Then, when the war ended, my wife and I had saved enough money so I could photograph for maybe eight or nine months without earning a living. That's when we came to New York, and I saw Steiglitz off and on. But I didn't have any particular rapport with him. I guess I'd held him up for so long as such a god almost, that it got to be silly. So he got to seem like a cranky old man to me. I don't like to say that, because he was a fine person.

C: Did anything happen during that period in New York that was of importance to your work?

C: Oh, yes, I met so many people who were important. Berenice Abbot, and Paul Strand, and Lisette Model, and the Newhall's, Beaumont and Nancy, who were then working at the Museum of Modern Art.

D: When you started to photograph in 1938, many photographers felt that their art had to be truly significant. And to be significant, it had to concentrate on social issues. You were then 26 years old, and the photographers of the moment, who were enjoying a great celebrity—at least among people who were following photography—worked for the Farm Security Administration. They concerned themselves with social documentation. Were you ever drawn to that way of working?

C: At a certain period in my life I thought that I ought to be. But I strongly believe that you shouldn't do what you can't do well. I took a few pictures of human relationships and stuff like that, but they just meant hardly anything to me. I think that social documentation is important. I'm nuts about the arts, and I think that if you want to produce something that has some meaning in terms of the arts, which has to do with human beings, that you should function the way you can function the best. You shouldn't try to run the 100 yards when you're a better jumper. You should try to find your way to do the best you can.

D: So activist, concerned photography did not engage you. Where did you find your way, and how did you determine the place and the potential that photography held for you?

C: I didn't know very much. The only thing I did know was that I could make a picture. And I didn't have to make a socially significant picture to make one. When I was invited to teach at the Institute of Design in Chicago, Moholy-Nagy was looking at my pictures, and he asked me, "Why did you make this picture?" I looked kind of dumb, and he said, "Oh, it doesn't matter. It's all right if it's only for a wish." And I think this is important.

D: Do you mean, if you wish to do it, that is sufficient reason?

C: Right, that's enough. You just get the idea, maybe, "I'll

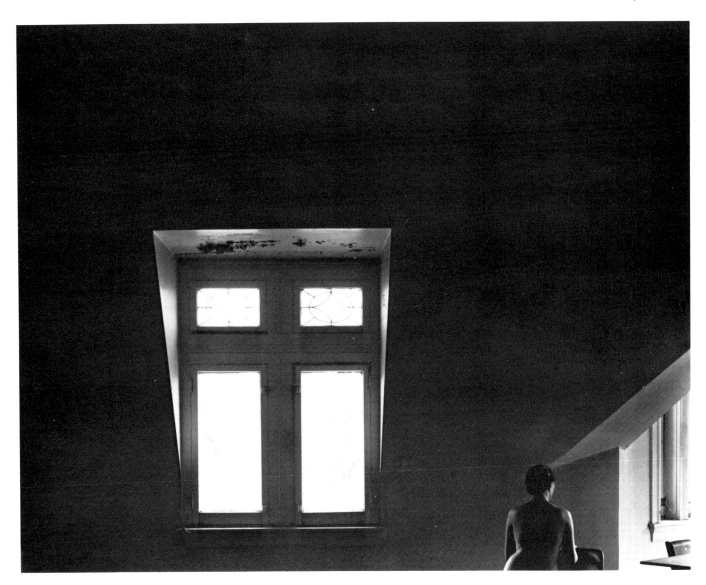

Eleanor, 1948

photograph birds flying,'' and you go out and you start. Maybe you don't end up photographing birds flying, but it starts you off.

D: Your first teaching job was at the Institute of Design in Chicago, established by Moholy-Nagy as an extension of the German Bauhaus. It was known as the New Bauhaus before it was called the Institute of Design. The Bauhaus had a very strong influence on the teaching methods and the aesthetic of the Institute. What was that experience like for you? And how did you get to Chicago?

C: Well, I was anti-education, but ignorantly. I thought that nobody could teach anybody how to be creative. I feel that comes out of the individual. But Arthur Siegel, the person who brought me to this school, thought you could teach creativity. I used to argue with him, but he liked my photographs, so he invited me to come to the Institute of Design. It just fit me perfectly. That is the way I would have liked to be educated. Fundamentally, the Institute idea was that in these modern times you have a machine, and the machine can produce furniture. So you don't use the machine to make Chippendale furniture; you make modern furniture like Mies van der Rohe or Le Corbusier. And the quality of the photograph, which would not be retouched, was to be a result of the camera, the machine.

D: What were your major projects at that time?

C: I don't know exactly how to answer. The fact is that I've been a limited person. I love photography, so I would take an 8 x 10 camera and photograph nature. I would photograph and I would get all tied up and tired of looking at the image through a big camera on a tripod. So I would shift to a 35 millimeter camera and photograph people on the streets. And later on, in order to break away from that, I would move the camera on street lights. What I'm trying to say is that when I got tired of one thing, and I felt I wasn't functioning properly, I would move to something else.

D: When you were in Chicago, you formed three friendships that seemed especially important to you. I'm talking about Hugo Weber, Mies van der Rohe, and Aaron Siskind. Can you tell us about them, and what role each played?

C: Hugo Weber came to the Institute of Design at the same time as I did. He couldn't speak very good English; I had a hard time understanding him. But he probably knew ten times as much as I'll ever know. He was very important in the sense that he just knew a lot. I don't think he influenced my photography, nor did Mies van der Rohe, nor Aaron Siskind. They influenced me as people in ways I've probably forgotten, just as my old friend Tod Webb influenced me as a person. This leads me into something else. I feel that some of the first pictures I ever made were as good as any pictures I'll ever make

again. As a result, I decided that what I had to do was to live strongly, to keep my photographs alive. I wanted to have a lifetime of experience, from beginning to end. I don't think in terms of saying, ''My last pictures are going to be my best.'' One of my very early experiences as a young man was sports, naturally. And then meeting my wife and being married. And then going to the Institute of Design, and so on. And then having a daughter, then traveling in Europe, and then my teaching experience at the Rhode Island School of Design. Now I'm sort of a half-baked businessman. But I feel that if all of these are rich experiences, and I can look at them with some kind of meaning, they'll nourish my photographs and I will have, I hope, a body of work that is a continuous piece of a life. It will show me as a young person and as an old man.

D: What were your first photographs?

C: The first ones, strangely, were photographs of grasses, and then reeds in the water. The goofy thing is that, as I went along, many of my pictures showed line. People would say to me, ''You have a deep concern for line.'' At the Institute of Design, people were concerned about all kinds of things like Albers' business of color theory. There always had to be something clever that way. So I thought, ''Well, maybe I ought to enter this kind of business.'' And so I went out and bought a bunch of black thread and some white cardboard, and I laid all the thread out on the cardboard. And I thought, ''Now I'll photograph line.'' But the pictures were no good. So I know it's deeper than that. It probably had to do with grass, and with hair, and with all kinds of things.

D: You began your own color work in about 1941, even though you did not show color pictures for more than thirty-five years. When you began, the technology of the process was quite different, and the art photography establishment was focused on black and white. What prompted you to experiment with color so early on? What were some of your problems and rewards?

C: Well, I wanted to be a big artist, so I wanted to do everything. And it was quite natural, as I said, that I got tired of looking with a big camera on a tripod. I began moving the camera on lights, and then I saw that moving the camera on colored lights and neon signs was very beautiful. In my early black and white pictures, I also made close-ups of walls. I had been impressed by Stuart Davis abstracts. I wanted to make abstracts, too. Not that I'm a nut on Stuart Davis, but his work opened up something for me. Then I felt that that kind of picture lent itself to color as well. In those days, if you made a photograph of a regular natural scene in color, it looked kind of goofy. And I thought I could avoid that by doing abstractions. I'm pretty sure the reason why I'm now doing color almost entirely is because I'm looking at color television and

color movies. Their color isn't the color of painting; it's a color a little bit of its own.

D: Were you ever interested in using the word in the same graphic way that Davis did? What do you think of some contemporary photographers' technique of using graphic material —words on photographs—and even painting on photographs?

C: Well, I think I'm old-fashioned. I think I'm stuck with the idea of classical music. I don't listen to classical music anymore, but it has a special quality, and it's made by these beautiful instruments. And I sort of believe that in photography, you have these fine lenses, and you make the picture with the technique that they're capable of responding to. And just like classical music, photography in that sense will probably die. So naturally I have to accept this new way. But it's not my way, that's all.

D: A number of critics think of you as the foremost exponent of the formalist tradition in photography, the art for art's sake position. Is it accurate to say that the function of your work is not to describe the public issues of the world, but the interior shape of your own private experience?

C: Yes, I think it's that. But I think it has to be understood that everybody has different abilities. I'm not political. I can't even sit on a committee. I never know whether I'm in order or out of order.

D: How did you survive in those colleges for so long?

C: By sneaking around.

D: You hid in the darkroom?

C: Yes, I hid in the darkroom. As far as I'm concerned, it's super-important to find your own way. I suppose you can find it with the greatest amount of knowledge and understanding, or with the least amount. But it will have its own feeling.

D: You had a strong religious upbringing. As a college student, your faith gave way, but it has been cited as an important influence on your work. John Szarkowski said that photography has been a semi-religious calling for you. Instead of daily prayers, you had daily picture-taking. How often do you photograph?

C: I photograph as much as I can. What Szarkowski said is true in that sense. I can't photograph all the time now because I've been on book signing tours, and have had quite a number of shows and what not. But whenever I can, I do. It has a spiritual effect upon me, probably because of my early attitude towards religion.

D: You mentioned earlier that it was important for you to believe in the possibility of something in which to believe. Did photography, in a sense, replace the more formal discipline of religion for you?

C: Yes, right. That's about as religious as I am now. You're really just hoping for something; you don't really know what you're doing, I don't think.

D: What procedure do you use? Do you start with any idea of content?

C: Oh, I always have to have an idea. But one of the ideas is just to be someplace where I'd like to be, whether on the beach or in the city, or photographing people. I think everybody has to have these things. The person who wants to do the social, document photograph has to think in those terms, and he has to look at people and what's going on in those terms. This is the way he feels right. This is his spiritual way. And if somebody has to make an illustration for a magazine, then he has to feel good about all the challenges that go with that project.

D: Well, in 1950 you had a very good idea. You knew a place where you wanted to be—on State Street in Chicago. You began a series of photographs of large, close-up views of the heads of passers-by on Chicago streets, photographing them with steep, upward perspectives.

C: I photographed them very close. A long time ago, I tried to photograph people walking down the street in Detroit. I couldn't think of any reason why; I just wanted to photograph them. I thought, I'd take pictures of them holding hands and with their arms around each other, shaking hands, or greeting each other. But it just didn't work for me. So I quit. Then later on I realized that what I really wanted was the people walking down the street lost in thought. They had an entirely different kind of expression. And the way I could do this was to use the telephoto lens, walk myself, and photograph them by setting the camera at 4 feet with a long lens. When their heads filled up the viewfinder, I snapped the picture.

D: What was your intent? Did you have technical experimentation in mind?

C: Oh, no, no. As I said, I wanted to make a picture. I never could do the technical thing. I'm not technical at all. That just bores me, and I'm ignorant about it too.

D: Well, then, how do you make your multiple exposures?

C: That's pretty dumb too, you know. I want to put something together. I just like to see how these two things go together. And sometimes I want to see how many images I can get on a piece of film.

D: How many *can* you get on a piece of film?

C: Well, I didn't mean it that way. I meant that in one particular picture, just for the fun of it, I got around 20 images. And it was one of my fine pictures.

D: What photograph is that?

C: It's in the El Mochuelo book. It's a photograph of lots of people in the alleys, where just a little sun is hitting them.

D: A frequent subject of your pictures is your wife, Eleanor. Among the most famous of these mysterious and self-

Harry Callahan

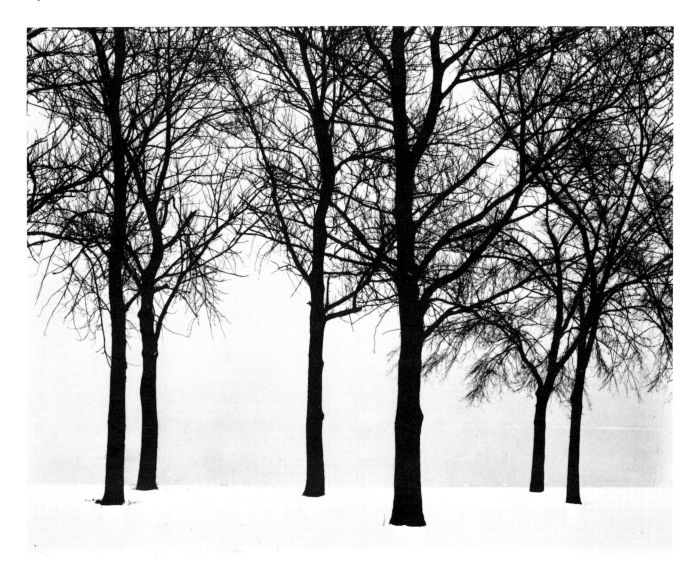

Chicago, 1950

contained photographs is Eleanor in the nude. In each of these photographs, the viewer's impression—well, at least, this viewer's—is of a dreamy, non-specific quality, where Eleanor represents the quintessential woman. Is that what you have in mind, a metaphor for womanhood?

C: No, I don't think so. I don't think anything I do has any monumental thought in any way. I always wanted to photograph her, I think. I photographed her when I hardly knew much about photography. After I saw Stieglitz's photographs of the clouds, I thought, ''I'm going to do something like that, too. I'm going to photograph water.'' So I photographed water for about a year, reflections and all that. I suppose Stieglitz's clouds affected me unconsciously the way Ansel Adams's series of wave sequences did. During that time I continued to photograph Eleanor, and then I realized that Stieglitz had photographed Georgia O'Keeffe. And that didn't really bother me; I thought it just sort of justified what I was doing. Once Ezra Stoller, an important architectural photographer, came and spoke to the students at the Rhode Island School of Design. And I asked him what pleasure he got out of photographing these beautiful buildings. They're already beautiful. ''Well,'' he said, ''I get a thrill out of it. I want a part of it.'' I think that's part of the feeling I have in photographing Eleanor. There's some beauty that you don't want gone. You want a part of it.

D: Is she your favorite model, and a willing one?

C: Yes, I don't have any feeling for anybody else that way. She was good at it, in the sense that she cooperated.

D: Why do you photograph all those beautiful buildings in Providence, in Ireland, in New York—throughout the world? What about them engages you?

C: In the early days I took it all sort of step by step, and I used this big 8 x 10 camera. I wanted to line up buildings. I didn't want them to be tilted this way or that. I wanted to take them so that all the lines were straight. So I carefully photographed them that way. I did that for quite a while, and I thought, ''Well, I can't do this forever. Nobody wants to look at them that way all the time.'' So I started doing something else: I started distorting them in just about every way I could think of. I think I've done nearly everything I've photographed that way. I've photographed Eleanor in silhouette; I've photographed her just in black and white, where she's very contrasty. I've photographed her distorted, but none of those are particularly good. In nearly every way I've worked I've gone back to the subject and tried it in a different way. I will photograph grasses and print them very contrasty, so they are just lines against a white background. Then I take different ones and print them very dark. I think all of this adds to photographic seeing.

D: Is this your attempt to distill the content, the essence of the photograph? Do you thrive on extreme limitations?

C: I have to keep photographing something until it's right. I could never be a commercial photographer, because if somebody asked me to photograph those glasses, he would want me to photograph them and then go away. This way of working makes the commercial photographer function best, but it doesn't make me function best. I might have to photograph those glasses for a year or two. I might only have to do so for a week, I don't know. Once I got what I was after, fine.

D: Your work is among the most diverse in all of modern photography. Other photographers tend to have specialties. Ansel Adams is absorbed by sweeping landscapes and vistas. Diane Arbus was near-obsessed with the freakish, Arnold Newman is known for his symbolic portraits. But your work has been known for its eclecticism. You've photographed figures, landscapes and architecture. You've photographed interiors, objects, multiple-image configurations, nature, uninhabited spaces. You're interested in so many things. How did you decide not to focus on any one special type of subject matter?

C: Well, I don't think that I decided. I think that photography has been so important to me, and my life outside of it hasn't been such a big deal, so to speak. As I say, when I got tired of photographing with a big camera, I took a little camera. I'd have to try something else in order to keep photographing. I just want to photograph. After functioning this way for a while, I realized that I didn't want to be a certain kind of photographer, a window photographer of an 8 x 10, or a 35 millimeter photographer. I think that when you get a style, you're sort of dead. It's like looking at a butterfly collection: Oh isn't this beautiful? Oh isn't that beautiful? I don't think it's telling anybody anything, about your life or life itself.

D: How often does the unexpected happen in your work?

C: I think one of the most important things for me as a photographer is that I have to sense when this thing happens all of a sudden. Then I have to make an issue of it. Once I was photographing my wife with a big 8 x 10 camera on the shores of Lake Michigan in Chicago. She was standing there smiling, and it looked just like a snapshot. I thought, ''This is terrific. After I print it I'll make 8 x 10 snapshots.'' So I started doing that. That's the unexpected. I'm trying to answer the unexpected. When I continued on that basis, photographing her and our daughter standing together, like snapshots, it drifted into something else, I had something else. By working at it—I hate saying working at it, because it is play for me—by doing it, I think that's how you discover. And that's the only way for me.

Harry Callahan:

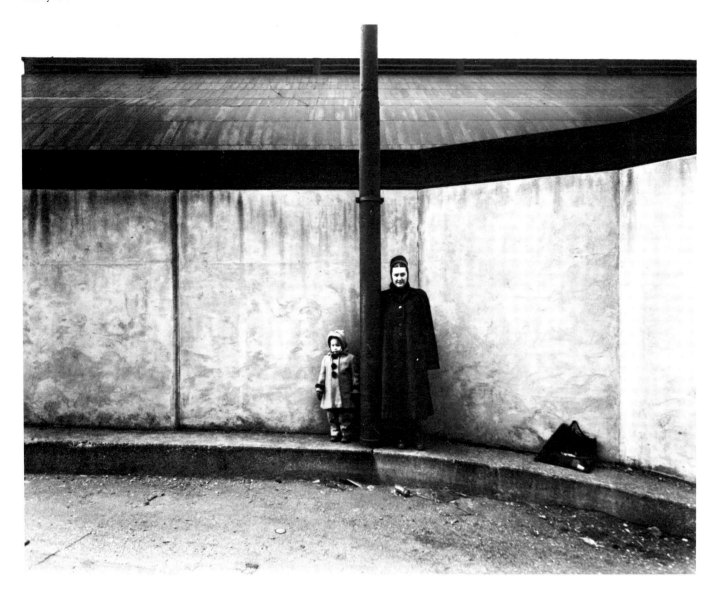

Eleanor and Barbara in Chicago, circa 1954

D: You've been an important influence on photography, not only through your work, but through your teaching. You started at the Institute in 1946, and went to the Rhode Island School of Design in 1961, Were all those years of teaching—and we're talking about more than thirty—a nourishing experience for you?

C: Oh, yes. I get kind of emotional about it. They were murder, too. But I think that going to the Institute of Design in Chicago saved my life. I didn't know what to do, how to earn a living or anything. In the early days at the Institute of Design, I put in more hours than I ever had before, even in a war factory. I watched the other teachers teach and so I learned how to teach. And I was successful with the students, I don't know why. I had good relationships with them. I guess that you don't know why you can make a good picture and you don't know why you can really teach either. And then after fifteen years at the Institute of Design, I went to the Rhode Island School of Design and I started all over again. There was just one little photography course that somebody taught one afternoon. So I established a photo department in the graduate program, very much like what I did at the Institute of Design. And to have all this happen in a new and different kind of school was extremely nourishing.

D: How important is school for photographers?

C: I think a school, whether it's teaching photography or any other medium, should just be honest and aware. As I said, I don't believe you can teach people to be creative, I think that's their business. And if there's any way that you can help them to think, to find out their own way, that's important. But I think education is more important as a way of making people civilized. I think it's important to have a good environment. In other words, you have good teachers and they get good information about the medium they're concerned with.

D: What information would you give to a young photographer today?

C: I really don't know. They would be lucky if they could have a full, decent life by getting a decent education. As for photography itself, that would have to be their own business.

D: In 1946, the same year you joined the Institute of Design in Chicago, your work was first shown at the Museum of Modern Art in the New Photography exhibit, directed by Beaumont and Nancy Newhall. How did that come about? And do you recall what photographs were included?

C: I don't remember the photographs. I know they were just color slides, lit from behind. I think Nancy Newhall was the one who did it.

D: Had you already met Steichen at that point? And did he significantly influence your career?

C: Well, I didn't meet Steichen until 1948. He had seen some of my photographs through my sister-in-law, Dee Knapp, who worked with him. And he came through Chicago because he had a good friend there, Wayne Miller. And so from then on I became a friend of Steichen. And he was always an unbelievable, wonderful supporter of my photography.

D: Was having your work shown at the Museum of Modern Art of real importance to your career?

C: Oh, yes. There wasn't much going on in photography. Photography was looked at as kind of a dopey medium, and is it art or isn't it art, and all that stuff. Just about the only place you could show was the Museum of Modern Art. Afterwards I was in a great many exhibits just with one or two pictures, so it was an enormous support for me.

D: In the last decade, your pictures don't seem quite so austere and distant. They're still machines that work, but nonetheless, in 1972, you started showing more and more color work, and you made that famous series of pictures of houses on Cape Cod. Your recently published book, *Harry Callahan in Color,* reveals still further that your work continues to develop, to change, and to grow. What are you working on now?

C: Well, I guess I'm still just trying to find myself. I've been so involved with so many things, I've sort of just run out and taken some pictures every now and then. Right now I don't feel too good. I seem to see things that I like and I'm excited about, but I just haven't given myself enough time to do what I want to do. And I'm not worried about it, because I've gone through dry spells many times. They used to be just my own dry spells; now it's because I've got involvements. I think I've got some good ideas. I never like to say what I'm going to do, because then I might just as well have taken the picture, or vice versa.

D: Since you've been photographing in color for almost 40 years, how did you select only about a hundred images for *Harry Callahan in Color?* On what basis did you choose?

C: I kept selecting them all through the years, which is not a good way. Nowadays, there are places to show your photographs. Artists should be able to show their photographs. That's fine. But in the old days I could never show my color. Once in a while I'd be invited to give a talk and show some color slides.

D: Is that why you waited so long to exhibit them?

C: Yes. And I couldn't afford to have them printed. I think I was making $4000 a year, and it cost $150 to have a dye transfer print made, so I never even thought of it. Over the years, you just keep selecting. When you go to show them the next time you select some more and you select some more, until there were an awful lot for the Matrix Press in Providence to choose from.

D: I am continually surprised by the large public that

Harry Callahan

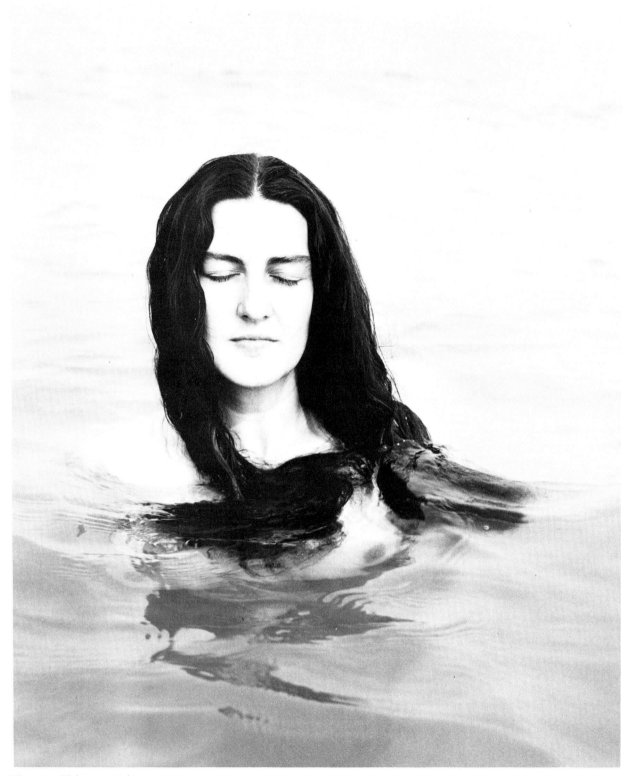

Eleanor, Chicago, 1949

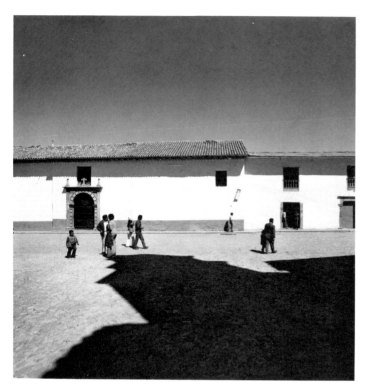

Cuzco, 1974

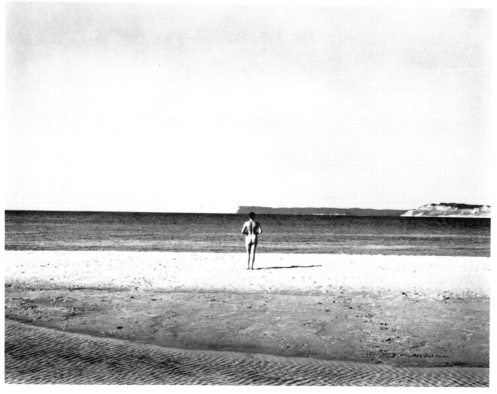

Untitled, 1949

photography has gained in recent years. You will never have to ponder again how to find the $150 to make that color print. You've referred to yourself as a semi-businessman these days. What did you mean?

C: Well, just that my pictures are selling. I have to wrap them up and ship them, and my wife is keeping records. Book-keeping and stuff, that's about all.

D: Did you ever expect all this to happen in your career, or that your life would unfold the way it has?

C: No, I never dreamt that I'd ever have an income from the sale of my photographs.

D: And what do you see as the future of photography in general, and of your own life and career in particular?

C: I have no idea. As in every other medium—music or painting or whatever—it's going to be hard for some people and lucky for others. I just feel lucky about what's happened to me.

D: If you had your career over again, is there anything you would do otherwise?

C: No, I don't regret any of it. I was too ignorant to realize that I was so poor in money, and yet so rich in what I like to do.

D: Was there ever a moment when you had your doubts, and thought perhaps you should seek another career?

C: No. Once, when our child was born, when we were really low financially, I thought maybe I should try to earn some money through my photography. But that ended pretty quick.

D: What did you do?

C: Well, I took my pictures to Steichen, and he sent me to Alexander Lieberman at *Vogue*. Lieberman said, "These are very beautiful. Would you like an assignment?" And I said, yes. So he said, "Could you do it next Tuesday?" or something like that. Here I was from Chicago and I had to go back and teach. And I said, "Oh, no, I've got to be back at school." I really think that unconsciously I was scared anyway. So he said, "Well, if a fashion show comes up in Chicago, let me know and we'll send you to photograph that." And I never did.

D: What was the most difficult photograph that you ever shot?

C: If it was a commercial job, and I had very few, it would have been one of those.

D: Did you ever work on assignment?

C: Yes, a couple of times. Here's a real ridiculous one. This fellow knew that I made a lot of multiple exposures. He wanted an ad which showed "the eyes have it." So I photographed my wife's eyes. I cut up a piece of cardboard and put it in the back of the camera and punched about 200 holes in it. I would focus on one of her eyes through one of these holes, and take a picture. Then I'd cover that up with a piece of tape. And I went on and on and on, tried maybe a hundred. It was very good, but it just happened to be something that this person knew I could do. And I felt good doing it.

D: Where did that appear?

C: Oh, I don't know. Some trade magazine about something, and it was called "the eyes have it!"...

Cornell Capa & Burk Uzzle

On the corner of 94th Street and Fifth Avenue stands one of New York City's newest and most significant museums, the International Center of Photography, which recently celebrated its sixth birthday. It was created through the enterprise, determination, and sheer unwillingness to say no, of its founder and director, Cornell Capa. He and Burk Uzzle are representatives of a relatively new, twentieth-century breed, the photographer-journalist, who brings not only concern and camera, but mind and insight to the events and people that move the world.

Barbaralee Diamonstein: Cornell, why did photography require a new museum?

Cornell Capa: Well, it really only had one, located in Rochester, New York—the George Eastman House, which was started in 1947. It was old George Eastman's home, and the Eastman Kodak Company wanted to keep it intact and make a museum of photography, including objects and old cameras as well as photographs. It was the only museum of photography in the United States, but it couldn't maintain itself. It could stay alive mainly through the generosity of the Eastman Kodak Company.

D: How is your museum different from other photography centers or collections?

C: The point was that somehow photography had no fans, not the kind of philanthropic fans who would support an institution for photography without a major patron—like the Eastman Kodak Company for Eastman House. There was a terrific need to find an identity and a place for photographers and photography within the confines of New York City. The

Museum of Modern Art has had a department of photography since 1940. During Steichen's time it really became a wing of the museum and it's very stong and very powerful. But it functions mainly as a showplace for photography. The Metropolitan Museum has a department of photographs and drawings. So when you say a new museum for photography, there is only one. Somehow this twentieth-century form of art and communication needed a home, needed the recognition. And as we knew from some other small countries, recognition only comes when you have a home of your own. We can't live in diaspora. You cannot really remember work which only gets published in magazines and books. We keep it present in a different way. This was a place where you could exchange ideas, where you could present work on a regular basis, where photographers and photography could have a home. This was a need that was not serviced before the center was born.

D: Why don't you dazzle us a bit with your accomplishment? What was the attendance when the Center opened? What is it six short years later, and how do you feel about what you helped unleash?

C: The greatest dazzle is that we're alive and well.

D: That's the miracle. . .

C: The second dazzle is that we have presented about 82 major exhibitions. We change exhibits every two months, six to eight weeks. We have two semesters of teaching with 3500 students participating. We have published a number of catalogues and books. And I think we have created a public for photography: I think we have increased photographic awareness on the part of viewers, and we have provided a platform both for discussion and for presentation of work for over a thousand photographers from all over the world. That's about the biggest dazzle. The third dazzle is that somehow we have met our expenses. It's a struggle, however. When I say "equal," you start playing small games, but we have taken an equal position as a form of art communication with the other cultural institutions in New York City. We are on "museum mile," which starts, for public relations reasons only, at the Metropolitan and goes to El Museo del Barrio. And we play an equal role with all these other institutions. That is a giant thing to have done. I never dreamt it would be that tough.

D: It isn't over yet. . .Now that everyone has a good camera and can take a technically perfect picture, Burk, what's the difference between good pictures and good snapshots?

Burk Uzzle: The good pictures simply have a higher visual order, or imperative, than the snapshots. Good pictures depend on a kind of intuitive recognition and may or may not succeed on other levels. Which might be just fine. I think there are some very distinguished, good snapshots.

D: What I'm really asking is , when does an image deserve and sustain the definition of fine art?

U: When you can keep looking at it, and keep finding more and more in the photograph over a period of time. When you feel that it sustains and nourishes you, first on one level and then on another, both as your own capacity to appreciate grows, and as the photograph simply becomes more powerful in its own right over a period of time.

D: Were you nodding in agreement, Cornell?

C: I'm a little bit amused, because the wonderful framed snapshot on your night table of the child twenty years ago is a very valid, wonderful snapshot which is looked at all the time. It constantly gains appreciation. So it need not be the aesthetic quality at all. What I was really smirking about is that if you want to buy a photograph and put it on the wall, maybe there's a different aesthetic consideration. Your own snapshot really belongs to you in some form: you have an attachment, sentimental or otherwise, to it. It already is fine art because you want to look at it and keep on appreciating it.

D: But that is intrinsic . . . there must be some manifest determination that one can make.

C: To be bought. To be published.

D: You're pointing to an economic consideration rather than an aesthetic one?

C: Well, they come together. If the photographs of your story for a magazine are accepted and they are printed, they have this other element of acceptance, because they have met whatever tests they had to meet. And of course you got paid for them. Now, if your photographs are not for sale in galleries, or being bought at auctions, or being accepted in museum collections, then you know that you have that other element as well. Somehow, a financial recognition of value seems to be part of the answer.

D: Burk, you started your career at age 15, and by the time you were seventeen, you were a photographer for a well known daily newspaper in your native North Carolina, the *Raleigh News and Observer.* And then you went on to Atlanta and Houston, where you were based as a free-lance magazine photographer. By the time you were twenty-three, you were a *Life* magazine photographer. Before you tell us how that came about, what does a 15-year-old do as a photographer?

U: Well, you hustle. What I did was take photographs of babies, that I hope are still hanging on some walls and maybe are appreciated in some way or another by children who are now grown up and probably parents themselves.

C: Those photographs were also bought.

U: They bought them, don't worry. They bought them cheaply, I might add.

D: How did you manage to sell them?

U: I grew up in a little rural community in North Carolina,

and I always needed to make money in photography. Certainly in the beginning, it was always to that end that I made photographs. I enjoyed it, and I did it because I really could do nothing else, and wanted to do nothing else to make money. So I had to make money from photography, because that was how I made my living.

D: Where'd you find all those mamas and babies?

U: I had a retired man who worked for me, because I was so small and so skinny and so insignificant looking, and I didn't have the presence or appearance to knock on a door and ask for a sitting. But this retired gentleman would go from door to door, and show some samples and say that the photographer would be delighted to come by and take a picture of the baby for a dollar.

D: And then you appeared?

U: He would book appointments for me, and then I would come back in a few days, much to the amazement of the concerned *parents*—as opposed to concerned photographers. So

yeah, I just hustled a little and then I worked in a bus station doing little portraits before those automated photo booths came along.

D: You were the manual version?

U: People went into the booth, and I took the quarter and took the picture and developed it. It was fun, though.

D: And in that short period of time, how did you then get to *Life* Magazine?

U: I think I just annoyed them to death, and they finally gave me assignments. I kept calling them with ideas. They were very decent folks. They always listened carefully and gave me work. Then they gave me better work. I was lucky, and I worked hard. I worked very hard. And I had the help of a couple of really wonderful *Life* correspondents, who somehow or another just believed in letting me work for them.

D: Did you have the help of any of those distinguished *Life* photographers?

U: A few. A lot of them were a pain in the neck, egotistical

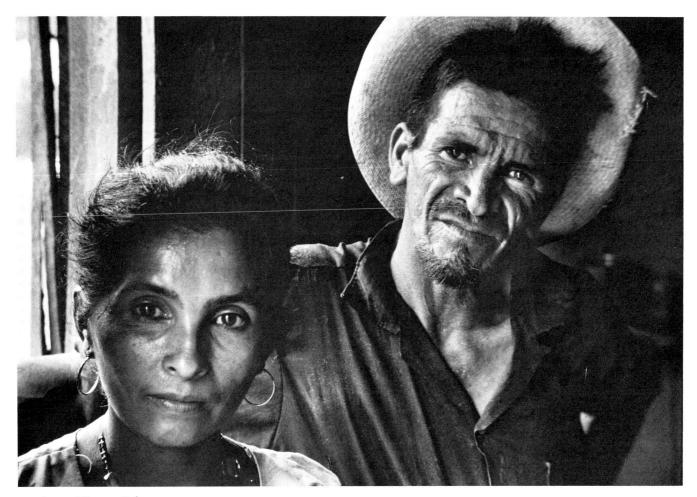

Honduras: Migrant Labor

Cornell Capa

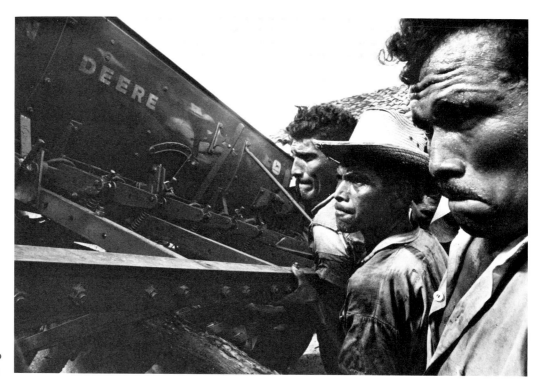

Honduras: San Bernardo
Colonization Project

Honduras: Clinic

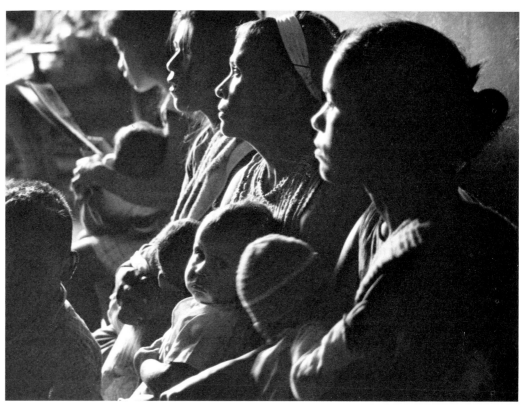

and so forth. They told me some things that were helpful on some occasions and not helpful on others. But by and large I liked them. Certainly they were helpful.

D: Did you work as an assistant to any of them?

U: No, I never did. I assisted other photographers, but never *Life* photographers. I hung around a lot with Gjon Mili, who later on was one of the really great photographers at *Life*. I printed photographs in his studio and he let me use his darkroom and look at his work. And he criticized mine a lot, which is the best thing that can happen to a young photographer.

D: You referred to "the concerned photographer," a phrase that is not only identified with Lewis Hine, but surely with Cornell Capa. You've spoken of the influence of Hine's work on your work, your life and your career.

C: The wonderful thing about Lewis Hine was that he did not call himself a concerned photographer. Actually, the term did not come into usage until the late 1960s.

D: Did you invent the phrase, you and your group, the International Fund for Concerned Photography?

C: Well, I only invented the phrase because I wanted to get a group exhibition going which would express some common denominator for six people I had in mind. I knew who the six were, but I had to get that common denominator.

D: And who were they?

C: My brother Robert Capa, David Seymour, Dan Weiner, Werner Bishof from Cincinnati. Then there was a young photographer called Leonard Freed, who had just started to emerge. And André Kertész, the grand old man of a certain kind of "people" photography. I looked for a common denominator, and what to call it. Eventually, on my winter vacation, I said "Eureka" to my wife. I said, "I got it!" She said, "What is it that you got?"

D: This time. . .

C: I really had the title and the theme for that exhibition. Their concern for mankind is what it was all about. And of course, from there to "The Concerned Photographer" was just one step away. I'm very proud of this one thing that happened. All of the concerned groups sprang up after "The Concerned Photographer." I had in mind the photographer who is the concerned human being, who has the capacity to bring witness to the rest of the people, the true eye-witness of our generation. Such photographers existed before this century, but they didn't quite use that term. It was very funny, you know, to think that in all the newspapers you had always had eye-witness reports. But they were never the photographers'! And the ideal eye-witness is the photographer, for God's sake. So I was pleased by the notion that the concerned photographer was the first concerned eye-witness, a human being who cared. The

fantastic thing is that the decade of the Sixties brought out all the anxiety, particularly in the United States, and the phenomenon of concerned citizens of all ilk and all sorts who sprang up all over the place. It was a wildfire. All the exhibitions which traveled all over the world, they traveled under the name "The Concerned Photographer", because the term cannot be properly translated into any foreign language. In Italian it sounds like a pregnant photographer. In French, it's *photographe engagé,* which could mean "the hired one". So going back to Lewis Hine and his famous statement that grabbed me as a photographer, he said, "There are two things I wanted to do, things to be appreciated and things to be corrected." And that is really my own thinking about photography, and that's what the concerned photographer's basic notion is about. All my own work, and a major direction of the International Center of Photography, is documentary or straight photography. It is concerned with the fate of humankind. That's really the mainstream of what the Center is about.

D: And how do you distinguish that from the sensibility of most other photographers, or most other artists?

C: Well, this question is as deep as the ocean. For a long time I had a terrible problem because a lot of photographers would come up whose work I couldn't show because they just came too early or too late, or because only so many can be shown. But their line was constantly, "Oh Cornell, am I concerned enough for you?" It becomes a slightly nonproductive operation.

D: What criteria *do* you use?

C: Excellence, and commitment and integrity, and not too many people go on from there. However, our exhibitions do embrace a whole panorama of photographic possibilities, expanding the horizons of photography, including the holography that we once presented. But the main thrust of the Center is in a documentary area of concern.

D: Among the things that Cornell does is to use art criteria for photography. And he's obviously demonstrated that you can take photographs out of a magazine and put them into a museum, including your photographs, Burk. I've heard you say that photography isn't art. I wonder if you really mean that? Is it journalism? Just what is it?

U: Gee, I don't know. I think it's just photography. I suppose I should know whether photography is an art. It's just not something that I spend much time thinking about, and I don't really feel prepared to say whether it is or it isn't. I can only really tell you that when I read biographies of artists and they talk about restlessness and things that they feel when they work and so forth, I think I feel something in common with those feelings. Now, I don't know if that makes me an artist, and I

don't know if the quality of my work makes me an artist. I don't really know if I could talk about photography, *per se*, as an art form. It really just doesn't matter very much.

D: You've said recently that you'd like to see a lot more good photography and a lot less preening.

U: Sure. Sure.

D: That's a new phenomenon?

U: Well yeah, I think photography is, happily, being taken very seriously these days. But I think along with that comes a sense of self-consciousness, and a great deal of a sort of cosmetic behavior on the part of some photographers. I think there's a lot of posturing and carrying on that may or may not be relevant either to the quality of the work or to the nature of the medium in any really intrinsic way. But that's certainly their right and their privilege, and I think it has had some positive benefit as well. It's certainly brought more attention to the medium.

D: Cornell, do you see that happening, too?

C: I'm with Burk's statement about flaunting. My need is much simpler in many ways, because I consider photography a form of communication, like language. Everyday language, and poetic language. I'm talking about how you express visually whatever you want to express. Is it art? It can be. It may be just plain solid communication. Maybe it's just reportage, which brings you documentation, fact on film and on paper. It gets read that way. But some photographs have an immediacy. Those are the ones you're talking about. Later on we go back to them and my God, all the quality, all the power, all the composition, all the light and shadow and all the elements that make an image—they survived 150 years of time. Now, to have 150 years of time being reflected in an object, become one image—suddenly you start seeing why the Mona Lisa means something. You find the same kind of imagery reappearing, and it gives us the same amount of impact, or more, than what originally appeared. And on top of that, it gives us a historic sense. So whether a photograph is art depends on how good the photographic element was when it was taken, and how it's transcended time. Now that photography has 150 years of history behind it, we have a fair idea which photographs have that kind of value. It could be partly aesthetic, partly historical, partly technical. But sometimes it all comes together, and then you have a masterpiece.

U: It's a very tricky medium. I think a lot of photographers can deal in baloney as well as feelings very convincingly. Photography itself is a very easy medium in which to be catchy and tricky and manipulative and . . . and to look very facile.

D: More so, you think, than other art forms?

U: I don't know about other art forms. I don't handle any other art forms. But I know photography is easy to do tricks in.

C: It's faster.

U: It's faster and it's convincing at the same time that it's fast. It has this aura of authenticity. And to the lay mind it can be very misleading. It's easy to conjure up feelings of authenticity when they really don't exist.

C: When you have a catch phrase like instant photography, it's instant because it develops in front of your eye, á la Polaroid. But photography is instant—it's instant any which way. It's a *double entendre*. It's instant one way or the other.

D: You used another engaging phrase and that was ''masterpiece.'' Tell us about some of the photos that you consider of sufficient aesthetic-historical-technical content to be classified as ''masterpieces''.

C: Oh boy.

D: You brought it up!

C: Well, Burk. Which picture of yours is?

U: Probably none.

D: How about some of those Cambodian pictures?

U: Oh, I don't know, I don't think they're masterpieces.

D: The boys in the trees?

U: I wish they were. I think it's a fine photograph, but it's too early to talk about masterpieces. That picture has more to do with a celebration of a feeling, and whether or not that feeling is going to be perceived as a masterpiece is something you have to think about a lot later. I don't really even want to think about it that way. I mean, you just go there and you see something and you feel it, and you try to get it on film in some decent manner. You do that with instincts which you've developed and learned. You have a honed sense of timing and you have forces in your life that take you there. All of these things are making you take the photograph when and how you take the photograph. Masterpieces you never set out to do, and I don't think you really think about them for a while.

D: Well, let's think about it for a while.

U: Cornell is in the masterpiece business. It's true.

C: I'll give you three or four. Some of them have much to do with being repeated images that you remember. Which is, of course, one catch to the problem. Many people remember masterpieces because they have seen them before. And that's kind of a double play. . .

D: Familiarity, and the comfort of recognition.

C: Right. Right.

U: But does familiarity alone make a masterpiece?

C: Well, you start realizing that it is one.

D: If the photograph has engaged so many people for such a sustained period of time, then you start looking for the qualities that have done that. Tell us some. Can you be specific? There must be a Stieglitz and a Steichen that you can cite. . .

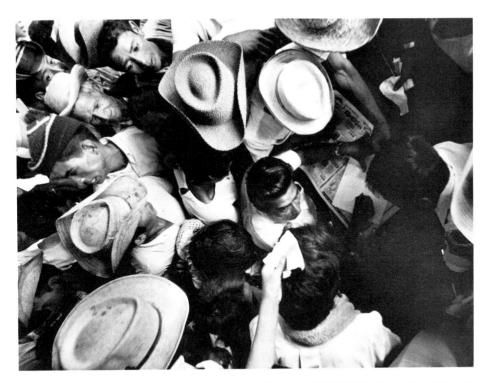

El Salvador: Migrant Labor

N.E. Brazil: Landless Peasants—
Rebel Priests

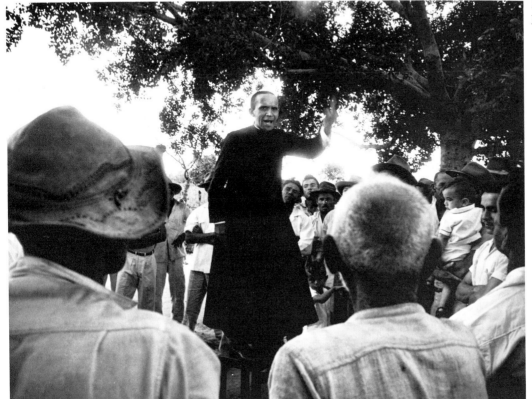

Cornell Capa

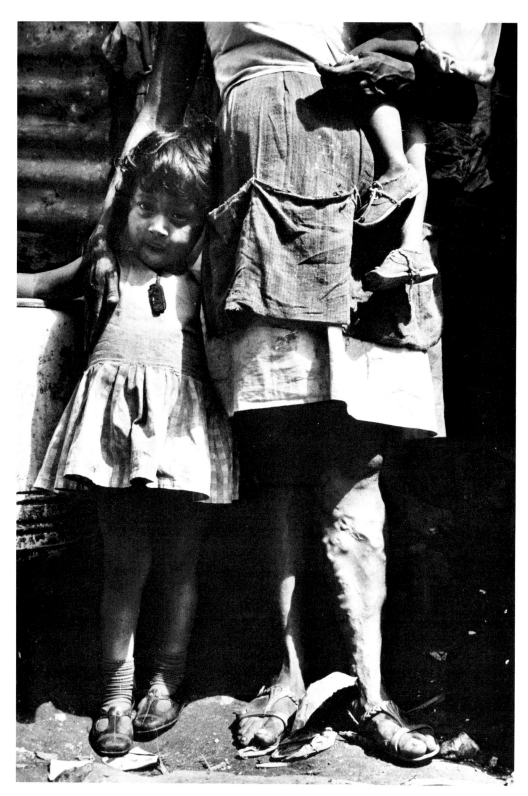

Malnutrition

C: Yes, of course. And an Adams, and a Cartier-Bresson. And you go on like that. "Moonrise over Hernandez."

D: Is that myth or masterpiece, at this juncture?

C: At this point, I think it's getting to the masterpiece stage. Cartier-Bresson's wedding couple on the swing. My brother's photograph of the falling soldier at the moment of death. A number of W. Eugene Smith's pictures of the Spanish village: one of them is of the man laid out, and the family surrounding the dead man. As photographed and lit, that picture talks to me, and, I think, keeps on talking to me thirty years later. Some are tricky because of the repetition and an aura that surrounds them. One of the things we're doing is talking about what's interesting about the newer decades. We saw all these photographs only in printed from, in magazines, books, reproductions. Now you can see the originals exhibited, and it makes a terrific difference. All of us, photographers, public, and all, start seeing qualities in the original print which we were not privileged to take in before. I think that's what's exciting about the last decade of photography—you see many more photographs in the original photographic print form. Sometimes it's a new photograph reprinted with a new technique. The exhibition of Ansel Adams' work at the Museum of Modern Art last year showed different periods in Ansel's own printing of his very same photographs. The differences in his own taste in printing one photograph changed through the decades. And it changed a tremendous amount. Same negative, but when his taste changed, his art became dramatically different.

D: For both of you, your lives and careers have changed markedly during the course of the last decade. Burk, you've done a great deal of commercial work, annual reports, all the other things one does to sustain oneself. Meanwhile, you have been doing what you call your private work. How do you see your work evolving?

U: Aside from being in partnership with the Internal Revenue Service, I just try and do the commercial work as well as I can, with craft and with responsibility. And then I dismiss it, and think about my personal work, which I suppose is about what I am. I like to photograph the things that I care about. It's a very private thing.

D: Why don't we talk about some of the things that you care about? You found a great deal of symbolism in the banal, from shopping centers to airports to bikers. What about those subjects involves you so? Are you telling us something about our society, about consumerism? What is the organizing principle of that part of your work?

U: Well, it's an aspect of American culture, as personified by a fellow who grew up in America, at a specific time and in a specific place. It's a country which moves me tremendously. I travel a lot, but I always have the most fun in America. I photograph the things that give me a kick about America. The craziness, the humor, the bizarre, the loneliness, the starkness. Visually, it's quite apart from Europe, I find. I think it produces very different photographers, a very different vision. Things go at angles and there are spaces that are different.

D: Would you contrast the two for us?

U: Here's a generalization to which I'm sure there are many exceptions, but as well as I can understand it, Europe seems to be more about curves and America seems to be more about lines. Architecturally, in the placement of buildings and the nature of streets. In the pace at which the people move, the materials used in all kinds of consumer goods, the look of automobiles. In the sound of the music which grew up here. In the parochialism—I mean the way the country has fairly tight borders compared to Europe and how that focuses it upon itself. All of these aspects of America have produced in me, at least, a person who likes to be on the road, who likes to be moving, who likes the highway culture, who likes the shopping center because that's my Point Lobos, I suppose. It's a certain relationship with nature. All of these things I feel in my photographs, although I don't always deal with them specifically. It's just the aura of the photographs: all of these things sort of come together. And I love to synthesize all these aspects of the culture.

D: Your photos also seem to emphasize a kind of seriality. I can picture two birds and three trombones and four mummers. Is there anything especial in the serial[1] nature that engages you?

U: It's there, but it really happened more because of the quality of the country than because of any artistic tradition. I mean, Magritte is not my favorite painter, nor is Dali. I haven't gone after surrealism consciously in a visual sense. I much prefer Edward Hopper to Magritte, and Matisse to Dali. No, I think it just has to do with the culture, and the way things come together. They have a very strange way in this country. We are a melting pot, that's how we started and that's how we present ourselves now, I think. And these photographs are a collage of all these things that come at us in America.

D: In the past decade, Cornell, you have spent perhaps even more of your time as an historian and administrator, than as a photographer. Do you ever regret having so little time these days for your own creation? And has the museum affected your own photographic work?

C: Well, I have resolved my problem much more simply than Burk has. From the day the Center started, I have taken no photographs. Therefore, it is hard to make my commercial photography and my personal photography live side by side. This problem for me just doesn't exist.

[1]Uzzle thought the interviewer was using the word "surreal".

Burk Uzzle

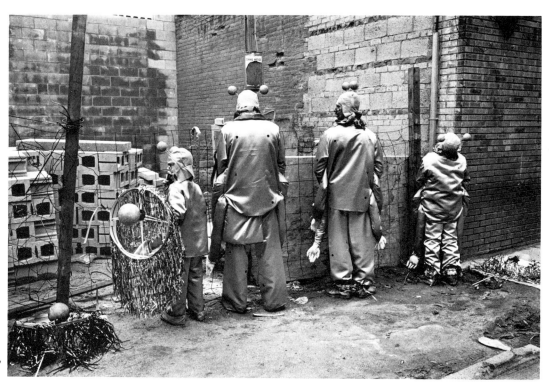

Mummer's Day Parade,
Philadelphia, 1979

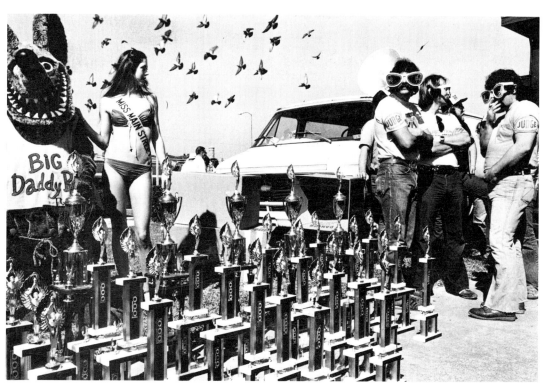

Miss Main Street,
Daytona Beach, 1979

U: I think that's our loss in one way, and our gain in another.

D: Are you getting ready to start photographing again?

C: No, not yet. But. . .

U: Well, I'll be the first to hand you a camera.

D: Do you have any plans in that direction?

C: Well, no, but I don't want to go into that for the moment. How does one do several things at once?

D: Was that a conscious decision on your part?

C: Very conscious. It was a conscious decision because I felt—still do, very much—that the kind of reporting work that I do, eye-witness work, many other photographers can do as well or better or almost as well. Makes no difference. The quality of the work is not that crucial to the verity of what you bring back. So I did not think that I was unique enough to make that point uniquely mine, that it would be so totally missed. On the other hand, there was no Center in existence, and I felt uniquely qualified, because of my attitudes to photography, to do what until that point had not been possible. So I felt the urgency and the need for a Center greater than the need for me to continue another great story, another medium-size story, another important story, another historical story, which I would be sharing with 55 other photographers.

D: I thought a story was never considered done unless one did it oneself. . .

C: Well, pat as it may be now, you carve out your own vision in that wilderness which is shared by very many. And eventually, by your own selection process, your story will be different; your pictures will be different. Many photographers went to Cambodia and did the Cambodian refugees.

D: And why did you choose to show the Burk Uzzle vision of Cambodia?

C: Because he has achieved a quality which is beyond the immediate, which has classic forms, which is an attempt to go beyond that particular dramatic tragic event. Thirty years from now, I may pick up his photographs and I will really feel visually, aesthetically and emotionally, what it was to be a Cambodian refugee in 1980. With his mind and his eye, with his controlled vision and controlled emotion, he brought me images I think will last. That's why his work was selected. For me, that sort of solved my problem of how to stop one career and exchange it for another. That's the important thing which really matters for me, and I would like to speak to that, because ours is a very frustrating profession, be it art or not art. Being art is not the important point at all. I really don't care if any of my photographs are ever bought or hung up by anyone. That's not my intention. I did my last book, called *Margin of Life,* with a sociologist and demographer, J. Mayone Stycos. I finished it in 1973, a year before the Center actually opened. The book came out at the time the Center opened. It's a book about poverty and land and human suffering and moral distribution of everything. We picked two countries, Honduras and El Salvador, and from this very, very small core of two small countries, we expanded the subject to Latin America, where both he and I had expertise. The continent was representative of the rest of the world in form A or B. It rang true. What is absolutely devastating is that now, seven years later, you pick up your *New York Times* every day, and you read about El Salvador and what goes on there. Unfortunately, it was in our book *then.* I would like to read one part of the introduction Stieglitz wrote for the book. His last paragraph says, "As scholars, journalists and photographers must probe, diagnose and call attention to, we hope we have done this. We hope others will do what they have to do." Obviously, we have done what we have done, and obviously, the rest of the people have not done it. The message there was visible, it was audible. Like prophets, we did all we could to bring it to your attention. And of course, the photographer's problem is even more frustrating on some levels than the demographer's. He deals with the so-called science of demography—facts, figures and all the rest of it. We work with human lives and images of people going along their own tortuous roads to death, and fighting for principles, fighting for their lives. We took the license to probe, because that's the important point about our photography. The camera gives us feeling and our profession is going to bring it to the attention of the world.

D: When you went to Latin America as a concerned photographer, you were involved with things that you felt needed to be corrected or appreciated. What do you think the effect of *Margin of Life* was?

C: Well, that's what I mean about frustration. Obviously it had no effect, because we cannot, by ourselves, bring on the desired knowledge or change of attitude. We hoped to be like Lewis Hine, who managed to bring child labor into focus by publication of his work. He was able to get a child labor act passed by Congress. Werner Bishof went to India to the Bihar province where people were dying of hunger. And Congress sent them some wheat. So there were some direct effects. Television and still photography managed to bring to the American public the knowledge of what the Vietnam war was about. In the United States we never had such a violent political time as during the decade of Vietnam. Photography, imagery, brought the war home and we revolted here.

D: Did photography, or television, bring the war home?

C: For me it's only a question of a change in technology. *Life* Magazine used to be on a weekly basis, a unique carrier of visual images of what was happening in the world in a kind of selective, powerful way. That technique has been taken over by television with tremendous impact.

Burk Uzzle

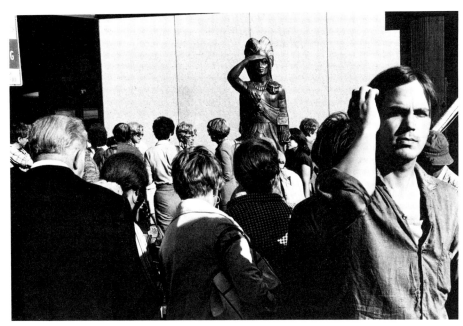

New York Street Fair, 1978

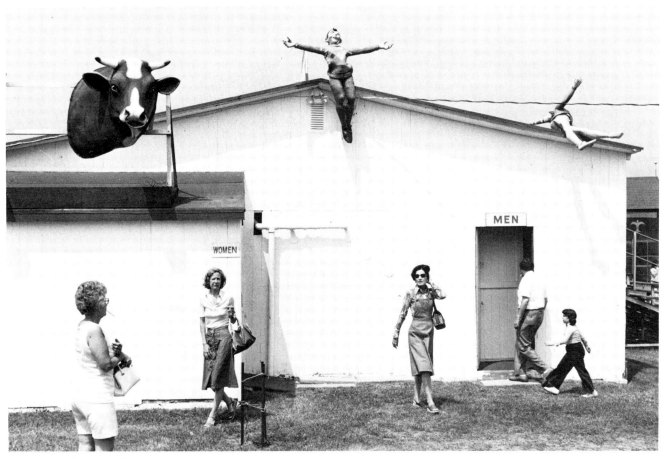

Danbury Fair Ground, 1978

D: And what does that mean for the photographer?

C: Well, I'll get to that. Eleven million people used to look at every issue of *Life* a week later. Today "60 Minutes", the magazine of the air, is being watched by 60, 90, 120 million people, giving a full hour of concentration. The program can effect a much larger audience with a much greater impact, working not only through visual, but also audio-visual effects, and commentary thrown in for kicks. So the whole nature of visual reporting, magazine style, has changed. *Life* and *Look* died in 1972. And *Life* came back about two years ago as a monthly. It's a photographic magazine, to be looked at. It has a million circulation. It is not looking for the kind of informational impact it used to present. So there's been a whole change in the medium. And a change in the medium also made a change in photography—there was much less urgency on the printed page.

D: Burk, what was your intent when you went to Cambodia? And how do you compare your experience, emotionally and professionally, with what Cornell just described?

U: Well, I think Cornell may underestimate some of the power that his photographs might have had and that the medium can have. I think photography is in many ways a modest medium. It serves itself best when it stands with an air of humility. It think it's even best to approach subjects in that context. But I'd like to point out that Smith's Minimata had a considerable effect in Japan. I'm sure people were affected by your book, Cornell, and I'm sure people did accomplish things as a result. I know that in Cambodia I photographed some people, especially children, who were later seen in magazines, and I know people traveled to Cambodia to look for and try to adopt specific kids whom they had seen. I've been involved in other stories where things happened, and while that's not always something you can count on, you do hope to bring attention to things when you go to places like that. At the same time, I think you go there for personal urgencies. It's very complicated. The fair answer to your legitimate and simple question is, I really don't know why I went to Cambodia, except that I just felt I should go there. I was attracted to it in a very personal way, to the nature of existence under those circumstances. I wanted to see what it looked like. It was a matter of curiosity, of somehow feeling a concern about existence, I suppose. It was very much an intuitive thing. Probably it wasn't as carefully thought out as it might have been. But when I got there, I felt at home in a strange way. I've always liked that part of the world and I've gone there whenever I could.

D: You once said about your Cambodian pictures, "I hope they reflect the subject first, and that I gave myself to the refugees." What do you mean? What was the nature of that gift of yourself that you think you've shared?

U: As I understand photography, the best photography comes when the photographer gives rather than takes. You give of your energies, you give of your understanding, you give of your perceptions, and of all that you are. You filter that subject matter through all that you've become and experienced, and you give something back, the gift of your vision, the gift of your understanding and so forth. That's really quite a different process from simply taking, from being a photographer who goes and sees something and just grabs the picture in an aggressive manner and just gathers in, somewhat callously or insensitively, what's in front of him. I think you have to take the picture in a very personal way. It has to mean something to you; then you give back. What's important is that gift—whatever you choose to call it, creativity or communication or just some sense of empathy and caring about the photography. I think that really is what brings joy, brings growth, not only to the person who does it, but to the person who receives it. So I had hoped that I would be able to give something of myself to those people, who really did a lot for me in a strange way. They taught me a lot about survival; they taught me an awful lot about what life is, you know, in an incredibly strong and primitive way. I'll never be the same again for having seen that, and seen those people.

C: I'd like to go back to your Vietnam question and the modesty Burk mentioned. The notion that modesty should become us is a very nice idea. However, I don't think that's necessarily the reason why we have fairly strong personalities in our work, and why it's those personalities that seem to produce the more outstanding work. Not only in photography, but in the whole world of literature and art. There does seem to be a common denominator in that one. The reason we are much more humble and modest now is because our wings have been somewhat clipped. It's more becoming now to be a little bit more humble; i.e., television is stronger.

U: I also think this has to do with the way you present yourself to the subject matter.

C: Well, I'm talking about the result, really. More on the other end.

U: I didn't think much about television when I was in Cambodia. I thought about the Cambodian refugees.

C: Well, I'm talking about the result of your work. I should have said one more thing before that. I understand from reading *The New York Times* fairly recently—I don't know if it's true or false, because one really doesn't know anymore what that story is—that the Cambodian famine problem has diminished. Well, it must have diminished due to much of the work done by still photographers and by other visual media, and radio and print reporting. So I think these media have

Burk Uzzle

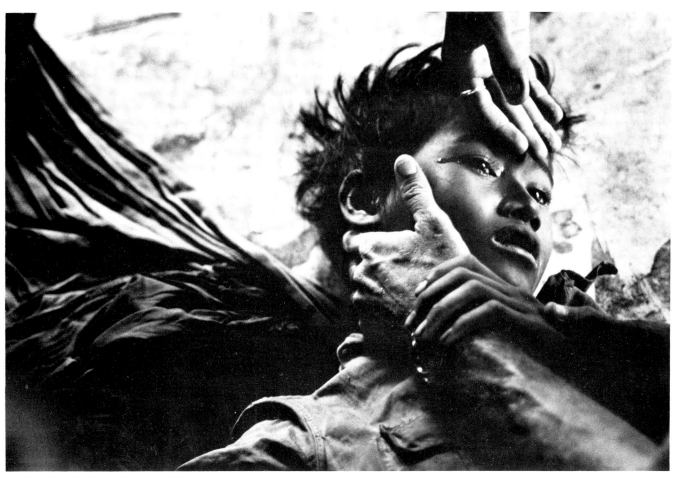

Cambodian Refugee Camp, 1980

New Year's Day, 1980, Cambodian Refugee Camp

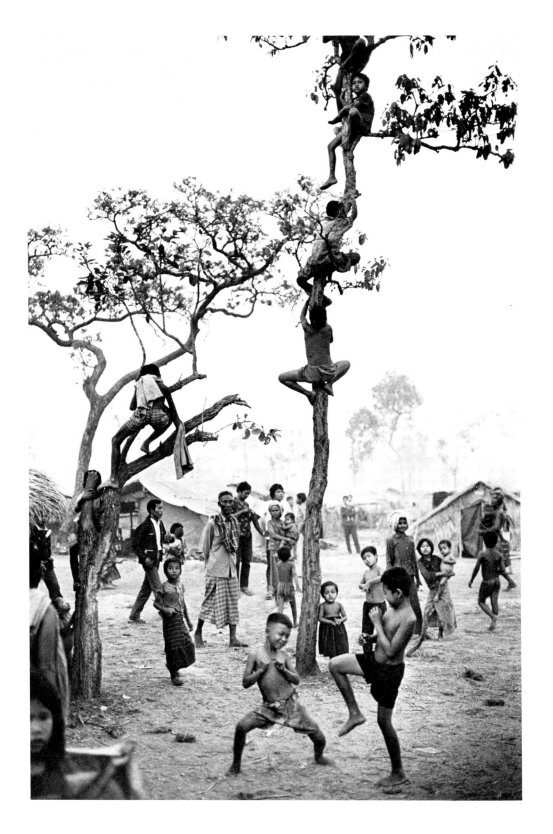

some effect, one way or the other. Which one has more, the Lord knows. Certainly in the case of Vietnam there was the burning Buddhist monk, and Eddie Adams' photograph of the police chief killing the Vietcong in the street.

U: Sure.

C: That inhumanity shocked us. And there was the napalmed child burning on the road, running toward the camera. These are all still images which were really imprinted upon our minds. Therefore, I'm not telling the story I saw during 15 or 30 minutes of the Vietnam war on a TV report. I'm telling you about the photographs which have imprinted themselves on my memory, and during that decade spelled out our impatience and not wanting to put up with that anymore. So photography, whatever the form of the medium, was the visual eye-witness, brought to the multitudes in some kind of cohesive form, artistic or not. It doesn't make much difference. We have affected history, visual reporting has affected history. And to me, that is enough.

D: There is a modest and humble band of brothers to which you both belong. . .

C: Modest? Modest?

U: Must be *your* family. Couldn't be mine!

D: I'm referring to that *Life* magazine without a printing press. Cornell, you were one of the originators of Magnum. And you, Burk, were its most recent president. What does the word mean, how does the organization function, what is its role? That's the most cheerful smile I've seen on either of you today!

C: I'm enjoying myself because it is his job to explain it.

D: Well, you can tell us the origin. And then you can refute his current interpretation. Isn't that what a meeting at Magnum is like?

U: Chaos is the only word for it. Magic and chaos.

C: The exciting thing about its birth, is that it started out with my brother Robert Capa, Cartier-Bresson, and David "Chim" Seymour in 1936, in Paris. The 35 millimeter camera had just been invented. And these three had the idea that they could do some photo reporting with a camera, without posing anybody. Then almost simultaneously came the major magazines of the world. It was like the invention of photography, which everybody invented at the same time. Magazines were imprinted almost all the time. *Paris-Match* in Paris, *Picture Post* in London, *Life* and *Look* in the United States, not to mention the German magazines which really started before that. So the whole of picture journalism sort of busted on the scene. Then came World War II, which really added to the confusion. Correspondents went, not with arms, but with their cameras, and covered all kinds of things. And when the war was over, there were the same three, plus two

other people, George Rodger and Werner Bischof. Well, we have a problem, because maybe it wasn't five, but seven.

D: How many members are there now?

C: About 30. Anyway, at that point the postwar group remet and made a conscious decision that they were going to be the worldwide eye-witnesses for worldwide magazines. They would not work for any one magazine. They would work for themselves and would enforce their own aesthetics and their truth, what they saw, on all publications that they would work for.

D: How did *Magnum* get its name?

C: Something large and bubbly and marvelous. That's what a magnum of champagne is about.

D: And in its current vintage?

C: Still hopping from rock to rock as the water gets higher. The meaning of it still is just responding to your time. Times have changed.

D: How is it different from any other corporate structure? Why do photographers need Magnum?

C: I think there's something in the relationship of photographers to each other. It's a family; it's not really a corporation; it's an experience, a human experience. It's sharing time not only with your work, but with other people to whom work is similarly important. It think it's a wonderful place to be because of that sense of excitement and unrest and response.

D: Who are some of the members?

U: Well, there are members in New York and Paris, but in New York there are Elliot Erwitt, Bruce Davidson, Charles Harbutt, Leonard Freed, Cornell Capa, Wayne Miller, Burt Glinn . . .

C: Marc Riboud. We have a temporary founding, eternal member, Cartier-Bresson.

U: Yeah, it just goes on and on.

D: And what was your most memorable experience during your presidency, Burk?

C: I have an answer to that.

U: Well, I think my most memorable experience was the day I was able to hand it over to the current president.

C: That was the same thing I thought of!

U: It's a wonderful experience to do, and to be out of. It's the greatest relief that you've done your job and paid your dues and can then go take photographs again. Which is after all why you're there in the first place.

D: And that's what we're waiting for you to do, Cornell. When will that be?

C: Soon. But I have one more word about Magnum. I think it isn't a corporation. The word is cooperative, because in its best sense, that's what it is . . .

Alfred Eisenstaedt

Alfred Eisenstaedt was born in 1898 in West Prussia. He has spent more than 50 of his 82 years behind the camera. One of the most successful and prolific of photographers, his work witnesses a world we want to remember.

Barbaralee Diamonstein: After an early career as a button and belt salesman, you became a photojournalist in 1929. Many people, including Henry Luce, have called you the father of photojournalism. Since you are one of the founding fathers of this modern form of journalism, what do *you* mean by 'photojournalism'

Alfred Eisenstaedt: First, I am not a father of photojournalism: let's say I'm a son. The father of photojournalism was really Dr. Erich Salomon. Now, I worked side by side with Erich Salomon, and this is how that happened: before I became professional, I sold one or two pictures to a weekly magazine like the *New York Times Magazine*. The art director said, ''Look, these are all very fine pictures, but you should do what Dr. Erich Salomon is doing.'' He was at the pinnacle of his career at that time. By then, I was very well known already in photographic circles. The Associated Press, who distributed my pictures to newspapers and photo magazines, said, ''Why don't you work as a free-lancer for us?'' So I bought a camera like Salomon's, an even better camera . . .

D: What camera?

E: It was the legendary Ermanox camera: a small camera, a so-called candid camera. We had to use glass plates. I photographed intensively the prayers at the Salvation Army and Marlene Dietrich, social functions, meetings of poetry societies and so on. I was never very good at selling belts and buttons. Actually, I was so bad, I hated myself. And on

November 29, 1929, my boss said, "Look, either you stay with us or you switch over to whatever you call it." I said, "It is photography. Photography." So I told him that he would know in two or three days, and on the 3rd of December I told him, "I'm switching over to photography." Everybody looked at me as if I had dug my own grave. Six days later, I was on my way to Stockholm to cover the Nobel Prize ceremony. Thomas Mann got the Nobel Prize in Literature that year for *Buddenbrooks*.

D: You are known for your generosity towards other photographers. You're willing to give a lot of credit to a lot of people. So I wondered if you'd be willing to share that title of the father, or the son, of photo-journalism with anyone other than Dr. Salomon.

E: Well, at that time nobody else existed. This was a wonderful thing. People ask me, "How did you break in?" I say, "Because there were no other photographers around." Today I couldn't do it. I mean, photography was unknown then. When I photographed Alfred Cortôt, the great interpreter of Chopin, in Berlin in 1932, I sat right beside him on the dais as he played in white tie. If two photographers had been there, it wouldn't have been possible. But I was the only one, because I was very much interested in art and music. There was nobody else around.

D: Earlier you mentioned the so-called "candid camera." What is the origin of that term?

E: I didn't invent the term; it was invented in America. I don't even know what a candid camera was. The candid camera is a myth. A candid camera is really not a candid camera, because everyody sees the camera. But before the candid camera was known, people took pictures with 4 x 5 cameras. They are large cameras.

D: I have read that a London picture editor coined the phrase, "candid camera", to describe the kind of photographs that were taken of people, rather than the camera itself. The term may have its origin in Salomon's work.

E: Yes, Salomon had a candid camera, and later, when he came to America, he had great trouble. He was the first man to photograph a session of the Supreme Court and he could never come back to the country. He had his camera built into a briefcase, and it was discovered.

D: What did you think of those ethics?

E: Oh, I think that kind of thing is never necessary. You see, I'm just the opposite. When people don't want to be photographed, or photographs are restricted, I obey orders. That's the reason that I am welcome everywhere. Some people, like Sophia Loren, for instance, ask to see the picture first. She has never rejected anything, but she sees them. And she and her husband, Carlo Ponti, welcome me as a member of the family.

D: She is one of your favorite subjects?

S: Oh sure, because she's terrific. There's no doubt about it.

D: You worked for the AP, even before it was the AP. Can you tell us something about that?

E: Yes. When I photographed the Nobel Prize award given to Thomas Mann, it was still called Pacific and Atlantic Photos. My second assignment ended in disaster. When I look back I can't believe it. It's very funny, you know, in hindsight. I was assigned to cover the wedding in Assisi, Italy, of King Boris of Bulgaria to the youngest daughter of Italy's King Victor Emmanuel. This was 90 miles north of Rome. I left Berlin with 240 pounds of baggage, just glass plates and steel cassettes and heavy cameras. I was just fascinated by the pageantry. All these choir boys in the procession to the church, and all these monarchs. There was King Ferdinand of Bulgaria—he had the longest royal nose, an enormous nose, I think. Mussolini strutted by. I photographed and photographed everything, and I was very happy. But when I came back to AP headquarters in Berlin, we developed everything, and they said, "But where are the bride and groom?" And I said, "What bride and groom? I never even saw them."

D: You forgot?

E: I forgot. They didn't even occur to me. I just didn't know. Ola, the head of the picture division of the Associated Press came from London and said, "This man has to be fired." But they couldn't fire me; I wasn't employed. I was a free-lancer.

D: What was your third assignment?

E: Oh, I don't know. I did all kinds of things. I very seldom photographed in Berlin or even in Germany. At that time, all these great political conferences were going on, and I covered them all, in Lausanne, in Geneva, time and again. But one of my first assignments came from Berlin, *Die Dame*. I still have some tearsheets. I did them for Kurt Korff, who gave Henry Luce the idea of starting a photo magazine.

D: Who was Korff?

E: Korff was the managing editor of the *Berliner Illustrierte*, the leading illustrated newspaper. Because I already had a reputation he wanted me to go to Switzerland, to photograph St. Moritz. I was a virgin then. I mean, I didn't know what was going on in the world. So I asked him, "What shall I do there?" And he said, "You can do anything you want, society and so on. If you can't get that, come back with a picture where snow looks like sugar. Then the trip will be worthwhile." I got that picture, but it was never published.

D: He never published it even though he asked for it?

E: No, that picture wasn't published, but I have it in one of my books. But I photographed Gloria Swanson, and Deterding, the president of Shell Oil Company, and fashionable

V J Day, 1945

society people at the Palace Hotel. I did all the pictures of Lady Astor skating at the Corviglia Club, and the Duke d'Alba. I photographed them all.

D: How did Kurt Korff inspire Henry Luce to start *Life*? How did they meet?

E: I don't know. I met Korff only once or twice. He was a rather invisible man. I still have a picture of him. He didn't say very much but he gave the idea to Mr. Luce, and Mr. Luce started *Life* magazine. I did quite a lot of work for *Life*.

D: By 1935, when the Nazis were growing in power and influence, you left Germany.

E: Before I left, I spent several months in Ethiopia just before Mussolini declared war. I did quite a lot of work there.

D: Did you photograph during the war?

E: Not during, but just before the war.

D: What about that celebrated photograph of the mud encrusted sole of an Ethiopian soldier?

E: I took that during a maneuver.

D: How did you get to Ethiopia?

E: I took a freighter from Marseilles through the Suez Canal, and travelled from Djibouti by train to Addis Ababa.

D: Do you remember everything?

E: At first I kept diaries, but I lost all my German diaries from 1934 to 1936. Every day I would write, but not observations, only telegrams of what I did.

D: Just a chronicle of the day's activity, and with whom you did it?

E: Yes.

D: Has that been valuable?

E: I mean, my goodness, things like that you don't forget. From Djibouti, it took three and a half days to reach Addis Ababa. But those were just wonderful times, because photography was really in its infancy. You could do anything. When I returned to Ethiopia in 1955, everything was different. I was surrounded by tribesmen, and they were threatening me. They had made progress. In 1935, everyone was still running around barefoot.

D: When you returned from Ethiopia, did you decide to leave Germany?

E: Yes, the head of the Associated Press decided to leave. It's very interesting—I had permission to work in Germany because I had been in the First World War. Only one other photographer had permission to work. Before I left, I wrote a letter to the propaganda ministry, to tell them to erase my name because I was leaving Germany. I was not kicked out; I told them I was leaving.

D: However, it would have been a question of time.

E: Yes.

D: Before that, you had the opportunity to photograph

several people who were not only influential but central to that rise of power. You have early photographs of Mussolini and Hitler and of Goebbels. What were the circumstances leading to these photographs? What do you remember about the sessions?

E: In 1934, I did a whole big story for the Associated Press on King Gustav V in Stockholm. And then I got a wire telling me to come to Berlin and proceed to Venice, where the first meeting of Mussolini and Hitler was to take place. Now, I was able to approach them close because about two months earlier, I had done a story for Kurt Korff on Italian society. So I knew all these ministers, the people who gave permission. That's the reason I was there. Hitler arrived in a Fokker plane and Mussolini was like a peacock, standing with his arms at his side. Hitler was only Chancellor of the Reich then, not Führer. He became Führer of the Reich two months later when Paul von Hindenburg died on the 6th August, 1934. So Hitler was in mufti, in a felt hat and a raincoat. Mussolini looked down on him. They probably never liked each other very much, especially at the beginning. I was so close to them that later on, when Mussolini spoke at the Piazza San Marco in Venice, I was arrested for one or two hours by police. They checked with Berlin whether I was really from the Associated Press. Everything was fine, and I took quite a few pictures there.

D: Where did they appear?

E: All over the world. The year before, in 1933, I went to Geneva where I photographed the famous picture of Goebbels looking at me. The 15th session of the League of Nations was going on in Geneva. Maxim Litvinov spoke, and Engelbert Dollfuss, who was later assassinated by the Nazis.

D: Your new book is entitled *Eisenstaedt: Germany*. You returned several months ago to Germany for the first time in 44 years.

E: Forty-four years since I worked there. But in 1962 or '63, I travelled for one and a half or two days to Germany, to Collogne, to receive the Culture Prize for photography. The Culture Prize was a big lens, with a scroll in gold leaf.

D: When you returned to Germany to work after this interval, did you think of it as your native country?

E: No, no, no. And I'll tell you, when I had approached publishers in America, they always said, "Nobody wants Germany." They didn't like it very much. But I know Gregory Vitiello, Editor of Mobil Oil's *Pegasus* Magazine, and three or four years ago, I showed him all the pictures of old Germany. At that time Mobil Oil wanted to publish a book. Later on, they dropped it. But it was picked up by United Technologies Corporation. Then we decided it would be a good idea to go back and do a book on Germany in the Twenties and Thirties and now. And this is what happened.

D: Why did you stay away so long?

E: Nobody asked me to go back. And I was busy.

D: Is that really true?

E: Yes.

D: No philosophical or other reasons?

E: No, no, no.

D: In what way did you find things had changed?

E: Oh, the older people, I'm sure, think very differently. For instance, when I went to Germany, I wanted to photograph two people I had photographed in the past, Leni Riefenstahl and Max Schmeling. It took months and months and months to get their permission. My departure from Germany was set for April 6, 1980. And Schmeling cabled us that he was available on the 9th of April, three days later, for 15 or 20 minutes, at 8:40 or something in the morning.

D: Did you . . .?

E: Yes, I stayed longer. I didn't want to stay longer. But I have made one mistake in my life and I didn't want to make it again.

D: What was that?

E: I didn't stay, and I have been sorry all my life.

D: Was it worth staying?

E: Oh, absolutely.

D: Why?

E: It has never happened ever that the same photographer photographed the same people 50 years later.

D: You've always said that you disavow any kind of political interest.

E: Yes. I am very apolitical. I read: I'm very much interested in politics. But I don't belong to any party.

D: But in your photograph of Leni Riefenstahl that you took recently, she was lit by a glow that produced some kind of equivocal expression, to say the least.

E: Airy.

D: To me, the aura created by that glow, and her expression, were not unlike Arnold Newman's portrait of Alfred Krupp, which has a really diabolical feeling.

E: No, no. You see, she works with a light table a great deal. Now, when you have a light table, you're lit from below. A bizarre photograph there, but I wasn't thinking diabolically. You see, I'm very different. I always want the best of any subject to come out. I never think of underlining ugliness or somebody's bad features. I always want happiness and goodness.

D: That's another reason everyone must want you to photograph them!

E: I never thought about it.

D: Well, did you ever have a subject whom you didn't like? I don't only mean personally, but someone who represented an idea or a way of life that you found in any way odious?

E: No. If I found such a person, I would still do my best and photograph them as I wanted. I never think in terms of politics or of giving someone a bad image.

D: Is there anyone you've ever refused to photograph?

E: I don't think so. I had real difficulties only with one man, and that was Ernest Hemingway.

D: Was he a difficult subject?

E: He was very difficult, yes. The Duke of Edinburgh was also difficult, but otherwise I didn't have difficulties. It is not psychology with me, but I have to know in a jiffy, very fast, the first minute I meet somebody, whom I can slap on the back, whom I call Barbaralee, or Miss Diamonstein . . . You have to sense this, you know. Now, when I photographed Churchill at his estate in Chartwell, in 1951, I had to wait more than two hours, because he was having lunch with the Whip of the House, a charming young man. We got tea—it was very lovely—and had to wait. When Churchill came down, he had had a nip too many, as often happened, you know. He said something like, "The captain was sitting on a ship and a big wave washed over." And he looked just like that. He was sitting there in the library, and I wanted to photograph him with some fish tanks in the background. Do you know what his hobby was? His relaxation? You won't believe it. Everybody laughs; they can't believe it. He watched the mating of guppies, these little tropical fish. So when I knelt in front of him he said, "Young man, don't photograph me, this is my bad side. Here is my good side." I wanted to do just him and the fish tanks, so I was perturbed. The charming Whip said to me, "Mr. Eistenstaedt, just do what the old man says, but do it your own way, too." Then Churchill said, "I'm a photographer too, and I know." So I photographed his other side. But he was charming. You have to play it right, you know. If he had refused, then I wouldn't have done it, naturally. But at that time, he was a little upset, some people told me, because two months earlier he had been photographed by Philippe Halsman.

D: Did he jump for him?

E: No, he didn't jump as far as I know. I don't think so. But he spent two hours in the garden, and he took much too long.

D: Why was Ernest Hemingway so testy a subject?

E: I'll tell you exactly. In 1951, I was sent to Cuba, to San Francisco de Paula, a suburb of Havana. We photographed a cover portrait of him for *Life,* for *The Old Man and the Sea.* At first I didn't know how to handle him. The door opened, and what do I see, Ernest Hemingway greeting me already with four letter words. Every sentence, I think, had four letter words. And he was standing there half nude, brown, very sun-very old, faded, dilapidated shorts. He said, "You call me

said, "You call me Papa, Papa." I asked, "Do you have a shirt to put on?" This upset him unbelievably. "What?" He said. "No, I don't have a shirt, why do I need a shirt? Look at my body, look Marlene Dietrich, Greta Garbo, Gloria Swanson, all these famous movie actresses love my body." I said, "Papa, look at me." I pulled up my shirt sleeve. I said, "Do you have a knife? A pocket knife, a sharp pocket knife? I'm very strong, you know." He looked. I wanted to show him that the knife would bounce off my muscles. He said, "Mary, Mary, he's a little Papa."

D: So the session went well after that?

E: Yes. At first he distrusted my intentions, he didn't believe me. I wanted different things. He said. "I will call my lawyers in New York." And Mary, his wife, said something I've never forgotten in my life. She told him, "Papa, if you do it, do it well, or don't do it at all." Great, isn't that?

D: Did he pay any attention to that?

E: He did. Anyway, the people in New York said, "Just go ahead and just do anything Mr. Eisenstaedt says." So we had lunch and he insulted me, naturally, the whole time. Bang, bang. Editors didn't pay him enough, only $40,000, which at that time was enormous. A priest came to lunch, and Hemingway told him, "This man has sold his soul to Mr. Luce." And so on and so on. I wanted to do a possible cover, so I said, "Papa, get up on the ladder." And he didn't trust me. I said, "Look I put my camera on the tripod, just look through the lens. This is what I want." And then the same afternoon we went into Cohima. All the fishermen there didn't know he was a writer. To them he was the great fisherman. Right in front of him, a little boy asked his father, "Daddy, who is that actor?" Hemingway got so berserk, he tore his shirt to shreds and threw it away. He had a stick in his hands. He smashed it to bits, jumped up like a goat. After ten minutes he came to his senses again, and said, "Look, Alfred, touch this. I've got a shrapnel wound on my head here." And oh, there'd be trouble all the time. The next day was horrible. We went to Cohima, where I photographed the hands of the old men, fifty feet from a restaurant called La Terrazzo. Hemingway was sitting there with a friend, and Mary, eating onions and something else, I don't know what. Drinking gin and rum. He thought I'd go snap, snap, snap, and that's it. But I just stayed away 20 minutes. When I came back, boy, he got so upset. He said, "You could have killed that man," and so on and so on. He meant the man could have died from heatstroke. We went to a deep sea fishing contest near the Morro Castle. The night before he told us, "Don't come too close to my boat when I'm fishing." He had a speedboat. "If you come too close, I'm going to shoot at you."

D: He didn't want you to interfere with the wake of his boat?

E: That's right. When we approached him, he said, "Don't come closer than 200 feet. We came 400 feet. And then that afternoon at the Royal Yacht Club, at the Morro Castle, I forgot to think about what I was saying. You always had to think what you were saying around him. He was drinking, and I had my two cameras around my neck. And he said, "Look Alfred, you came too close. I shot at you." I said, "O, Papa, I don't believe it." "Don't believe it?" He dropped his glass and almost broke my spine over the railings by the water. He didn't hit me but he feigned it. I put my hands around his neck to pull myself up, because otherwise I would have fallen. Never say you don't believe Papa. An hour later, he went to the Floridita Bar with Mary and some friends. Naturally he didn't remember anything. And Mary said, "Gee, Alfred, I didn't know that you like men." She thought I wanted to kiss him. She didn't know what was going on.

D: Did you ever go back again?

E: No, I never saw him after that. But there have been other difficult assignments. Last year, I had to photograph Baryshnikov. We were told we didn't have too much time to photograph him. He would be available between 10:45 and 11:00. We were at the theater at 10:30. I had my cameras already loaded. At 10:35, Baryshnikov came in and said, "You have to finish, you have to be out within five minutes and not six." He was rehearsing for the television special "Dance in America." He was really very nice, but not helpful. It was raining outside, and it was so dark, that I had to photograph with the lens wide open, 1.2 at a 15th to a 30th of a second. There was no light, and he was so nervous. I said, "Mr. Baryshnikov, this is a time exposure. Would you be so good not to move." For one second, he looked at me and I could photograph him. It was a full page in *Life*. You know, things like this happen, and you think you can do wonders. I could only take one picture. I couldn't do him rehearsing. Nothing. A portrait, that's all I could do.

D: That must have been difficult for you, because you find the picture essay a particularly satisfying form of communication. Do you think it's a more truthful and a fuller story than a television broadcast?

E: The difference is that television has set up things most of the time. When I do stories for *Life,* I try not to set it up. You have to go behind the scenes. When you look at television, you can't keep the pictures. But when you photograph you can keep a print forever.

D: Has television changed your career?

E: I have had a television set only since about 1963. After Kennedy was assassinated, I bought a television. But the demise of *Life* was related to television. *Life's* circulation was about 7 million, and the advertising rates were enormous. TV

Ethiopian feet, 1935

advertisers could reach a larger audience more cheaply, at that time.

D: How many *Life* photographers were there among this elite corps?

E: At one time there were 32 staff photographers at *Life*.

D: Was there any unifying force or principle shared by the 32 *Life* photographers?

E: We had to have talent.

D: Was it a nurturing, creative environment?

E: Oh, yes, We photographers were a little different. Now, when I started, Margaret Bourke-White, Peter Stackpole, Thomas MacAvoy and I were the first staff photographers.

D: How did you get assignments? Could you choose? Did you have a specialty?

E: No. We could sometimes suggest. Today this happens very rarely that anybody suggests. That the editors say what they want is much better.

D: Why is that better?

E: You have to try to sell an idea. For instance, in 1962 I had to do a story on the behavior of monkeys for *Life* magazine. I had to travel to India. Now, they published two pictures of monkeys, but I was there six or seven weeks. Monkeys were all over India, so you had to go all over. I photographed all kinds of things besides monkeys. For instance these lovely pictures of the Taj Mahal.

D: One hears a great deal about the ''decisive moment'', as Cartier-Bresson called it. I have often wondered about the photographer's missed opportunity, like your second assignment. There must be a number of missed opportunities in a lifetime, particularly when you've been photographing as long as you have, covering so many events and people and circumstances. Are there any opportunities that you feel you missed in a particular place?

E: No. I don't remember anything I missed, only that bridal couple in Assisi. But there are several instances which I've forgotten. It has something to do with *Life* magazine. For instance, people always ask me, do the editors tell the photographers at the beginning what they have to photograph. I say no. We are all individualists; we can do anything we want. Before *Life* came out, the Hearst papers would tell the photographers, ''We want this and this,'' and ''Do this and that.'' But for *Life,* you can do anything you want. I remember at the beginning we had an editor, Daniel Longwell. He said to me once, ''Alfred, you have an assignment.'' I had to do an essay on Roosevelt Hospital here in New York. Longwell said, ''The only thing I do not want to see is blood. Do it as you would a college.'' It is the opposite today. Two or three months ago *Life* had a story shot in an operating room. People were standing in blood up to here.

D: You came to this country in 1935, and about a year later you were working for Henry Luce at *Life* magazine. You had a lot to do with the two original dummies of the magazine. What was it like in the early days of *Life?*

E: Heaven, it was heaven.

D: What was the direction, the genesis and evolution of that magazine? After all, you worked on the dummy and you stayed with the magazine until the end of the first *Life* in 1972.

E: The *Life* photographers were a special elite. Those times will never come back.

D: Elite in what way?

E: Every youth in America, or the whole world, wanted to be a *Life* photographer. *Life* was like a glamorous movie queen. We travelled extensively, and did so many stories, and saw the world. It was wonderful. Money was available for travelling and so on.

D: When the magazine was starting up, what was its approach? What was the idea behind all of this? Who was the first editor?

E: If you read *Witness to Our Time,* you will see what Luce wrote in the introduction about seeing the world, recreating some of it. This was all written before the advent of TV. The demise of *Life* started a few years after TV appeared. At that time, we showed the world what the world looked like. But if Nero died today, you would see television footage of him dying not an hour later, but five minutes later.

D: In 1965, someone made a count, and by then you had done 1,728 stories for *Life*.

E: Yes. By now I have done more than 2500.

D: Can you tell us some of the themes that you covered in those 2500 stories—from monkeys to Sophia Loren. Which were the most memorable?

E: I have done memorable things. For instance, the story - 18 color pages - of Marjorie Merriwether Post. She was the heiress to the General Foods fortune. She had a big estate in Washington, a big estate in Lake Placid, and in Palm Beach. So I had to cover them all. It took a very, very long time to do it.

D: What was your longest assignment?

E: Oh, going to the Galapagos and doing a story on the rain forest in Surinam. In 1955, I went to Ethiopia again. And I travelled with Vice President Nixon.

D: Where did you travel with Nixon?

E: In Central America.

D: Have you covered many inaugurations?

E: I have covered the inaugurations of Truman, of Eisenhower, of Kennedy, and of Nixon.

D: You did the official portrait of Kennedy?

E: Yes. It was a pleasure to work with Kennedy. He liked my work. I did pictures of all his ambassadors and his staff for *For-*

tune and *Life* magazines. He wanted me to take the official photographs. He postponed the assignment from evening to the next day, so I had to buy extra safety pins to close the curtains in the Oval Room to keep out the daylight. He was a very nice, charming man.

D: Are you planning to cover the Reagan inauguration?

E: No, I don't think so. You know, the only president I didn't photograph was Carter.

D: How did that happen?

E: We have so many photographers running around in Washington. And *Life* didn't publish Carter.

D: Did you ever photograph Ronald Reagan before he was elected to the presidency?

E: Oh, yes, when he was Governor of California. Yes. I photographed him in 1970. On the back of this photograph, it says, "Governor Ronald Reagan and Eisenstaedt in San Francisco, October, 1970." We both haven't changed too much. See what he wrote in my book.

D: This is one of your famous autograph books, I assume.

E: I have several books. They're all full.

D: This one says "To Alfred Eisenstaedt, with appreciation, with memories of the easiest and most pleasant sessions I have known. Best regards, Ronald Reagan, October 5, 1970. San Francisco, California." Here are James Buckley, Bob Haldeman, Richard Nixon and Rosemary Woods, who all say what a pleasure it is to be photographed by such an expert. This inscription from Haldeman, May 20, 1970, says, "With appreciation for your great skill and artistry in a profession which I enjoy as a hobby." Here are Herbert Klein and Chuck Colson. You must have photographed everyone that day.

E: All the President's men. . .

D: Colson says he is glad he is joining your gallery. He would be "even more complimentary if you had successfully erased his double chin." They all see themselves as part of the Eisenstaedt gallery. Your books of autographs are legendary. Have you asked people for them for a long while?

E: Yes, all except Bing Crosby. When I came to this country I didn't know who Bing Crosby was. I photographed him years and years later.

D: Here are two more, from a month earlier. One says, "To Alfred Eisenstaedt, a sensitive and perceptive artist, with a high regard and many good wishes from his friend, Henry Kissinger." And right below that, it says, "To Mr. E." Do you think it is possible that he didn't know how to spell your name? This goes on "With fond memories of a day in October, 1970, in Ohio when you were taller than I was with the help of a friend." I'm talking about John Erlichman here, who had a lot of help from some friends, and even gave some. This is a letter dated about a month ago, from United Technologies,

the sponsor of your German Exhibition. It's from the president and chief operating officer of that company, who remarks that he's pleased to have been with you at your opening at the National Museum of American Art in Washington. He is delighted for you, and for all that you've done to help both this country and United Technologies make this an outstanding exhibition. This is from Alexander Haig, now the Secretary of State. He signed it "Al," from Al to Al. Tell us something about these people, all of whom obviously have great affection for you.

E: I photographed Alexander Haig and Henry and Nancy Kissinger time and again, when they were with Nixon in the White House.

D: You've photographed Nixon over probably a twenty year period. Where there any surprises or something new that was revealed to you?

E: You mean, politically?

D: . . . Or personally.

E: Personally, I got along fine with him. But the last time I photographed him was in May of 1970, after the disturbances near the White House, after he invaded Cambodia. He was very different then. He was very troubled. When I photographed him, it was almost too obvious. The pictures were published in *Fortune*.

D: Where and why did you ever get the idea to have everybody sign your autograph books?

E: I'll tell you. When I covered Italian society from Germany in 1932 or 1934, I travelled with a woman reporter. I was always interested in beautiful leather-bound books. She said, "What you should do is start keeping autograph books." I started with small books. I even have Goebbels and Dollfuss.

D: What are you going to do with all those books?

E: They will go to my sister-in-law. They are very valuable.

D: As we sit here in your windowless office, surrounded by all these beautiful yellow, red and black boxes, it's obvious that you are an orderly and organized person, something many photographers, unfortunately, are not.

E: I have another room, which is not organized. And I'm presiding over some disorganized mess even here in my room.

D: Well, the boxes make it look very tidy. I read somewhere that you have given your negatives to Time Incorporated, and a big photo archive to Yale University. Is that accurate?

E: No, no. Yale University once wanted that. Thank goodness, it didn't happen. No, when I go to heaven, this all goes to Time Incorporated.

D: Why did you choose to do that?

E: Because then they will be a living monument. If you give things to Yale or the Beinecke Library, who wanted my photographs, or to the Library of Congress, it sounds wonder-

Alfred Eisenstaedt

Hemingway at Cojima, 1952

ful to read in the paper—"Eisenstaedt gave his entire collection to the Library of Congress." But you know where it goes? Into a sub-basement never to be seen again.

D: Let's come back to the autograph books for a moment. Have you learned to use them as a technique for getting to know your subjects?

E: There is only one autographed name whom I didn't photograph, and that was Picasso. I think I gave my autograph book to Bob Capa in the Sixties. He said, "Look, I'm going to have to do something about Picasso". I always start a book with a famous name. And he wrote right on top. There are loads of people I haven't done. Indira Ghandi, for one. I photographed Khrushchev, but never Brezshnev. I have never been to Russia. Now I don't travel so much anymore.

D: Besides knowing which people to call by their first name, how do you make your subjects feel more relaxed, more trusting? Obviously, one of the things that you do, is to give people a sense of confidence.

E: First, it naturally makes a difference that people have heard of me. This helps. But it wasn't always that way. And I rarely mention that I'm from *Life* magazine. I come as a friend. I have very little equipment. I read quite a bit, and know the news. I can talk about music, art, and everything. The least important thing is the camera. I talk to them, as man to man, or man to woman. And people probably trust me.

D: But sometimes you've had to resort to simple techniques when there is an unwilling subject. What about Tojo, the Japanese who you photographed just before he was executed?

E: Sometimes there are moments when you have to exclude your brain, react only with your eyes and your fingertips. Exclude the brain, because if you start to think, it's too late. When all the war criminals were brought from Sugamo Prison in Tokyo to be indicted, I was standing there with other reporters. They walked this way, very slowly. So, within a thousandth of a second I thought, "What do you do to attract his attention?" And in a flash of a second, I said, "Tojo, look at me." He was startled, so he turned around with a surprised look. That's the picture.

D: So, sometimes the simplest and most primitive form is the best.

E: Then I travelled with the royal family of Great Britain. I had to photograph the Queen coming out of a church somewhere. People said, "What did she wear?" I said, "I don't know, I saw only a fleeting image and photographed it." Just no time to think, react. Eyes and fingers; exclude your brain. It's very important, for portraits, that you talk to people. People have to like you. You have to know something. I don't talk about cameras. I have my little camera. When I met my late wife, for instance, I photographed her several times,

and she said to me, "But where is your real camera?" This small Leica is my real camera.

D: Do you generally set your equipment up on a tripod as you're talking to people?

E: No, very seldom. Sometimes it helps, but you don't have to do that every time you take a portrait. Sometimes people pull back from it, and put their heads at the wrong angle. Because I don't like to be photographed, I come out horribly. I just don't know how to pose. My late wife was wonderful the first five or ten years before the camera. But later on, she was a little self-conscious. I can't pose. Because I want to look good I end up looking terrible.

D: We need another Eisenstaedt to photograph you. Have you ever had photographs made of yourself, that you think measure up to the standard of your own work?

E: Yes, my late wife took some pictures. You see those pictures over there? They are all Eisenstaedts with me in them. In the old days of *Life*, we always had to bring back pictures of ourselves on assignment. Quite often these were used in the front of the magazine or somewhere, for promotion.

D: Other than talking to people and quickly sizing them up, how do you make your subjects comfortable? Obviously photographers say such uninspired things as, "Look this way," to their subjects.

E: You see, my strength is more or less in composition. So when I look at your face I see already that the background is correct or incorrect. I move you, or I move the background. For instance, the last thing I did, about four weeks ago, is not a good picture. I photographed five people at the Jewish Theological Seminary. With Ambassador Sol Linowitz. I used flood lights instead of strobes.

D: Why don't you like using strobes?

E: Strobes help a little bit, but I wouldn't be the original Eisenstaedt any more. Strobe pictures all look alike. If I were younger today, then I probably would have strobe lights, but then I would need an assistant. It is a very different game today.

D: What are the more striking differences? *Life* photographers, including yourself, went out by themselves and did what they had to do. Today, photographers have a whole retinue of assistants.

E: Yes, but I don't. I always go alone. Only very rarely do I have an assistant. When I photographed the essay on Marjorie Merriwether Post's mansion, Mar-A-Lago, in Palm Beach, I needed one assistant to light it. Otherwise photographing wouldn't have been possible. Today, strobe is absolutely imperative when you work commercially, doing fashion photography or annual reports.

D: Another difference is the emergence of photo agencies.

They are lifting the burden of administration from many photographers and photojournalists. There are agencies that get assignments, arrange transportation, have messengers and film developers, allegedly leaving the photographers free to shoot the stories. How have these agencies changed the field, and how has the field changed in your time?

E: Oh, I don't know. I don't have an agent, so I can't tell you.

D: Did you ever have an agent?

E: I had an agent once for some commercial work after *Life* folded up. But the interesting thing is that the art directors at agencies are all young people. They are accustomed to working with photographers who are under thirty. Somebody who is 35 is an old man. And somebody like me is inconceivable. I should have been dead 50 years. I didn't realize this at the time, but they don't want to work with a man who has a name. Did you know that? They think that he will expect too much money. But you know what actually happens? He asks for too little because he doesn't know the going rate. The agents of some other photographers ask for much more.

D: Besides the question of money, one can direct a lesser known photographer in a way one cannot with someone who has established an independent reputation.

E: Could be. I only know the most important thing: they don't work with anybody who is a little older.

D: What do you consider the most striking changes in photography in the most recent period?

E: Oh, there are many, many young photographers who have enormous talent.

D: Are there any to whose work you particularly respond?

E: No, there are many people. I was asked the other day—I had to laugh—''Do young photographers come to you for advice?'' I said, ''Me, for advice? No, I go to them for advice.'' I mean they shoot differently, technically differently. The young photographers today don't come to me, they know everything better.

D: Have you ever been interested in teaching?

E: Oh, no. I give lectures, sometimes. No, I couldn't teach.

D: Why?

E: Nobody would believe me. They would ask me about strobe and I don't know anything about it.

D: But you are emphasizing the technical aspects, something that's really never concerned you.

E: But you see, most people ask about technique and about things that are not important to me. I started as a self-made man, developed everything myself. Nobody could help me because there was nobody there. I had to learn everything myself.

D: What if they asked you about the most important things

we should know about your work. How would you answer that?

E: It probably has very much to do with personality. I have some humor left, and I just don't take myself too seriously. Sometimes people are awe-struck. I once asked, ''Why doesn't so-and-so come over to me'' and I was told, ''Oh, he's in awe of you.'' I said, ''In awe of *me?*'' What is a photographer compared to a doctor? to a composer? to a great scientist? Nothing. I think this is the most horrible thing, for a person to say he is in awe of anybody. In the beginning, in 1938, Wilson Hicks, the famed picture editor, sent me to Hollywood. And he said to me, ''Alfred, I have only one piece of advice for you. Don't be afraid of those movie queens. You are a king in your profession, don't be in awe of them.'' I've never forgotten this and I have learned not to be in awe of anybody. I look up to people, but I am not in awe of them.

D: No subject has ever intimidated you in any way?

E: If you are the President, I'm not in awe. These people, whether it's the President or whoever, don't like to be looked upon in awe. They don't like it.

D: You've had a very rich, full, exciting, glamorous life, and I assume you have few regrets that you became a photographer.

E: I *have* had a very, very full, rich, exciting glamorous life. Let me say, I am still with Time Incorporated. Nobody, probably, is as old as I am. But I don't look and act like it. Right? I have done more than 2,500 stories, and the most important thing is when I come to a person, I don't think photographically, I come to a human being.

D: I know you never wanted to be a button and belt salesman, but how about something other than a photographer? Would you have preferred to be a musician or a doctor, yourself?

E: Oh, no. If ever I should retire, I have other hobbies. I love music, walking, and horticulture. The number one would be horticulture. I am very interested in orchids and cacti. I have all kinds of books, and soils and earth and mulch.

D: Do you have a greenhouse?

E: Oh, I'll tell you a story about that. In the late Fifties, I travelled with John Hay Whitney to Thomasville, Georgia, where he gave a party for thirteen generals. He showed me his wonderful greenhouses and I said, ''Oh, that plant over there would be wonderful for my little greenhouse.'' So he said, ''Take anything you want for your greenhouse. How large is it?'' I said, ''18 inches high and 30 inches long.'' Naturally we laughed a lot about this.

D: Has it grown since then, your greenhouse?

E: Oh, no, no. I have different things in it. It changes a little bit all the time.

D: Some of your early works were sepia-tinted nature studies which might be related to your interest in horticulture. How

Above left
Carol Lombard on motorcycle, 1938

Above right
Marilyn Monroe, 1955

Ronald Reagan, 1970

Alfred Eisenstaedt

Melitta Brunner in St. Moritz, 1932 Robert Breguet on Ice, 1930

did those projects begin?

E: It was part of the trend. The paper was brown, then. I became a photographer on account of this picture. I printed it myself. It was 1925 when I photographed this. This tennis player was the first picture I ever sold in my life, for $3. It was taken in Johannesbad in Bohemia, now Czechoslovakia. I was there with my parents and I was very interested in photography. I had this 9 x 12 centimeter Zeiss Ideal camera, with glass plates. I photographed a whole scene of a sunken plaza. The picture was very small, but you could see the benches around the plaza and trees in the background. Everything was fine, until the next year when a friend of mine came to me and said, "But you can enlarge this." I said, "What is enlarging?" I had never heard of it. He showed me a contraption on the wall. You put your camera, slide it up and down, like an enlarger, and you can do anything you want. I saw the possibilities, and then I started to really photograph.

D: Do you ever crop your photographs, or do you frame in the camera?

E: I frame in the camera. But let me explain. You only crop when you photograph for books or for yourself. Otherwise, when you work for *Life* or for any other magazine, the picture you do will be printed in full, and the director at that magazine crops as he wants.

D: Do they retouch as they want, too?

E: They probably retouch, too.

D: Do you ever retouch your own photographs?

E: No.

D: What about all those beautiful women? And those double chins Chuck Colson would rather not have? Famous people, don't they want their pictures retouched?

E: Sophia Loren never asked me to retouch a picture. Never. We may spot something; if you have something here, we may take it out. But retouching could be done on the negative, or on the print.

D: Would you object to your photographs being retouched?

E: No. If they want to retouch, let them retouch.

D: Is there any reason why you still use the 35 millimeter camera?

E: I've had all kinds: a 4 x 5 camera, the 2¼, 3¼ camera. It is much easier; you can do anything with a 35 millimeter camera. Today photographers prefer them.

D: Do you prefer to see your own work in books, in magazines, or on the wall in exhibitions?

E: Nobody ever asked me that.

D: Well, in a way, photography is a lap art. There you can really be intimately involved with it. It looks different on the printed page, than it does once it is museumized.

E: When you think of an exhibition, the exciting day is always the opening day. And then you don't go there anymore. I like my work in magazines and books, yes. An exhibition is enormous work. If somebody asked me to put together an exhibition today, I just wouldn't know what to do. I have so much stuff. I wouldn't even know where to start.

D: What's your idea of the perfect assignment, in terms of place, or subject matter? Or in terms of the length of the session?

E: The ideal assignment would be to spend several days with Sophia Loren again.

D: She is your favorite?

E: Yes.

D: What's your second favorite assignment?

E: Expeditions, nature. I don't know whether I could do it today, but I would go where there are flowers. I was in the rain forest, in the Galapagos Islands, I was in India.

D: In the last few years, of course, the interest in the field of photography has grown so much, that it has changed the way people look at and take photographs. Are you surprised?

E: Every photographer is amazed at how much money you get for your pictures at auctions.

D: Did you ever expect the world to celebrate photography, either aesthetically or monetarily, the way they do now?

E: No. In the beginning, at *Life* we didn't really think of money. I mean, we did it for the excitement of being a photographer. But after *Life* folded up, then everybody wanted to go commercial on account of money. And there are many photographers who can't make a living from photo-journalism at all. They have to go commercial.

D: Do you think of photography as an art form?

E: No, I don't think my photography is what people call an art form now. As far as I know, the type of photography I do is not very much recognized at the Museum of Modern Art. They don't think of anybody from *Life* as an artist.

D: Do you think of yourself as an artist?

E: No, as a photographer. I'm a photographer; I'm not an artist. People say it's art. I may have artistic feelings and may express myself in artistic form. But I can't say of myself, "I'm an artist."

D: Did you ever expect your life to unfold the way it has?

E: No. God, no. Very few people do. Now, I was always very conscious that I wanted to be a photographer's photographer. I watched myself very carefully. To do the job the way I do it, the photographer has to be in excellent health. Otherwise you can't do it.

D: Has your long term relationship with *Life* been an important influence on your life? Has it freed you?

E: Oh, I tell you, *Life* magazine has probably prolonged my life. You see, before my 80th birthday, I tried always to hide

my age.

D: Why?

E: An agent told me it was very difficult to get an assignment at my age. I was afraid that if people knew my age, they wouldn't look at me anymore: the girls wouldn't look at me. But I'm accepted now even more than before. I am surrounded by young people. I'm everybody's friend. I'm the older brother of the young photographers. They think I'm as young as they are. But I have to work on that, too. I don't drink, I don't smoke. I lead more or less a regimented life. On Saturdays I walk on Jones Beach all the time, even in winter. For 15 or 20 years, I travelled everywhere with my pedometer, to see how much I walked. I walk 24, 28 miles a week.

D: How many photographs are in your archive?

E: I would say I've taken a million, at least. I've been doing this since the late Twenties.

D: Are there any that are especially important to you? How about the waiter on skates in St. Moritz?

E: Yes, that's an outlandish picture, a very beautiful picture. I love it. This picture of the waiter on ice skates is known worldwide.

D: There are some images that are not as predictable as others. Here's a picture of a cowboy chasing a bull near Amarillo, Texas.

E: I did a big story on Texas. It took me six weeks. I wanted to photograph a cowboy in action, so we went to the Bivin Ranch, which is about 175,000 acres. I told the cowboy to chase the bull. But the bull saw only me, and he charged me. I looked the bull straight in the eye and he was one-thousandth of a second away from me before I moved out of his way. When I came back to *Life* several weeks later, the first thing they asked me was, of course, "Did you get a picture of that bull?" Yes, I will be remembered when I'm in heaven. People won't remember my name, but they will know the photographer who did that picture of that nurse being kissed by the sailor at the end of World War II. Everybody remembers that.

Elliott Erwitt

One of the most versatile photographers—an accomplished photojournalist, a successful commercial photographer, an independent filmmaker, the one-time president of Magnum—Elliot Erwitt is also an inspired humorist. He was born in Paris, spent most of his years in Italy, and came to the United States in the very early 1940s.

Barbaralee Diamonstein: Since the age of sixteen, when you were a student at Hollywood High School, you've been a professional photographer. How did all that begin?

Elliott Erwitt: I came to the United States in 1939, in fact, just before the war started. I got into photography by accident. Everybody's got to do something, and photography seemed pleasant enough. So I started doing it.

D: What was your first job?

E: I don't exactly remember the first job. I was fascinated by an old plate camera that I saw for sale, and I bought it and started playing with it. Things developed from there.

D: I've read that you worked in a photo factory that churned out fan photos of movie stars. One of your weeks on the job was spent washing and drying twenty-five hundred Ingrid Bergmans.

E: Yes. Well, that was after I had already started to be a photographer, at least I was trying to earn my living in photography. I didn't immediately start taking pictures for fun and profit, so I did things like working in dark rooms.

D: Did you work while you were a high school student?

E: Yes. I took pictures at school events, such as senior proms. That paid a little bit. I took pictures outside school, of people and children, dogs, houses. I made prints for people. That's how I started.

D: Three people are often cited as having played an important part in your early career. Can you tell us about the roles of Edward Steichen, Robert Capa and Roy Stryker?

E: When I came to New York, Roy Stryker gave me my first grown-up job, with Standard Oil of New Jersey. Years before, he had been working for the Farm Security Administration, but when that petered out he went to Standard Oil, where he remained for many years. He established a library of photographs a little bit in the FSA style, except of course that when you have clients such as Standard Oil of New Jersey it's a little bit different. Many good things happened while he was there. For instance, the Flaherty film that was shot in Louisiana. Many of the photographers who were with him at the FSA came along and contributed to this library of photographs. I happened to come along at that time and he hired me.

D: How'd you come to meet him?

E: Well I came to New York and I started making rounds, seeing people who might give me jobs, and he was one of the people on my list.

D: One of them was Edward Steichen, who was the then director of the Department of Photography at the Museum of Modern Art.

E: Right. He was also on the list. I mean, the list was smaller than it is these days. It was a list of a half dozen names.

D: Well, how did a young photographer get to the Museum of Modern Art?

E: By bus, mostly! I'd just get off at 53rd Street. But, actually, people were more accessible in those days; life was a little simpler, I think. You just called first, saying you would like to show some pictures, and generally you were seen. There were not as many photographers around as there are now, I guess.

D: Was it as easy to meet Robert Capa, who was the then president of Magnum?

E: Magnum was a very small company at the time. And yes, Capa was accessible when he was around. In fact, he saw everyone when he was around. He was seldom around; he lived mostly in Europe.

D: By your early twenties, you had already won a *Life* Magazine prize, and had a photo chosen for the "Family of Man" exhibition at the Museum of Modern Art. Can you recall how that came about?

E: It was 1951, the same time that I was drafted into the army. I had a little camera with me, and I took pictures during basic training of whatever was accessible to me. I sent in those pictures to this contest, and won a second prize.

D: What was the photo?

E: It was a story, about army life, I guess. It was called "Bed and Boredom." And it just described in pictures whatever was accessible to me during basic training.

D: What did you do with that $2500 prize money? It was a large sum, particularly for a young soldier.

E: Well, I think young soldiers can use money as well as anybody else. As soon as I was shipped overseas, I bought a car with the money. Which made me a little bit more mobile than a lot of my friends were at the time.

D: Soon after, you also had a photo in the "Family of Man" exhibition. Did you ever expect the world to celebrate and proclaim that exhibition the way it did?

E: I wasn't thinking about the world proclaiming anything. In fact, I had a number of pictures in that exhibition. Apart from Steichen, the man who was in charge of putting the exhibition together, was Wayne Miller, another photographer and Magnum member. He did most of the research for that exhibition. I suppose it's really he who found my pictures, and who submitted them to Steichen for the final selection.

D: How important to your career was your inclusion in that exhibition? And how important do you think that exhibition was to the explosion that has taken place in terms of popular interest in photography?

E: Well, that exhibit certainly was very popular. It was the most popular exhibit up to that point. I don't know that anyone expected it to be so amazingly popular. I personally didn't like the exhibit very much, but I was very pleased to be part of it, because it brought you notice. Actually, I felt the exhibit was a bit corny. In retrospect, I think I'm right. "Family of Man" was kind of a grand idea—a lot of quotes from poets under pictures, and that sort of thing. What I object to now, in retrospect, and I did at the time too, is that there were many bad pictures in it. The pictures were used to illustrate a theme; it was sort of an exercise in illustration. There were many wonderful pictures in the exhibit, and there were many rotten and stupid pictures. A lot of the pictures supported the theme of the exhibit. That's what was wrong with it. However, the public liked the exhibit very much, and the theme was important. It all worked out.

D: And which of your photographs were included in that?

E: I don't remember them all. One I do remember, of course, was a picture of my first child, at the age of six days, with her mother. It became known because it was in this exhibit. It's still being used a lot, and that was twenty-eight years ago.

D: By the time you were eleven years old, you had adopted your third country and your fourth language. Looking through your own photographs, books by you and about you, your self-portraits, it seems to me that some are almost a masquerade—an Afghan hat here, a blonde wig there. What are

Cannes, 1975

Cannes, 1975

you really saying about the whole question of personal identity?

E: Gosh. Nothing, I guess. I think if you take a picture of yourself, you might as well try to be a little amusing about it. I think most people take themselves a little bit too seriously—put pipes in their hands, things like that. So I thought that doing something a little offbeat might be more interesting.

D: Humor is a very central part of your work. I've often wondered how you've managed to skirt that very difficult line between humor and sarcasm.

E: I wish I could answer you. I don't worry too much about things like that. I just do what I do, without thinking too much.

D: The viewer might assume that you think a great deal before you take a picture, since your work is frequently characterized by ironic juxtapositions. Very often, you seem to focus on the gestures of humans and animals to create the humor in a picture. Is that accidental? Do you discover it in the contact sheets, or do you frame it while you're taking the picture?

E: Well, I obviously frame it while I'm taking the pictures. I don't know why the snapshots that I take show this sort of thing. You can't study them, because if you start to study them they're gone long before you finish studying them. The pictures that you are referring to are instinctive pictures. They have nothing to do with figuring out special meanings or juxtapositions; you just see something and you take a picture of it. And then, of course, you look at your contact sheets, and you make discoveries there.

D: Well, what are the strategies that you use to achieve the results we see in your work?

E: Well, let's see, strategy . . . I do take pictures of dogs and I bark at them sometimes. But that's really to attract their attention more than to convey a message to them.

D: I hear you not only bark at them, sometimes you even duel with them.

E: Yeah, I have a horn, a kind of automobile horn, that I use sometimes.

D: Harpo Marx style?

E: I guess. It depends on the camera. If it's a big camera, it's a big horn, if it's a little camera, it's a little horn. That's to attract people. You can't take a picture of people's faces if they're turned around. So you blow your horn and they turn toward you and you take their picture. Is that what you mean by strategy?

D: When did this 'humanistic' wit begin to emerge in your work?

E: Oh gosh, I don't know, I don't think that a photographer,

or anybody, ought to be a judge of his own stuff. I think that ought to be left to other people.

D: Well, one of the other people who has talked about your work is John Szarkowski, the director of the Department of Photography at the Museum of Modern Art. He has said that you're known for almost confusing understatement in your photographs; that they deal with the empty spaces between happenings, and with anti-climactic non-events. You call them anti-photographs. What do you mean by that, and what do you think he means?

E: Well, I don't know what he means, but it sounds good to me. As for anti-photographs, I was looking for a catchy title for my book, and a copywriter friend suggested it. He explained what he thought it meant, but I've forgotten.

D: Many of your anti-photographs show dogs in poses and activities that recall human attitudes. You've been doing series of dogs for more than twenty years, on six continents. So there must be something very special about dogs. Why do they interest you? Are you making a larger statement when you photograph them, particularly in juxtaposition to humans in terms of size, scale, animation?

E: Well, dogs are everywhere, except in China. I was in China recently, I didn't see any dogs at all. But dogs are everywhere, and therefore they're available to be photographed, you see. When you walk around with a camera and you're snapping away, and you see a friendly dog's face, you take his picture because he's there. If there were horses, I guess it'd be horses. I don't go taking these snapshots—and they are snapshots—with any large cosmic idea or philosophy.

D: You also have a penchant for photographing underdogs, lowly animals who persist in the face of every kind of adversity.

E: What's an underdog?

D: Very tiny dogs . . .

E: That's what I thought. I separate my work into several sections. I suppose you're referring to the pictures that I take for my own amusement.

D: And for public pleasure as well. You've collected them in a book.

E: Well, I suppose those pictures are my real work. The rest is what I do for a living, which is something altogether different.

D: How did the book begin?

E: Every once in a while I take time out and look at contact sheets of pictures that I've taken during the year, or during the past years. I noticed without any special purpose I had a great number of dogs in the photographs. And so I said, "Gee, maybe I can do a dog book or something. There seems to be a lot of dogs." For some stupid reason, books always seem to have to have themes. You have to have the crutch of a theme: the book has got to be about something. People are not relaxed

enough to . . . You can't have just pictures; they should be about something, or they have to have an idea. Anyway, it seems that people like dogs. The fact that the pictures are really not about dogs at all, doesn't matter to me. I just had these dogs, so I took all these dogs together and then went out and shot some more on purpose.

D: Among your best known photographs is the classic photograph of the Nixon-Khrushchev kitchen debate that you took in Russia. I've often wondered if that picture accurately reflected what was going on at the moment. Was it a genuine confrontation? What was the nature of the conversation? I have felt, and I wonder if you would agree, that the photograph and its publication globally affected not only the public, but the political perception of that confrontation.

E: I'm not a Nixon fan, and I wasn't at the time, either. Now it's fashionable not to be. That picture was just a nicely composed picture: it was unique because I was the only person there at the moment. I don't think it reflects anything in particular, just a lucky shot.

D: Was there a debate going on?

E: I think that it was one of those dumb things that politicians do for the public, really. Nixon was saying something to the effect that we eat more meat than you do and we'll surpass you in twenty years. It was no debate. Political debates generally are not held in Macy's kitchen. They're held at negotiating tables. This was a tour through the U.S. fair in Moscow. They just stopped there, and had a little discussion. It was interpreted by the press, or whoever interprets these things, as something momentous.

D: Earlier, you distinguished between your personal work and your commercial work. From the very beginning of your career, you seem to have had a very clear vision of what you had to do for money, and what you had to do for pleasure. How have you managed to turn your commercial photography into your private gain? Does it interfere? Does it inspire? Does it facilitate?

E: Commercial photography seemed to be compatible with what I had learned, what I was interested in. And I was able to do it. I mean, that's how I earn my living. And photography at that point, in the beginning, was my hobby. I took pictures for fun, for my own amusement. As my career grew and as photography became more in vogue—not the magazine—some of the personal work took over and became important and became saleable. This is something that I never would have dreamed about when I was doing these pictures thirty years ago. My life was divided, and still is, although the lines are a little bit confused now because you can sell your snaps, which you couldn't before. Now, some of those pictures are commercial pictures, to the extent that they are sold. The

other kind of work, which is quite different, is supplying what clients want. I keep on doing that because that's my profession.

D: Do you develop your pictures yourself?

E: Occasionally, when I'm in a hurry. Developing is a mechanical kind of thing. I print a lot. If I care about something particularly, I'll make black and white prints.

D: You've always prided yourself on your versatility. Whether the assignment was a photograph of a head of state or a food shot, you were both available and interested. Once you said that "all photographic assignments, bar none, are logical problems that have logical solutions." Aren't there any great secrets in photography, particularly with someone like yourself who is really very knowledgeable about technique?

E: If you're talking about commercial photography, there are absolutely no secrets. It is a matter of solving logical problems. As for the hobby aspect, I don't know if there are secrets. There are interests, personal interests. I think the only real technique in photography, something that is not easily learned from reading the instructions on the box of film, is a sense of composition, a sense of timing and a sense of the subject. That's all. A person with reasonable intelligence can easily learn everything else.

D: What advice would you give to a young or beginning photographer? Is there any special schooling, or any special technique that you would suggest?

E: No, my only suggestion would be to develop interests and pursue them—nothing more.

D: Are you saying that it's important to be well-informed?

E: It is, sure. To develop interests so that you can direct yourself to what you want to do, that's all. Taking pictures is really very, very simple.

D: You respond to the work of a number of artists. I wonder if you can tell us who they are.

E: Yes, I have a long list. Certainly in photography it's a pretty classic list. I have very little interest in fashionable photographers, or in people who are interested in color, and that narrows it down pretty much. So the old classics—Bill Brandt, Cartier-Bresson, Kertész—these are the people I respect. And the others, who are current and popular, I'm pleased to see that they're doing well, and that there's a place for them. But I'm not personally interested in what they do.

D: Why do you have so little interest in color?

E: I'm not interested in taking color pictures. I cannot manipulate color film the way I can black and white. To me, color always seems to be pretty, and the prettiness gets in the way. That's a narrow view, I realize, but that's my view. Almost ninety-five percent of everything I do is shot in color. I do a lot of editorial work, commercial or magazine

Elliott Erwitt

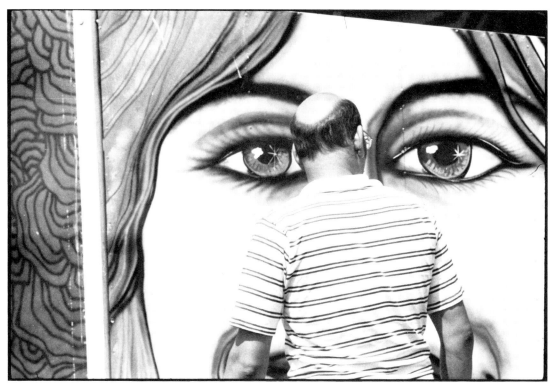

Maine, 1976

St. Marie les Bains,
France, 1977

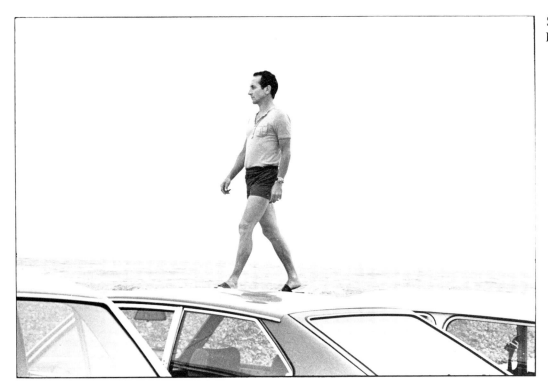

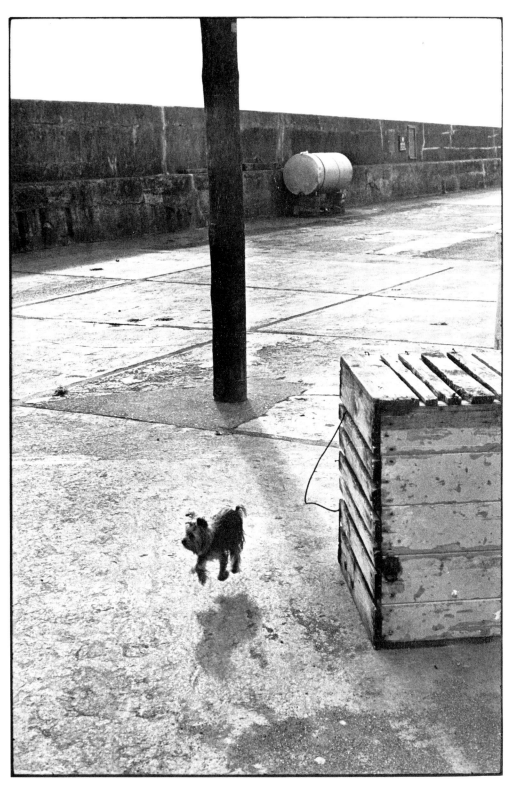

Ballycotton, Ireland, 1968

Elliott Erwitt

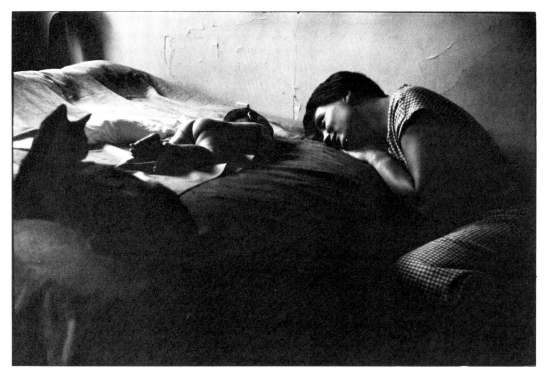

New York, 1953

Wyoming, 1954

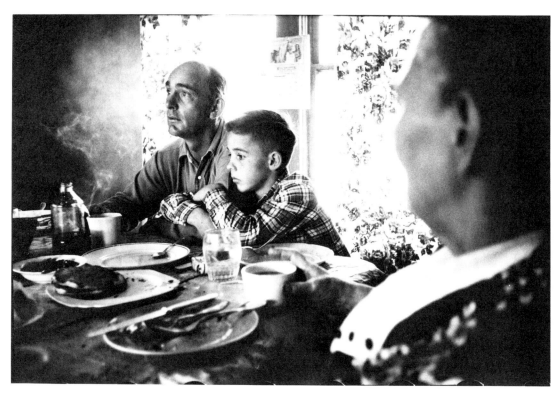

assignments, and they're all in color. These days, only my personal stuff is in black and white. Even my movie work is all in color. Of course, in movies I think color is absolutely appropriate because there you are not abstracting, you're giving information as fully as possible. Color is information, that's all. It's just more clues to what you're seeing.

D: You are turning more and more to film work; is there a particular reason why?

E: The reason I like to work in film is because there's more to it. It's more complex. You can deal with a subject in a way that you can't in still photographs.

D: What relationship do you see between film and your still photography? Do your movies share that same theme of the human experience?

E: I hope so. I certainly don't think it makes any sense to do movies, which are generally a disaster from a financial point of view, unless you're trying to get something across, unless you're interested in dealing with subjects. Any subject that doesn't deal with the human condition is not a subject, at least for me.

D: Two of your films that were most widely seen are "Beautiful Body Beautiful," and another on black marching bands. What were you trying to get across in those films?

E: I would not consider "Beautiful Body Beautiful" a personal film. It's an okay kind of commercial film for cable television. I'm in the process of editing that film on black marching bands. It's a film that parallels another I did years ago that seemed to have a big audience, quite a nice success, called "Beauty Knows No Pain." That film was about the Rangerette Corps in Texas.

D: Cheerleaders, aren't they?

E: Yes, totally dedicated 17-year-olds who work very hard at being majorettes. And this new film, about a black marching band of great reputation in Florida, parallels this subject. Highly motivated people who are doing something rather strange. I mean, they work terribly hard to do something that might seem a little bit silly, but isn't. The thing about pictures and movies is that you really shouldn't talk about them; you should see them. That's the problem with magazines, with books, with editors. They all have to do with words. People are not secure enough to let the pictures do the talking.

D: Sometimes your photographs are so subtle that I wonder if a large part of the audience gets them. Do you consider a photograph successful if the viewer *doesn't* get it?

E: Obviously not. If the viewer doesn't get it, you've failed to communicate. You must communicate.

D: In your photographs, so much depends on that special found moment. In your films is there a succession of these special found moments that you search for?

E: The wonderful thing about documentary filming—and that's what I'm interested in—is that sometimes when you least expect it, some magical thing happens. That has a parallel to still photography.

D: One of the magical things that you wish would happen is to be freed from some of the budgetary constraints of making a film. If you were not restricted, what sort of film would you make?

E: I would even go back one step. It's not being restricted by a budget; it's to get a budget in the first place to do something that you might be interested in. Once you get a budget, you more or less work backwards and within its confines. But it's difficult to get anybody in documentaries interested in the sort of things that interest me. It's not impossible and it happens from time to time.

D: What would you like to make films about?

E: It's always the same thing; the subject doesn't really matter. I hope it's the same in my personal photographs. It's always the human condition and nothing else, really, expressed in whatever way, whether through dogs, through majorettes, through anything. That's what you're dealing with; you're dealing with people and what they think and what they're like, their emotional side.

D: You're accustomed to taking a very long philosophical view, and you've often seen the results of your patience. On your first magazine photographic assignment, more than twenty-five years ago, you were part of a Magnum team called upon to photograph children of the world for *Holiday* Magazine. What happened?

E: Robert Capa, who was then the benevolent dictator of Magnum, was always trying to find work for the rest of us, in one way or another. He was an extraordinary fellow with a great deal of imagination. He was always selling ideas to magazines—generally ideas that would require a lot of photographers and a lot of stories, sequential things. He came up with this idea of doing children around the world. I think afterwards he also came up with doing women around the world, and so on. It was just a way of keeping us employed doing worthwhile things.

D: What were you assigned to do?

E: On the children thing I did a cowboy child. I did two stories. For the first one, I went to Colorado and Wyoming, and I did a cowboy child. I thought it was a very good story, one of the few times where pictures done for a magazine also had a life elsewhere. I still exhibit those pictures. Anyway, that story was rejected by the magazine because the child seemed too sad. It seemed to me a dumb reason at the time, because some children are sad. But you see, magazines have certain points of view. Anyway, I went back at a different time and did

another cowboy child, this time a happy cowboy child in Colorado, and that one did appear.

D: Was the first cowboy ever used?

E: Yes. We always get back the copyright of our photographs. Then we make whatever use we want of them. The story was certainly syndicated—both of them were—and probably appeared in many magazines around the world.

D: More than twenty-five years later, it was used as the basis of a series of advertisements by yet another company. So it underscores the fact that a good picture *is* a good picture, and also that record keeping and good files are important for a photographer.

E: There's no question that if you do reasonable work, it will have a life beyond its original purpose. That's why so much past work looks old and boring. Pick up a magazine of ten years ago; you can hardly believe that you were impressed by most of that stuff. Whereas, thirty-four years later, the good pictures by the people I mentioned before look better and better and better. Good work has a real life. Work done to fill pages and to fill concepts of editors and books, has to do with fashion of the times. It might be interesting historically, but actually it is not terribly interesting.

D: You spend a great deal of time traveling. I assume that when you are on one assignment, you are also taking other photographs. What was the longest or most telling assignment you ever had?

E: Some years ago, I did a book for Time-Life Books about Iron Curtain countries. There was no brief from Time Inc., because at that time it was really quite difficult to photograph in Hungary, Czechoslovakia, those countries. So anything you did was useful. You didn't have to start out by doing this and this and this; you could just go and look. Consequently, I got some nice pictures. I was really working for myself, for my perceptions, rather than for some editor's preconception.

D: But you're always surrounded by the preconceptions of an editor, a publisher, a client. Are those constraints very difficult to work within?

E: They're very easy, much easier than the limitations that you impose upon yourself. You know what your clients want, so all you have to do is get it. When you yourself are looking, you don't know; you want to be surprised; you don't come with preconceptions. You just come with an attitude. Then you can react to the world. In the old days, when we shot for *Life* Magazine, we knew, "Hey, that picture's going to be good on the left hand side; this is a good vertical; this is a good double spread." That is deadly, really. I mean you're making layouts. . . .

D: You're shooting according to text?

E: Yes, shooting to make seven pages. It's the way life is.

D: The way *Life* was.

E: No pun intended. Yeah.

D: I think there is only one magazine in which your work did not appear frequently, the original *Life* Magazine.

E: No, no, no. I worked for them many times. I was blackballed after a while, after that book, because of rights. The book was for Time, Inc., which is part of *Life* Magazine.

D: What were the circumstances?

E: Well, I was president of Magnum at the time, and therefore I was the most aggressive person about rights.

D: I thought it was called activism when you wore a little button! During your presidency at Magnum, you started a campaign, and did in fact wear a little button. What did that say, and what was it all about?

E: One of my little jokes, I guess. I had a button made for all my colleagues to wear if they wished to. It was not mandatory. The button carried a translation from English to Latin, saying that copyright is sacred. I thought that whenever we saw an editor and discussed an assignment, we would wear this button, which was in Latin. If the editor was a visual person, he would ask you what the thing on your lapel said. Then you would tell him, and that would somehow convey a subtle hint to the editor.

D: What happened between you and *Life* as a result of your campaign?

E: Well, we won. I mean, we didn't work there for a very long time—a lot of us, not just me. Some of us worked in a very reduced way. But eventually they saw, as everyone else does, that indeed the pictures you take are to be your pictures. Eventually they should revert to you. You're really selling only the use of your pictures, not the copyright. I think that's pretty much accepted now, except, and quite rightly so, in totally commercial works, advertising and corporate work. Even there, there's a gray area.

D: How has Magnum changed since your early days there?

E: It's bigger, the people are older. The concept hasn't changed. The idea was to be independent, to live in a way that you wanted to, through photography, and to have an office that dealt with most of the business part for you, making it easier for you to funtion in photography. That still remains. The emphasis of our work is a little bit different, but that has to do with the market, not so much with the interests of photographers. We take in photographers who are interested in the world. We would not take people who only do still lifes of toilet paper. That kind of person would not come to us, and we would not be interested. We are interested in people who are interested in the world, and in the human condition. That's a given. Then we have to make a living, which has to do with the market. So we have people who are able to function in

that market, who are professional enough to supply clients with what's required.

D: Was there ever a period in your photographic life when you had second thoughts about continuing as a photographer, or felt that your work was not going in the direction you wanted?

E: Everyone has good moments and bad moments. I don't think I ever thought the things that you suggest. There are times when somehow you don't take very good pictures for a very long time and then it comes back. I haven't ever had any thoughts of doing anything else, except for film perhaps. But even that would not replace taking the pictures I'm interested in. Just in addition.

D: You've often said that you'll always be an amateur photographer. What do you mean?

E: Exactly that. An amateur photographer, or an amateur anything, is a person who does it primarily for the love of it. My personal photography is done for that reason, and I don't see any reason to change that.

D: One artist whose work you have cited frequently during your career is Modigliani. What interests you about his work or the circumstances of his existence?

E: Oh, I just like his paintings, that's all. He had a bohemian life, but that doesn't interest me in the slightest. I take an interest in art; I take an interest in painting, and I have certain sympathies. I have a very strong sympathy for his work. It's nothing more than that. I don't see any parallel there.

D: Much has been said about your great gifts as a comedian. Over and over again, you are likened to Charlie Chaplin and Harpo Marx, and I can understand why. Is that the way you see yourself?

E: That's high praise indeed. I'm not an actor, but if the pictures I take are amusing and can be compared to actors making people laugh, fine.

D: I assume you see humor in most circumstances.

E: Yeah. Yeah. I enjoy absurd things; I like black humor.

D: When visitors get off the small elevator to your apartment, they are greeted by a huge stuffed moose head. What does that tell you, or us, about the human experience?

E: Well, I think everyone has to be somewhere. I think it's a nice decorative piece. It occupies almost the entire hallway. I'm looking for a companion piece.

D: What do you have in mind?

E: I think another moose. I'd like to have people duck as they come out of the elevator. I think that might be amusing.

D: There are certain recurring themes in your work. We've talked about dogs, but we haven't talked much about beaches. What is the constant attraction to the beach?

E: I'm very often by the sea or the waterfront, and I find

that's a good place to take pictures. Like with dogs, I find the beach is in most places.

D: What do we reveal about ourselves at the beach that you find particularly engaging?

E: I don't know. I just go there and take pictures, and I hope that if there's anything to be revealed, it'll be in the pictures. But again, I'm working on a book about beaches, because it's a theme, and as I mentioned before, it's good to have themes these days.

D: What is that book entitled?

E: *Son of Beach,* but it's just a working title.

D: There is a story that after your parents divorced, your father picked you up one day at the beach where you had gone swimming. You were wearing only your bathing suit, and your father decided that it was time that twelve-year-old you and he should have a new life together. Right then and there he drove to Los Angeles where you made your new home. Is that story true?

E: Yeah. I don't remember the bathing suit part, but it's true, largely speaking. He wanted to go west. It was perhaps fashionable in those days to go west. He essentially kidnapped me, and I went willingly.

D: You were born of Russian emigré parents in Paris, and spent much of your youth in Milan. A great deal has been written about your father, who had a varied and complex life and career. Boris Erwitt was born a Jew in Odessa, and renounced formal religion until 1957, when he became a Buddhist priest after studying in Japan. Has that discipline influenced your personal view of the human condition, or your own professional concerns?

E: No, not at all. What my father does is what he does. I'm delighted that he did all those things. He's an interesting character. He's always been a student, an avid reader, and a man of passionate interests, and that's one of his interests. But that's governed his life, not mine. I'm interested in Buddhism from a distance, in the same way that I'm interested in anything.

D: I also read that during his long travels away from home, he encouraged you to document the everyday circumstances of your life in his absence. Did that discipline and your diaries have any effect on the way you document the rest of the world now?

E: Perhaps. I have no idea. I really don't try to look for reasons for everything. I think it's a mistake to look for a motivation for everything. You just go out and do what you do. Don't think too much about it, because it takes the spontaneity out of everything.

D: You are always trying something new, and you really delight in versatility. Is there any new project, or any new

photographic style, that you are involved in or contemplating?

E: Well, this beach book is one new project. I have another book completed, which is looking for a publisher now. The subject is the St. Tropez beach in France. If I don't get it published it'll become a chapter of my larger beach book. I have a film, a long film that I am negotiating for right now.

D: What is the subject?

E: This is an assigned film, and the subject is outrageous wealth. The working title is *Outrageous Fortune*. I would also like to do an exhibition of pictures I took when I was sixteen and seventeen years old, which to my surprise seem to be my best pictures. I was looking through the contacts. There's not that many of them, but they seem to be fresher and more interesting.

D: What is the subject, the content, of those pictures?

E: Just pictures I took around, of Hollywood High School senior proms, anything.

D: Which of your exhibitions has been most satisfying to you?

E: I had a large exhibition at the Smithsonian about fifteen or eighteen years ago. I enjoyed that one the most, because I went and watched the reaction of the people.

D: Did you photograph it as well?

E: No, no, no, no. Nobody knew me there, so I could watch with impunity, and it made me feel good to see the reaction. It was a large exhibit, and it was very pleasant.

D: Do you carry a camera with you most of the time?

E: Yeah. I do.

D: I know one of the things you've done on this most recent journey was to buy new equipment. What kind of equipment do you use?

E: The equipment I use to take my snaps is very simple, an old Leica, and that hasn't changed in twenty-five years. The stuff that I go to Europe to get is specialized stuff for movies, or a new fast lens, or parts for something. Things that aren't available here.

D: Did you ever expect your life to unfold the way it has?

E: I don't know that I had any particular expectations. I don't look too far forward; I just live as it comes. I don't have any particular projections. Actually, you got me to talk about my projections for books. I don't think I've ever thought that far in advance.

Horst P. Horst

Horst P. Horst has been a photographer for nearly 50 years, working first in Paris, and later in this country. He is internationally known as a photographer of famous faces, how they look, and how they live. His distinctive style is as celebrated as that of his subjects.

Barbaralee Diamonstein: Horst, you were born in Germany, and studied architecture with Walter Gropius and Le Corbusier before joining Paris *Vogue,* as a staff photographer, in the early 1930s. It all started when you were an art student in Hamburg. How did you come to know Le Corbusier or Gropius?

Horst P. Horst: Well, I didn't really know Gropius. I went to the school where he taught. I was a little bored with Hamburg, and I wanted to go to Paris, so I wrote a letter to Le Corbusier asking whether I could start working with him. He wrote me back in a few days. So I packed up, and within a week I was in Paris, at Le Corbusier's. And, poor man, he didn't have any job at all at that time. He was making plans to pull down the Marais, to build workmens' flats. Everybody in Paris hated him for it, and he was not a very outgoing man. As a matter of fact, Dali said something funny about him. He said, ''He's a puritan, he's a Calvinist, he's a masochist, and he's a sadist.''

D: And since you spent considerable time with him, would you agree with any of those evaluations?

H: I am afraid so.

D: So we can assume, then, the time you spent with him was limited.

H: About a year or so.

D: And what did you do during that year?

H: Oh, I worked on a Paris apartment that belonged to a

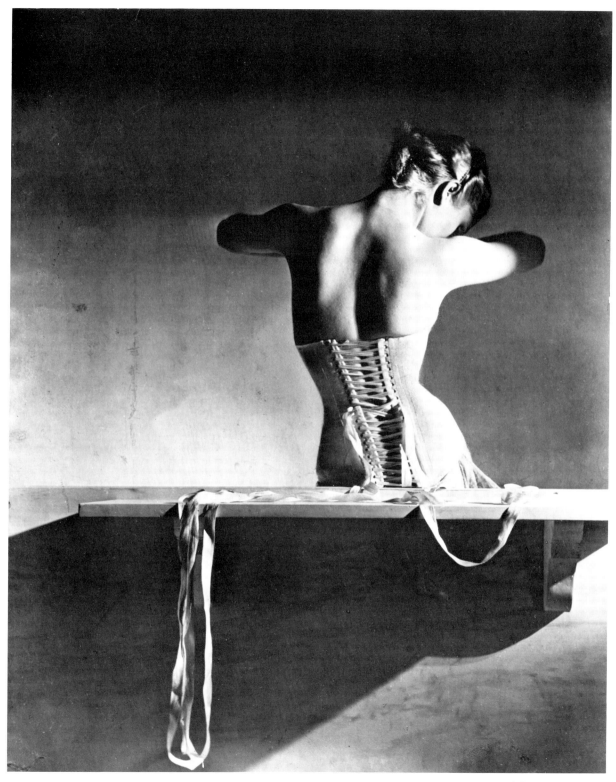

The Corset, 1939

very rich Mexican. He wanted a very modern apartment, with antique furniture in it. I had to spend one year making drawings of the bathroom, because it had to be changed all the time. Le Corbusier got a little bit bored with it, but you know that was the only job we had.

D: Is that why you so readily abandoned your career in architecture to turn to photography?

H: That's right. I was very lucky. There was an art director, Dr. Agha, from American *Vogue* in Paris. We lunched with friends, and he said, ''Why don't you try photography?'' So I said, ''I don't know anything about cameras and I've never taken a photograph in my life. I've never seen an elegant woman in my life. I don't know anything about dresses or fashion.'' And he said, ''You go and do it.'' He let me have the *Vogue* studio twice a week for three hours. I arrived, and there was a model, all dressed up. And, of course, there was an assistant who knew the technical part of photography.

D: Had you ever used a camera before?

H: Never.

D: And what was the piece of equipment that they handed you?

H: Oh, this enormous camera, the 8 x 10 thing, practically on roller skates, with the film holders next to it. It was a very complicated instrument. They published my very first photograph.

D: Well, no wonder you've described your first photograph as a brave click of the shutter. Can you remember what you were photographing?

H: Oh yes. It was a girl, naturally . . . in a black suit, with a silver fox and a black hat.

D: After such quick success, you must have been readily convinced to pursue a career in photography.

H: Oh, yes, especially with a little bit of money coming in.

D: Something that you had not been accustomed to until that point.

H: That's right. When Hitler came to power in Germany, I didn't want to go back there, naturally. I was a refugee, so to speak, and a deserter on top of that.

D: A deserter?

H: Yes, I hadn't enlisted in the German army. So I just worked for a living, very much like George Hoyningen-Heune who was thrown out of Russia. We had to work for a living.

D: Hoyningen-Heune was the man to whom you became an assistant at Paris *Vogue* in the early 1930s?

H: Yes, but I wasn't really an assistant. I came in once in a while to make a photograph. He was very fussy about who was in his studio, and he had his old assistants there. Once in a while I helped him build a set, but during the picture-taking, I wasn't there.

D: Were you closely associated with him? Was his work and life an influence on you?

H: Oh yes, definitely. It was then that I really got interested in photography. I tried to find out what makes a good photograph, and I started to learn about art.

D: How did you do that?

H: Well, I went to the Louvre, and I got to know people like Bérard, who was a marvelous painter at that time. I got to know people like Cocteau and I talked about art and all that. So that worked very well.

D: And what did you decide made a good photograph?

H: Well, of course I still don't know. But it depends whether people like it, whether it's a success. It's been very difficult for me to find out what's really a good photograph. I can hardly ever choose one, when I've taken twenty or thirty pictures.

D: Except while you served in the United States Army during World War II, you have worked consistently for nearly fifty years for Condé Nast publications. What was it like to be working for Paris *Vogue* in the early thirties, when *Vogue* reigned almost supreme in the world of fashion?

H: Especially French *Vogue*. At that time there were hardly any American dressmakers. Practically everything came from France. Fortunately, the editors and the people I had to work with on French *Vogue* were very nice and very kind, and they helped me. Because I had the jitters, obviously. I had to do the collection suddenly. It wasn't easy, and they helped tremendously. Then in 1932, I had to come over to America for the first time. I was supposed to be here for about six months with Mr. Nast. And that was so different to me that I didn't like it at all; I wanted to go straight back to Paris. As a matter of fact, Mr. Nast fired me. One day he took all the photographs I'd done while I'd been in New York, and laid them all out. He knew a hell of a lot about photography. He was unbelievably good, and he pointed out what was wrong with this and that. Then he said, ''I suppose you think you'll be as good as Steichen.'' And I said, ''If I didn't think I would become as good as Steichen, I wouldn't do it.'' He thought it was the biggest insult ever, and he said, ''You can leave when your time is up here.'' I was furious. I said, ''I'm going tomorrow.''

D: Did you?

H: Yes.

D: What did you do?

H: I went back to Paris and French *Vogue* picked me up again.

D: Who *was* Condé Nast, and what was his role in the history of fashion and fashion photography?

H: He was the publisher who started *Vogue*. I think his influence on fashion photography is the equivalent of Diaghilev's in ballet. He started the whole thing. He got

Steichen. He was a fantastic man.

D: What did Steichen do for him?

H: Well, I didn't know that much, but I do know that Steichen, having been a painter, gave up painting, tore up all his paintings, and took up photography. Condé Nast had used him for *Vanity Fair,* where he made portraits. They were fabulous pictures, unbelievable. Steichen also did fashion, and a lot of advertising for Pond's Cold Cream and so on, and it became a tremendous new adventure. You see, nobody had ever done anything like it before. And that was all Mr. Nast's doing, the whole thing.

D: Did you know Steichen in Paris?

H: Not in Paris, I knew him here. He was always very nice. As a matter of fact, when he left *Vogue* and went to the Museum of Modern Art, he said I should replace him. Damn nice of him.

D: And you did.

H: Well, you can't replace somebody with his kind of talent, you know.

D: Condé Nast was known for his very exacting standards. What was it like to work for him? Did he ever reject photographs, or set restrictions?

H: Yes. He picked the photographs himself with the chief editor. There were some people who complained, ''You're picking this and that and the other thing. But why don't you ask the rest of the editors what they think?'' So he made out a list and they had to sign the number of the photograph they liked best. That didn't work at all, because there suddenly were six different numbers, not one he could take. So he started again, choosing what he wanted.

D: Did he give you a list of rules to work by? Were there certain things that he did not permit you to do?

E: Oh, yes. First of all, we had to use the 8 x 10 camera. We were not allowed to use Leicas or anything like that. We were furious, you know, because Cartier-Bresson came along with his marvelous photographs, and he could do what he wanted because he was rich.

D: So you were restricted to being studio photographers rather than shooting out in the street?

H: Absolutely.

D: As a result, you had to improvise and constantly devise and invent new schemes for the interior of that studio?

H: Exactly. We used to build sets like crazy, for every new collection. What is the new collection going to be like? Is it going to be romantic? Is it going to be Italian? You had to guess. We usually made two or three types of sets before we actually photographed the dresses.

D: Were those sets often realistic?

H: Sometimes. They started out being realistic. I tried to be realistic. But then the photograph would look too much like a studio photograph to me. So I invented much more romantic, theatrical situations.

D: At the very same time, there were very important movements in modern art going on in Paris. How much of that influenced the work in your studio?

H: Well, of course I was influenced, because at that time, painters and intellectuals and dressmakers were all friends. It's not like today, when there's a complete division between dressmakers and artists. Then everything was together. So naturally I met Dali, who painted lobsters on dresses for Schiaparelli.

D: At that time in Paris, the artists and the couturiers were often close friends. But who influenced whom? Who and what were the greatest influences at the time? We know about surrealism. Were there any important art exhibitions that were translated into fashion terms?

H: Oh yes. There was the first surrealist exhibition, with the cow on the piano and that sort of thing.

D: Were there any other art exhibitions that were significant?

H: Well, there were, but it was so funny, that period, and times change so much. A friend of mine suddenly had access to the attic of Renoir's family, and they let him have all the little bits and pieces of sketches. Well, he had Renoirs, and he had a gallery, and you could buy a Renoir for $30.

D: Did you do so?

H: Yeah, I didn't want to, but I thought, ''Renoir, hmmmm . . .'', you know.

D: Did you feel free to develop your own style within the rules set by Condé Nast, when you began at *Vogue?*

H: Oh yes, absolutely. The editors in Paris were so encouraging, the more inventive it was, the better. I liked black very much. As a matter of fact, once one editor came in with a candle when I said, ''Please, some light.'' You couldn't see a damn thing; it was all silhouetted.

D: Did Condé Nast permit you to crop pictures or manipulate negatives?

H: Yes. This all was done in Paris. If you worked here, you see, it was different. Condé Nast looked for realism too, because of the influence of Henry Luce, who had started *Life* magazine. There was a funny little story. Henry Luce and Condé Nast were saying, ''Now which photograph would be better? The realistic one or the studio photograph?'' So they gave Tony Frissel one dress to shoot outdoors on the beach, and gave me the same dress for the studio. The readers were supposed to write back and say which photograph they liked best, the studio one or the outdoor one. Well, about seventy-eight percent were for the studio photograph. Mr. Nast said, ''I must have put the question wrong.'' He never gave you even that

much.

D: There is such a sharp contrast between the kind of minimalist work that you did with Le Corbusier, and the fantastic and surrealistic works that you did in the studio. How do you explain that great and rapid change in your work?

H: I don't know exactly. Maybe it comes from my rather romantic background. I was born in the country in Germany. This was around Weimar, where there were the German theaters and the Bauhaus people. The students were great friends of mine. It was through them that I got into modern art, but the German lieder and all the romanticism still stays with me. I mean, I was brought up with it.

D: Who else besides Steichen was working at *Vogue* in those days?

H: Oh, there was George Hoyningen-Heune, Steichen, and Cecil Beaton. And there was somebody else called Nelson, but he usually did portraits only for *Vanity Fair;* he didn't do much fashion.

D: Hoyningen-Heune was a very good friend of yours, though he did not stay as long as you did. Why did he leave?

H: That was a funny thing. Dr. Agha came over and wanted to draw up a new contract with George. We had lunch together, the three of us, and Dr. Agha said, "Now, you know George, we love you, you're marvelous, you're the best. But we'd like you to behave." Well, George took the table and threw all the spaghetti right in Dr. Agha's face. He walked out and went to a telephone, and called Carmel Snow at *Harper's Bazaar,* and said, "I'm in the street; you can have me for anything you want."

D: And how did she respond?

H: She said, "Oh yes"; she adored him. My god, yes. He was number one at that time.

D: Did his behavior improve?

H: Oh, yes, yes, yes, she knew how to handle him all right.

D: Did Cecil Beaton know how to handle him?

H: George was from way uptown, you know, he was very grand.

D: He was a Baron, wasn't he?

H: Yeah, he was, but Cecil wasn't. Cecil was getting there, and George had the whole thing.

D: So how did all three of you get along? Did you influence one another?

H: Oh, there were a lot of jealousies. Not between George and me, but Cecil was very jealous. Oh boy!

D: He was a friend of yours?

H: Oh yes, we saw each other; but, wow!

D: Sounds more like a friendly enemy.

H: That's it. He wrote me a very nice letter just about a year or so before he died. He went on about "those marvelous photographs you took for French *Vogue.*" So I wrote him back, "I wish you would say in public what you wrote to me in private."

D: In the 1920s and 1930s, Paris was, without question, the center of modern art. How concerned were you then with the avant-garde art that was going on?

H: Well, as I told you, we knew everybody: Gertrude Stein and Dérain. We used to go to cafés every evening, and chatter along with whoever. It was cozy. And nobody acted famous; these were just people trying to do something.

D: You've often said that your fashion photographs were meant to be portraits of human beings as well as illustrations of their ideas.

H: Right.

D: Did this mean that you spent time forming relationships with the people whom you photographed? That you really felt you had to know them, and what they were about, in order to portray them in any significant way? Or were they prototypes or metaphors?

H: No, no, not prototypes. They were all tremendous characters, you know. I love people, I love to photograph people, I love to get at them, and bring out their qualities. This interests me very much. That's what hits me most. I'm doing a book on old-time movie actresses. Absolutely fascinating.

D: You photographed many of those actresses in their younger days.

H: Now I'm doing the same people, plus quite a lot of others whom I never knew before. And they're marvelous people. Wonderful.

D: Who are the people involved?

H: Oh boy. Name them. Anyone you ever heard of! Bette Davis, Myrna Loy, Loretta Young. Some I've never heard of myself; I didn't know who they were. What's her name, the girl who climbed up King Kong? Fay Wray. And Ruby Keeler. Fascinating.

D: Other than obviously showing the passage of time, how have these people changed as subjects?

H: Oh, some of them, like Bette Davis, are as good as ever. Most of them are pretty well off, and I suppose a little bored. But the ones who really interest me are the ones who don't have a nickel, or are living in hospitals. Like Mary Astor. Unbelievable. Louise Brooks. Unbelievable people.

D: And are you going around to photograph them at the moment?

H: Yeah, I've just done about sixty of them. I need about ten more for the book.

D: Over the course of the years, who were your favorite models?

H: Gale Sondergaard. She looked like a tiny little Mexican something, unbelievable. There was one girl called Lud. She was an absolutely adorable girl, a Russian refugee, a poor little churchmouse. She brought the clothes to the studio; she was the delivery girl from the dressmaker or something. I saw her sitting outside the studio, and I just said, "Dear, you must take a picture." No, no, no, she didn't want to have her picture taken. But I finally persuaded her. And Mr. Nast said, "Well, I don't think that's right. Her nose is wrong," or something. Anyway, I kept on photographing her, and she became the top model, and then Mr. Nast wanted to marry her.

D: Did he?

H: No. No, she married a lion tamer, I think.

D: During that period, at the very beginning of World War II, you came back to America. What were the circumstances, and for whom did you work while you were here?

H: Also for *Vogue,* Condé Nast. Actually, I came back after George Hoyningen-Heune left in 1935. I came back here for three months, then three months in Paris, three months here, three months in Paris. I went back and forth four times a year, doing the American stuff and then the European collections. When the war broke out, I took the last boat, the Normandie, which sank the day after we got there. And my last photograph there is that corset.

D: The fashion photograph of the corset?

H: That's right. Four o'clock in the morning. Last picture.

D: Then, when you came to this country, and started to work for *Vogue,* you took a leave of absence to work for the United States Army. What did you do when you were in the service?

H: Well, I was a combat engineer. Not that I knew anything about it, but that's the way they trained me. I never felt better in my life. Then the general of the fort where I was stationed heard about me, and wanted to have his picture taken with his wife. I went, and he got me a job with *Yank* Magazine for a little bit. Then I was pulled into the Pentagon to photograph generals, and I lived in Washington for about a year.

D: What do you mean, to photograph generals?

H: Well, they had to have their portraits taken. And the funny thing was, they only had tiny little bits of lights in the Pentagon. I said, "Well, I can't take pictures with those," so they sent me to New York to order the right kind of light. And the lights arrived—exactly the day I was discharged.

D: You've had a very glamorous life as a photographer. You've taken pictures of the beautiful, of the celebrated, and sometimes even of the distinguished. I was going to add reigning beauties, but the phrase sounds archaic. How did all of this affect your life?

H: It didn't really, because I've lived a very simple life, I think. I live in the country. And I love landscaping and working in the garden, and I like fresh air. I very seldom go to dinner parties. I don't live the glamorous life.

D: Do you think photographing the celebrated and the famous and the members of café society, as well as the politically or artistically distinguished, limited you in any way? Do you think you were ever at a disadvantage because of that association?

H: No. On the contrary, it certainly opened all sorts of doors. That's what I like about it: you can creep in anywhere.

D: You certainly did manage to creep into a lot of places. Let's discuss some of your subjects. Why don't we start with Coco Chanel, who was one of your great friends.

H: Yes. Well, for ideas and for charm and for kindness—oh, she was a staggering woman. Unbelievable.

D: And how did she affect your life?

H: When I took her photograph, the first one I took, she said, "Well it's a very nice photograph of a dress, but it has nothing to do with me." And I said, "Well, how can it have anything to do with you, because I don't know you?" So she said, "Oh, you come to dinner." So I went to dinner; I saw how she lived. And then she sent me a sculpted background, and since nothing was good enough, I found this canapé, or sofa, that once belonged to Marie Antoinette. And she arrived, and she wasn't feeling very well, because a love affair had broken up or something. And there she was lying on this sofa, and I just photographed her. And she loved the picture so much, she ordered hundreds and hundreds of copies. And then she said, "Now how much do I owe you?" And I said, "You couldn't pay me."

D: Why did you do that?

H: It was a pleasure that she liked it. She was the queen of Paris at the time. After that, she gave me practically anything, anything. She took me to attics with wonderful furniture from another house she had given up, and she sent me every little bit. The trucks arrived full of stuff. Unbelievable. Very kind, very nice, wonderful.

D: You've described her as "the star of the circus." If she was the star, who was the ringmaster?

H: Oh, I suppose Noel Coward, and Cole Porter.

D: Two more of your subjects, and friends of yours, too. Can you tell us a little bit about photographing them?

H: Photographing them was nothing at all. In other words, they came to the studio. They were well known and naturally I was terrified. So Noel would talk and all that, and the contact with him worked right away. It was very easy and we became friends. Cole was rather tricky. He tried to be very chic and very smart and good, lunching with Lady Mendl, and so on. And I had to go with him, in a Rolls Royce with a chauffeur and a

Coco Chanel, 1938

valet. It was a bit of a bore, but he was very nice.

D: Greta Garbo was a fetish in Paris in the 1930s, as she was, I guess, everywhere else in the world. Obviously she was then still willing to be photographed, because you made a very splendid picture of her.

H: Well, actually, I did that here in New York. She had a great friend, George Schlee, who was married to a dressmaker called Valentina. And on Sundays when they wanted to go somewhere they called me up and came for lunch. Garbo and George Schlee always turned up, and she was very sweet, very nice. She played with the frogs in the pond. She asked if I had white chickens that would lay brown eggs. I always had to buy some brown eggs for her. One day she wanted to meet Edith Sitwell. So the Sitwells came out, delighted to meet Garbo, of course. Garbo was one hour late, and when she arrived, she walked straight through the house down to the pond to play with the little frogs again. She came back and she sat at the other side of the room, opposite the Sitwells, and wouldn't talk. Finally, the sun came out and everybody sat on the terrace and they talked and everything went very well. I think a photograph of that scene is in my book. And Edith said, "You know, she's very, very nice: she's not at all like an actress."

D: Was she? Is she?

H: Garbo? No, not at all. She's easy as pie. Very, very nice, very shy. You know all the funny stories about her shyness. But when she came out to us, she practically stripped, lying in the front lawn, taking sunbaths, with a nice little drink or something, and talking.

D: So your friendship continues?

H: I haven't seen her. The last time I saw her was when I went to California, about a year or two ago. She was on the plane, sitting in front of me. And she just said hello and how are you? Then in Los Angeles, she just disappeared. When I was waiting for the luggage to arrive, suddenly she came up and said, "Oh dear, help, please can you help with the luggage? The people who are supposed to pick me up aren't here. What shall I do?" So I helped her with the luggage and the people arrived. And that was it, the last time I saw her.

D: Not everyone you photographed was as reticent as she. One of your very well known subjects was Gertrude Stein. Were you a part of that circle, too?

H: Oh yes, sitting with Janet Flanner around the Café de Flore. It was a very small café, with nobody there, just a few people. Picasso was there with Dora Maar, who was a photographer. And that's why I never took his picture.

D: Dora Maar was also his model. You never took his photograph?

H: No.

D: Because of Dora Maar? Did she not permit it?

H: "Uh-uh. Nothing doing," she said.

D: She said so? Or you just assumed that?

H: No, no. We asked. "No, no, shut up," Dora said.

D: Janet Flanner was the American-born, French correspondent of *The New Yorker,* a celebrated and gifted chronicler of life in Paris for a good part of the century. She was a great friend of yours. In fact, she wrote the introduction to one of your books.

H: That's right. She helped me tremendously in the beginning. She wanted me to take her portrait as *The New Yorker's* man, Eustace Tilley, with the monocle. She wanted to have the same hat and all. I did it, and she loved the photograph. She said, "You have to have an exhibition." I had taken about eight photographs or something at that time. But she arranged an exhibition in some cellar, in some bookstore, somewhere. Nobody knew about it; nobody came, I'm sure, but she wrote it up in *The New Yorker.* And Mr. Nast read it, and he said, "He must be all right if Janet writes about him."

D: In fashion photography, I guess one is forced to change more than in almost anything else.

H: Sure. That's the essence of fashion.

D: Responding to the dictates of the times, or the fashion, the women of the moment. How did that reality affect the development of your art and influence your work?

H: In the Fifties I got a little bored with this whole fashion thing. Then, fortunately, Diana Vreeland came to *Vogue,* and she asked me to photograph houses, which I'd never done before. There was one she especially wanted, that belonged to Consuelo Balsan. Through a friend of mine I got in contact with her, and it worked out. She was an American by birth. A Vanderbilt she was, considerably Vanderbilt.

D: Where was this house?

H: Her houses were in Palm Beach and in Southhampton. *Vogue* said, "No matter if it takes you three months, whatever it costs, just do it, do it, do it!"

D: Was it unusual for the economically privileged to permit photographs of their domestic interiors and private lives?

H: It was unusual. They didn't want to have things published. Even now, a lot of them don't.

D: What sort of camera did you use?

H: Since I had never done it before, I took my little Rolleiflex along, and I just looked into it, with no lights or anything.

D: What kind of lens?

H: A normal lens, 80 millimeter lens. Just one lens.

D: And is that how your innovative style of interiors started?

H: That was the whole thing, apparently, It's so funny.

D: You have made an enormous contribution to the photographing of interior design and interiors of houses. How

George Hoyningen-Huene, 1931

Muriel Maxwell, 1941

would you describe your own special contribution?

H: Well, in this particular case, I was supposed to photograph the way the people lived. So you don't start out to rearrange the furniture, you see, or do lighting. When it gets dark, it's dark. There's nothing you can do about it. Apparently that was completely different. Usually people brought a lot of light and every chair leg was straight. I tried to make pretty pictures out of whatever there was, in the actual light. When I did the Guinness' place, for instance, I went to Leixlip Castle in Ireland, and nobody was there except the maid. I started photographing. There were dead flowers all over the place, and full ashtrays, and rumpled up cushions. But that's the way they lived, and Diana published it.

D: How did the Guinnesses feel about it?

H: Oh, they didn't mind.

D: For your photographs, have you permitted interiors to be rearranged and, if so, how much?

H: No, I don't permit it.

D: How much have you permitted the owner to rearrange, for the photo-taking occasion, the way they really live?

H: Oh, I think it's up to them. You see, if they want to have the house photographed the way it is, that's the way it's going to be photographed. It's up to me to find out which way it works, what makes a picture. But I don't start pushing furniture around.

D: In the evolution of fashion, there are many new names who have come along since Coco Chanel. And if there is a contemporary reigning counterpart, it is Yves St. Laurent.

H: That's right.

D: You have photographed him for many years, too. Can you tell us something about the circumstances of those photographs?

H: Well, he wanted to have his portrait taken recently, so I did it. And he also wanted to have his house in Marrakesh photographed. So I went and stayed with him for about a week or ten days. And he was there, and he couldn't have been nicer: very shy, and very precise at the same time. He wanted to be photographed in white all the time. And I said, "You can't do that."

D: Why?

H: It becomes a bore. So he brought out some blue caftans or something here and there and it worked very well. Otherwise, on six or eight pages he looks the same everytime. It's not right.

D: Did he design the interior of his house in Marrakesh?

H: I'm sure he picked out a certain number of things, but there was an American man there who helped him find things. I don't think this man decorated really, because St. Laurent wanted his own way. Definitely.

D: You did not get an opportunity to photograph Picasso, but you have photographed his children.

H: That's right, I like Paloma very, very much. Oh, she's wonderful. It was about two years ago, when she married. I was in Paris, working for French *Vogue*. And suddenly somebody said, "Paloma's going to be photographed tonight." And I thought, "Oh, Jesus Christ." It was 8 or 9 o'clock in the evening, and I'd had a full day's work. But the moment she came, she had me right there.

D: Has Diana Vreeland, the former editor of *Vogue*, influenced your career?

H: Well, she started me photographing houses. Definitely, absolutely.

D: With the aid of hindsight, and all that you've seen and done, from a sociological or economic or political point of view, would you photograph the same people in the same way again?

H: Oh, no.

D: What would you do otherwise?

H: It depends on the circumstances. With these people, I don't make up my mind before how I'm going to photograph them. Something is happening, you know, and you have to capture it, understand it, and try to bring it out. But I don't think we should photograph somebody with preconceived ideas. Then it's not the person. When I photograph people, I do it so that the ones I photograph like it. That's a success, you know. It's true. But once I photographed all the First Ladies, five of them, I think. And I didn't know where to photograph the last one, Rosalynn Carter. I had already photographed all the different rooms in The White House with nobody in them. So I opened a door, and it happened to be a nice day, and there was a monument outside, and the cherry blossoms were out. And then there was a little flower arrangement somewhere, and I pulled out the narcissi and threw them in her lap. She was sitting near a window. And that was much more in keeping with her spirit than being in a grand house like The White House. Although I think it is one of the most beautiful houses I've seen.

D: Among the houses that you've seen, are there any, other than The White House, that are particularly memorable, either because of their grandeur, their excellence, or a particular experience that you had there?

H: Oh yes, sure. Pauline Rothschild's was the most extraordinary, full of invention. Absolutely extraordinary place. And then there was a house here in Stonington. It was a church. Part of the church was a gallery, and the owner lived in the other part. And the number of ideas was absolutely unbelievable. Marvelous.

D: A church recycled into a residence?

H: Right. And up in the tower, there was a hammock and some little table. The whole thing was absolutely remarkable, all done with nothing, you know, with no money whatsoever.

D: You've created a world of beauty and elegance that is often based on a great deal of economic privilege. Do you think that it still is convincing or appropriate today?

H: Oh, I think so. But again, it depends on the type of people, who they are. Money itself doesn't do it. You can buy fashion, be very fashionable, spend a hell of a lot of money on your fur coat, and it doesn't work. Then somebody who has no money at all can do it. It happens all over the world—the peasants in the Alps, or the black people in Africa. They have such elegance it's unbelievable.

D: One of your books is called *Photographs of a Decade*. The decade you were referring to was the 1930's, and the book was published, I believe, in the mid-1940's. In the introduction, you wrote that those photographs were social history. You said, ''I believe quite humbly that these portraits may be studied one day as clues to a vanished epoch, as we see the Third Empire through the eyes of Nadar, and the American Civil War through the eyes of Matthew Brady.'' What do you think your portraits reveal?

H: Well, definitely the period, you know. That's for sure.

D: And what do they tell us about that era?

H: Well, the era was a very peculiar one. There had been the gay Twenties, or whatever they call it, that flapper period. And then things sort of boiled down a little bit, and a war was threatening. So everybody naturally was conscious of this thing. It was not a matter of going out and showing off your diamonds and things. It was rather, ''Oh my god, it's going to go.'' You had that feeling. And that's the sad sort of background of what was supposed to be the elegance of the Thirties.

D: How do you compare the celebrity photographs of the Thirties to the kind of celebrity photographs that someone like Andy Warhol has taken during the last decade or so?

H: Oh, I think he has a very good approach. Very personal, which is important. Very, very personal. They're effective. I've

End of the Party,
Rome, 1951

seen some good ones he's done. He did a very good one of Yves St. Laurent that's marvelous, done with very little and still very strong. Very good.

D: If you were to give advice to young photographers, is there anything that you would especially tell them, either to caution them or to try to assist them?

H: They do come and ask me, and I never know what to tell them. You see, you have to find out these things yourself. You should never copy anybody, any photographer. I never look at other photographers, because they're disturbing, I think. You have to see it yourself. As Mr. Nast said, you can make a marvelous photograph out of an ashtray. Or Steichen with his egg. He always said, "If you photograph an egg, you will photograph it a thousand times and each time it will be different."

D: So they shouldn't be looking at the work of other photographers. At what *should* they be looking?

H: Themselves and how they see things, how they understand things.

D: What kind of equipment do you use?

H: Now I use mostly Hasselblads and Rolleiflexes with different lenses.

D: Do you think equipment matters?

H: No, not at all. It really doesn't. Absolutely not. You know Steichen's famous story. He did a photograph to disprove what people were saying: you have to be technical like this and technical like that, this, that, and the other thing. He took a cigar box and made a hole in it and put the film in back and made a photograph without a lens. I believe the photograph is now in the Museum of Modern Art.

D: There is, of course, a great difference between the mechanical function of taking a picture, and the human judgment required to make a picture. And the amateur photographer, myself included, is particularly interested to see new products or improved versions of older products. Are there any that we should know about?

H: No. Things are made too easy through technical tricks. When the light meter is built in, or the whole thing is built in, and all this sort of thing, it's not right, you know. You lose control, you see, the mechanics are taking over then.

D: What were the most difficult moments in your own photographic career?

H: Gee whiz, I wish I knew. I really don't remember. You means the flops I had?

D: Were there some?

H: Oh, sure. I have to think but there were, I tell you. If I ever write a book, there'll be a lot of that.

D: Do you think there was a key moment in your own photographic development when you knew that what you wanted to do was to remain with photography? Or when you thought of leaving photography? Or when you felt you had at least reached a way of making a picture that was of some genuine satisfaction to you?

H: No, I always like to continue. I like to work, you know. It keeps me going at my age. Just ask me to do it and I'm right there.

D: What are you working on now?

H: Well, that book, and then some things for *Architectural Digest.* I have to go back to Paris and do something over there for French *Vogue.* But as for evaluating one's work, I really don't think one should do it oneself. Let other people worry about it. There's always this question, is this art? Well, what do I know? It's for other people to find out whether they think so.

D: Earlier, you were telling me the going price of one of your photographs. Did you ever expect an aesthetic or monetary value to be attached to the work of so-called "commercial" photographers?

H: No. This is absolutely brand new. We'd never thought anything about it. Most of the photographs were thrown in ashcans and forgotten.

D: After almost fifty years of taking photographs, what sort of method do you use to keep your files?

H: I found a very nice girl—actually, ICP and Sotheby's sent her to me.

D: Do they exhibit and sell your photographs?

H: They only sold a couple of them, I mean, you know when they're available through somebody else. I haven't sold any through them myself. One suddenly appears somewhere, and is auctioned off. The last one went for $3,600 or something like that. Unbelievable.

D: Have you kept all your negatives?

H: No. I think I have most of the negatives from the late Forties, Fifties on. But the thirties, those are all gone. Those went in Paris during the war. God knows what happened to them. It's a pity. One of the photographs that was auctioned was one of Chanel's. I had to buy it myself.

D: Why?

H: Because I haven't got it. I haven't got the negative or anything. And that's the one she liked best, too.

D: Is that the one that's in your book?

H: No, it's another one from the same sitting. Like my book now, I imagine I'll have to buy it myself, you know.

D: What was the most difficult assignment, or the most difficult subject you ever had?

H: Photographing cookies, maybe. Cookies.

D: Cookies? For whom did you do that?

H: I think Pillsbury or one of those companies. For advertis-

ing. Well, I didn't do very much about it, you see, because they know all about cookies, and I don't. They come and they lay them out, and they arrange a little bit, and they put the light on, and that's it.

D: And that's the way the cookie is photographed?

H: That's right.

D: During the nearly fifty years that you have taken pictures of fashion and interiors, how has that kind of photography changed?

H: Well, it tries very hard. But I think women like to look nice and attractive, you know.

D: I'm referring to the photographing of that fashion. Certainly during the last ten or fifteen years, we see some new trends that were certainly never seen before, either in family or women's or fashion magazines. And the changes are certainly exhibited in fashion magazines more than in others. I wonder if you'd comment on that trend?

H: If you want to sell a magazine, I suppose you have to shock once in a while. Maybe that's where it is.

D: How frequently is once in a while?

H: Oh, that's up to the editors. I'm not an editor. I'm not going to get into that; I am just a photographer. They know what they're doing. Obviously, they're doing very well with that. That's the way it works. But it doesn't mean it's going to stay that way.

D: And what do *you* think of it?

H: Well, obviously, as in anything else, there's Helmut Newton, who does some very good photographs, and there are others that are irrelevant.

D: Who do you think are some of the best young fashion photographers coming along? Deborah Turbeville?

H: Yeah. But then she has sort of a sad, lost kind of a thing. I mean, it's effective photography, but it's not my style. There are some people who have something. That character thing is very important there, I think.

D: Did you ever expect your life or your career to unfold the way it has?

H: No.

D: What were your expectations?

H: Well, that I make a living, and try to have a good time at the same time. I'm not a businessman; I don't know how to run a studio. I did have one, but I don't know how to do those things.

D: Why did you give up your studio?

H: I was being sent all over the world by Diana Vreeland to photograph people and houses. And people were sitting there in the studio with nothing to do. So I gave it up. Then Diana Vreeland got fired and now I wish I had a studio. It was rather nice. But anyway, I can do without it.

D: Were there any photographers, other than those that we have discussed, who were a particular influence on your work, either in the past, or presently?

H: I think Nadar influenced me quite a bit. As a matter of fact, after the war I went back to Paris and I went to Nadar's studio and bought about one or two hundred of his pictures, all for almost nothing, 50c a piece. Amazing photographs. Amazing.

D: Do you collect the work of other photographers?

H: No, I haven't done that much. I have a few Steichens and a few Cecil Beatons.

D: And Heune?

H: Yeah, all of Heune.

D: How did that come about, that you have all of Heune?

H: He bequeathed them to me in his will.

D: Were you deeply involved in the exhibition of his work at the International Center of Photography?

H: Oh yes. Oh, and how. My dear, for about a year I'd been working with his things for that show. They were very good. I think the exhibition was marvelous. First-rate.

D: If you were to design your own exhibition, what would it be like?

H: That I couldn't do.

D: What photographs would you like to be included?

H: That's like asking me to pick my best pictures or something.

D: I think I *will* ask you that, or at least, which are the ones that give you the greatest pleasure?

H: Well, there are some funny ones, you know. I mean, the one with the chairs. I like that. I like the Turkoman in Persia and his horse. I love that. Definitely moody, it can't be too realistic. That's why I don't like strobe light. It's too blunt. I always said to everybody, strobe light is not realistic at all. this light doesn't exist in reality. You never see anything like this; it's completely artificial.

D: In the photograph called ''The End of the Party,'' which appears at the end of one of your books, there is a courtyard at the Hotel Excelsior in Rome, with empty chairs strewn about. It is a very moving and, for me, poignant photograph, particularly coming at the end of a book. Were you making a statement, or a moral judgement, by including the picture in that way and in that place?

H: Including it in the book, of course, was deliberately done. The end of a party, you know. But when I photographed it, I just went through the bar-room and I saw the chairs down in the courtyard. And I just photographed them, finishing the film in the camera. But it looked very pretty, I thought.

André Kertész

André Kertész, one of the greatest living masters of photography, has had the longest creative career in the history of the medium. He is famous for capturing the look of Paris, but for many, many years—more than forty-five—he has lived in New York, and for much of that time in a twelfth-floor apartment overlooking Washington Square.

Barbaralee Diamonstein: You've arranged for it to snow today. What about this view has continued to absorb you for so long?
André Kertész: I'll tell you exactly. Originally I came to America for just one year. Then, when the war came, and we decided to stay on, we just decided to find some definitive place, which you knew wasn't a bachelor apartment, but charming, nice. Something homier. And this building just came up. Around the end of the war, I decided to drop in; I wanted to see what was going on here. And I had the opportunity to look around, look everything up and down. Now I know what is good for me. If you go very high, you lose too many things. If you are too low, everything looks the same. A little higher is not enough. This is the best point in the whole house, the point for looking.
D: From your own study?
K: Yes. We are over the trees. If you're sitting on my terrace, you see only the tops of the trees. If it's spring, you can see the people moving about. Winter, fall, summer time, you see the trees. And fantastic background. So we took a normal lease for three years. My wife was always more practical than I, her whole life. She discovered very shortly that we didn't have enough closet space. ''So we can't stay here.'' But after the three years were up, we found nothing, absolutely nothing comparable. So we gave up and we stayed. After three more years, we found absolutely nothing. And after that we gave up.
D: How many years have you been here now?

K: Twenty-eight. That was really very wonderful. I was the first in the house. Slowly, slowly, I built up my Washington Square book, and much of the material you find in my other books, too, of New York. The view is absolutely unique.

D: Why don't we start from some of your beginnings, unfold the story of your life and your contribution to photography. You were born in Budapest in 1894.

K: I began photographing in 1912. I tell you what happened. When I was six years old, I was visiting my relatives in the country, not far from Budapest. In the attic I found very nice old magazines, illustrated with woodcuts or prints, but not with photographs. I liked them very much; I fell in love. And I thought later maybe I could do somthing similar. This was my idea. From that moment, I began looking at things the way I would later when I was photographing. Really, I did the right thing. But effectively, I began photgraphing in 1912. From the point of view of composition, I was ready. The very earliest thing I did was absolutely perfectly composed. Balance and line and everything were good, instinctively. This is not to my merit. I was born this way.

D: So you think that education is not so important for a photographer? Is photographic ability something that one is born with?

K: Yes, I was born with this. I began by looking at everything the photographic way, not the graphic way.

D: What is the photographic way?

K: You see my picture and you say, this is the photographic way. I never tried imitating engraving, or printing, or design, the way the other so-called big names did. I never had an epoch, you understand? For a long time, photographers, including Mr. Steichen and that whole bunch, were engrossed in imitating the other arts. Steichen was born in that epoch; he didn't have the photographic feeling. I had the photographic feeling. Steiglitz was the very first who had the photographic feeling. To me, Steichen was a very clever advertising photographer.

D: While Steiglitz, you felt, really understood the photographic way?

K: Steiglitz was born with the photographic feeling, too. I had no idea Steiglitz existed. He had no idea I existed. There were many other people born approximately in this epoch, like Alvarez Bravo—we discovered we had the same feeling. He began a little later, but he had the same feeling.

D: Did you ever meet Steiglitz?

K: Yes. Steiglitz wanted to meet me because of my distortion pictures.

D: You started to experiment with distorted nudes while you were still in Hungary, and then worked on them at greater length when you came to Paris.

K: Steiglitz knew my friend, Gyula Zilzer. And my friend had my distortion work. In 1936, I came over here for the sabbatical year with Keystone, and then I met Steiglitz. Steiglitz had the photographic feeling, and later I discovered Kasebier, who had a photographic interpretation with warm, feminine feeling. All the others were imitations of salon art.

D: In your pantheon of first-generation artists who understood the photographic art, rather than derivative art, you would put Steiglitz, Kasebier, and Clarence White?

K: Yes. Bravo I only discovered three years ago. I didn't know he existed; he didn't know I exited.

D: You have said that you became interested in illustration in the attic of an uncle, and that you started to be interested in photography at the age of six, and finally that you took your first picture at the age of twelve. What was your environment like at home? Were there artists or musicians in your family? Was your own interest in art an accepted thing?

K: No, absolutely not. No artists but intellectuals. My family was a middle-class family.

D: Your father was interested in books, but he was not a bookseller?

K: No, no. My father was a literary man. He was reading day and night. I remember it very well.

D: Did your family encourage your artistic pursuits.?

K: The old things I discovered in the attic were the very first sign. I became interested in pictures generally. In the family we had a camera, and girls, boys, everyone grouped together, and we took photographs of children and parents. I pushed the camera button too; I made something. But that was not what I really wanted to do. I had a dream to take pictures, to have my own camera. But in those days one began working only after passing the baccalaureate. And so one had no money of ones own. I had pocket money of course, and I could have asked my parents to buy me a camera. But I was too proud. I did not like to ask. In my whole life I never asked anyone for anything. I decided that in time I would make my first money and buy a camera. In the meantime I looked at everything as I would through a camera, trying to imagine things this way and that.

D: You started your career in a stockbroker's office. Is that correct?

K: Yes, and after the first World War, when I wanted a change, I left and found another office. I hated that too, I wanted to do photography. But photography was not a profession at that time. Mostly I did the little things that were available to me. Things of everyday life, pictures of the landscape. I don't like showing off. I don't like to imitate. I want to do the things I feel. I concentrated on this. I was uneducated photographically, as far as technique went. For developing, we had a big family armoire.

Chez Mondrian, 1926

Satiric Dancer, 1926

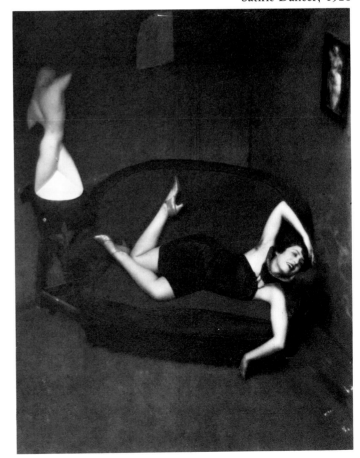

André Kertész

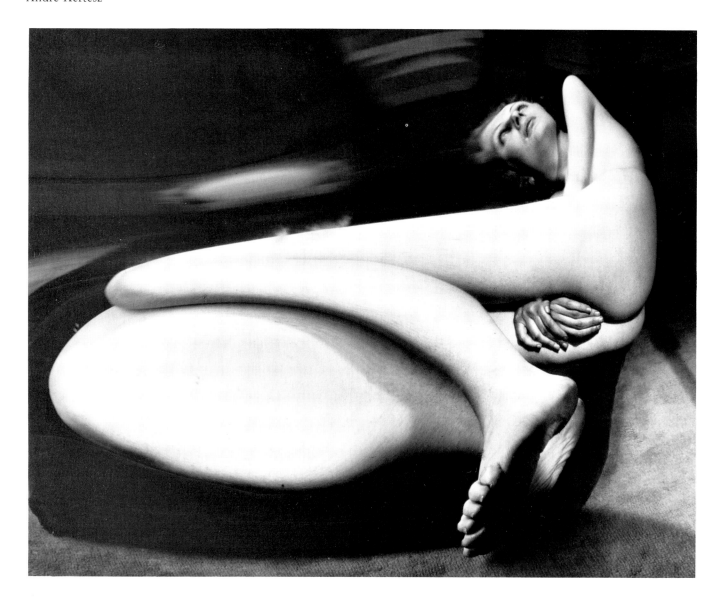

Distortion #40, 1933

D: You used the armoire as a darkroom?

K: I put a small developing table inside. I couldn't close the door all the way. It was dark, but not dark enough for the plates. It was no good. Slowly I discovered that.

D: By trial and error?

K: Yes, by experiments. Mistakes educate you. This is what I tell everybody, young people who come over. "Make a mistake. The second thing will be better and the third time it may be perfect." Slowly, as I learnt to develop plates I overdeveloped this, underdeveloped that. Through my mistakes I educated myself. I read the books or instructions, but the experiments educated me. After I'd made some discoveries and learnt things I wanted to photograph something beautiful I'd seen. I would look at it from a distance, but when I came closer it would look different. It would look different in the camera. I tried to find some method by which I could get closer without changing the first impression. Today I use different lenses. But then, there were no such lenses. So I started to change cameras. I had two, three different ones, one after the other. Optically, I began an education for myself. This way I really learned photography. In the end I did exactly what I wanted.

D: You're a lucky fellow.

K: I *am* a lucky fellow.

D: Before World War I, you were photographing landscapes, and then you went into the army. You were injured during the course of your army service. However, you never took pictures, even though you had your camera with you. You have said it may have saved your life in one instance, but you never took pictures of the bloody scenes of battle. Was that a conscious decision?

K: Look, I was in the first line. It wasn't possible to take photographs in battle. I am sure my officer would not have understood. If you make one wrong move in the first line you can get killed. I took pictures of what went on without combat. We might go one week or more without combat. I took photos of what was behind the first line, but not during battle. That was not possible. Besides, what interested me was daily life in the first line. Sitting in the trenches, reading letters or playing cards, praying or thinking of the family. My idea was that if I survived, I would develop these pictures. I came back. I developed. And when I showed the work to my regiment, they liked it. I presented life in the first line and behind it. My regiment decided to publish a small book and sell it for the Red Cross. Then I was sent to Albania, but fortunately not for very long. After that I was in command of a section of Russian prisoners, and I was also sent with a transport of important papers that were to be taken to Vienna. That was just at the very time when we lost the war. The train that should have taken me from Rumania to Vienna was stopped at Budapest. I arranged for the transport and then I was free to find my way back to my regiment. I arrived at the headquarters and it was empty. I did not find my things where I had left them. The place was almost deserted and nothing was left of my pictures or of my equipment. Everything had disappeared and no one could tell me what really had happened.

D: So there was nothing left?

K: No, I found only two negatives. One was broken. The book we had planned could never be published. So many fine photographs were lost forever. I had many interesting distortions in that bunch. I think you know my underwater swimmer. That was the other negative I found. I am glad it was saved. But there were many other interesting ones, and only that one is left.

D: When did you take the photo of the underwater swimmer?

K: In 1915, I was wounded and my left hand was paralyzed. I had my arm in a sling. It was difficult to put the plate in the camera, but I kept exercising my hand and little by little I could manage. We wounded were in treatment, massage, and in summertime, swimming every day in the pool. It was a beautiful blue. I remember sitting there talking in the noonday sun. And sitting around the steps with the boys, I would be looking at the water. I saw the reflections on the surface and the movement in the water. It made distortions, and I began to photograph. The boys all wanted photos of their girlfriends and said that I was crazy taking photos as I did. All right, I am crazy. Now, in this bunch of pictures intended for the Red Cross book were many distortions which I shot sitting by the pool. The good photos were selected for the book, and they were lost. But the left-over isn't too bad.

D: Did you start the distortion series then?

K: This was the beginning, sitting around in the pool. That gave me the idea. During and after the war, I began with the auto.

D: The auto?

K: Reflections in the auto lamp, and in the garden globe. I began making funny portraits, funny distortions, which nobody was doing then. I had the idea, but no opportunity. Then in 1933, along came Querelle, the editor of *Le Sourire*. That was a girlie magazine.

D: Not the kind of magazine I would have associated you with. But you were willing to work for them?

K: I tell you what happened. It's a charming, charming story. Vertés, the illustrator, a friend of mine, called me one day and asked me, "Can you photograph for Querelle? Querelle asked me to ask you." I called Querelle and said, "If you want something, why don't you ask me?" He said, "I'll tell you frankly, I don't want you to refuse me." Beautiful.

D: And you didn't refuse him.

K: It's beautiful. It's very French. I accepted: I like girls too! Querelle said: "You have an idea for me? Doesn't really matter what this idea is if there are girls in the picture, so do anything that you want. I take everything." And he did.

D: So the first results were published in *Le Sourire*?

K: Yes. Querelle gave me a small studio to use. He also gave me two models. One was a spoiled, very rich Russian girl, Najinskaya. Charming and very rich. The other was a former showgirl, a dancer. One young and one old. I used both for the very first sitting. Querelle was very enthusiastic and we went on. I finished the work in four weeks with a couple of sittings a week. The chief editor for the *Journal Vue*, for which I was a regular collaborator, was a very spiritual guy. He was a caricaturist too. I did the photographs and he did the captions. I had great freedom to work the way I wanted. We had fifty or sixty pictures for a book and everything was ready. Just then, before the book was printed Hitler came to power in Germany. We didn't know what was going to happen. *Alors*, Querelle thought we should wait because he planned to sell the book mostly in Germany and central Europe. We thought this little man Hitler would be washed up in two, three months. You know what happened. He wasn't finished, so we could do nothing with the book.

D: Meanwhile the Keystone agency and the man who owned it kept on writing to you and asking you to come to this country.

K: He asked me for a whole year.

D: And you never responded?

K: I knew the director in Paris. His cousin was in New York. My answer was, "Absolutely not interested. I am at home in Paris." I was completely accepted in Paris, but *completely* accepted in Paris.

D: By then, you were a celebrated photo-journalist in Paris, and there was little reason for you to leave. And your wife didn't want to leave either, did she?

K: Oh, not interested. There was no reason. We had everything. We had worked it out the way we wanted it. My wife was artistic, she had a great feeling for the arts, singing, dancing and painting. She said: "If you accept this New York offer, I'll divorce you." But then I had lunch with Ernie Prince and he talked me into coming over for a while. So I said to my wife, "Look, why don't we go for a year, just to have a change." It was never my intention to stay. But we agreed to come for a year, and that was all.

D: Did you have a specific assignment from the Keystone when you came?

K: No. A contract, yes. Two days before I left Paris, the State Department sent somebody to offer me French citizenship for artistic merit. This was the biggest thing you can imagine.

France usually accepts the big artist, but doesn't give citizenship. But the French discovered that the style I had started was purely French—and Hungarian. More exactly, Budapestian. Budapest makes a difference. You understand? So I told the State Department, "I'm very touched, but look, here is my ticket. I am leaving for one year. After I come back, I'll call you immediately." I couldn't come back. This is what happened.

D: Because of the war?

K: Not the war. The war came much later. I had no money in my hand. If I had had the money, I would have come back immediately after I discovered that I had been cheated. Effectively cheated.

D: Why were you cheated?

K: I was a reporter. I came over to do reportage, not commercial photography. But Ernie kept me in the studio. I told him, "Ernie, I came to be a reporter." "Yes," he said, "I know, but while we're getting organized, please, I ask you to do commercial work." I felt very, very bad. What could I do? I was here, paralyzed. Time went on and on, and there was no reportage. In the end, I did one reportage for *Look* magazine, which was new then. When my picture was published, the credit on it read, "Ernie Prince."

D: Your photograph, but his credit?

K: Yes. Meanwhile, you remembr Dr. Agha? From *Vogue* magazine? He was the art director for Condé Nast. Maybe five, six weeks after I arrived here, Agha called me. I'd never met him, though he'd used my work in Paris. He said, "Why don't you come over and visit me, and work with me?" I said, "If you want something, call Ernie Prince." "You working with this guy?" Agha opend my eyes. This is what had happened: Prince had lost his credit and he was trying to build himself up with my name. With the commerical work.

D: How did you get out of that?

K: After eight months, I was finished. It was impossible to go on any longer. We wanted to go home, but we didn't have our money. My money came much later, during the war. By then I was an enemy alien, fingerprinted.

D: Did Dr. Agha give you work?

K: After I left Keystone, Agha offered me work immediately. *Harpers* did so too. I had already worked with Agha—indirectly —in Paris, for *Vogue*. Earlier I had met Willard Morgan, the man who introduced the Leica. Lester, Morgan's partner, had a relative in Paris. Morgan was helping *Life* find a regular picture director. He introduced me to the boys—the reporters —at *Life*. They liked my work, but they said, "You're talking too much with your pictures. We need only a document. We have an editor to write the text." My answer was, "What can I do if my pictures talk too? I can't touch the camera without expressing myself."

Marc Chagall and his family,
Paris 1933

Calder and his circus, 1929

D: You moved in 1925 from Hungary to Paris, and abandoned commerce for the camera, and the challenge of your art. You were one of the first photographers to turn your small camera onto the street. For more than sixty years now, you have been photographing on the streets. When you went to Paris, you met and greatly influenced two young men. One was Brassai, and the other was Cartier-Bresson. Is it accurate to say that you helped to start them on their photographic careers?

K: I started Brassai. Lately, I hear he's telling a different story.

D: There were other Hungarian photographers from your early life who influence as a group; such as Martin Munkacsi.

K: I had very little personal relationship with him. He lived in Berlin. He was a very genial person, and I respected him. What he did was excellent. *Malheureusement*, he died tragically—of a heart attack, during a football match.

D: There was another Hungarian, Laszlo Moholy-Nagy.

K: He was a real genius. For the first Bauhaus exhibition he came to Paris. Naturally we got together. He showed me his mobiles and asked me to photograph them. Jokingly I said, "Why don't you photograph them yourself. You are a photographer too." But he said, "I only play with photography." That's what he did. He played with photography. He was a great guy. When I came to America he wanted me to teach in Chicago at the New Bauhaus. I didn't accept.

D: Do you regret never having been a teacher?

K: No. I am not the type. Look, I am a teacher, but not an academic teacher.

D: Many young people have come to you, throughout your entire life...

K: I understand. But I am not an academic teacher. Theory and so on is not for me. I don't have theory. Anything I do, I am doing with instinct. You feel, you do. That's all. No explication.

D: Why were all these Hungarians so interested in photography, early on?

K: Well, I can only tell you about myself. Before I left for Paris, when I was working in an office, I think it was in '23 or '24, I sent a few pictures to an amateur photographic exhibition. I wanted to see what would happen. And, shortly, a postcard came from the secretary: "We want to talk with you, please come over." I went and was surpirsed to see that they liked my work. They felt that I had done something personal. But they asked me to make photographs with bromine, imitating the art of engraving. This was at the time when Steichen was fashionable, the salon epoch. So I had to say I couldn't do it. What I do is pure photography. I don't want to imitate anything. They would have awarded me a prize, but I could not produce the kind of photographs they wanted. I said, "You do what you

do, and I do what I want to do." They gave me a diploma. I still have it somewhere.

D: You have lived in New York for about forty-five years now. And you have been an American citizen for almost forty years.

K: Yes, yes.

D: But for a long time, you work was neither aesthetically or commercially treasured. Do you ever regret coming to this country in the first place? You had a brilliant career, and then suddenly...

K: I was completely pushed down here. If I had stayed in Paris, I would have continued my career, which was beginning fantastically well. I had a horrible time here. The reason for this is, I think, that America was not ready for what I was doing. Beaumont Newhall and Steichen were the competent people.

D: Newhall came to see you early on and wanted to show your work.

K: While I was on the ship, coming to America for one year, Newhall tried to find me in my Paris apartment. He needed material for the first international exposition at the Museum of Modern Art, to be held the next year, 1937. Many weeks later, he came back and visited me here at my hotel. He told me what he wanted, so I said, "Take your choice." He took four or five pictures. One was a nude distortion. I was very glad he wanted to use this distortion because I had been doing nude distortions for only three or four years. Paris had accepted them very nicely, Germany and central Europe were beginning to and I hoped America would like them, too. Newhall said, "Yes, I want to use it, but can I ask you to cut down the sex in the picture? What you did is pornography. I insisted, "No, and no and no. How would you like it if someone cut off the top of your head or your finger or your leg? You are complete the way you are. My picture is complete the way you have it in your hand."

D: Were you able to hold your ground about not cropping the picture?

K: No. In the end, I was completely confused. I had been in America only a few weeks. And he was adamant about no sex in the picture.

D: So you did crop it?

K: Yes. Look, I have the original print that was exhibited in the Museum of Modern Art. I am selling it for one million along with the story!

D: Do you make a distinction now between pornography and art? Is anything pornography to you?

K: In pornography you can make out, too. You can make out in everything. The killer can be an artist, too. But pornography should be artistic.

D: You have always said that France never forgot you...

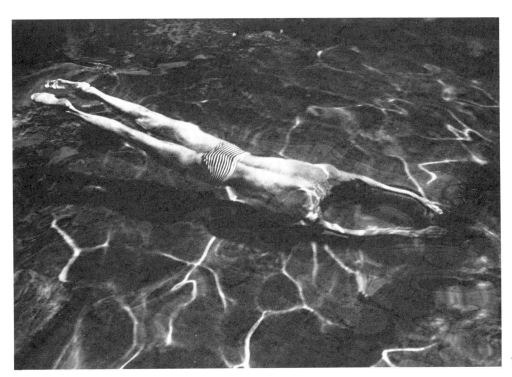

Underwater Swimmer, 1917

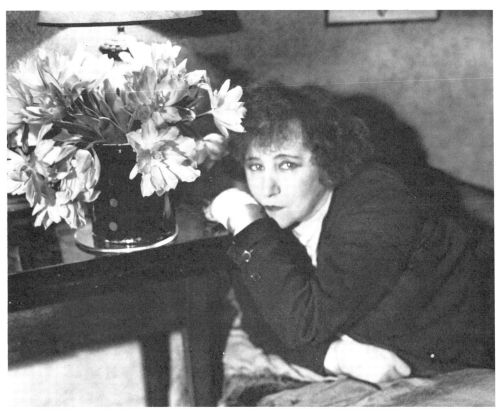

Colette, Paris, 1930

K: No, I was accepted there. There is something special for me with France. After so many years here, Paris recently gave me a decoration, with a declaration, "You are the most Parisian photographer." It came out of the clear blue sky, after I'd lived here for forty-five years.

D: Not only did France not forget you, you never forgot France. Some of your most memorable images were made in France during the eleven-year period that your lived there. Do you think of France as your artistic home?

K: Yes, the French I have never left. Really. Frankly, I lost too much when I left France, but America gave me no opportunity to do what I wanted. If I lost too much, America lost too.

D: When I think about your life, and what you have gone through, I am always amazed that your camera still has a very gentle, romantic point of view. How do you manage?

K: I guess I am romantic. I am sentimental.

D: But how did you sustain yourself?

K: In spite of everything that happened to me here, I am always romantic. It is a miracle. This is the only answer, it is a miracle. Can you imagine, I came over after my European career, and I had my first one-man show here in New York after I'd lived here twenty-seven years.

D: When you were seventy years old, you became a celebrated international artist, and a leading photojournalist. For the last ten years, you have been going over your work and putting it in order and publishing books—in fact, making variations on your own work. What have you concluded now that you have been reviewing for more than a decade? What's the most important thing that we should know about your work?

K: Understanding. That's all. I never wanted to sell my work. If people accepted it, they accepted it; if they didn't they didn't. I didn't want to go in another direction in order to be accepted. I had my style, I didn't want changing into an American, I didn't want to do documentation. I'll tell you a little story. Alexander Lieberman was a young man. He was a nice guy, a very nice guy. We worked together at the *Journal Vue*. When he became art director for Condé Nast he called me. "André, we can work together." I said, "I am a reporter, you know, this is not for me." But he asked me to help him out with *House and Garden*. I accepted and worked very hard. I changed the picture style of the magazine. And other magazines called me. He offered me an exclusive contract. I had done something to give a different feeling, touching something sensitive. It was a nice success. But later on he changed. He wanted ordinary commercial photography. Things happened to make me think over my existence, and I decided it was time for me to leave. I like to let things out of my hands only when they are perfect.

D: Do you photograph every day?

K: No, no. I've had the same roll in my camera maybe four weeks. I photograph when I see something interesting. If things don't interest me I don't shoot. There is no hurry now. I have patience.

D: You don't believe in the decisive moment. How would you describe your moment, when you finally photograph?

K: I can see something that interests me. I will interpret it the way I feel and that's all.

D: How did you manage to sustain yourself, aesthetically and economically?

K: I made my living mostly selling my material. I had very bad experiences with different dealers...

D: Do you sell it mostly yourself?

D: I've learned the hard way. Now I want to have the check with the order. Only then do I send the pictures. This has been my system now for four or five years.

D: Are you your own dealer now?

K: Yes. I make my living selling. Now I've become too popular.

D: You have given a lot of pleasure to a lot of people since you started to photograph more than thirty years ago from this twelfth-floor window overlooking Washington Square. Certain subjects—the Square, rooftops, chimneys, drainpipes—have continued to appeal to you. Where did you get the idea to photograph from inside the apartment? One day you looked out the window and you saw this fantastic view?

K: Oh, exactly. This was the place that gave me everything I wanted. You think you are in Paris. This view is completely Paris. From the other window I am in New York. The subject isn't dictating to you. These are not artificial things.

D: You have always developed a special photographic vision, not only from this apartment. That is, to photograph from a certain vantage point. Where did you get the idea to photograph from on high, looking down?

K: Back in Hungary, very early on. I discovered that I had more to see and more to compose. I began around 1913 or '14. I went into the village and up into the church and looked down. The scene was wonderful, very interesting.

D: And you have always followed your instinct.

K: Yes, yes.

D: In fact, I think you said that, for you, photographing was a way of expressing yourself with pictures.

K: Look, the best expression is my dedication in the Paris book: "I write with light, and the light of Paris....*est ma bonne copine.*"

D: One of the subjects that has absorbed you for many years is birds in flight. All one has to do is look around your library and see the recurring images of birds. What about birds has had special fascination for you?

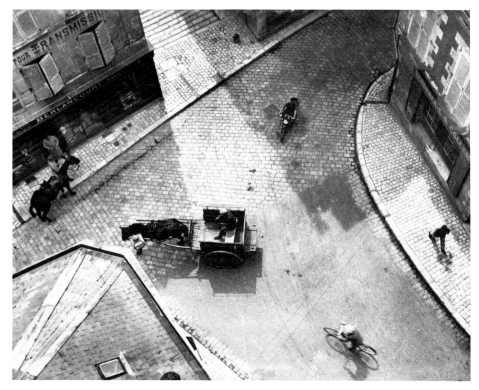

Carrefour, 1930

Chairs of Paris, 1927

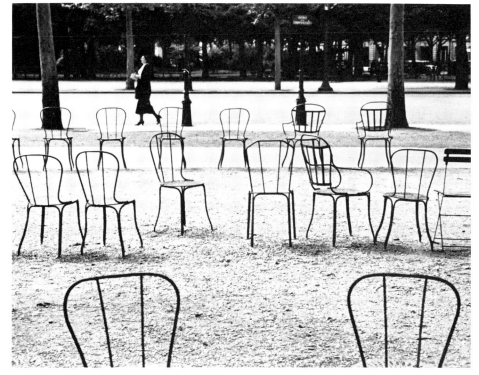

K: I was maybe four or five years old, visiting my relatives in the country. I went in the stable, and a little swallow fell down. I was desperate. I thought the bird was dying. But it was nothing. The family would tease me about it—"André, you remember the little swallow?" I would go out into the forest to see how the birds were. Same thing with the frogs. We would spend the whole day in the water, swimming and fishing. In Easthampton, some years ago, Elizabeth and I were on vacation. Believe it or not, in all the years I had been in America, I had never seen a swallow. But in Easthampton I saw one. The swallow flew back and forth. I begged him to play with me. In the end I had a very charming photo of this swallow.

D: During our conversation you go from English to French; you go fishing, you *peche*. Do you think in English? Do you think in French, or sometimes in Hungarian?

K: Many times I mix things up. But what can I do?

D: We've talked about the F/64[1] group and technology, and you've said that it is such an American way.

K: If you want to write you should learn the alphabet. You write and write and in the end you have a beautiful, perfect alphabet. But it isn't the alphabet that is important. The important thing is what you are writing, what you are expressing. The same thing goes for photography. Photographs can be technically perfect and even beautiful, but they have no expression. F/64 for me is calligraphic photography. For these people the minimum was the maximum.

D: These are the super-technicians?

K: These are the master technicians. Nothing else. Maybe you have an artistic point of view. The subject is good. But you're killing it with the super technique.

D: Many young photographers come to pay you homage, and to show you their work. What kind of advice would you give a young photographer?

K: Work honestly. Use your honest instinct.

D: So many changes have taken place in the seventy years that you have been involved with photography—seventy-five years, if you count from twelve years old. Some changes have been technical advancements, but also photography has been publicly accepted as an art form. Did you ever expect it to happen that way?

K: Beginning from the first moment I felt drawn to photography, I never gave up. Never gave up. I hadn't been in Paris a year and a half, when I had my own show. A photographic show, no imitation...

[1]—Group F/64 was the descriptive name adopted by an informal group of photographers active in California during the 1930's (including Edward Weston, Imogen Cunningham, and Ansel Adams). F/64 is a camera lens' smallest aperture that makes a sharply focused image. The term F/64 was associated with photographers on the West Coast who practiced the "straight" approach to photography. (Group F/64 exhibited together only once, in 1932 at the M. H. de Young Memorial Museum in San Francisco.)

Ray Metzker

Ray Metzker has been exploring the frontiers of experimental picture-making for the past twenty years. By using various forms, from the single negative to murals that contain more than fifty prints, his inventive work has extended conventional ideas about photography.

Barbaralee Diamonstein: Ray, what made you back away from the single negative and prompted you to experiment with multiple imagery?

Ray Metzker: I guess it was about 1963 or '64, shortly after I'd arrived in Philadelphia, when I just found that the single image was going dead on me. I felt that many photographs were simply very quiet arrangements.

D: What makes a picture alive, or dead, for you?

M: There has to be a dynamic to it, a dynamic that is there in the visuals. There's a dynamic that comes of surprise. There's also something that touches us, that seems to reveal. I'd say those would be the main things.

D: You started taking pictures when you were thirteen years old. How did you discover photography?

M: Oh, just as a young person looking around. And I think I had a few friends who were talking about it. One day I ventured into a camera store on my own and picked up a little 25¢ book, *The ABC's of Photography*. I took it home and read it; it sounded intriguing. And then I went after photography.

D: What were your first photographs?

M: They were probably taken along the shores of the lake.

D: In your native Milwaukee?

M: Yes, in Milwaukee, so the lake was Lake Michigan. I grew up in a suburb of Milwaukee. Our home was maybe five or six blocks from the lake, so it seemed a natural place to go.

Ray Metzker

Untitled, from *Sand Creatures*,
1979

Untitled, from *Sand Creatures*,
1979

Untitled, from *Sand Creatures,*
1979

Untitled, from *Sand Creatures,*
1979

D: And you kept on going, with your camera in hand, all the way through college. Didn't you work as a photographer during your school days?

M: Once I got familiar with the medium, I was eager to work for the high school newspaper and the yearbook. And then I had a good opportunity in college, when I was offered the job of doing public relations for the school. So that gave me a great deal of experience in a journalistic sense.

D: What did you do as the public relations person?

M: I photographed anything and everything that was going on in that college, whether it was a football game, or a swimming meet, or dancers, or the religious groups meeting.

D: Did you find a specialty?

M: No. As a matter of fact, at the end of my junior year I decided that it was starting to get monotonous. And so I simply quit, and decided to concentrate in the art department—on such courses as sculpture and painting. I worked with some of the instructors there on my own photography.

D: To when do you date the beginning of your life as a professional photographer? Was it after college, was it during the army, was it after that?

M: I think I would have to say that the determination came as a result of my military experience. That explanation came to me on the train riding into New York today. Looking into the darkness, one will seek the light. I think that the military was such an unrewarding experience, it was so dismal, I knew that that was something I didn't want to have happen to me in my own life. I didn't want my life to remain with that kind of interest. So I came out of school and decided that I was going to explore photography in a much freer sense.

D: And how did you go about that?

M: Well, it all really started when I went to the Institute of Design in 1956. That was one of the great decisions of my life.

D: When you were at the Institute of Design, there were not very many students and not very many teachers. However, there were several very influential people. Who were your mentors there?

M: The photographers teaching at the Institute of Design at that time were Harry Callahan and Aaron Siskind. They have been very important to me and my work. There was a climate created at that school which those two—Callahan and Siskind—certainly professed, the idea of being open and looking and experimenting. And that so connected with the ideas that were forming in my mind when I was in the military.

D: What was the emphasis of their program?

M: Oh, I'd say looking. Going out and looking.

D: What do you, as a teacher, see as themes that most engage your students, these days?

M: That's very difficult to answer. That is a big question in

my mind, and I think probably in many other teachers' minds when they're dealing with students. What really are they looking for? What motivates them?

D: And what do you find these days?

M: Maybe it's not so very different from other times. But fame and fortune in the glossiest terms seem to be a preoccupation with them.

D: Well, maybe a photographer nowadays has more possibilities of achieving those ends.

M: In a different way. The fame of the older photographers, the people we refer to as the masters, like Callahan and Siskind and Sommer, is based on their own discovery of the medium at a time when the medium was not glamorous.

D: And now?

M: Now, it's so alluring that many people are persuaded by very quick looks to jump in, and it requires much more work. It's an extremely sophisticated medium. Kodak doesn't really tell you that. Kodak tells you that it's very simple; a simple medium. But in order to make sense with it, you need a great deal of understanding and application.

D: One of the things that you've managed to do is to take what is generally thought of as the vice of photography, its mechanical and duplicative nature, and turn it into a virtue. I'm talking about the multiple images that you use. How did you come to the multiple image?

M: I think the multiple images were some kind of response to my environment. They were made in Philadelphia, beginning around 1964. My impression of Philadelphia in those years was that architecturally, on the streets, it was a very monotonous town. It wasn't very stimulating.

D: Why did you go there?

M: Because it afforded an opportunity to teach. After graduate school, and spending two years in Europe thinking about what I wanted to do, I came back to the United States declaring that I would like to teach photography.

D: Then, to use your words, around the mid-Sixties the single, fixed frame image became dead for you. So you tried to extend what you did with photography. How did you go about that?

M: One way was simply to block my working with a single frame. I could go out on the street and see something and say, "Gee, maybe that would be a good picture, or that would be right." And then I said, "No, no. You're thinking in terms of a single frame. Forget it." In order then to really proceed, I began with some questions like, "Can I use the entire roll of film as a single negative?" A roll of film usually had thirty-six exposures, and so I would say, "How can I see this as thirty-six instead of one?"

D: Did you manage to do that?

M: Oh sure. That's how the big composites came about. Once that strip was there, I began to see that it wasn't enough. I wanted to build on that. So I started laying them out and that required decisions about equipment. I needed an 8 x 10 enlarger so that I could print ten inches of film at a time.

D: Did you have all that equipment?

M: No. I found the enlarger and then I also had to modify it. I had to build some things in order to make it work for my purpose.

D: How does that composite technique relate to cinematography?

M: It relates in that it's dealing with time. There are images made at different moments, and the viewer's impression is that it can be cinematic. After all, it is a number of frames. I never felt that I was trying to imitate some aspect of film. I was much more involved with seeing those multiple images simultaneously. I was not trying to have a beginning and an end; I was not trying to lead the viewer through those images in any particular order.

D: Are you saying that you are more interested in multiplicity and succession than in a filmic technique?

M: I realized in the years following, that complexity is a key issue with me.

D: What does that mean, Ray? I think *that's* too complex for me. . .

M: Well, it's too complex for me, too.

D: So how do you deal with it?

M: How do you deal with your life?

D: It's not easy!

M: Well, that's the answer. You look for metaphors, descriptions of what you know or experience, and complexity is the term that I find I return to, many, many times over.

D: Content and visual effect are obviously very important to you.

M: Content and visual effect, yes.

D: Would you describe those multiple works as mosaic?

M: My term is composite. But I guess mosaic is fine.

D: What does composite mean? A composite of what?

M: It is a composite of time; it is a composite of various relationships. Most of my pictures are populated with figures, so they're all different relationships of these figures in a setting. And then it's also the composite of all the various frames.

D: So many of your multiple images are abstractions that are architectonic and minimalist in their approach. But do they stem from a reality that you have in mind when you start?

M: Oh, definitely.

D: Your work is so varied, from the abstractions to single pictures of people out in Chicago's Loop or on an Atlantic City beach. Is there some thread, some unifying principle that holds them all together?

M: I never find the term that does it. I could say it's complexity, or it's a truth, or it's a love. That's very abstract. And then somebody says, "What are you talking about?" But those things are the deep, deep motivator.

D: Many of your pieces emphasize your manual participation in the photographs themselves. How much of your work actually takes place in the darkroom?

M: In the composites, there's a great deal of work that follows after the prints are made. As for the desire to get in and touch, to manipulate—perhaps manipulate isn't quite the right word, but I'd say that to enter in and to touch seems to be an idea that goes through a lot of the work. And I think that's true of the "Pictus" series as well.

D: The "Pictus" series has a rather distracting name. What did you have in mind?

M: The series beginning in '76 is entitled, "Pictus Interruptus." And that's just an enjoyable title for me.

D: What were you interrupting?

M: I'm interrupting the vision. Whether you want to say it's the camera vision or it's our vision, it is the vision that I'm interfering with.

D: By literally placing something else—a piece of paper, your hand—either in front of the camera or in front of the image that you are photographing?

M: Just in front of the camera, yes.

D: And what was your intent when you did that? You returned to the single image with that.

M: Right. The "Pictus" series comes out of a preoccupation with what I call the vacuum cleaner effect of the camera, the fact that it picks up all this detail. Many people find the effect fascinating, but to me that's symptomatic of our time. We allow ourselves to get involved with all this detail that after a while never really does say too much. I guess it helps to keep us from being bored. And the series is one of those situations where you keep your attention riveted on all that detail and you never really see where the large things, the major things are. That seemed to make a great deal of sense to me, so I constructed an image around that idea. In fact, I'd say I constructed some kind of system of working around that.

D: One of the other ideas that preoccupies you is the notion of water. You'll readily admit that the more fashion conscious probably go to other beaches—but something apparently attracted you to Atlantic City. What about Atlantic City so fascinates you, that you went back over a very extended period?

M: The initial attraction was to a beach located close to Philadelphia. I went for my own relaxation. It was only after I was on the beach, looking around, that I felt there was so much going on I just wanted to photograph. It really underlies

something that I said earlier, that at least for me, photography is a response to an environment. That is a major factor in my working, although ''Pictus'' doesn't sound like a response to a specific environment. But many of the things that I've done, like the Mexico photographs, are about being in a place and reaching out, and trying to know that place. Asking, what is this about? And as I'm asking that question and looking, I find I have to have the camera and begin to work with it and see what is coming out of it.

D: So the camera is your probe in your response to the environment.

M: That's a good term for it, yes.

D: You've certainly moved around a great deal over the past twenty or twenty-five years, from Chicago to Europe to Philadelphia, New Mexico, Greece.

M: Well, yes. I had a good bit of wanderlust.

D: Your beach series has been collected in a well known book, called *Sand Creatures.* You found many of these sand ''creatures'' in either intimate or delicate moments. Did they know that they were being photographed?

M: For the most part, no. I think my approach there was really to be very restrained. . . the observer. I wanted the subject to speak for itself, so that meant looking in, but not making contact with.

D: Do you prefer that?

M: I think yes. The role of the observer seems very important to me.

D: By what moral standard, in terms of observation, is one governed as a photographer? What do you think in general, and specifically in terms of your own life and work?

M: What would be the moral standard? You're not asking how far do you go?

D: I think that is a better way to put it.

M: You are aware that there are times when photographers violate the subject.

D: From time to time I have been aware of that . . .

M: Well, I certainly could say that photographers have gone too far many times. I was very aware of that issue when I was on the beach at Atlantic City. I realized that the things attracting me were the intimacies. Things that people were doing seemed to really belong in the privacy of their homes. But that was the discovery: once people were at the beach and had established their stake-out, then they would eventually relax and act as if they were at home. I realized that my being that close might be interpreted as an invasion. And also, because I was interested in showing people when they do unbend, I felt that there might be some moments that could be considered not pleasing. But I realized that if I were just exploiting these people, if I really didn't have respect for them, I wouldn't be able to go out and photograph, to go that close. When I am not respectful, somehow the subject will know it, and the whole situation falls apart.

D: Is there a standard of physical beauty that you look for, and what have you found?

M: The beauty is in that moment when these people reveal themselves. It's a moment of truth. For me, this element of disclosure makes the photograph. I mean, everyone will say there are strong formal factors working in those images, and that's true. I can't help that; that's the way I see things. But the photographs that I'm going to select out of a group will be those that have that extra touch of disclosure.

D: You've referred to your photographs as notations, expressions of your thoughts. For you, photography starts with a relationship that is outside of the individual who is taking the photo, or the subject of that photo. I guess it's some higher reverence.

M: The higher reverence is in that fundamental attitude I have about my being. I don't think I can work if I don't have a reverence for this thing that's around me. There has to be that idea that this thing is very marvelous or very wonderful, and that one wants to try and know it, or grasp it. There are just so many terms that you can use, you know.

D: How often does the unexpected happen when you work?

M: Always. And that's why one works.

D: But you are such a carefully considered individual, who uses a great deal of planning and thought and self-censorship. In fact, when you described your transition from single images to composites, you said you'd walk around and see things you wanted to photograph and inhibit yourself from photographing them. There is a great deal of consideration to your thoughts, and I assume to your process of photographing.

M: Maybe the analogy is to some kind of hunter. The hunter is aware that there's this marvelous creature, and begins to find out something about that creature. Its size, its color, its habitat, what it feeds on. And then, if you want to capture that creature, you've got to take this understanding and fashion a method by which you finally come and catch it.

D: Do you think you're approaching that moment, or have you already done so?

M: Oh, I think in my photographic experience, it's happening all the time. That's the adventure of it. The real challenge these days is trying to get an idea of what those marvelous creatures are. You have to go to the books and turn the pages, you know. It's a looking process. What else is out there that I can go after?

D: Was there ever a moment in your photographic life when you thought perhaps you didn't want to go after it any longer? Apparently you dislike being bored, so you keep on extending

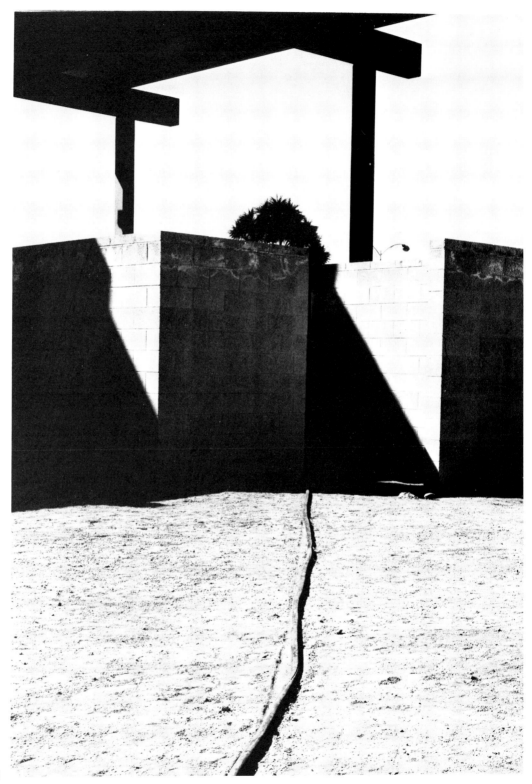

New Mexico, 1972

and expanding and looking for new ways to express yourself with picture making. But was there ever a moment when you thought maybe you should reconsider?

M: There have been many moments in what you see as being a love affair. But as you know, we often talk about love and insert hate into the relationship. There was a very major, very important time when I didn't think that I would go on.

D: When was that, Ray?

M: During graduate school. I had a very dark period. It seemed that the subject was overwhelming and I wasn't making any headway. It was a period of despair and I just didn't even bother to photograph. Much of that lasted through the winter, and then on a bright sunny day when I was walking down an alley, I just saw something and I said, ''I have to get my camera.''

D: What did you see?

M: It was probably something to do with a tree and a fence. At that time, it wasn't anything very extraordinary. But there was a relationship there, and it caught my eye. And I was motivated to act.

D: You've said that you don't consider yourself a mainstream photographer. How would you refer to your work? Someone called you an intellectual wanderer. Would that fit?

M: It sounds like too much these days. Maybe I'm just a nutty guy working away, that's all.

D: What kind of cameras do you use? And does it matter what kind of equipment one uses?

M: I've used a number of different cameras, some that are considered the best. And when I've worked on the beach, I've used a half frame that was practically a toy.

D: In periods when you either question what you're doing, or need support or just camaraderie, are there any photographers that you number among your close associates or mentors?

M: I always find that question difficult to answer. There are other photographers with whom one discusses work. There are many photographers whose work I'm aware of. In terms of mentors, I don't know that I would admit to that now.

D: What about Callahan and Siskind? Do you still maintain a relationship with them?

M: Oh, definitely. They're obviously mentors. And they were very important as models in my life.

D: You've just returned from teaching at Columbia College in Chicago. How does it feel to return, more than twenty years later, to the very place where you were a student? Your work was first exhibited in the Loop in Chicago.

M: Right. And the school where I'm teaching now is located about two or three blocks away from the Loop. So I see the Loop every day when I go to school, and I have returned to

photograph there.

D: Have you? And how do these photographs differ from the earlier pictures?

M: Oh, I haven't really thought that one out yet. But I just find that it's very stimulating.

D: Among the things that stimulate you are things other than photography—for example, music and kinetics. You've said that works by composers like Stravinsky and Bartok are especially important to the development of your work. What ideas have occurred to you because of the music or through the music? Does it provide some kind of inspiration for you?

M: Music, particularly percussive music and some of the moderns you mentioned, were very instrumental and played a major role in the development of the composite. Prior to the composites, I actually was working with electricity and lights and moving objects—call it kinetic sculpture. It was an interest, but it also required technical ability in which I found myself lacking at the time. I had to make a decision, whether I was going to move into that area and go after a better understanding of electricity and gears and maybe cabinetmaking, all the things that would have been required. And I realized that I just didn't want to spend that amount of time. I came to realize that I'd had more experience in photography, and therefore, it was easier to say something and to get at the subtleties and to control it, really. So if that were the case, why not just go ahead and try and take the ideas of kinetics and bring them into photography?

D: How did you do that?

M: That was part of that composite, that repeated image. I mean, in the composite you'll find that there are certain visual elements that frequently repeat themselves or flow through the whole piece. That stems from my interest in kinetic sculpture.

D: Are there certain photographs that are a key to the development of your own work?

M: As one is making images, there's this flow; there are certain images that one stumbles on. Sometimes it's with great delight and sometimes it's with puzzlement. But I can recognize that signal, and I'm apt to take the image and tack it on the wall or put a small print of it in a book. Trying to hold it.

D: What are some of those images?

M: The image we were looking at earlier comes from New Mexico. It's an image of a wall with bright sunlight on a good part of it. The sky is a deeper tone, and there's a shadow at the bottom, representing some of the ground. The wall itself is printed in such a way that there is no detail. And that description just leads right into the ''Pictus'' series, although the photograph we're talking about was made in 1972. The ''Pictus'' series didn't start until 1976. So there are those times

New Mexico, 1972

when one sees an image and it makes an impression, but I am not able to say why it makes the impression, or to say what is to follow. But somehow it seems that that image gestates within, and then one encounters some similar situations later on. On the second encounter, they seem to have a rightness to which I can say, "All right, now I will proceed." Frequently that happens—I know that I'm proceeding without even recalling what that key picture was. And it's not until I'm going through the files or I'm seeing older work that I'll say, "Oh yes, that's clear now." There's another image in the "Pictus" series. It's an image that was probably made in 1964 in Philadelphia. It's just a close-up of a plant form. Well, instead of the "Pictus," it relates more to the "Whimsies."

D: You're talking about your "Whimsies and Whispies" series? What do they mean?

M: They're something that come to mind when I'm working. And that's fine.

D: In the "Whimsies and Whispies" series you combine multiple images of plants.

M: Right. That started in New Mexico.

D: There were separate photographs of plants?

M: Yes. And they were then assembled into little diamonds. In each diamond shape there were four of these plant forms. The idea was that they were put together rather arbitrarily, with a certain capriciousness. And at that time I felt there was a whimsy to them.

D: What precipitates the change of subject matter? Is it environment?

M: It's in environment, and one's experiences, what one is seeing. It is all part of a growth process in which two things go on. One is exhausted or is becoming tired of something. And meanwhile, an attraction to something else is building. So I'm caught between those two, and that's what's moving me along.

D: Very soon after you became a student in Chicago, you had your first exhibition at the Art Institute. That, of course, is very unusual. How did that come about?

M: We were required to do a thesis project at the Institute of Design, and mine was a study of the Loop. It was called "My Camera and I in the Loop," and it turned out to be fairly extensive. I'd say there were 120 photographs in the series. And when it was completed, it was shown around at the Institute of Design. The director, Jay Doblin, suggested that I take it to Hugh Edwards at the Art Institute. Hugh looked at it and said,

"We must do a show." He was a very wonderful person. He had one of the most exciting gallery programs anywhere in the country. He did many, many different things, and he was very encouraging to younger photographers. So that was a wonderful experience.

D: Which of your exhibitions has been the most satisfying?

M: Well, a very important show was "The Persistence of Vision." It was organized by Nathan Lyons at George Eastman House, either late '66 or early '67. Lyons brought together—really for the first time—a number of photographers who were working outside of the single frame.

D: Who else was shown?

M: Let's see, Jerry Uelsmann, Robert Heineken, about three or four more. My memory is terrible.

D: But you do have a very vivid memory of the first job you ever got. And it was a commercial one. In those days you had no telephone. How did they ever find you, and what was that job about?

M: Well, that thesis managed to get me into a number of things besides the Art Institute. Somebody who had seen the thesis at the Institute of Design talked about it to the designers at Container Corporation. They were looking for a photographer to go around and document their whole operation, because they wanted to do a book. And after they saw my thesis, they hired me.

D: For how long did you work for them?

M: About six or seven months. When they hired me, I was just loading trucks for an industrial towel house.

D: So it was a real boon for you. Have you ever had any other commercial clients or employers?

M: There were a number of jobs that also came to me when I was in Chicago. Alcoa was one of them.

D: You decided to give up commercial work for teaching and the kind of work that you now do. What prompted that decision?

M: I like the idea of being free enough to go out and discover something. It isn't just discovery, you see, it's based also on a desire to reflect. As you've observed about the way I talk, I don't always nail down the specifics. It's that nonspecific that I think about, that I'm looking at and trying to incorporate along with a specific. And many times when you're on a commercial assignment, you're working only with a specific.

Joel Meyerowitz

Joel Meyerowitz has been photographing since the early Sixties, when he took to the streets. He is one of the photographers who has made the transition from seeing in terms of black and white to recreating a world defined by color. A leading figure in the new color movement in modern art photography, he is admired for his exploration and masterful handling of the effects of light and shadow.

Barbaralee Diamonstein: Joel, you were working as an art director at a small advertising agency when you decided to try photography. How did that decision come about?

Joel Meyerowitz: I had been assigned to travel downtown with a photographer named Robert Frank and observe his shooting for the afternoon. I thought to myself that I'd never seen anything like that before, and when I returned to the agency that afternoon, I resigned. I felt that there was something else out there for me, something other than sitting in an office and making thumbnail sketches of products and advertisements.

D: Did you know anything about taking photos?

M: Photography was, on the one hand, a mystery to me, and on the other hand, a commercial enterprise. I had seen the work of Richard Avedon, Irving Penn, Hiro, and Magnum and *Life* photographers, but I had never seen any "serious" work. I thought that all photographs identified as "Matthew Brady" were the work of one person. I didn't realize that he had dozens of people working. And it didn't occur to me that serious photography existed. I just knew that I had to go out in the street and photograph.

D: How did you learn technique?

M: Well, that's something you do by doing it. I wasn't smart enough to ask about a school. I'm not even sure schools existed at that time. I borrowed a camera from a friend and I made

Joel Meyerowitz

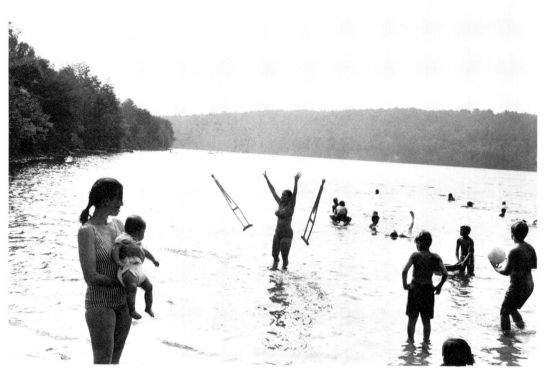

New York State, 1970

New York City, 1971

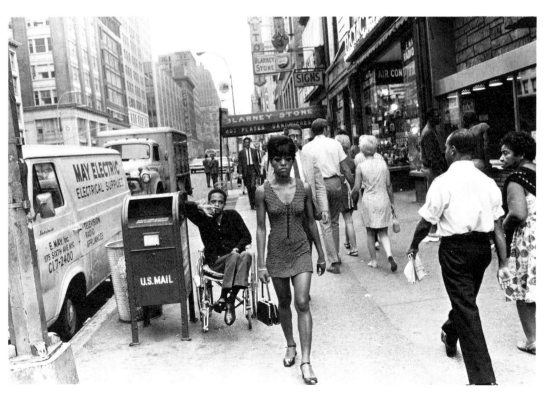

photographs. I shot in color right at the beginning because I couldn't print black and white—and color seemed to be the most natural thing. In the evening I would look at the slides and if they were too bright, I would plan to make them darker next time. If they were too dark, I'd make them lighter. It was a very pragmatic, simple-minded approach to making photographs.

D: What made you take to the streets?

M: It's all out there. Every day I would look out of my office at the action on the street, some thirty stories below, and I would wish I were out there. So, when I got my first camera, it seemed natural to go right to the street. That was the stream. That's where the fish were. That's where I wanted to be. Walking the streets provided me with all kinds of opportunities involving chance and time and speed. Anyway, I didn't see photography as something that I should manipulate, that I should arrange like flowers or a still life, anything studio bound. I felt that it was about instantaneity.

D: And memory?

M: And memory, too. You have to remember everything you do, so that you can always build on it the next time you work. When I photograph, I have a machine that chips away at a thousandth of a second, a 250th of a second. I learned to make gestures in that small sliver of time, to somehow thrust myself into a crowd, into a situation. That's what I saw Robert Frank do, that first afternoon. I think what moved me more than anything else was the fact that he was in motion while he was making *still* photographs. It seemed to me some kind of irony that you could flow and dance and keep alive, and at the same time chip things away and just cut them off. I liked the physicality of that.

D: You've described growing up in the Bronx as lower-class, but fun. There must have been something very special about that environment for you and your two younger brothers: Rick is a first-rate illustrator who works for the *National Lampoon,* while Steve is an up-and-coming entertainer-pianist. What or who in that environment was so special as to inspire all of you?

M: Well, I think that the throbbing energy of the tenement and the street pervades your life. There's always a drama outside your door or your window. The neighbors down the hall enacting their ''Molly Goldberg'' family situations, and right outside your window, lovers in the street and quarrels and fights and car accidents and peddlers going by. It was a very full environment. As a kid growing up, I watched it from my window. I listened to everything and I learned to pay attention. This was before television, and I liked the serial quality of the ongoing dramas and comedies. My mother and father were positive people. They never said no. They always said, ''Okay, if you want to do it, do it.'' So I'd try it. If you fall down and get up, you'll do it again. It was never, ''Watch out, you'll hurt yourself,'' or ''Don't try anything.'' So there was an invitation to experience things and to experience yourself, and I think I've maintained that. I try to maintain it.

D: Every generation has a different set of resources, and you've said that the serial nature of comic strips and serialized movies have influenced you. What effect did they have on your vision, and what do you think is the resource of the current generation?

M: I think it's an interesting way of looking at it. When you make photographs with a small hand camera, there are 36 images on a roll and you can tick them off one after the other. In some ways, you don't need to make a monumental, significant, ultimate image. You can make a piece of something, a piece of something else. When I mentioned serialized dramas outside my window, I was also thinking about the Saturday afternoon movies, that same kind of serialization. They left you hanging week after week. You wanted to go back and see what was coming next. In still photographs, which are those fixed parcels of time, you might make a literature out of a bit here and a bit there, rather than making single great masterpieces. You can think about weaving them together so that one image will lead into the next. I think this way of working is much more like language. As for the coming generation, I assume that the media that people are brought up on will influence how their photography looks. There's a casualness about photography now. People just go plick!—like that—and there's a picture. It isn't based so much on framing or rules of composition, or anything academic or classical. It's about the content. It almost doesn't matter if it's framed nicely. If the content is strong and you can feel something in the photograph, you've got a photograph.

D: Is that a good or a desirable thing?

M: I think so. That's where photography brings itself into our consciousness. It's fixed and hard. Everything else is trailing along, film and video have time involved. Photography is about stillness, instant feeling and definite stillness.

D: Your earlier work is part of the modern tradition that is referred to as ''street photography.'' I wonder if you'd explain what that means.

M: Street photography: to me, it means being out on the street using your wits and a sense of yourself in that place, your willingness to deal with chaos and arbitrariness. Things come at you and you have to work with them and be responsive and full of feeling. You have to pay attention. Reveling in the chaos of the street, I think, is what underlies the idea of street photography.

D: There are several central figures to that movement. To whose works do you most respond?

Joel Meyerowitz

St. Louis, 1978 (Original photograph in color)

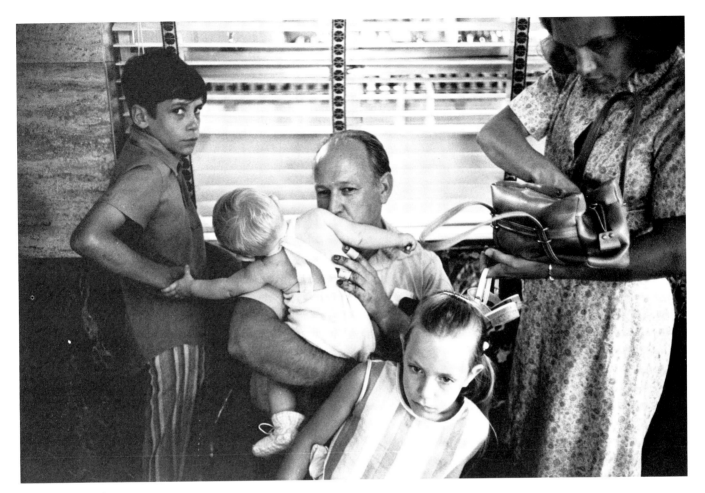

Atlanta, Georgia, 1971

M: I think that Garry Winogrand is the reigning duke of street photography. He's got the most playful mentality. He's alive to the possibilities of the street, he's careless in the most wonderful way, and I think what's in his mind is in his photographs.

D: You have a particular reason for assigning that regal role to him. He was one of your early mentors.

M: When I first went out on the street after seeing Robert Frank, I sauntered around Fifth Avenue and I would bump into this curly-headed guy with a camera, here and there. Occasionally we'd see each other working and we would join forces. Some days I would accompany him on his rounds and he would accompany me for whatever I was doing. And I began to see what his appetite was about. I think that's what I learned from Garry: that you could trust the street to provide, that there was lots out there, that life was a thrill. Since he was ten years older than I and had a lot of experience on the street as a photographer, he showed me what was possible. That's my debt to Garry, more than anything else.

D: Do you think that he has a signal role in photography? You mentioned that it was he who changed the terms. What do you mean when you say that?

M: Well, he made something break free. He said through his photographs that it's *all* subject matter, everything. You could look at a monkey on somebody's shoulder and something else happening over here and if you could put them together, they *were* together, they had a new meaning—about what, he didn't know and I didn't know. But photographs add up on their own terms and make significant contributions to what's possible. I think that's what changed the terms. Robert's pictures were important in another way. They showed something about what an intelligent overview of oneself and place might produce in a body of work. Garry's photographs were more physical and zany. They let in more things for subject matter, and I like that. They're about the possibility of all kinds of things.

D: Were there any other members of this roving band? How do you photograph in collaboration with other people?

M: Well, ultimately it tears you apart. It sends you all on your own way. Tod Papageorge and Garry and myself were a mixed trio on and off for several years. It was more or less for the pleasure of the company that we were keeping. Occasionally on the street we'd hit on the same thing and we knew that three cancelled out all three photographs. Our temperaments were certainly different. Everybody makes his own picture. It was just being there together and keeping a dialogue alive on the street, watching for everything—like jazz musicians playing together. Someone sets the tone and it picks everybody up. Some mornings one might get up and just say, ''Oh, I'd like to stay in bed today,'' and all of a sudden the phone rings and someone says, ''I'll meet you at the greasy spoon at 8:15.'' And you're out, that's it! You don't have a chance to succumb to whatever laziness or lack of appetite you have. You're out in the street.

D: How did you survive in those early days, a free-lance photographer in 1962?

M: That was really before I was a free-lancer. I was just a photographer, and the superintendent of a small brownstone on the West Side, and I also did paste-ups and mechanicals and designed small magazines. I sort of kept ends together. Later I was asked to make commercial photographs, and that's how I've supported myself since.

D: To young photographers just 'how you do it,' seems such a mystery, particularly combined with the words, 'commercial photography.' How do you deal with that?

M: I accept it very straightforwardly, perhaps because I had some time as an art director, and I was conversant with the needs and the demands of advertising photography. So it wasn't scary. I know that in advertising what you must give is a sense of confidence. Most art directors are concerned that if you screw up they're going to lose their jobs. So you have to say, in a sense, ''Don't worry, when I go out there and make those photographs, it'll come out. Relax.'' That comes across through the way you present yourself. I've been able to make a living doing automobiles and coffee and cigarettes.

D: You've said there are only about three or four other well-known photographers in the business who do the very same thing as you do: real life location work. Do you do any studio work at all, and if not, why not?

M: I'm not at home in the studio. I don't know what to make of no scenery. To me, it's more thrilling to be out on the street, on location, on the edge of the Grand Canyon or in Curaçao or Paris, and have a handful of people and make an accident look like it just happened, or have a celebration—put it together so it feels like things I've observed before. I just do what makes me feel right.

D: How does that square with your view that you really don't need grand subject matter, that you really don't need the Parthenon to make a picture and that you like working with ordinariness?

M: They're very different concerns for me. One thing has nothing to do with the other. I've said that I like working on the street and with ordinary everyday objects, because that's what I've trained myself to see and to respond to. I recently picked up an 8 x 10 view camera, and that certainly changes the nature of the game. That camera isn't as flexible and responsive as a small camera, so by the camera's nature, you photograph differently. The subject matter changes. Things do

become more stately, or more still in some way.

D: Until about three or four years ago you were best known for your street photography, and then you abandoned your hand-held 35 millimeter camera and changed to an old-fashioned, large format Deardorff view camera, the kind used by nineteenth century landscape photographers. That is quite a departure. Did any set of circumstances force or cause you to take that kind of risk?

M: Yes, there are qualities within the medium that force you to confront your own behavior. I think you do that at every inch along the way. You judge your own work, see where you're going, where you're coming from. And that raises certain questions. One of them, for me, was the quality in the color printing and in the image itself, because photography is about prints. You hold a print in your hand and get absorbed in it. It draws you in. You have to have this thing to hold.

D: You switched from black and white to color in the early Seventies, and then you switched to your view camera around 1976.

M: Right. The switches aren't complete. I still photograph with a small camera almost daily but I've learned to use two different instruments, to play two different kinds of music, to experience two different feelings about time. One is about duration and the other is about instantaneity. I had always been strongly in favor of color. I think it's a half step closer to the way we feel and see reality, but I had to work in black and white because you couldn't print color with the kind of ease and command that you could print black and white. At a point in the Seventies when color technology made one more turn in the revolution in photography, I understood that it was the moment to throw all the risk in that area. You know, technology has always changed photography. For instance, when the wet plate went to the dry plate . . .

D: Won't you describe the equipment that you now use and some of the issues that prompted that shift.

M: The issue in which I was most interested was the description of things in a photograph. I felt at some point that black and white, 35 millimeter imagery was degraded in some way. If you made a print larger than 11 x 14 inches, it began to turn into grain and gristle in some strange way. I wanted something more articulate, and color has that characteristic. It's very full, it has a long, elegant tonal range. I'm not a salon printer or a salon photographer. I'm interested in seeing what I see as clearly as I can. Color seems to do that. So I made some investigations into printing dye transfers from 35 millimeter color negatives and slides and the like. It became too costly and so I had to pull back. The other still maintained certain uninspired descriptions and so I thought, "If I'm going to photograph in color I should risk working with a larger format camera and get a more descriptive image." Description is the name of the game. The thing that tells it most fully will be the thing that's most adequate for the task. So I purchased an 8 x 10 view camera.

D: A vintage one, too.

M: It's my age.

D: Literally?

M: It's a 1938 camera. We're the same age. It was actually made in March of 1938 which is when I was made. So I have a funny instrument to travel with.

D: Yet another companion. . .

M: Right. I went to Cape Cod for no reason other than to take my family to a place that was convenient for all of us, and the Cape provided me with opportunities to look around. I had no idea what I was in search of. That's not how I think about making photographs. I go to a place to be in a place. When I'm there I try to make photographs about how I feel about being there. Somehow Cape Cod changed the nature of my game.

D: How do you contrast your old style with your new style?

M: One is about physical activity, gesture, spontaneity, thrust. It's fast-click. You have no time, no expanded time, to examine your feelings. With an 8 x 10 view camera you have time. There is this idea of duration; things sit there waiting for you. If you have a feeling, you can make a photograph about that feeling, and somehow endure with it while you're making the photograph . . . I've learned about two different ways of understanding.

D: In the late Sixties, color technology made new advances. How has that new technology affected your work?

M: That's what makes the print more visible now. In each period in photography there's been a technological advance, from the wet plate to the dry plate, from the view camera to the hand camera. More people began to make photographs, a newer version of photography emerged, and so on down the line, until the Seventies when we got very good color film, and adequate dark room equipment, and paper to make color prints that are as easy to make as black and white photographs, as true to the description of the things they see. It's encouraging to work in that material right now. Earlier I had thought to myself, "I'll never work in black and white again." Now I realize several years into making photographs in color, that there are certain tools and materials for certain subjects. If there was something I felt I needed to see and say in black and white, I would use black and white. But I feel it's all in color right now.

D: Today's audience for photography is art-oriented; as a result they are often suspicious of work that is beautiful. Have you ever experienced a bias against pretty pictures?

110

M: Yes, some critics feel that if you take a picture of what looks like a beautiful place, you have only done half the job. I don't think that my work looks like that. If you go to the very places where I stood, it's unlikely that anybody else would want to make those photographs. There's an empty bay, strewn with seaweed, some bottles, boats turned on their side, or there's a dumpy little bungalow or a fence with some chairs—nothing to speak of. What confuses some people is that when you see something, in its great clarity and stillness, it glows. It becomes beautiful and it's so convincingly beautiful that people say, "Well, that *place* is beautiful." Not necessarily so.

D: Color has always been the unwanted guest in photography, best left to amateurs. Has color photography finally shed that inferior status, assigned to it by partisans of formalist black and white photography?

M: I think it may be the other way around, that the partisans have shed their prejudices, that there's been enough color imagery coming out now. There's a whole young generation of photographers who pick up color right away, because now there's a choice. What happens is people begin to see that you can make a color picture as interesting as a black and white picture. It doesn't have to be about that red coat over there or that blue object sitting on something else. It can be about your ideas; it's as full of ideas and questions and imagery as black and white photography, and so on its own terms it becomes convincing.

D: You have had several unusual ideas during the course of your career. More than a decade ago, you made an unorthodox comment on what could be described literally as the passing scene. I am referring to the photographs you made through the window of a car traveling at 50 miles an hour on a 20,000 mile tour that you took through Europe, from the British Isles to Morocco and Greece. Was that an assignment? Did you have precise instructions?

M: No, it was a trip, something I earned and gave to myself. Part of traveling is sitting in a car every day, going from place to place. But how many times have you been sitting there and someone says, "Did you see that? It's wonderful!" And someone else turns around and says, "What?" And it's nothing more than a figure walking across the landscape or it's a horse kneeling down—some ordinary, unnecessary object, or unnecessary event. What I think happened to me was that I recognized those things as significant. Through the camera you could reach out as you went. With one thousandth of a second you could snare that event and hold it fixed in any way that you reached for it, with purely photographic instinct. Not formalist. I wasn't trying to set up any terms. I did it blindly, or dumbly if you will. Before I came back, sometime during the

trip, I understood that something was happening, that the heightened sense of my response was to those things that were out of reach. Certainly I could have stopped the car, run back fifty feet or more, and taken a photograph of something else. But what I saw as I passed was "the necessary moment" and only the camera could handle that.

D: Is "the necessary moment" a new phrase?

M: Hardly. Cartier-Bresson's "decisive moment" will suffice for all of us.

D: You met Cartier-Bresson at an early point in your own career, under rather unusual circumstances.

M: Well, it was one of those thrilling moments of "childhood." I was out at the St. Patrick's Day Parade photographing with Tony Ray Jones and another photographer, and there was a man in the crowd, darting and twisting and turning and pirouetting and leaping. We were astonished by this fantasy in front of us, but we assumed that it could only be Cartier-Bresson: the three of us had been photographing together for about a year, and had only recently seen his book. We just deduced that those pictures were made by someone who pirouetted that way. I went over and said to him, "Excuse me, sir, are you Cartier-Bresson?" And he said, "Non-non . . . are you the police?" I said, "No, I'm just a photographer." Then he said, "Yes, I'm Cartier-Bresson. Meet me here afterwards and I'll take you for coffee." It was astonishing. We stood back a few paces, and we watched him. He was a thrilling balletic figure, moving in and out of the crowd, thrusting himself forward, pulling back, turning away. He was so full of a kind of mime quality. We learned instantaneously that it's possible to efface yourself in the crowd, that you could just turn over your shoulder like a bullfighter doing a *paso doble*.

D: I guess you also learned to use the camera as a weapon.

M: Oh yes, that's true. I saw him hurl it at somebody—a drunk who came out of the crowd trying to reach for his camera. Bresson threw it at him. It was tied to his wrist and it sort of snapped out and came back into his hand and turned.

D: Sounds like a yo-yo. . .

M: Well, it was very much like that. He just pulled it in, like a third baseman. It was effortless. The other fellow, stunned, fell back into the crowd. And Bresson was gone.

D: Did you meet him?

M: Yes, we met afterwards, and he took us for a walk up 86th Street to a coffee house. And he did what everybody says he's supposed to do. He disappeared, in mid-conversation, pht. . . he was gone. Like that. He was up a flight of stairs making a picture and back down again. We didn't miss a beat in our conversation. He was there and back, there and gone. You learn from things like that. You say, "I'll try somehow to use that physical awareness of myself as part of my photography."

Hartwig House,
Truro Cape Cod, 1976
(Original photograph in color)

Wilson Cottage,
Wellfleet Cape Cod, 1976
(Original photograph in color)

That's if you're going to work on the street. I think that's where it belongs.

D: Cartier-Bresson is the role model for many street photographers. To previous generations of photographers, social awareness and social commitment was an essential element in their work. Like a number of other color photographers, your work is meticulous and impeccably printed. But it appears to be directed toward a very different audience. For whom is it made? Is it made for collectors, for museums, for art magazines?

M: There's only one answer. It's made for me. There's no audience, as far as I'm concerned. I'm the audience. Outside myself there's no one more interested than I am. I want to see what I'm curious about. Sometimes I'm interested in social things. At a time your interest goes that way for several years, and then you drop that, for some reason. It's inexplicable. Your appetite changes. You can't eat spicy food, so instead you become interested in light or weight or substance, and then you bounce back. One of the thrills of that Picasso retrospective was to see that in a year, he would turn his back on black and white paintings and go into a kind of radical color. And then he would turn back again and paint family pictures or portraits. He turned when he felt like turning. There were no rules for him, except things that he wanted to change, and that's how I've learned to behave. Bresson figures in this, in some very important way. He's something that you have to get over. You have to give him up at some point. I have had to give up his use of the decisive moment. The fixed incident in a frame was something I felt that I had to abandon while making color photographs with a small camera. And when you do that, you also shift away from social concerns. It's not a permanent shift, it's something that's necessary at the moment, something you have go give up in order to discover what else might interest you. That's my reason for making photographs, to see what I'm interested in.

D: What makes a photograph? For what do you use the medium?

M: I like to find out what my temperature is at any given time. That's really a simple way of saying it, but it tells me where I've been, what I've found most interesting, what possibilities there are, what questions the medium raises. I think questions are a very important aspect of photography. You question the medium itself, you question your own behavior, you question your fascination with things.

D: Are photographs for looking at things?

M: Yes. Real hard. I study photographs, I read my own photographs for many years.

D: And what do they teach you?

M: They teach you about your own unraveling past, or about the immediacy of yesterday. They show you what you look at. If you take a photograph, you've been responsive to something, and you looked hard at it. Hard for a thousandth of a second, hard for ten minutes. But hard, nonetheless. And it's the quality of that bite that teaches you how connected you were to that thing, and where you stood in relation to it, then and now.

D: Since 1965, one of the most photographed objects in this country has been Eero Saarinen's 630 foot arch in St. Louis. It's dominated that city and for several months of your life, it dominated you. In the fall of 1977, you used that arch as your subject; in spite of the fact it had been photographed so often. How and from whom did that commission come? Why that subject matter, and why that place?

M: On a visit to St. Louis earlier that year, I was introduced to Jim Wood, who was then the director of the St. Louis Art Museum. He had seen a number of my Cape Cod photographs, and on instinct, he said, "Could you come to St. Louis and do that?" Well, that work was for the Cape, and St. Louis was for St. Louis. I had spent a day in the city and it felt right to me. What can I say? I've been to a lot of places and they don't feel right; they don't invite you to come back and look around. But something about the emptiness of the downtown area, the proximity of the river, the grace of the arch, all of it said, there's something here. So I accepted. We got a small grant from the National Endowment for the Arts, and from a bank in St. Louis. And I was asked to come out and spend four weeks over a period of a year to do what I felt like doing, which was walking around and discovering myself in St. Louis and photographing what was interesting to me. That's what produced those pictures. They're basically the curiosity of a stranger in a strange place.

D: You've been called the very model of a Museum of Modern Art photographer, a product of the photo-aesthetic promoted by that institution. What does that mean in general, and would you say that it is a fair or accurate description of you?

M: I don't think so, because in the same paragraph, the photographs were spoken of as being like calendar photographs. So how do you equate calendar photographs, whatever they are, to museum photographs, whatever they are? Some people view the museum as too powerful a place, and it's not. The museum is a library. It holds ideas; it has changing bodies of work; it's very much the width and breadth of the real stream of art, photography or painting. And the man who stands in the best position to see what's coming down that stream, is John Szarkowski, and he is a real fisherman. He loves the sport, and he stands in that river and he picks up whatever comes his way, and he says, "That's interesting. It's a little

St. Louis and the Arch, 1978 (Original photograph in color)

small; I'll put that back; it'll come by again next year." I think his generosity and his appetite for the game bring us a wild range of photographs to look at and to think about. That museum has shown sculpture photographs and hand-tinted photographs and pictures from cars and color pictures and 35 millimeter and bank camera photographs. It has had all kinds of things in it, so I don't know what a museum photograph should look like. They're a varied lot.

D: Among your street photographs, very few record specific events. However, there is one that depicts an accident in Paris. Is it surprising to you that that photo is probably among your best known works?

M: Well, it's not surprising. That's the height of the decisive moment aesthetic. Something happens, you happen to be in the right place at the right time with a tool. You make a picture, because you know how to make pictures in situations like that. Quite often when I've shown that photograph people have screamed at me, "Why didn't you run over and help that man instead of taking a picture?" And I usually answer, "Well, I don't speak French that well. I couldn't assist that man, and all those other people were standing around, why didn't they help?" In a way, you're an opportunist. You make pictures out of what's handed to you. And that was a mystery and a gift and a once-in-a-lifetime happening. It marks the end of a certain way of working for me.

D: That particular picture?

M: That's what I meant when I said that you have to get over Cartier-Bresson in some way.

D: Do you only vanquish your creative fathers when you better them? Or at least equal them?

M: No, sometimes you have to say, "That's a wonderful block in the road. I think I'll take another path." I want to cut the path for myself, because it's more interesting to go through the woods and see where you're going to come out.

D: What path did you take after that?

M: I've been forced by the materials of photography—color film, slow color film, and the hand camera—to pull back in space. In order to get the kind of descriptive space that I want, to tell the incident wholly and clearly, I've had to move back some paces. When you do that, the incident loses its power, its draw. You become less related to that incident. Pretty soon, you begin to see that there's more out there, that there's architecture that goes up and streets that go out, and people over here and over there. The whole thing is the photograph, not just the thing in the center. So you might just try and make photographs out of the whole thing, which means relieving the pressure a little bit, and not necessarily making a photograph that's hinged on a thing that you trapped. People always look at that kind of picture and say, "Oh, I see, the fallen horse

over there." So what? It just says that you hit the nail on the head that time. There are other things to see.

D: You once said, "I can't photograph something I don't like." That's an enormous luxury. Is that correct? Have you ever had to do that?

M: No, I haven't had to do anything like that. What I mean is, that I can't go and photograph Bedford-Stuyvesant for pleasure. When I go to a place like Bed-Stuy I feel the need of the place, and I can't make aesthetic works out of someone else's depredation.

D: You've been in the thick of things and on the streets all of your life, and are especially partial, I suspect, to street photographers. You're currently working on an historical survey of street photography. What will that be about, and to what era do you date its origins?

M: That project began at the very point that I let go of Bresson's decisive moment. When I started needing pictures that were more open-ended, and less incident bound, I thought, "Why are these pictures so different from me? Why are they so tentative in some way? They look like failures." So I began to go through history to examine other photographers, just looking to see if other people were engaged in the same problem, with slow films or awkward cameras and the like. I began to see that throughout the history of photography itself, in Europe as well as in America, people made pictures against all odds on the street. I wasn't alone in reliving the incident. Quite often those pictures in the past could not capture an incident. They just took the general flow of life in the street and made pictures; that was enough. My own change of values and my curiosity led me to make an investigation, and that picked up some weight. I joined forces with a man named Colin Westerbeck, Jr. who writes about photography, and we began giving ourselves the pleasure of afternoons in archives and museums looking at photographs. No axe to grind, just looking to see what was there.

D: What have you found?

M: We found a very rich history of people who were crazy in the street, who had the right kind of temperament for street photographers. People who were willing to risk it all with the snap of a shutter.

D: Is that risk factor very important to you? About a year ago, you took a trip on the Yangtze River in China, following exactly the same path that Mr. Thompson did in the 1860's. How did that opportunity come about? And what did you learn from it?

M: Oh, I wish I could have taken it his way. He had twenty mules and a dozen coolies to carry the baggage. He really had himself a time. I was given that trip as the beginning of a new era in American tourism in China. Someone said, "Go to

China and take these pictures, just photograph.'' So I went. I traveled up the Yangtze, made all kinds of pictures in small villages where they had never seen a Westerner, ever. It was a shock to have twenty of us descend on a village with movie cameras and Polaroids and transistor radios and everything. A barrage of technology on the Chinese.

D: Corrupted them?

M: I don't know that they're so easily corruptible. I think that they're living in a way that's appropriate to their needs and their population. They must have thought that we were just robots attached to those machines.

D: What came of that work?

M: Some work can sit for a while. That work is fermenting for me. I was thrown into the Yangtze, and the work is thrown back on my shores now. The pictures are interesting, but I can't see what to make of them right now. They don't fit into my life here. So I look at them, and I'm trying to find out what I did when I was there—whether I was socially aware, whether I was just making photographs, what advantage I made of the situation. I'll know soon.

D: Your work frequently records the interplay of natural and artificial light at twilight. At what time of day do you work at your best?

M: Well, I think that because I work with two different materials, I have two preferred hours. I love the sunny side of the street in the middle of the day. You can find me on Fifth Avenue any glorious day. Because of the view camera's qualities, there's a tendency to work with it later. The film has a long way of looking into the twilight. It's very tough; it records everything. It draws all the information out of that time and makes it very palpable in some way. It has the time of day and envelope of the air and the moisture I feel in it. It's a real window into that time. It's not something I thought of beforehand; it's something I discovered as I worked during that first summer. That's part of the process that I was talking about before. It's really revelatory. You discover that that's what you like, that's what you can see.

D: For obvious reasons, some of your photographs have been compared to the work of Hopper. Do you think that is a fair estimate?

M: Well, I think that the relationship of Cape to Cape makes it appear that there's some relationship there. But in fact, the solitary quality and the dryness of Hopper's vision is not what I'm interested in. We just went to the same place and were struck by similar things. I'm moved by his work, and I love it, but I don't think it's a fair comparison. His work is something far deeper and richer.

D: You started your life as an art student. To which painters do you most respond?

M: That's hard. I love what goes on today. As for the past, I have too large a list of people whom I like, for all different reasons.

D: Gene Thornton, the photography critic, says that the old color photographers celebrated what he describes as ''the wonders of the wilderness unspoiled.'' Unspoiled by man, that is. The new color photographers celebrate the wonders of urban sprawl, American style. Where do you place yourself on his spectrum?

M: You shouldn't compare yourself to anybody else. You save yourself a lot of trouble. I don't know where I fit. I'm living in my time. When I'm in the country, I photograph in the country. When I'm in the city, I photograph in the city, and I don't see the distinction as necessary. I don't need to make a camp of landscape photographers who love the preservation of the wilderness as opposed to those who are doing urban sprawl. It's just not a real argument to me.

D: Calvin Trillin once wrote a very amusing piece in *The New Yorker,* claiming your St. Louis arch for his home town, Kansas City, which he maintains is the true gateway to the West. Is the West a gateway for you as well? Do you plan to go further in your work in the American landscape, exploring either the mountainous regions or the deserts?

M: I love taking photographs wherever I go, so I'm sure I'll be in the Southwest sometime, and I'll make photographs there. But I can't say that I have a fortieth parallel idea, that I want to traverse the country and cover every inch of it along that line. I just take it as it comes. I did learn something about working in the West when I spent time in St. Louis. The subtle character of the light is enough to change things for you. Things feel differently out there. There's dust in the air, as opposed to the clarity of the air in New York City. Or maybe it's the difference between being on the coast and being inland. I'm sure if I was in the desert I would understand something about the desert. But you have to stand in the desert to know about the desert.

D: Is there a key moment in your own photographic development, other than that photograph you mentioned earlier? Did anything else push you forward and advance your own technique?

M: Well, it was a big step to cut off black and white work and commit myself to color. You're really changing the nature of your response. It's a very different game out there. Black and white has more form. Somehow pictures look like there's a compressed formal structure running through them, tying events together. In color there's more of a languid flow from one thing to the other. Learning how to make that switch was a departure for me.

D: Talking about your vintage 8 x 10 Deardorff camera,

you've said that when you look through it, the images are all there, but they're upside down. How do you adjust for this?

M: You spend some time on your head! I helped myself by taking a mirror and making a reflex out of it. I turned things right side up. At first, it gives things a wonderful mysterious surreality. People seem to walk on the ceiling, and furniture floats.

D: How do you compensate, and how do you get the same immediacy and urgency that you get by looking at things with the naked eye?

M: It's a wonderful absorption in the thing itself. You learn to give up content in context, which is what you do with a small camera. You're always looking outside and seeing it right side up. Now, when you're in the dark of the cloth and the camera, you have a theater for yourself. That theater is fascinating. If things are upside down without gravity, you accept them, and somehow make a picture.

D: How important is scale?

M: It's part of everything. It's about where you put yourself in relation to things. The French call the lens the objective. It puts you at a distance from the things that you view. If you choose to stand eight feet from things, and use a very wide lens, it all goes soaring backwards. If you go very close to it, it comes crashing into the camera. So you have to find your feeling in space. It's almost conversational, how close we sit or stand when we talk to each other. If you find the right place in space for yourself, you will understand something about your scale, relative to all things. You have to know how to find the right place. . .

Duane Michals

Duane Michals, the modern master of the photographic narrative, uses his camera not as a tool for capturing moments out of the real world, but as an instrument for revealing his inner state. Telling stories with pictures, he creates mysterious and sometimes bizarre sequences, groups of structured photographs that embody a narrative progression.

Barbaralee Diamonstein: Duane, you have described yourself as having come to photography late in life. When and how did you shift careers and decide that you were a photographer?

Duane Michals: I was never an amateur in the sense that I didn't want to grow up and become Cartier-Bresson. When I was about 26 I went to Russia. As a result of that trip, I decided to become a photographer. I was pushing 30 when I made the fatal jump.

D: How did you do that?

M: I thought, "Look, if you want to be a photographer, why aren't you?" I had no real answer for that. I decided that if I didn't have the courage to do it at 30, I sure in hell wouldn't have the courage to do it at 40, so I had better do it right away.

D: At what were you working when you made that decision?

M: I had been a graphic designer. A mediocre . . . no, I wasn't mediocre, I was better than that.

D: You were good enough to work for some leading magazines . . .

M: Yes, but that doesn't guarantee anything. At any rate, I was at a small studio which was going out of business, probably because of me. It seemed an appropriate time to try something new. I did, and I'm glad.

D: What did you do during that Russian trip, that led you to believe that photography was the medium in which you could best express yourself?

M: I went essentially as a tourist, and I borrowed a camera. I didn't even have a light meter, and I sort of guessed everything. If I had thought of myself as a photographer, I probably would have been too self-conscious, and the photographs would have been really bad. Luckily I just wanted to take nice pictures of Russians standing there. That's how it started. They were good photographs, and I knew that.

D: You have described your first pictures as history, the real world.

M: To me, real is a very relative word.

D: Relative to what?

M: Relative to what most people think it is. I probably don't deal with it the same way most people do. Consequently, my photographs don't really look the same way that most photographers' work looks.

D: At some point, you became disillusioned with what many of us do call history or the real world, and you had the idea of working with serial images. How did that begin and evolve?

M: It came out of a need to express something. I realized that the things that interested me weren't the things I would find on the street. I would have to go out and make them happen myself. I was never a reportage person. Even today I don't walk around with a camera hoping to find a wonderful accident. It came out of the need to talk about things that really disturbed me, things that I consider very important. Like what happens when you die, and what happened to yesterday, and all those silly things that kids ask—but we as grownups don't ask, because we know better. Those are really the important questions that should be asked and never are. Not just by photographers, by everybody. Everybody should ask, "What the hell's going on here?"

D: So you've used your camera as a journal in which you record intimate thoughts, self-reflection, and, very often, philosophical musings?

M: Well, intimate sounds sort of spicy. But, yes.

D: Sometimes they are sort of spicy.

M: Yes, I know.

D: How do you differentiate between that which is spicy, that which is art, and that which is pornography?

M: You mean, nice spice and bad spice? I'm also a phrase maker—you musn't believe everything I say. Well, I think the work speaks for itself. There are no lines. The important things can't be defined. Our problem is we are always trying to make definitions for things, and that's where we get in trouble. Definitions are a way of controlling things, because once you've defined something, you leave no room for change or growth. The important things can't be defined that easily. That's why poetry is so expressive . . . is so important and elusive. You recognize art or you recognize poetry, and you really can't define why you're moved by it. But you're being touched in some way. Those moments are very rare, and very seldom in photography, as far as I'm concerned.

D: We are in a period that considers what has been defined as directed reality, as desirable and even fashionable. You're willing to limit yourself to constructing experiences in order to photograph them. Why are you willing to do that?

M: It seems the only way to deal with certain subjects. The only thing we know for sure is what we experience. If you look at a photograph of somebody crying, you register grief. But in fact, you don't know what people are experiencing at all. You're always protecting your version of what that emotion is. What is known is only what I know. The only truth I know is my own experience. I don't know what it means to be black, I don't know what it means to be a woman, I don't know what it means to be Cartier-Bresson. So I have to define my work in terms of my own truth. That's what the journey is all about, if you are true to your own instincts. The great wonder is that we each have our own validity, our own mysteries. It's the sharing of those gifts that makes artists artists.

Most photographers are of the reportage school. American photography's always dealt with going out and documenting the façade of a building. It's very seldom dealt with the interior landscape. Social landscape was a very big number in the Fifties, or I guess Sixties, I don't remember anymore. But my kind of photography has really been somewhat of a wolf in the henhouse, in the sense that in America it hasn't been accepted that much. It is accepted now, but it's a relatively new notion, to sit down and think about something and then make it happen, rather than looking for it. But my truth, the interior truth, ultimately is the only truth.

D: When you are developing a work, do the words, the plot, or the image come first?

M: It's the chicken or the egg. It really depends on the notion. Most of all, I pay attention to my mind. We all have minds, and most people don't pay attention to them. We're all so distracted, incredibly distracted by the noise of the culture. You can't walk down the street, or turn on a television without seeing that the whole culture is designed to distract you. Maybe that's why I'm attracted to Eastern religions which really deal with the more interior dialogue. I really work totally out of my mind and my imagination. I pay attention to all those little vagaries and the little weird things that pop into everybody's head. I don't invent them; I just notice them and I do something about them. I don't look for a photograph, I realize that I am the photograph.

D: It's been said that the more your narrative sequence matures, the more the stories that you tell—which once seemed fantastic, almost innocent fairy tales—become perverse

and closer to home. Some critics say that they also get more and more dependent on running captions, to the point where you seem as much, or sometimes even more, a writer as a photographer. What is your intent? Do you want to synthesize literature and photography?

M: For me the key word is expression. How well do you express yourself in terms of your needs? I'm not at all a purist. I hate the idea of being a purist. There's something embarrassing about a 48-year-old man being pure in that sense.

D: Do you think of yourself as a short story writer?

M: Yes. Yes. I feel like Carol Burnett. Yes, I do. I don't believe in categories. If the key word is expression, and if I want to express myself with photographs and writing, that's terrific. I don't believe in any rules. Rule-makers are the people that you have to watch out for. I love the idea that now I'm painting with photographs. It's like discovering a muscle that you haven't used in 20 years. It's terrific. So I keep all my doors open, I don't limit myself to anything. In some cases, the writing is much more interesting than the photograph. And that's okay, too. What's key is how well does that communication take place?

D: In addition to being a photographer and a short story writer, you have written eight books, and you speak widely to students and other audiences. In one talk—I believe it was at Ohio State—you talked about the creative potential of mistakes. How does your own work incorporate the accidental?

M: I don't use the accidental as much as I should. I believe in the accident, and I love the accident, but I don't want to have an accident. But if an accident occurs, I'm certainly the first one to use the accident to whatever. In a sense, almost everything that we encounter seems to be an accident. In fact, the nature of the accident is a wonderful thing to talk about. It's a wonderful notion that somebody should photograph some day. But I would be very open to using whatever accidents occur. I think most photographers depend one hundred percent on accidents, and if they don't find a wonderful accident, they're out of business. They walk around the street with a camera waiting for this incredible thing to happen. Because my work is so structured, it doesn't leave that much room for that accident. But I love accidents.

D: Has the unexpected happened when you work? Can you tell us about an example?

M: I wish I could. Not as often as I'm sure a number of other photographers have had wonderful accidents. I've had wonderful accidents get away.

D: Although you plan your sequential photographs before you begin to shoot, do you ever change your concept to exploit some unforeseen circumstances?

M: No. I can't think of any case where I really was working,

and then this wonderful accident occurred and sent me off on a tangent. It probably has happened. I probably put it out of my mind because I don't like to think that I did something by accident.

D: Your interest in Eastern religion must be very relevant to your work and the way that you work—not only your conviction that the unknown and the unseen are more real than so-called reality, but the very premeditation in what you do. Is this in any way linked to either your Catholic upbringing or your current more meditative commitment to Buddhism?

M: I always say that I'm a professional photographer and a dilettante mystic, and I would much prefer to be a professional mystic and a dilettante photographer. But there's still time. I was brought up a Catholic, and I was a very heavy Catholic; I used to *mea culpa* all the time. I finally outgrew it; I simply asked too many questions, and the answers that they were giving me didn't fit any more. I'm very much attracted to Eastern religions because they don't give you answers in that same sense. They really ask questions. I think photographs should not give you answers, I think photographs should ask questions. Photographs should not tell me what I already know, photographs should contradict me. But most photographs tell me what I already know. They spill the beans.

D: Well, in one of your photographs, you made certain that it would not be so easy for us. In 1976, you made a photograph whose only image was its caption. It was entitled, "Failed Attempt." I assume you were referring to the failed attempt to photograph reality. Then five years earlier, in 1971, in your book, *The Journey of the Spirit After Death,* there was an imageless caption that said, "Oh, To Be The Light." In both of those instances, I think you've suggested that a photograph is nothing but illusion. And not only that, you've also suggested that the only reality is light. Is that fair or accurate?

M: Yeah, I think it's very fair and very accurate. I'm not that accurate myself about it. But it's like reading one hundred love stories and falling in love: they're two different experiences. So far I've read one hundred love stories; now I want to fall in love. Most photographs are love stories, but they're not the real thing. Oh, that doesn't make any sense does it? You see, this is my earth suit, and I'm stuck in this earth suit, and you're stuck in that earth suit. I can only deal with the reality of this glass and making sentences this way and looking at 5 o'clock. But these are all appearances, this is the packaging. Photographers are always describing the package very well, but they never talk about the content. They show me what a person looks like, they show me the what of things, but they don't show me the why or the how. You are not what you appear to be. None of us is what we appear to be, nothing is what it appears to be. But we're so used to this, we don't see it anymore.

Duane Michals

I build a pyramid, 1978, from *Merveilles d'Egypte*
(Courtesy: Sidney Janis Gallery, New York)

Photographers are always looking, but they don't really see anything. They're looking so hard, but they never contradict me, they never contradict my assumptions, which is very important.

D: In many of your photographs, light sets the mood and even creates the metamorphosis between images. But in your scenes, you also have allegories of creation and death and reincarnation, in which people are sometimes shadows or auras, and sometimes they fade and sometimes they brighten into stars or whole galaxies. Are you saying that light—the light-sensitive film you see—is the mystical reality that you photograph, as well as the medium?

M: Well, I really shouldn't talk about that, since I haven't been illuminated. That's really what I want.

D: What does that mean, Duane?

M: What it really means is that you know something. I don't really know anything, most of us don't know anything, we only think we know. We know a lot about elevators and automobiles and money, things like that. But we don't know anything that's really important. This culture isn't designed to make you ask those questions. I have a really strong life sense. I know that I'm not going to be alive in maybe another 25 years. Every time somebody I know dies, their deadness makes me more alive. And I want to know what's going on. I really do. All those things that defined my reality, like the Catholic Church, have simply collapsed. I think it's terrific, but it's very scary. I'm not prepared for it, and that's what's really reflected in the work. Anyway, getting back to the original question, I think that we are the light, we simply don't know it. But luckily, in spite of ourselves, it doesn't matter.

D: Very frequently, images of 'mirrors and windows' appear in your photographs. In a sequence like "the girl who was hurt by a letter," there are seven pictures in the sequence. The last picture shows a girl bent and weeping over a windowsill, and she's holding an open letter in one hand. That is a fairly literal description of the series. Can you explain how you feel the meaning of that summary photo, that seventh photo, is changed by the preceding six photographs?

M: If I showed you the photograph by itself, it wouldn't quite have the same impact. What sparked that notion was how an innocent piece of paper can become very destructive. I mean, things by their nature seem to be innocent. It's the way we view them. Any letter from the I.R.S. is instant panic for me. I just see that letterhead and I know it's bad news bears. Those people are not nice, and so they only write when it's trouble. Letters are like time bombs. Somebody writes one to you, puts it in the mail, you get it usually a week later, and it blows up in your face. So letters are very, very important. At any rate, the whole idea of this woman's vulnerability to a let-ter, to this innocent piece of paper, and the fact that this paper can completely destroy whatever happened before that paper arrived, that she's changed because of that piece of paper—I think it's incredible.

D: To pursue that letter analogy of yours, probably one of your best known images is a photograph taken in 1975, called "A Letter From My Father." Even to the casual viewer, the photograph becomes a repository of painful memories. Obviously it has all sorts of private and very emotional meanings to you. Did you write the caption at the time the photograph was taken? What about the genesis of the picture?

M: That's one of my favorites. It means a great deal to me. My father died in 1975. I had taken the photograph in 1960. It's a picture of my mother and my father and my brother, and it's actually the true situation. When I left home at 17, my dad always said that he was going to write me a letter. But he never did. So I kept saying, "Well, when are you going to write the letter?" Finally, when he retired, I kept saying, "Now you have all this time on your hands, where's the letter?" He never did write it, but it became a big joke. We used to sort of joke about it: "Oh, I'm going to write it." And so when he died that was my instant response—to deal with it that way. The photograph by itself is one experience, but the photograph with the text is quite another experience.

D: So it is a sequence that has one image.

M: Well, it's not a sequence, it's just a photograph with writing.

D: In one of your early works, you explained the meaning of sequence, and I think it's the title of your first book as well.

M: Yes, it was.

D: You compared the sequence to haiku. A haiku is usually thought of as a single and compressed expression of an image, or of a moment. So could you explain how your sequences are both sequential and single compositions?

M: I think haiku is by its nature a three line poem. You know, "the bird flew over the lake, the shadow fell". I can't do a haiku, but it's a brief moment between two people, two people passing each other. It's not that instant, it's that atmosphere that you can't explain. I see a haiku as really not a moment, I mean, in the sense that you're talking about. I see it as three sentences that create a moment, and I see sequences of six photographs or seven photographs that also create another kind of moment. No photograph by itself would have said the same thing that all six photographs together would have said. They create another atmosphere. Bill Brandt says good photographs have atmosphere, and I agree.

D: To the works of which photographers do you most respond? Are Brandt's among them?

M: Actually, I'm not inspired by photographers very much.

Most of the people I take from are really writers or painters. I don't take that much from photographers. My two favorite photographers in the whole world are Robert Frank, who I think is wonderful, absolutely wonderful, and I love Thomas Eakins—I don't like his portraits very much; I'm sorry, Tom, that's the way it is—but I do like his photographs. Important work always has the sense of the individual in it. You look at Paul Klee, you look at Atget, you know that nobody else would have done that. That's what's so wonderful about it. There's the power in the artist's work, that sense of his vision, and you're moved by it. It's extraordinary.

D: You said before that you like having your assumptions upset.

M: Yes, when I'm contradicted. The only way I've ever grown is when all of my definitions have been contradicted.

D: The work of the surrealist painter, René Magritte, had that effect on you from the very beginning. Tell us about your experience in meeting with him, in photographing him. What influence has he had on your own work?

M: Well, I think that if you're lucky, you run into five people in your lifetime who open you, and he was one of my five. But it's not going to be apparent, necessarily, and it may not be the one you're married to, and it may not be the Pope or the President. But it's that person who introduces you to yourself, and permits you to be what you can be. When I looked at Magritte's work, he posed wonderful questions, and he contradicted my assumptions. Roses do not fill an entire room. Trains do not come out of chimneys. He showed you a painting of a pipe and he said, "This is not a pipe". . . I love that. He was also a very photographic painter. When I realized that he could present these questions in a painterly way, then I could present my own questions photographically. It freed me enormously. I could do anything I wanted to do, which is wonderful.

D: You have referred to the work of a number of painters who are photographers as well, painters like Sheeler and Eakins. Their influence has freed you, because you have taken to a new technique yourself. That is, you are painting on your photographs now. Is that an attempt to make unique a duplicate object?

M: I don't know what it is, as a matter of fact. I'm defining it now. But part of it is that it's just another way of expressing myself. I was always jealous of Magritte, because frankly, I've never been able to get people to fly realistically. See, I have to work with photography, and people believe photographs. They don't believe paintings, which gives a photographer an enormous weapon. It's a wonderful vehicle to contradict people's assumptions, because when you do something in a photograph that doesn't happen in real life, the fact it's a photograph is very disturbing. So I was always jealous of painters. Magritte could have people raining out of the sky, and I simply couldn't do that. So I realized that if I could paint, then maybe I could have another thing I could do. And that's what's happening. I'm teaching myself how to paint after thirty years, and I find it scary as hell, but wonderful.

D: Do you think of yourself as a surrealist?

M: I don't really think of myself that way. I don't know anything about labels. I don't think of myself in those terms. I just think about the work, about what I'm doing at the moment. That's what I think about most of all.

D: Was Magritte a seminal influence on your life?

M: Yes.

D: Did you ever meet him?

M: One of the glorious things about being a photographer is that if you like somebody, you can go take their picture. I spent a week with Magritte in Brussels the year before he died, in 1965. He was a totally amazing man, because he had this wonderful head, I mean he had a mind that was so extraordinary. And yet he lived like a banker. When I went to his house, I was very disappointed. I wanted him to live in a cave, you know. I wanted fists coming out of the wall holding torches, that sort of thing. And here he lived in a very swell section of Brussels, and he had a maid and a crystal chandelier. He dressed like a businessman. You could walk through his studio into the bedroom and not even know that you were in his studio. He was unlike all those kids loafing around Soho. He looked like he really belonged down on Wall Street. That was such a wonderful contradiction, the fact that the man looked like a banker, and yet had an imagination that was so extraordinary. He's my favorite subject. We had lunch one day, and we were watching Magritte's favorite TV program, which was "Bonanza." We're sitting at the dining room table, and the maid is serving us our soup. It's myself, Magritte, Georgette, his wife, and a TV set sitting where the fourth person should be. We're talking French, and I'm having soup with Magritte watching . . . well, you had to be there, but it was fun.

D: Double or triple exposures are frequent in your work, and so, I assume, are double and triple *entendres*. Do you use puns or wit to consciously create space or multiple meanings?

M: Well, I think that if you're a very serious person, it's very important to be very silly. So I love to be ridiculous. In fact, I'm probably not silly enough. But I love humor. I think it's the one defense we all have against the human condition; or I don't know what you want to call this place we're in right now. Humor is the marvelous thing about the human creature, I mean the fact that we can even laugh at all, considering everything.

D: What place does humor have in your work? It's in your

philosophy, but how is it translated into your work? Some people might even think of you as a writer of ghost stories.

M: Well, I've also done a series of terrible limericks, that are really disgusting. I'd give you some but they're too vulgar for television. I like to be bawdy if I can.

D: Your own life, like so much of photography, relies also on double exposure.

M: Let's talk about the double exposure in photography, too. You see, I think if you have to put up with all the limitations of the camera, then the photographer should use everything that the camera can do. And certainly one of them is blurring and double exposing. That should become part of a photographer's vocabulary. I find it's very useful, because people in real life do not blur or double expose, unless you're drunk. It's like smudging people on film, and it's terrific. That's one of the tools that a photographer can use in contradicting reality, or talking about reality.

D: It's a notion that so engages you, that you've managed to do that in real life as well. You come from an American-Slovak small town family in McKeesport, Pennsylvania. Your name, Duane Michals, certainly would not reveal that. But you yourself have created a Slovak working class alter ego called Stefan Mihal who has not assimilated a name, yet leads a far more typically American life than you do as a photographer and artist. Tell us a little bit about that alter ego. When did you decide that Stefan Mihal was either a necessary or desirable ingredient in your work?

M: Actually I am second generation. My grandparents came from Czechoslovakia, but my parents were born here in Pennsylvania. I think the question of personal identity is the essential question. I'm not a Gurdjieff person, but he says that we all live in a state of wakeful dreaming. Plato, another biggie, says that the unexamined life isn't worth living. I think that there are some people who find themselves at half past 68, going on 69, and they don't even know that they're alive. They have no idea of the whole question of "who's sitting in this chair talking right now? Where did these ideas come from? How did this occur? What combination of events made this happen?" I think it's extraordinary. And I think that all of us have an alter ego. He's the person we never became. Think of the total opposite of you. In my case, it would be somebody who loves football, who likes to drink too much beer, who's married and has seven kids and who works in a factory. I mean, a person who you are not. It's like matter and anti-matter. If I should meet him on the street, we'd probably blow up. We're completely opposite. All of us, we're none of us as simple as we appear to be, either. There are all those myriad identities that we have. The person I'm presenting now is an "on" personality. This is my show biz personality, my good side.

D: But the same words, and the same ideas that you've used in conversation, are recurring themes in your life. They may take on a different expression because of a new chemical, physical or technological arrangement, but they are you in another sense, aren't they?

M: Oh, yes. But getting back to that question, why this other person? Who am I? These are really the essential questions of what life is all about. It's not photographing more trees or more façades of buildings, or strangers on the street. It's the questions you really want to know about. Who is this person talking? What are my roots? We all have roots. What's that all about? How did I get here? What did my family give me? What are the weaknesses? Where's the joy, where's the strength? The thing that you see so often in Jewish people and all black people, that inner strength. I want to know about that. And that's what it's all about.

D: Where did you get *your* inner strength?

M: I think I got it from a wonderful attitude of my mother and father, a belief in the possibilities of things. I had absolutely no reason, sitting in McKeesport, Pennsylvania, to believe that all the wonderful things that have happened to me could have happened. But their attitude was: why not? Take a chance. What have you got to lose? You can do it. That is such a wonderful gift. I hate to hear about parents who put their kids down. I hate to hear about anybody who puts anybody down. We should all encourage each other; we all need it. And that was the great gift of my parents, to let me know that it could happen.

D: Well, perhaps it was widespread in that tiny town of McKeesport, Pennsylvania. I don't think one can think of it as Athens, but there is another famous person who was born only two years before you in that same town. He was descended from an immigrant steel-working family. He, too, won a scholarship to Carnegie Tech, and he, too, rapidly became a success. When you lived in McKeesport, did you know Andy Warhol? Have you met him since?

M: No, I didn't know Andy in McKeesport at all. When I was growing up I think he had already moved to Pittsburgh, but he was originally from McKeesport. I met Andy when I came to New York. Andy's my *landesman*, I suppose. I'm second generation, and I guess it's that second-generation, depression-kid kind of energy. Which all those fat a . . . oh, I'll say it—fat-ass kids sitting in front of television sets with all the air-conditioning don't have, I don't think. But there's something nice about being a little lean. Hard work is okay.

D: For some artists, the medium itself is the end. For you the technique, or the tool, does not seem quite so essential to your vision.

M: Well, the mind is essential to my vision. The technique

follows. If you can drive a car you can take photographs. The mystique of the camera is something that always amazes me. I think photographers tend to hide behind it. You know, the F/64 and all the other stuff. And the photographs are essentially boring. As I've said before, I'd much rather see a bad print of a sensational idea rather than a gorgeous photograph of a . . . you know, that's just my print school of thought.

D: What kind of equipment do you use? Or does it matter?

M: I use Nikons. I'm not an equipment nut. I think that you should know your equipment and forget about it. Can you see Joyce and Steinbeck and Hemingway all sitting around comparing typewriters? You ought to see my Olivetti, wait till you see my new electric!

D: Then the message is not the medium.

M: No, but it's essential to the medium. Forget about the equipment. Learn how to use it, and then forget about it. The trouble with photographers is they know very well how to take photographs, they simply don't know what to photograph. You can learn craft. But you can't learn that sense of ''Wow''. That's what you want.

D: Did you study with anyone? Did you work in anyone's studio as an apprentice?

M: No. I had one wonderful friend who was a big help to me and taught me everything I know technically. I still go to see him, a wonderful guy named Dan Entin. But I've always been very much of a loner. Even working commercially, I don't have a studio, or an agent or any of that.

D: Actually, you are one of the few photographers who manage to deal with your commercial work. You still sustain yourself in many ways by work you do for magazines, corporations and the like. And it interests me, the structured image of work on assignment, and the structured image of your work itself. Is there a correlation, a transference of any discipline from one to the other?

M: Yeah, you see, photography is a smorgasbord. When you do the jobs, you do the pickles, and then when you do your own work you do the dessert. No, I don't mean pickles, I love doing jobs. I really do. And whatever you do, it should be done well. So it's just as much pleasure for me to do a commercial assignment, as it is to do my own assignment. They're just for different reasons. I like to work about two days a week, actually. I don't want to do too much. But I like to make enough money to live comfortably. I will always do commercial work, because I don't want my private work to have the responsibility of supporting me. I want it to be free of that.

D: Do you find that you're able to express yourself as freely in commercial work as you can in any of what you call your personal work?

M: Commercial work has certain definitions. That's why it's

commercial, because they're paying you to satisfy their needs. I understand that very well. If you don't want the money, then don't go crying. Photographers who put down their commercial work always annoy me, because that's simply another kind of work. It's honorable work and it's terrific. But part of the reason they're hiring you is because they're selling something. I never think of fashion photography as art, because the whole point of it is to sell a dress. I mean, you can set the dress on fire; you can have a dog rip it off, you can have a chauffeur eat it off, but the point is that without a dress to sell, they wouldn't have taken the photograph. Art has something to do with much more profound an issue than hemline. The nature of fashion is to be transient, and the nature of art is to deal with something that is not transient.

D: Is there any image that is part of your commercial work that you find especially satisfying and enduring?

M: Mine? Well, a lot of my commercial work isn't that commercial. I can't photograph cars. There are a lot of things I can't do. I can't use a big camera. I've turned down catalogues. I couldn't do a catalogue, unless it was really a spicy catalogue.

D: You can do an annual report.

M: I've done annual reports, yes. I do fashion about five or six times a year, and I love it. But there's a lot of things I can't do, because technically I don't know how, and I don't want to learn.

D: When I referred to the photograph called ''Letter From My Father'', you mentioned that it was among your favorites. Are there any others, among all the thousands of images that you've made, that have special meaning to you for one reason or another?

M: They all do for one reason or another. My kind of photography only comes into existence because I care enough about the idea, and I'm moved enough by it, to make it happen. It's not something I ran into on the street, or an accident I encountered. It's really something that disturbed me or touched me in some way. So I'm most interested in the one I'm doing at the moment, but many, many of them I love. I love one so much I can't remember what it's called any more.

D: Why don't you describe it for us?

M: Well, things are queer. I like things that are queer very much, simply because they're just a wonderful trip that questions that notion of what time is. Which photographers very seldom do, although photography deals with time better than any other art form. I like a really spicy one called ''Take One to See Mount Fujiyama,'' which is full of all sorts of sexual allusions. It's wonderful. It's very playful. I've done a lot of things I like, yeah.

D: Why don't you tell us about some of them?

M: I like ''Building My Own Pyramid in Egypt'' which I

Duane Michals

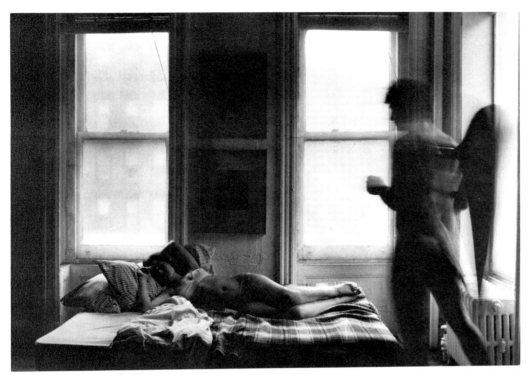

The Fallen Angel, 1968, from *Real Dreams,* 1976 (Courtesy: Sidney Janis Gallery, New York)

When he was a young man, it seemed impossible that he would ever grow old. Now that he is old, he cannot remember ever having been young.

from *Homage to Cavafy Portfolio,* 1978
(Courtesy: Sidney Janis Gallery, New York)

thought was terrific.

D: That is a sequence?

M: Yes, yes. That's the one where I went out and in view of the real pyramids, I built my own pyramid. Which seemed reasonable.

D: With layered rock?

M: Un-huh. Actually my pyramid is bigger than their pyramid if you view it at the right angle. Pyramid envy . . .

D: You have another photograph where a California surfer appears in the tomb of Seti I. What was the genesis of that photograph?

M: Well, that was just so extraordinary. I had gone to Egypt surrounded by people my age and older, and suddenly in the middle of this tomb was this kid who was a California surfer. He had a cowboy hat, no shirt, and a chain around his neck. He looked like the kind of kid who would have been in there in Seti's time, three trillion A.D. or B.C. There was something universal about him. If he hadn't had the cowboy hat in his hand, he could have been that same Egyptian kid who was carrying water in to the workers. I love that notion, the anonymous person. And suddenly here was this kid who looked just like that.

D: Your work and your life are concerned with spirituality, on the one hand. On the other, I wonder if you are bothered about the business of photography.

M: No. Business goes with the territory; this is called being alive in New York City in 1980. I keep the business end of it to a minimum. I don't consider myself a particularly aggressive person, yet I survive. One of the big rules is the rich get richer and the poor get poorer. The same thing applies in photography—the more you get published, the more you get published. But nobody wants to make it happen. You've got to get the ball rolling. So I always encourage people. If you want something, for crissakes go get it, make it happen. It has a life of its own. Business I deal with, but it doesn't run my life. I live comfortably, and that's all I want.

D: Is Duane the businessman, and Stefan the spiritualist?

M: No, no, Stefan's too drunk most of the time.

D: So Stefan has a better time of it?

M: I don't assume being drunk is a better time at all. I believe in moderation.

D: Duane believes in it?

M: Yeah, but semi-stoned is fine. But I forgot the question. You got me so excited about it, I think I'll have a drink!

D: Do you limit editions of your work? Do you only make single images, or do you not worry about how many impressions exist?

M: No, I limit the edition of photographs, because I think that once photographers enter the print market, then they should adhere to the rules of the print market. If I'm going to spend a lot of money for a photograph, I want to know damn well there aren't going to be three thousand of those things floating around. It's a way of respecting the buyer as well as myself. My big mistake was not making editions big enough. I never dreamt I'd sell twenty-five of anything. Want to buy a picture?

D: You referred to being alive in New York. How important is it to the work of a visual artist, a photographer specifically, to be part of New York, at this point in time?

M: It depends on the nature of your work. Les Krims is a very talented and successful photographer who made a wonderful career living in Buffalo, New York. You don't have to be in New York. If you're part of New York, that's something else, but if the work is true, it will out. Of course, it's not that simple, but I love being in New York. I also live in the country and I love being in the country, but I could do my work anywhere.

D: Has the New York art world in any way influenced your own style of imagery?

M: No, not at all.

D: What do you consider the most significant influences on your style?

M: Well, I don't know, really. I'm very eclectic and I take from everything. I take from poets. I love Cavafy, he's a wonderful poet and I've taken a lot from him. My God, Picasso is the biggest taker—he invented taking. It doesn't matter as long as you come up spelling Mother or whatever. I can't think of anything in particular, but I'm not really ''now'' in New York. I'm sort of another generation.

D: Your sequential photographs most often have a frame-by-frame narrative progression. Some people suggest that the logical next step for your kind of serial imagery is to make the transition into film. Is that something that you have ever considered?

M: No. I made a little film with a friend of mine and some other people made a film about the work. But if I thought I was spending more than a hundred dollars a day on something I'd be hysterical. And I'm such a loner, and I would have to write it, act in it, direct it and film it. I couldn't deal with all these lights. I've worked on movies. I couldn't spend seven hours to set up a shot where a lady gets out of a cab, and says, ''Get me out of here,'' and then she can't even say that properly.

D: How long does it take you to set up the sequences that you do?

M: Well, most of the work is done in my head, so that when it comes to the actual shooting time it's very easy. I can do the whole thing in an hour. I'm very fast.

D: Where do you generally photograph? Sometimes you've

used restaurants and bus stops, but you generally structure an indoor scene.

M: I'm always looking for rooms. When I go to people's houses, I always look around. Actually, my grandmother's house is the best place in McKeesport because she has basic furniture, real furniture, no Breuer chairs, no Albers on the wall, no African sculptures. You know what grandmothers have, no-nonsense furniture, stuffed sofas with antimacassars and Jesus on the wall.

D: Does she have a no-nonsense attitude about your work, too?

M: She's dead. She didn't have any idea what I was doing.

D: You've mentioned several times that you are a loner, that you're not part of one school or one clique or another. Nonetheless, you manage to be included in exhibitions of the most distinguished photographers. I'm thinking especially of John Szarkowski's celebrated "Mirrors and Windows". That show strikes me particularly because "Mirrors and Windows" are themes that recur throughout your work. What do you have in mind when you use that as a prop? Do you have any idea what John had in mind when he entitled the exhibition?

M: No. I have a lot of opinions actually, but I have no opinions about contemporary philosophical notions. I've never read Susan—I was going to say Strasberg—Susan Sondheim—

D: Sontag. . .

M: Sontag's book, and I didn't get involved in the discussion about "Windows and Mirrors."

D: But how about in your work?

M: I love mirrors and I love windows but I don't think we're talking about the same ones. My windows are always a little dirtier than I think Szarkowski's are. I don't really relate to that.

D: And how about your illusions?

M: Yes, well, my illusions *are*. But I don't think he's dealing with that. He is really a window guy. I don't do windows.

D: Not very long ago there wasn't a place for photography in museums. Charley Harbutt, who at the time was president of Magnum, once said, "We ain't art, we're photographers. You can put a painter in an empty room, and he can create a picture, but a photographer in an empty room can do nothing. We need the world." Do you think that photography is art?

M: Sometimes, and sometimes art isn't art. In fact, most of art isn't art and most photography isn't art and there may be only five artists in the whole world right now. I don't know who they are. I know who one of them is, but I don't know who the other four are.

D: Why don't you give us a hint?

M: I don't know who the other five are, but Harbutt's totally wrong. Absolutely. See, that's the basic mistake of photographers. The whole notion that without those rocks and trees and funny-looking people standing on the corner eating carrots with the American flag they wouldn't have a picture to take. They completely bypass this incredible thing that we are—the mind. The best part of us is not what we see, it's what we feel. We are what we feel. We are not what we look at. Harbutt's saying when these eyes close it's all over. We're not our eyeballs, we're our mind. People believe their eyeballs and they're totally wrong. What would Harbutt do if he really had to just sit in a room and think of the wonderful kinds of things he would create? All the other art forms are based on the imagination. A writer comes to an empty piece of paper and everything that goes on there comes out of his head. A painter comes to an empty canvas and everything that goes on there comes out of his mind; the photographer's the only one who has to walk around with a camera to find something that exists. He's always documenting something, something he knows nothing about. But why can't he invent? Why can't a photographer be a novelist instead of a reporter? That's why I consider most photographs Muzak photography. I find most photographs extremely boring—just like Muzak, inoffensive, charming, another waterfall, another sunset. This time, colors have been added to protect the innocent. It's just boring. But that whole arena of one's experience—grief, loneliness—how do you photograph lust? I mean, how do you deal with these things? This is what you are, not what you see. It's all sitting up here. I could do all my work sitting in my room. I don't have to go anywhere.

D: Do you have an internal audience, a set of benchmarks that you turn to?

M: No. I don't know what I turn to. Obviously I feed off my own self. I'm very self-motivated. I do what I say I'm going to do. Nobody has to assign me something. I create my own energy. I create my own enthusiasm and I think without any of these things, most photographers will have a terrible time. They're always going to be looking for something. I don't really do that. I wish I did, actually.

D: I guess now I have to ask you the inevitable question. What next? What do you expect to be doing next year, ten years from now?

M: I don't know. That's what's so exciting about it. I wouldn't limit myself to any possibilities and I have no idea what I'll be doing next year. Probably more painting. I feel sorry for people who know exactly what they're going to be doing next year—the same thing they did five years ago. But how wonderful to have all your options, especially when you're older. When you're a kid it doesn't make any difference. The whole world's sitting there and you're twenty-one, and oh, boy. But to be forty-eight and oh, boy—that's the trick and

that's wonderful.

D: You've said several times that you don't like labels. How would you like best to be described?

M: Cute, darling, very kissy, very kissy. . .

D: You *are* all of those things.

M: Well, what else is there?

D: I think you're right. What are you working on now?

M: Well, the painted pieces and the drawings, which is wonderful because it's so difficult and scary and I can make a total fool of myself. I think it's very important always to be living on the edge where something is always possible, where you're not quite sure what this is about—that's the excitement.

D: When you first started to work, what were your first shows, your first reviews like? How did you respond to them?

M: There was a wonderful little gallery in New York that most people don't know about called The Underground Gallery that Norbert Kleber ran for a long time in his cellar—well, his cellar was his apartment so his cellar was half gallery. He made no money. After Limelight Gallery and the Image Galley, which lasted for a brief period, Norbert was the only thing between oblivion and photography in New York. It was a wonderful period. If you sold something it was for about 15 dollars and Norbert would paint the whole gallery so it was a wonderful time. I had a number of shows there. For the group of people who showed at that point, like Garry Winogrand and

A LETTER FROM MY FATHER

As long as I can remember, my father always said that one day he would write me a very special letter. But he never mentioned what the letter would be about. I used to speculate what the letter might contain; what secret we two would share, what intimacy, what family skelton

might now be revealed. I knew what I hoped the letter would say. I wanted him to tell me where he had hidden his affections. But then he died and the letter never arrived. And I never did find that place where he had hidden his love.

Duane Michals: A letter from my father, 1960-75, from *Real Dreams,* 1976 (Courtesy: Sidney Janis Gallery, New York)

myself and a number of others, that was the only place you could show outside of the Modern. But at my first show, when I showed sequential photography, most of the people walked out. Half the people left because it wasn't photography, and it wasn't reviewed. The critic at the time asked me, "What is this?" I really believe everything is a matter of definitions—absolutely every phase of our lives, as a matter of fact. But the important thing is, you spend the last half of your life unlearning all the definitions of your first half, which is the hardest part. But these people all knew what photography was and I simply didn't, and I still don't know what it was. So they rejected it. But when I had the show at the Modern it suddenly became okay because I had the imprimatur of the Museum, and by 1972 there was a whole pavilion for Photo-Kino called Sequential Photography.

D: When did you begin writing on your photographs?

M: I was going to say 12 A.D., but that's not right. I did a book called *The Journey of the Spirit After Death,* and I began to use little captions in the book, just little sentences, and then it just seemed to naturally expand itself. Sometimes I really feel that a word is worth more than a thousand photographs.

D: A word?

M: Yeah. I'm a book person. You read something every now and then and you savor it, it's just something said so well. There's a wonderful French phrase I want to tell you about. It applies to every political candidate, or any politician you ever knew, also all those bible thumpers on television who are selling Jesus, and every salesman. And it says that "he is too sincere to be honest." I just love that phrase.

D: Have you incorporated that in a photograph yet?

M: No. But I loved it. I just think it's so terrific. And when I said, "Oh, to be the light," on the last page of the book, I love that, because that's what I really felt.

D: All during the course of our conversation you have been very straightforward in articulating your own personal ideas and preoccupations. One of your central concerns is the whole notion of human awareness.

M: Oh, absolutely. I think we're like 20 cylinder cars, and we're all operating on 2 cylinders. I may be operating on 3 cylinders. But it's possible to operate on all 20 cylinders. We're sitting in the middle of an incredible miracle. This is a miracle. I'm a miracle. We're walking, talking miracles. You probably have to be on your death-bed to realize that you're a miracle, just when it's too late. But it's possible to know now, saints know now. If there's some way that we could understand that

being alive is simply not a matter of consuming things and using deodorants. It really is a matter of being a walking, talking, once-in-a-lifetime offer in the universe that's never going to appear again. All those wonderful culminations that made me—and not Stefan—that came together to produce this instant, will never happen again. And this is only 30, maybe 60, 70, 80 years, which is nothing in time. We don't even see it; we are so dead, you know. Maybe I use the photograpy somehow to explain myself, to remind me that I'm alive. But I don't know how to do it. There are people that do it, they really know it.

D: Do you think you use your art to confirm that notion of your own aliveness, almost as an educational instrument?

M: Not in that sense. I feel that I use my work to explain my experience to myself. Photographing it somehow helps me to understand it. All those little nooks and crannies . . . I sound like a Thomas' English muffin, nooks and crannies. I mean, all those little corners in the back of your head. And I'm a product of a commercial world, too.

D: Let's get back to your spiritual world. You have told us that you recently began experimenting with painting over photographic images. What engendered that work? Are you happy with the results?

M: I'm getting happier. It came out of a need to express myself. To express yourself is so important. Every now and then you pick up the *Post,* and there'll be an article about some guy in New Jersey who's usually an insurance salesman who comes home and shoots his whole family. And the neighbors always say, "Oh, they were so good, they never fought, such nice people." And they're all dead. You know, the guy never expressed himself. How awful not to be able to express yourself, to say out loud, "This is what I think." This isn't what Diane Arbus thinks; this isn't what Ed Weston thinks; this is what I think; this is what I feel. Isn't that extraordinary? That's always the impulse. I feel so sorry for people who can't do that. But they can if they just free themselves.

D: How do you define the difference between illustration and the traditional definition of art?

M: Well, sometimes art is illustration. It depends on how it's used. That's a hard question. Sometimes it's illustration and sometimes it's just thrown paint. Art can express itself many, many ways. You have to really judge it in terms of the particular condition that it's expressing. How well does it express what it's trying to express?

Barbara Morgan

The play of rhythm in dance, in light, and in metaphorical thought has dominated Barbara Morgan's life's work. She has been a true innovator in her experiments with movement, the techniques of photo-montage, and light drawings. Her best known works, the legendary photographs of Martha Graham and other dancers, are considered the quintessential statement on how dance may be looked at and recorded.

Barbaralee Diamonstein: More than fifty years ago, you said that photography was not an art, but journalism. What caused you to recant those words, and when?

Barbara Morgan: Well, that's a very big question, but I'll try to do it justice. As a child in California, I was inspired at a very early age to paint. At about age four and a half I woke up one morning with a horizontal beam of light coming into my bedroom, and above my bed it struck a little drawing of a tree that I had never been conscious of. And I jumped out of bed and ran into my parents' room and said, ''How could a tree get into my bedroom?'' And my mother said, ''Don't worry, it's not a real tree.'' I said, ''But it's a tree.'' She said, ''No, no, it's a painting of a tree.'' ''What is a painting of a tree?'' ''Well, your great uncle, Benjamin Coe, made it. He's an artist.'' and I said, ''Then I will be an artist.'' So my parents were very happy, and they got me paints, paper, brushes. I always painted. In 1919 I was at UCLA, where of course I majored in art. After I graduated, I was asked to join the faculty. I was the youngest member. And, of course, I painted. I also got married to Willard Morgan. Before we were married, he never had the courage to say, ''Why don't you photograph as well as paint?''

D: Why was he especially interested in photography?

M: He had expected to be an experimental chemist. Then he found that he was allergic to certain odors in the laboratory. He became a writer, but he loved experimenting with chemicals. He had begun to feel that photography was the logic of imagery making, you see. To make a long story short, he had become really enraptured with photography, and was reading about it and studying it and then experimenting. So, here we were, very much in love, but he was saying, "Photography will be the twentieth century art." I said, "You're crazy." "Oh, you wait," he said, "Photography will be the international language." "What do you mean?" He said, "Well, to put it simply, a picture describes something without words. So if you take a picture of a cat here, and somebody in China sees it, you don't have to say 'cat' in Chinese, you've got a cat."

D: How did you come to agree with him?

M: There are two answers to that one. We didn't have very much money, so he set up our darkroom in our bathroom. Every time I went to the bathroom, I learned about photography, because there would be negatives hanging and dangling, and prints washing in trays. I would say something simple like, "Now, you've got one dark one here, and the same thing light. What's the meaning here? And he would very eloquently describe the whole concept: "Well, I'm experimenting, so I want to see how this dark one conveys a certain feeling. Perhaps this light one is better." I never studied photography; I absorbed it. However, I experimented, too.

D: At this point, were you teaching in the art department at UCLA?

M: I was teaching water-color landscape painting, abstract design, and block print-making. I also installed exhibits, which I loved doing, because we had Korean pottery and all kinds of things. The director of the department at that time was a very open-minded, experimental person who had been to the Orient and was very much involved with art around the world. So one morning, I was asked to come into the office and she said, "Now Barbara, I know that the trustees of the university will condemn me for even considering photography as an art. However, I'm going to take the risk, and I think the young man whose work you'll be hanging tomorrow is truly an artist. I'm going to stand up for that possibility."

D: Who was that young man?

M: Edward Weston. At that time, 1926, his name didn't ring any bell except to a few people. He had just returned from Mexico. The next morning he came in, and we shook hands. All the men on campus wore ties and so forth then. Weston was like the hippie of the day. He had on a white shirt with short sleeves and a big open neck. He wore corduroy pants. The moment we began getting the pictures out of the boxes, oh boy, it just hit me.

D: What were those photographs?

M: Well, a lot of the familiar ones, of course. I think the pepper was among them. Anyhow, the moment I saw it, I realized Willard was right, photography can be an art.

D: In your meetings at UCLA, Weston used a phrase that has stuck with you all your life. What was that phrase and why was it so influential?

M: Well, we hung all these things over several hours. Oh, the moment I saw them, especially the rhythm of the pepper and so forth, I thought if I ever—I mean, I didn't think, it just went through me like wildfire—if I ever photograph, my things have got to move. And then after we'd hung them and established a very fine relationship, I said—and now I shudder to think how naive it sounded—"Mr. Weston, could you tell me what you're truly trying to do?" Well, he didn't shudder; he said, "Let me think." Then he said, "What I think I'm truly trying to do is to portray essence." And again that just went into me like wildfire. So that night when I got home, I said to Willard, "You were right. It can be art."

D: However, you still did not become a photographer?

M: No.

D: But you became a photographer's assistant for a while. You worked with your husband helping him light the things that he photographed. I assume that was a very important influence on your later work.

M: Yes. I'll tell you how that worked. You see, before the Weston experience, Willard had said, "Now I'll teach you photography, if you'll teach me design and composition." And I said, "I'll be happy to teach you composition and design. But I don't want to learn photography." We both loved Frank Lloyd Wright's architecture and there was a considerable amount in the Los Angeles area. So Willard was very smart. Knowing that I did enjoy it, he'd get me to come along with him so that I would make the final decision on the composition. Well, it augmented my interest because when you're looking through a 5 x 7 camera, you're looking upside down. I got a kick out of seeing Frank Lloyd Wright upside down. Meanwhile, I was really learning how to trigger the thing, although I hadn't intended to. But then the real way that I got into photography on a major scale was each summer when the vacation period came. Willard and I would hop off to the Southwest, to Arizona and New Mexico for the three month period. I would be painting because I was exhibiting with different societies and he would be photographing and getting material for his articles in magazines. He would get me to wear a camera around my neck no matter where I was, and said, "Even if you don't think you're a photographer, if you see a rattlesnake or something, just click the shutter." So we

did all kinds of crazy things.

D: You also did a lot of very interesting things. In the late Twenties and early Thirties, you traveled throughout the Southwest to see Indian rituals and Indian dances. In Indian tribal life, the dance is one of the unifying forces. How important, enduring and influential an experience was that?

M: Well, it was one of the most profound experiences of my entire life. In fact, I'm wearing this Zuni ornament, which is more than an ornament to them, it's a ritualistic object. I guess it goes back very far. My ancestors came to America just after the Mayflower, and I had always felt guilty that my ancestors had taken the land from the Indians. And so I had made quite a study of Indian lifestyles, art and so forth. When I was a student, one of my teachers was part Spanish and knew a lot about how the conquistadors had taken away from the Indians. She had the same kind of feeling of guilt. She happened to know a great many people in the Southwest, so that when we wanted to go to some ritual—let's say a corn dance or sun dance—there would be someone at a museum we could go and question and ask how we should behave so we wouldn't insult them, and how to understand. So we were very careful about going. We didn't go like tourists, because the Indian rituals were not done like entertainment here in our culture. They were a way of unifying the tribe with the sun, with the earth, with the corn, with the snakes, with life. And to have full impact, they would start with the first ray of light in the morning. We had our funny little car, crude little car, and we would drive up to the mesa the night before, sleep there and wake ourselves up, usually at four o'clock, so that we'd then be able to watch the medicine man come out of the kiva and climb the ladder and salute the sun and chant to it. Now, he was doing this purely on his own, he wasn't doing it for an audience. The people were still sleeping up on the mesa. But we wanted to hear and get the feeling of it. After a while we'd hear a mother yelling to a little child or a dog barking, and we knew people were getting up. We would wait until we heard enough sounds to know that it was all right. Then we would very gently amble up this circuitous path up on the mesa. We would usually see a little kid chasing a dog and catching it and then the mother calling and so forth. We would never barge in at all, just stand around and look at the sun. Then suddenly you'd hear the drums beating, and the first sign that the dance was to come. It was usually a very quick and simple thing. They'd return to the kiva and then after a while the whole thing would get going. They'd dance for a while, and the people would begin to gather. And then they'd go back in the kiva for another half hour or so, and back they would go. I'd take my pulse in the early morning, 4 o'clock, and during the entire day with the coming and going, coming and going, by the time the last ray of sunlight had disappeared, there was such ecstasy among all the people, such a sense of unification. People would be hugging each other, and lifting their eyes to the sun. The whole place was just like an ecstatic unification of people to the earth, to the sun, the whole thing. And my pulse would be way up. It was ecstatic, but not crazy. And so that's just a tiny part of the experience.

D: But it has been very central to your own interests and the recurring aspects of your work. You were born in Kansas, raised in California, an eleventh generation American. Is there something that you consider to be particularly, or even peculiarly, American about your work?

M: Oh no. I'm American, I hope I'm human. Well, I think perhaps I'm American in one sense: I guess I inherited from my parents the idea that you should always experiment. Maybe that's part of it.

D: Among your close friends were Edward Weston and Charles Sheeler. Did they influence your work and your style?

M: I taught at the university for five years, and by that time, 1928, Willard had started to use the Leica camera, which was then a very strange little thing. By 1930, Willard had had so many articles in so many magazines using this funny little camera, the Leica, that the Leica people in New York had asked him to have an office there so he could describe to the many people who thought it was a funny little toy, how you could use it. So we came back to New York in 1930, and began to have many friends, of course. Charles Sheeler was one of them.

D: His work must have been particularly appealing because he, too, combined the life of a painter and a photographer, living both with distinction.

M: Yes. He was one of our many dear friends.

D: Within five years after you came to New York, you moved to the suburbs.

M: We didn't go to Scarsdale, where I live now, until 1941. At first I was painting and exhibiting, and Willard was doing all kinds of experimental things with the Leica. He was asked to give many lectures, and we went, oh, from Boston to Chicago, et cetera, et cetera. He'd get me to come along and run the slides, so I'd go see the museums wherever we were. By 1932, we were getting along so very well, we decided it was time to have a child. So we had one, and then by 1935, we had another one.

D: What happened to your work during the course of all of this?

M: I was just desperate because I adored my children and I would never do anything that would hurt them, but if I painted all day, as I normally would, I would destroy the children. So then Willard said, ''Now look Barbara, you are a

photographer, you just don't acknowledge that you are. But since most photography is actually done in the darkroom, I could be with the kids at night and you could be in the darkroom then.'' And so it was that or nothing. My children came first, but how could I be a photographer? Well, of course, I'd taken thousands of pictures for Willard, never considering myself a photographer. Then I began thinking, ''Well, this is the only way I can be true to myself and feel honest.'' I knew that, yes, photography is not simply clicking the shutter and stealing from fact, but still I had never really tried to convey my own concepts. I had never gotten into my world, which was more philosophical or fantastic than Willard's, so I thought, ''How can I be creative and not be a thief, not steal from nature or from reality?''

D: Did you think of photography as an examination of the exterior world, while most of your life until that point had been the life of imagination?

M: Yes, exactly. I studied art history for many, many years. I was highly aware of Hieronymus Bosch and I was in the Lascaux caves before they were closed to see those prehistoric things that have all kinds of fantasy in them. So there's nothing new about photo-montage, really—it's just going from painting into the camera-making of the picture.

D: A large part of your work is in the form of photo-montages. What do you mean when you say that photo-montage is the only way to achieve complete honesty in photography?

M: Well, I was overspeaking a little bit.

D: But in essence, you really do believe that.

M: Yes. Of course, I'm not saying that that's the only way. It's just that for me, it would be embarrassing to stand in front of something and just click it without conveying some additional, subtle meaning. Or not necessarily subtle—maybe an obvious meaning. When I was doing the planning for Willard's Frank Lloyd Wright architecture, I tried to carry it beyond the obvious. Very often I would try to emphasize some aspect that gave it another dimension that wasn't merely architectural. See? But the other thing that I think is bearing on this is that as a child, I used to hear a lot of poetry read by my mother. Walking a mile to my home from school, I'd get into a walking rhythm and poetry would come into my mind. However, when I'd get home, I'd scribble it down, and I wouldn't let anybody see it, because I didn't think I was a poet. But at the same time, I realized that I was seeing it in my mind's eye. Usually a poem is not realism, so when I reached this point with my children, it just came to me that the only way I could be visually true to myself was to add another element of imagination.

D: Many of those photo-montages have social commentary;

particularly two of the images. One is Madison Square Park, and another is a photograph of the skyline of the city at night, I think from 23rd Street, that has a shell fossil formation superimposed upon it. Can you describe those two images, and why you decided to put them together?

M: Sure. This first one is spring on Madison Square. My studio was on 23rd Street, on the fourth floor overlooking Madison Square, and I had some very nice windows there. I had a work table right by the windows so that when I was working with my negatives or whatever, now and then I could just look into the Madison Square. And one day I was sorting through a big heap of negatives. This was during the period when I was photographing Martha Graham, but that's another story. I had just placed a photograph of Eric Hawkins in a certain spot, and I was really analyzing it, the movement and so on. At the same time, when I looked outside, it was snowing, and people were staggering through the snow. And at the same moment, a friend entered my studio carrying some tulips, and said, ''Spring is here,'' and dropped them on my table. And so I just impulsively put the three ideas together, and that was that. It was the spring of '36, I guess.

D: And the fossil formation?

M: The fossil formation is '65, much later. I had been in New York City all that day, and there was so much racket. The ambulances were screaming and police whistles and everything. I had done most of the day's work on the street, so I was just fed up with it. I was living in Scarsdale, New York—and I got back to my studio there and saw a little fossil about this big that a relative had sent to me from a glacier in Alaska. It was supposed to be eighteen million years old. So I thought, ''Ah, New York is turning into a fossil.'' I instantly remembered a negative that I had in what I call my component file. When I'm shooting various things, I usually take at least four pictures, even if I think I've got what I wanted on the first crack. Then the ones that I discard, if they have some future potential, I put them in the component file. So the moment I saw the fossil I instantly remembered this picture of New York at night when the Chrysler Tower was fairly new. I was attending a party in a very tall skyscraper and shot this picture. So I grabbed this negative of the city, which was 4 x 5, and I took a piece of paper and laid it down, I drew an enlarged fossil where I wanted it to be. I took the little fossil, set up my 4 x 5 camera, and enlarged it to that size, shot it and developed it. Then I used the two as a sandwich.

D: You've said that some painters use photographic elements plagiaristically and others have done so legitimately. How do you draw the distinction? Of which painters' use of photography do you approve?

M: If a painter is going to use a photograph that he or she did

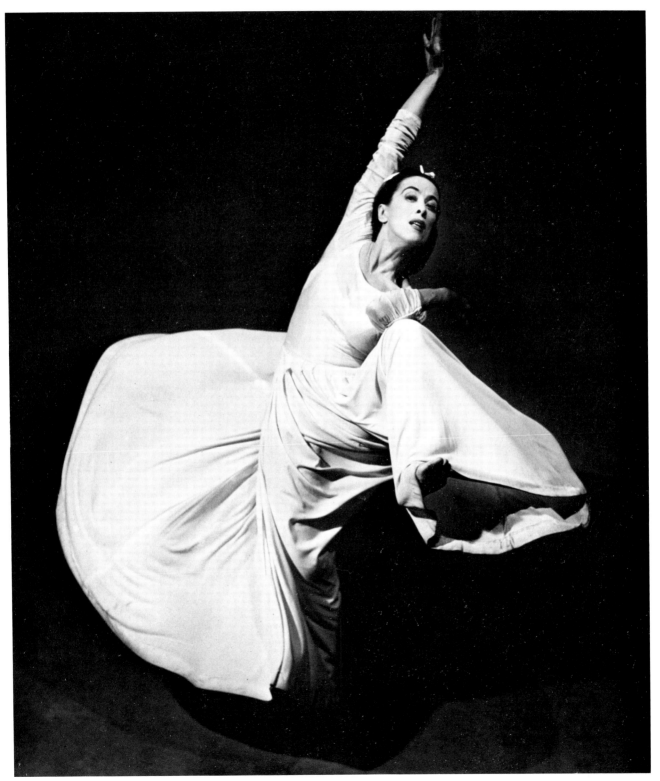

Martha Graham, ''Letter to the World'', 1940

not take, I think it's only honest to say so, just as a writer would. If a writer quotes Shakespeare, then that's okay. But if he just uses Shakespeare and doesn't say it's Shakespeare, I think it's crooked. And I think the same thing's true when a painter manipulates photographs. Speaking of things that are not good, one day in Scarsdale the schoolteacher came over and said how disturbed she was over what was happening to the children because of TV. Well, that was several years ago, of course. She said, "I feel our children are being brainwashed. What can we do about it?" I said, "Well maybe I can think of some kind of photo-montage, using your photograph, and then changing your vision and making you brainwashed." I took her picture, and then to show that she was "brainwashed" and her optical intake had changed her, I had these light things to imply that something was entering her brain. Then I distorted her eye, and so I call it "brainwash".

D: Some photographers—actually I'm thinking about Duane Michals—use paint on photographs. Have you ever considered combining both media?

M: Well, I've thought about it. I've never really done it. I don't know where they are exactly, but maybe the closest thing is my light drawings.

D: I think there is a photomontage based on a light drawing on the cover of *Barbara Morgan: Photomontage,* the catalogue of an ongoing exhibition of your work.

M: Oh yes. The name of this one is "Pure Energy and Neurotic Man." In other words, the grabby instinct of the human psyche.

D: How did you create that light drawing? How is that accomplished?

M: My light drawing concept came just when I was concluding the designing of my Martha Graham book. When I was a child in California light was always haunting me, it was a mystery to me. My bedroom faced the east, and every morning, when the first ray of light would come and touch the little twigs of a small tree outside my window, I was just magnetized.

D: You experienced a certain kind of light and space?

M: Yes. And then later, much later, when Willard and I were in the Southwest and we would attend these Indian rituals to the sun, I saw the intensity of their kind of mystical relation to the sun, and it has always been a very deep experience to me. Well, when I had designed my Martha Graham book, I had left the last page open. So then I was reading *The New York Times,* and there was an article about a sociologist who was experimenting, trying to decide whether it was efficient for a person to put lids on cans. They had put a tiny little flashlight on the wrist of this woman and they were taking sequential pictures. The flashlight was making a funny little weaving shape

like that. I looked at it and I thought, "Well, it's not art and it's not beautiful, but why not?" Then it just hit me like a brainstorm. I ran out and bought a lot of black cloth and I bought curtains for all my studio windows and I put a big piece of black cloth over the wall where I was going to do it. Then I made myself a black robe and a black mask, and set up a 5 x 7 camera to start with, later a 4 x 5, and I got one of Martha's dancers whose husband was an artist, so she would understand more about it. I got her to come and stand there by the camera and I took my little flashlight and experimented in front of the black. I was wearing a mask and everything. When I'd raise my finger, that meant she should open the lens. Then I'd do things; I'd be counting so I'd know what rhythm I was getting. I did a whole bunch of them, and then went into the darkroom, developed them to see what I was getting. Now, in this case, though, I'd click on, click open—see stars. And I'd swing it and they'd come up here and then swoop to make it wide. It goes gently and then to descend it goes rrrp, like that, and then to make these things you go . . . click on . . . off. See, and it makes these dots. Well, this picture was a much later thing, of course, when I was doing photo-montage and the idea was the pure energy is here, but there's neurotic man, the grabby person.

D: When you first saw the work of Edward Weston, you knew when you photographed that your work would have to have movement, and during the course of these more than forty-five years, you've used the dance—not just to demonstrate photography but to try to find its fullest meaning. Almost forty-five years ago you met a relatively undiscovered dancer called Martha Graham, for the first time. What were the circumstances of your meeting? What was she doing in 1935 and what were you doing?

M: As a prelude, perhaps, I should make a brief statement. When I was about four or five in California, my father, very whimsical but very philosophical, was always challenging my mind. Each month when *Scientific American* and other magazines would come in, he would start me out with some experimental idea. And so here we were sitting out under a tree, and he picked up a little pebble and said, "Do you think this is moving?" And I said, "No." And he said, "Well, it doesn't seem to be, does it, but just imagine, inside this little pebble there are millions and millions of dancing atoms." And I said, "What's an atom?" And he said, "Well, come on, we'll go and see." So then he showed me the little drawing of what an atom was. He said that everything in the world is dancing inside, even if it's not dancing outside. My father was always challenging me like that. We had honeysuckle growing all over the place and he said, "Why do you think the honeysuckle wants to grow like that?" "I don't know."

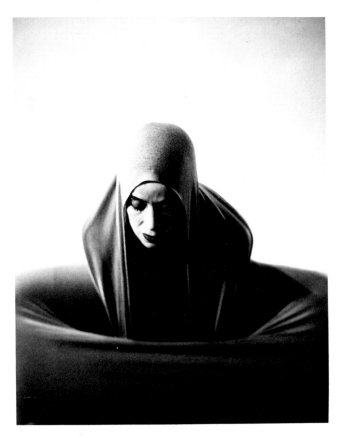

Martha Graham, ''Lamentation'', 1935

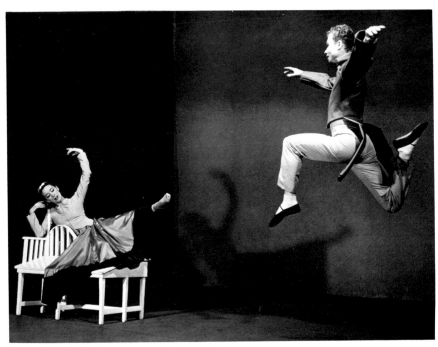

Martha Graham and Merce Cunningham, ''Letter to the World - Dear March Come In'', 1940

"Well, it's a funny word but when you're older it won't be funny; it'll be meaningful. Now, let's say 'heliotropism'." And I would have to say 'heliotropism' about ten times. The movement to the sun, trying to get to the sun. My father was always just making me realize that what we see on our exterior, so to speak, is nothing. It's the inner life of everything that has the real meaning. And so from then on, I've always seen within as well as without. To me, unless something is active or has vitality, it's dead. Then, when I was a young student at UCLA, the art historian was very much into Oriental art. As I'm sure you know, Orientals are deeply concerned with movement and rhythm, so that went right along with my father's philosophy. Unless I can get the energy of something moving, I'm bored. When we were back in New York, we began to go to several performances that might possibly be interesting experimentally. We went to these unknown dancers' performances and were utterly shook up and I just instantly thought, "I wonder if there's some connection to the Indian ritual," because it had the feeling, somehow.

D: And *was* there some connection to the Indian ritual?

M: Well, yes, we had become good friends with Julian Bryant, who started the International Film Foundation. He and his wife, Marian, who taught dance at Sarah Lawrence College, were having dinner with us. We got to saying, "Well, have you been looking at anything interesting lately?" I said, "Well, this terrific dance that I saw just knocked me out. It's so similar, somehow to our Indian experience." Then Marian said, "Why, we know Martha. She comes out to discuss things with my students in the Sarah Lawrence Dance Company. And tomorrow Julian's going to be making a documentary film. Why don't you come along?" And then they said, "Bring your Leica." So the next night we went to a rehearsal. It wasn't a serious thing. Julian was down in the aisle grinding away, and I was up on the apron of the stage with my Leica. There were little moments when Martha wasn't dancing, so we began to talk. And I said something like, "We were deeply impressed by your beautiful dance. And I had the strange feeling that there might be some connection to the Indian ritual in the Southwest." And she said, "Absolutely. That's one of the deep experiences of my life." And then, without knowing what I was saying, I said, "I would like to do a book on your work." And she said, "I'll work with you." It was just like that.

D: Just like that?

M: It turned out that Louis Horst, Martha's musician at that time, was very deeply involved in trying to understand the rhythm changes in Indian music for the ritual, as I was, also. With our music I can tell when there's going to be a change, but with the Indian ritual I could never quite predict it. I found it just haunting. Martha and Louis Horst had gone up into the Taos-Santa Fe area, to see the Penitentes and to hear their rhythm, which is utterly different from the Indians', utterly different from ours. And much later, when I was photographing Martha in "El Penitente," we were both so aware of that whole incredible experience.

D: How did those sessions between the two of you evolve? What form did this collaboration take? You may have had an instant beginning with Martha, but then what followed was six years of intense communication. You photographed her the very first time you met her, but that certainly wasn't the procedure you used as time and your experience unfolded. Had you had any previous experience photographing dance?

M: After our meeting there with the Bryants, we decided that we would do a book. But there is a prelude. Earlier I had seen an exhibit about Isadora Duncan at some library. And previously, when I was still a student at UCLA and was taking figure drawing, the model was sitting on a stool, just sitting there, and I was bored, so I went to the professor and said, "It's boring, can't the models do something, have some movement?" The professor was indignant, and said, "You are studying anatomy." Several of my other friends were bored too. And we had heard that in the dance and gymnastics department, a young dancer who had studied with Isadora Duncan came on campus a few times during each week to give another dimension to their teaching. So about four of us went to ask her, "Could we study with you, just maybe an hour and a half or something like that a week?" We said we would never be dancers. She said, "Well, I'll never be a painter, but I'll be happy to see if I can help you." She had all kinds of percussion instruments and drums from many countries. One of us would be the dancer just for half and hour and one would be the drummer, or play the castanets or whatever. And the other two would be drawing. Then we'd switch. Well, we learned so much that way. When we were drawing somebody, and if he or she had an urge, an inner urge to move or think or do, or feel, we wanted to feel what was going on inside the person and then portray the exterior body form. And so it was that inner life that we were after, just as my father said it's the inner energy of things that we really are concerned with. The exterior's only a tin can, our bodies are like tin cans.

D: In many cases, your photographs are the only ones that exist of early Martha Graham dancers. Did you ever discuss certain movements or whole dances with Martha Graham before you photographed them?

M: Always. I never did it commercially, I never did it in performance. I would go to many performances before I would tackle it. I would try to go to a small theater or to a big one and see how the spatial environment of the stage effected the inter-

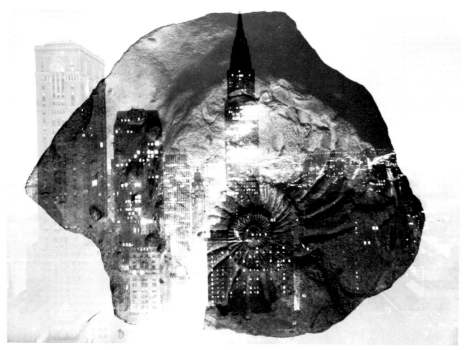

Fossil in Formation, 1965

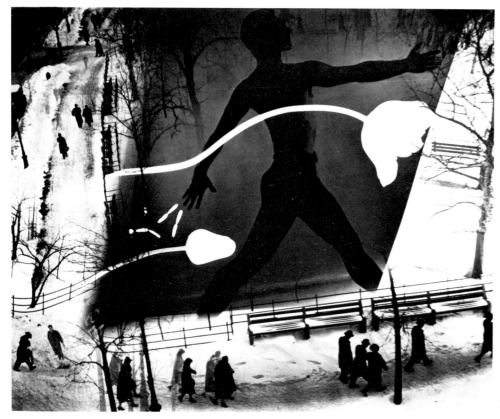

Spring on Madison Square, 1938

Barbara Morgan

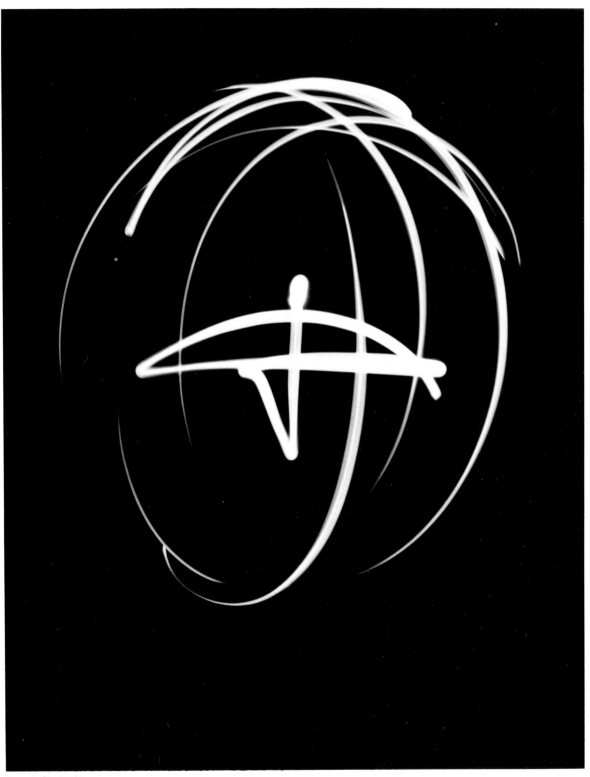

Samahdi, 1940

pretation of the movement. I would also watch the lighting. Now, when I was still a teacher at UCLA, there was a new little theater started in Los Angeles, and they asked the art department if anyone there could help them, because they didn't have any money and they were just exploring. My husband was getting me to learn about photography and I was getting him to learn about art history. We had a friend who was a curator at the local museum in Los Angeles, and she would let us come in on Sunday morning at nine o'clock to photograph until noon. I would do the lighting and Willard would set up the camera. I learned so much with him, not realizing that I was learning. For instance, if you had some African sculpture with the light coming from the head, then they were a deity. If you had the light from below, making shadows, the piece turned into a devil. See? I learned so much just exploring and experimenting like that.

D: Lighting is a very important part of the special impact that your dance photographs have. Probably the most renowned of the Martha Graham photographs is "Letter to the World." What is Martha Graham meant to portray in that image?

M: It has to do with Emily Dickinson, she was in agony because of her unhappy love life, until she realized that her urge to make poetry was her deepest urge, and that that had no restrictions. So in the last three pictures in that section is a kick. It means she's giving in to reality, to tragedy. And I made her go right with the horizontal line in the background. Her arm and her body and her jaw, everything, conveys that giving in to reality. But the inner swerve, the sweep of the spirit is to portray the inner energy of imagination that will ultimately become her poetry. I made all kinds of studies of timing. If I wanted to make her skirt terribly intense, I might shoot maybe a ten thousandth or a thousandth of a second. If I wanted it tense but fluent, I probably would shoot it at a six hundredth of a second. In working on this whole energy factor, I made countless experiments with the timing element, ten thousandth, one thousandth, six hundredth, four hundredth, one hundredth, et cetera. And all through this whole thing, every gesture is controlled by my awareness of the emotional impact that timing creates.

D: All of the gestures have real meaning. None of your images are without content. I'm thinking of the torso of Martha Graham in "Ekstasis", that really shows something very significant in her work and yours.

M: The body was actually not moving in this case, but I wanted it to give the sense of rhythm nevertheless. So I made it

as sculptural as possible, but at the same time emphasized the subtlety of the texture of the garment in it. And to make it more sculptural I simply chopped off her head and feet. I've studied sculpture of course, and Greek sculpture especially. I wanted to have as much variety as possible, both aesthetically and emotionally. So many of Martha's dances are tragedies. Well, the drama of course is involved there, while this aesthetic sculptural quality of "Ekstasis" was on the positive side. And so we'd go from positive to negative and back and forth, from movement to tranquility and so on.

D: Do you think that your photographs interpret the dance or record crucial or dramatic moments?

M: Well, I would always go to many performances, and I'd try to see it under the scope of distance, compressed or expanded—there are differences—to see what the body did. But of course, before all that I would talk with Martha—what was her concept, what was her inspiration, how did she get into it, what was her real meaning and so forth. Then I would do nothing. I would simply let these intakes jump around in my brain. And after a while, I would realize that there might be ten moments that conveyed the concept of the dance, if it was, say, a twenty minute dance. There's so much repetition in all dance. I said to Martha once, "Why do you repeat, do this and then this again, 1, 2, 3, 4, why?" She said, "For a real practical reason. During the first gestures perhaps the people in the audience are not really looking. They're wondering, 'Oh, did I put the cat out?' Then during the second gesture you're really getting them with you. The third gesture you're saying the final meaning, the inherent meaning. Then, with the fourth gesture, you're repeating it, but launching into the next motif." That made a lot of sense to me. What I was after was that center, that most important meaning, the third gesture. After I had been to several performances, and seen the dance, then that ultimate meaning would be haunting me and I'd see it visually. I'd call Martha and say, "I think I'm ready." So then we'd get going. Now, I didn't photograph in performance, as I told you. My studio was large enough, and I had different backgrounds, so I could photograph solos and duets there and sometimes trios. Martha and I knew the very generous, warm man, who was head of the theater department at Columbia University. He allowed us to use his theater for nothing. I'd use my own lights, plus his lights, but I'd do all my own lighting. So that's where we'd do our group things and there were other places where we were allowed to photograph, too.

Arnold Newman

Arnold Newman has specialized in portrait photography for over forty years. His byline appears under a staggering number of painstakingly composed pictures of nearly every well known contemporary visual artist, many actors, musicians, kings, emperors, and the last seven Presidents of the United States.

Barbaralee Diamonstein: Since about 1839, portraiture has been a favorite subject of photographers. However, in the recent past, portrait photography has been considered a lost art. That is, until you brought something new to the medium. You have created what has been referred to as environmental or symbolic portraiture. What is meant by those references?

Arnold Newman: Well, first I'm startled by your statement that portraiture was lost till I came along. That is not the case. Like every worker, in any creative medium, you come along and you just simply try to add something to it. There were a lot of marvelous things being done when I came into the field. I just had my ideas, and I went my way, and I should be given credit perhaps for adding a little bit to it like everybody else does when they come along. As a matter of fact, there were many—Stieglitz, Steichen, Man Ray and others—who in a sense influenced my work. But just what environmental portraiture is I'm not too sure, though I get credit for it. I simply went out into the field and photographed men and women in their homes, in their offices, in their studios. I just couldn't think of bringing people into the studio all the time, photographing them in a sterile atmosphere. To me, photographing people meant photographing them with all the creative means that I had—concepts of design and so on, where they lived and where they worked. Soon it became symbolic, if

you want to put it that way.

D: Before the economic pressures of the Depression caused you to change the direction of your work, you attended the University of Miami in Florida on a scholarship to study art. In early examples of your work, it's quite obvious that you had a facility in both drawing and painting. When you left school, I believe after two years, your visual interest shifted to the potential of the camera. By now you have the title of court photographer to the world of art. You have photographed more than two hundred artists, at least one time. How do you relate your interest in artists as subjects to your own youthful concerns?

N: Well, I didn't mean to make a series of photographs of artists. My intent was prinicpally to experiment in portraiture. I hate the word portraiture, by the way. I prefer to call it photographs of people. When I came to New York in 1941, things were still difficult because of the Depression. There wasn't very much money, and I was unknown. I had this desire to make photographs of people, but I didn't know anyone, I was from out of New York. I wanted to experiment with some ideas I had, and the artists were absolutely perfect for that. Besides, they were my heroes, and it was a great chance to meet them. I did many of them. But immediately, as soon as I got to be better known, and had better connections, I was working with other people, and not just artists.

D: Your very first job was in the photographic section of a chain store. You've referred to that as a blessing in disguise. How is that possible?

N: Well, I was sort of thrown in among the wolves, so to speak. Thrown to the wolves. I found I had to quickly learn how to do anywhere from twenty-five to fifty portraits a day, for 49ᶜ each. That was 1938. You just had one half of a sliding 5 x 7, that's a technical phrase, but you had a 5 x 7 negative and used only one half of it. Then the next person would come in, smile, bam, next, smile, bam, and out. What happened is that I had to learn very quickly how to adjust to the people, and how to get them to adjust to the camera, and how to get them to react without being overbearing, without making them frightened, how to put them at their ease. And in a sense, it was part of a general training. It could have been superficial, if you were not aware of the consequence, you see. But the experience was fantastic. There were a lot of basics one had to learn in a hurry. I was delighted to leave the job, of course.

D: About a year afterwards, you came to New York on a trip, and while here you went to An American Place, the gallery owned by Steiglitz. You met and talked with him. What advice and criticism did he give you then? And what influence did that have on the path of your own life?

N: Well, of course Steiglitz was a man I greatly admired. I didn't have any idea that I was going to meet him the first time I visited An American Place. One doesn't always remember the exact words. People who have total recall after forty years sometimes make me very suspicious. I do remember that he used words like "inventive," but the word that he kept repeating was *honesty*. He kept urging me then and later to be honest. We had many discussions about a lot of other people's work. He told me why he liked them, and didn't like them.

D: Can you be specific?

N: We were talking about painters as well as photographers. I would say a conversation with Steiglitz was frequently about one percent you and ninety-nine percent Steiglitz. I shouldn't say that; it's unfair to the man. He listened to me very carefully. But I was very anxious to have him talk, and he was very willing. You have to remember that this was an opportunity for a student to hear one of the greatest masters who ever lived. Quite a fantastic experience.

D: Soon after that you met Beaumont Newhall. Was Steiglitz instrumental in introducing you to Mr. Newhall, who was then curator of photography at the Museum of Modern Art?

N: I met Steiglitz first. I happened to accidentally wander in to his American Place when I was still a student. When I'd been in photography two years, I went to visit Beaumont Newhall to show him my work and to see whether I had any reason to continue. I was working by myself, I had no idea where I was going. I was sort of lost. When you don't live in New York City, and you're out in the boondocks, there is no one to talk to, nobody to bounce your ideas against. So somebody said, "Why don't you go see Beaumont Newhall when you get to New York?" And I did. He became very enthusiastic and he said, you must meet Steiglitz. I hadn't met Steiglitz formally. Newhall called him up and sent me over. It was only a block and a half away. And that was the beginning of a fantastic experience. The very next day I was offered a show in New York by Dr. Robert Leslie of the AD Gallery, which in those days was for graphic artists. About three months later, I had a two-man show with Ben Rose in the fall, and that began my whole career in New York.

D: Did your association with Ben Rose, a very long term friend and colleague of yours, really start when you were in the same Boy Scout troop?

N: I was twelve years old and he was two years older, so he really was my Boy Scout patrol leader. Unhappily, Ben died just a couple of months ago.

D: You mentioned that you hated the word portraiture. Why do you respond so vehemently? What is a better reference?

N: I don't know a better reference—maybe photographs of

people. But I dislike the term because of what it has come to mean in the public's eye. No word by itself is wrong; it's the meaning that other people attach to it. In this case, portraiture is a term that has taken on all these barnacles. All these terrible things that have happened to portraiture, both on canvas and in stone and metal, and then in photography, are done to please the subject. The photographer is nothing more than a whore who sits there thinking, "Will it please the subject? Will I be able to sell him this picture? Or will I be able to please him so he will buy it?" The result is that little by little people have begun to look down on portraiture, forgetting that the greatest artists in the world, from Rembrandt to Holbein, on to Steiglitz and Strand and what have you, have all done portraiture and loved it. I happen to particularly love photographing people. For the most part, I've been able to avoid that situation, where I had to go out and only please that person. I've had to put up with some of that in the past, but I've gotten rid of it.

D: All of it?

N: Well, it comes up once in a while, but rarely. I have less trouble with businessmen and executives than I do with movie stars, who I refuse to do for themselves.

D: How do you explain that?

N: I don't know. Maybe it is because people who are successful have less vanity as a rule. Movie stars and actors have been written and talked about a lot. They have bruised egos, and even when they're quite famous, all they have is themselves. They have no other ability but to go on and portray somebody else. They don't know how to be themselves, and it becomes a very difficult thing. Only a few of them are able to say, "I don't really care. I have warts; photograph me with the warts." I've discussed this with many actors and actresses. They agree.

D: You've also observed that the portrait is a form of biography. I wonder how many of your subjects actually complain that they either have too many wrinkles or are too ample or something else.

N: Well, I'm only . . . 12½ pounds overweight myself, and I'm worried that—on camera—it looks like more! I get up every morning, and I shave and I look in the mirror, and I find a young, handsome, slim man staring back at me. That's *my* imagination.

D: As you've pointed out, what you see is really the distortion of the wide angle lens.

N: Yes, wide angle would only exaggerate it if it's close enough. We all have an image of ourselves, and we'd like to project that image. The trouble is most of us have another kind of an image of what we'd like to be and think we are. And therein lies the problem. A lot of people have made a lot of

money catering to that with all kinds of retouching and airbrushing and even distorted lenses. They use all sorts of things. And it's amazing, nobody really knows. It's fine, if you're going to please somebody. That is a product, just like an undertaker sells a product, or a hardware salesman sells a product. I'm not interested in product, I'm interested in ideas about creativity.

D: Have you ever retouched any of your photos?

N: In the past, when I did commercial portraiture, we used to do a little of it.

D: And recently?

N: Well, thank heavens, one does not have to. I'll tell you something interesting. It used to be that you could never get an executive or anybody of any consequence, even a politician, to accept a photograph that was not retouched. By the way, one of the first things that got me started was a photograph of, I think, Teddy Roosevelt, that I saw in a biography—I've always loved biography and history, even as a child. I remember looking at this stuffed, embalmed walrus in the front of the book, and it was labeled "Teddy Roosevelt." Not until I came across these inserted pages of a blurred snapshot of him, grinning like mad with his foot on a rhino and holding his gun, did I have any idea what the man was like, what part of his environment was like, you see. Then I realized, this is what a human being is all about. Not these overdone stuffed things. Then magazines like *Life* and *Look* and *Holiday* started to do full page covers and inside photographs of these same people, and they had no opportunity to say, "I want to be retouched." It was like the *Good Housekeeping* Seal of Approval, bang. If *Life* says it's okay, it's all right; I can have wrinkles. It was amazing. I did a lot of these photographs for *Life,* and to our surprise, the subjects wanted to buy prints for themselves, unretouched. They never asked about retouching. In other words, it was finally accepted. I think it's the first time in the history of art, because Holbein had trouble, Goya, and all of them had trouble with their sitters.

D: There is a strange kind of contractual arrangement that I imagine exists between the photographer and the sitter. How do you go about choreographing a sitting? What procedure do you use?

N: Well, if I could tell you exactly, then I would be able to say, "This is how you go about doing a portrait." There is no single way. It has been instinctive to a large extent. I arrive, I look around, I look at the area, the studio, the office, the home, the factory that somebody is working in, or is used to being in, or is symbolic of. For instance, once I did a photograph of the chairman of General Motors on an assembly line. Now, he was dressed in a business suit. But the basic idea was to use the assembly line in this vast factory, in the

Arnold Newman

Piet Mondrian, 1942

Igor Stravinsky, 1946

I.M. Pei, 1967

background, going on for miles it seemed, as a symbolic background rather than reality. It depends upon the circumstances, on what you want to say about that person, *how* you want to say it, and how you want to use your graphics and bring it all together. The graphics, the very style of composition you create can give mood and meaning to the photograph. Before the photograph, you try to learn as much about that man or woman as possible. If they're an artist, you know their work, or you try to know their work. If they are in business, you try to find out what they're about, what their hobby is about. If nothing else, it gives you something to talk about. If you can get interested, you can get people talking, and a thirty-minute session with the President of the United States can stretch out for an hour and a half. You can even have a cup of coffee with him later. That's how busy they are.

D: What do you say to a subject before you begin to take a photograph?

N: You don't stage it. You wait for things to happen. You'll say, "I think I would like to photograph you over here. How about standing behind the desk for a moment for me?" And they'll do that. Now, let's face it, if you've got a very irritable subject, a man who is pretty rough and tough, specifically President Johnson, you don't say, "Well, why don't you stand there for a few minutes?" You just can't do that. As a matter of fact, he gave me fifteen minutes, and of course I took forty-five. I had to loosen him up, to get him used to the idea of photographing. I had to take a risk. I took risk shots, my insurance pictures, in the beginning. They were not bad, but they were stiff and he was uptight and mentally looking at his watch, so to speak. Later, I got him relaxed. We were kidding, he leaned and he was talking like this, because he was waiting for me to get my camera ready again. I was doing this on purpose. Finally, when he relaxed, I said, "Don't move." Very often, you'll tell people, "Don't move or I'll kill you," that sort of thing. And they stop! They're very relaxed, and they comply. But later they may say, "But this is unnatural." I say, "The only unnatural thing about it is that you're holding it, you're not moving around. But I just wanted to do another couple of shots." Each situation is one you have play by ear. I have to create an image out of nothing. I am not doing a street scene where things happen, and I can stop it. Even there, the greatest of them all, like a Gene Smith, or a Cartier-Bresson, will stand there in that frame, waiting for something to happen within that frame. They've described it that way. Well, what I'm doing is trying to get the situation to work for me within a given frame. That's why one moment I will be free with a hand-held 35 millimeter camera, the next moment I'll have an 8 x 10 nailed to the floor. Depending upon how I feel, I have to go about that particular sitting.

D: How important is Cartier-Bresson's "decisive moment" for your work?

N: Every moment is a decisive moment, even if you wait a week for it. "Decisive moment," by the way, was not a phrase that Henri gave his pictures; it was an editor. It's a good phrase, like all simplistic catch phrases, that really gets students questioning their own way of working. The real problem is that so often they think, "Well, if it's the decisive moment, that's what I'm looking for." What they should be looking for is photographs, not the decisive moment. When they decide that the photograph is ready for them, that's a decisive moment. If it takes an hour, two hours, a week, or two seconds, or one-twentieth of a second—there's no such thing as only one right time. There are many moments. Sometimes one person will take a photograph one moment; another person will take a photograph the other moment. One may not be better, they'll just be different.

D: By the way, who was the editor?

N: I don't know. He told the story himself one night. But it's marvelous. Half the time my books have been titled by editors. I say, "Okay, sounds good, go ahead. Sell my books, fine."

D: I didn't think you gave up control over anything, Arnold!

N: You do so only when you know they're right.

D: Under what circumstances do you do your best work?

N: When I'm thinking clearly. I've taken pictures in the middle of the street, in the middle of Times Square, on a platform we built for Helen Hayes, the queen of the American theater. We got a pretty good picture. Of course, it took a week to plan and some twenty odd policemen to hold back the crowds on the side. The lights wouldn't work for a while. We had it planned down to the nth degree, but at the very moment of shooting, we were able to get her to be very spontaneous. She was a delight to work with.

D: How much intimacy with, and manipulation of, your subject is necessary to get the kind of distinctive results you seek?

N: If you manipulate your subject then that's exactly what it's going to look like—manipulation. The subjects have got to be relaxed, just like I am here. You have to get them to the point where they're relaxed. If you don't, you can't take photographs. Or they're not going to be what I like to call the "common denominator" of that person, the way they sit, stand, lean or what have you.

D: Beaumont Newhall also described your work as going far beyond obvious symbolism. He said that you subtly recreate the world of the sitter. You have been widely quoted as saying that you do not take a photograph, you build it.

N: I don't think any student, any photographer, any person should take pictures the way I take pictures. I build them

because it's the way I am, and that's the way I should be. If I try to be something else and try to take pictures or talk to you humorously because I think I'll get a few laughs, no. Somebody else, like Duane Michals might be basically funny. He is that way, he makes me laugh all the time. But he is being himself. A writer must be himself, a painter, all of us—or else suddenly we lose what we have.

D: Have you ever photographed anyone that you dislike?

N: Only rarely. I've turned them down. But one that I particularly have in mind is Krupp, which is one of my better known photographs.

D: . . . where you portrayed him as the devil. How was he willing to be subjected to that kind of photograph?

N: Well, it was one of those long stories. After the fact, you wonder absolutely how in the world it happened. To this day, I really don't know how I did it. Briefly, an editor for a magazine said they wanted to do a cover story on Krupp. I said absolutely not, I won't do him. The editor knew I was going to Europe, and wanted me to continue on to Essen. He asked me why not. I said, ''Well, I just think of him as the devil.'' And they said, '' Fine, that's the way we think of him.'' So I had no choice; I had to say yes. I realized I'd gotten myself trapped. So I decided that I would think of a few ideas, but I couldn't, and I was quite concerned. Many telephone calls and cables went back and forth, and I arrived in Paris and did my work there. The day before I went to Essen, I checked with Krupp's executives by telephone and it was agreed that they would meet me at the airport. Here I was about to do a hatchet job on one of the most important men in Europe. You have to remember that he was a war criminal, and that he had been released from prison not too long before. He had used slaves, and had not allowed them to die, but had weakened them by overworking them and then had shipped them off to extermination camps. That is why I felt the way I did about Krupp. When I got there, I was ushered into a small room. My assistant was waiting outside. And they said, ''We're terribly sorry, but the photograph is cancelled.'' Well, I looked at them, and I knew that in Germany, a Nazi-like group still remained in the Krupp steel works. There's only one way of dealing with them. They understand only one thing, and that's levels of importance. For them, Krupp was at the top. They were close to him, and I was just another photographer as far as they were concerned. But they were being very nice to me in this smooth, oily way. And so I simply banged my fist on the table, and I said, ''How dare you do this to me?'' They were so startled, because nobody dared talk to them like that, unless they were their level or higher. So they immediately began to whisper among themselves. I said, ''I demand to speak to Krupp.'' I didn't say, ''I demand he pose for me,'' you see. That would

be assuming too much. But they went to Krupp, and he said, ''Of course.'' I showed him my photographs. Now, you never see Satan on earth at all like he is in pictures. Very often, devils are very sweet, gentle people in appearance. The worst people in the world. Today's real villains are, as Hitchcock said, unrecognizable in broad daylight. Well, that's the way Krupp was. He looked like a nice, distinguished gentlemanly human being. He looked at my pictures; he said ''Mr. Newman, I love your photographs. I think we should take photographs.'' So I made preparations, and I worked this out where I got the lights to come from under his face, the usual cliché. The problem was that when I got him there, it was working but not really working. I had built a little platform about two meters high, six feet high, and long enough to accomodate both of us. He straddled a chair at my request. I didn't want to overdo it, and the lights were working beautifully on him, but it just didn't give me what I wanted. I said, ''Herr Von Bolen''—that was his family name; he married into the Krupps—''could you lean forward?'' He did, and my hair stood on end. There was the devil. I did a whole series of pictures. I was doing Polaroids to check out exposures, and I tucked them away in my camera case to hide them. Later, I found out that they broke into my room while I was out to dinner that night and took photographs of my Polaroids. We had proof of that, because they showed editors here in New York photographs of my Polaroids, which I had only shown to two people. Krupp then declared me *persona non grata* in Germany.

D: Does that embargo still exist?

N: Actually, he didn't have the legal right, but now he's dead. And the whole family business went downhill. He was not that good a businessman. He could manage with slave labor, but not in a democracy.

D: Some of your portraits seem to be psychological collaborations between you and your subject. One that particularly comes to mind is your very well-known photograph of Mondrian. The photograph really does bring to mind the austere and rectilinear compositions for which he is so well known. It seems to me that all art builds on previous art. There you have him posing alongside his easel, and you have incorporated his work into that piece. What if Mondrian had forbidden your mimicking his compositional style in that way?

N: Well, I wasn't mimicking it; I was echoing it. There's a big difference.

D: That *is* a better word.

N: And I did it deliberately. When he saw the results, he loved it. He loved it so much, he gave me the original drawings of ''Broadway Boogie-Woogie.'' it was the only thing he could give me. I was stunned at the time. With my photograph, I was trying to say what Mondrian meant to me. That I would copy

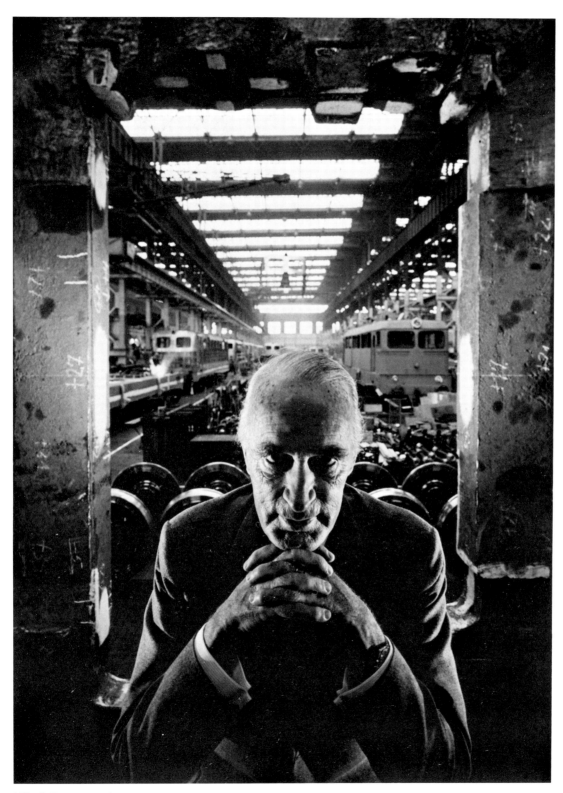

Alfred Krupp, 1963

his work, or anybody else's work, in order to do it, would be horrifying to me. Then I'm not creating, I'm merely copying. A lot of people do that. For me, I wanted to give the *feeling*. The man, by the way, was also stiff, linear, and very formal, just like his own work. But warm inside. The delicate balance was always there in the painting. I used to watch him work. I was twenty-three or twenty-four at the time, and he used to invite me to come visit with him. Seeing him and all these other great artists right on up to the present day has been like a fantastic post-graduate course in art. We'd stay on for hours talking over dinner or drinks. In that particular picture, there is nothing of Mondrian's own work in there. There's another one in my forthcoming book of photographs of artists where there are some paintings, but they are merely echoing whatever else goes on in the photograph. Take them away, and you still have a Mondrianesque kind of composition.

D: The familiar image of Mondrian is not in your new book about artists, *Portraits of Four Decades*. But there is an image that is totally unfamiliar to me. Why have we not seen that Mondrian before?

N: There is a good reason. There are a number of them like that: Léger, and also many de Koonings. When you go about making a portrait, you have many ideas, and you work them out. With Picasso, the only thing that stopped me was not Picasso, but that I simply ran out of film after several hours. When I reminded him he had an appointment, he just kept saying, "Stop talking so much and keep shooting." The thing is you're working out many different ideas. At the time when you make up the first ones, you say I like this one best. I can't tell you how many times I've gone back ten, twenty, thirty, even, in this case, forty years later, and realized I liked the other one as much, and sometimes better. That is why I decided this time I would run that Mondrian. You can't choose between your children. Some may be more successful in this world than others. But you know, deep down they're equal. This time I think this second shot of Mondrian'll have the same reception.

D: Has that shot ever been printed before?

D: No, never. Well, yes, in a booklet that Yale put out for a recent Mondrian show.

D: You are not only a photographer, but a collector, and have been know to swap your photographs for art. You've developed quite a collection. Do you ever swap photos for photos?

N: Oh, yes. To me photographs are art. I mean, what is art? You can go on and fight about it. We all forget that in some periods even painters never signed their paintings, because they were considered craftsmen—like people who put up the stones for the cathedral. But right from the beginning, I always thought of photography as being an exciting medium for me to live with, the same as painting and so on. I think I was supposed to have some Steiglitzes. He told me to come and pick them up, but I was too embarrassed to go back and get them. I didn't want to impose on him. Later I realized too late that he meant it sincerely, and I should have gone back. Art never represented money to me, because particularly in those days you couldn't sell them for anything. Mondrian couldn't sell those drawings for $5. I didn't have $5 to frame them. For three years they lay in an envelope, and then I put them in cheap frames and I was very proud. Not that I owned Mondrians, but that I could live with Mondrians, and could enjoy Mondrians. Only in recent years have they begun to represent investment. I dislike that feeling. It's nice to know that maybe you can sell them, but that doesn't interest me or my wife, or my children. They're not interested in that. They love the drawings the same way we love them: for their own sake, not their monetary value.

D: Did you ever expect the world to celebrate the work of photographers, or your work, with such esthetic and economic interest as they do currently?

N: Absolutely. Right from the time Steiglitz told me they would. I just suddenly remembered, that's one of the ways that he was a pioneer. He said, "Maybe it'll happen in your day." It suddenly just comes back, after some forty odd years. But I must confess, I wasn't sure, I didn't know that it was going to happen this way during my own lifetime. Unfortunately, some of my friends never lived to see it.

D: When you met Steiglitz, you had already begun to experiment with cutting up photographs and reassembling them, making brilliant use of cropping. Did Steiglitz ever comment on that? Did he tell you anything that was helpful at that point in your career about using less than orthodox methods?

N: You have to remember that Steiglitz had shown collages by painters earlier in the century. He had shown Picasso and Matisse before the Armory Show in 1913. I think he began to show their work in 1908. I don't know whether there were any collages during that period. The point was that he was receptive to all of this. He taught me that although I love a certain way of photography and my own way, I should be receptive to so many other people. I already was at that time, but he also helped free me in many other ways—not to be so pedantic, not to feel that there are rules and regulations. I don't remember reading anything in the Koran or the Old or New Testaments which says that art should only be in a rectangular form, or that one cannot cut it or tear it or puncture it or whatever. There are not rules. Any good artist will tell you that. What are rules? They're man-made, by people who have very little imagination. That's how academies flourish, that's how these institu-

tions and official art of any sort come about. That's the thing we always have to be careful about, and I got that feeling totally with Steiglitz. He hated people who laid down rules and regulations. Although in some ways he did himself, about the treatment of artists.

D: Your 1954 photograph of Picasso is the result of a closely cropped and rotated negative. Is that correct?

N: I used a small portion of a 4 x 5 negative, which was part of a series I did. I loved the whole photograph. I still think it is a successful photograph. What I realized in examining the photograph was that the most exciting thing was his face and his eyes. What if I were to blow up just that little section and make that the full image? I blew it up and it was successful, it was the old story: less is more. That closely cropped head with those fantastic eyes increased the impact of the picture, rather than decreased it. It became one of my best known photographs.

D: Do you call that vignetting?

N: No. Vignetting is letting things sort of fade off into space, losing the image into white or black. That is a phrase which came from etching. It's an optical kind of thing. Too many people use it badly for so called artistic effect.

D: You have said, ''There is nothing wrong in using vignetting, as long as it is used to make an honest photographic statement, not to imitate etching or painting.'' And you have also said earlier, ''It seems perfectly all right when Larry Rivers or Robert Rauschenberg combine photographs with paint, so why should it be wrong for a photographer to do that?'' But recently, when Larry Rivers created an image called ''Homage to Picasso,'' including your same Picasso photo; you thought that it was wrong for a painter to do that. A heated exchange resulted between you and Rivers when you objected to his print. I gather you and Rivers are now on calmer terms. Can you tell us some of the background of that incident, and its current status and resolution? What engendered that exchange of letters to the editor?

N: Oh, I think this is a tempest in a teapot.

D: You made that little tempest, Arnold.

N: Well, *we* did. When Larry and I bumped into each other about two weeks ago, we looked at each other, grinned, and shook hands. And Larry said, ''Look, we've been fighting too long in public. Let's talk this thing over in private.'' Then he told me that his letter to *The New York Times* in answer to my letter, was not printed in full because it was too long. They had to cut the things which clarified his views, which didn't put us that far apart. My objection was not the use of a photograph in a painting. My gosh, I've encouraged that, as you said, and I think it's one of the art forms. My thought was that he borrowed somebody else's art, incorporating it into his own

without even saying, ''With apologies to Arnold Newman,'' or whatever, and therefore giving the impression that it was his photograph and his concept. I don't think Larry was trying to do that. He doesn't have to; he's too good an artist. I don't want to put any words in his mouth, because we're going to be having a kind of symposium, which will be the first time we'll talk about it publicly. We're just going to try to find where the parameters are in the use of work which is 'at large.' Legally, it was a copyrighted photograph. Morally, it was a creation by somebody else, me. He admitted that. Now, recently, another person has been using photographs as a basis for painting, and has been almost unanimously lambasted, because he really added very little except superficial sorts of things. Without the photographs, that he did not make although they happened to be available to him, his so-called paintings would not have existed. Now, a lot of painters are beginning to take their own photographs. In fact, you can go back to Degas; you can go back earlier than that. Because photography was sort of naughty at that time, it was supposed to be not a very good creative medium, therefore, you didn't mention it. But since Degas and even before him, a lot of painters used photographs. Gradually they got the courage to use them within their paintings. This I think is fine. People like myself and Duane Michals and a lot of others have been doing collages and so on. Now, Duane and I are using paint and other medium with photographs. There's nothing wrong with this. Do you like it, or don't you? If you don't like it, fine. I like it, fine. That's the end of it, as far as I'm concerned.

D: When is a photo a reference and when is it a terminal point?

N: I have no idea. You've got to look at it and determine that. I think a reference is simply something you go by. If you copy it, if you cannot do without that photograph and it's somebody else's creation, perhaps that is borrowing improperly for creating, particularly if the photograph is well known. It's too easy to see through the premise of the so-called artist who is doing it. I wouldn't take somebody else's negatives and print them, no more than I would take somebody else's photographs and use them in a painting.

D: You're credited with producing a number of definitive images of famous personalities. I guess your most widely known image is that of Stravinsky.

N: This was a very exciting opportunity for a photographer just beginning his career. I'd already had a few shows, was well known. *Harper's Bazaar* said we'd like you to photograph Stravinsky. I'd worked for *Harper's Bazaar* rather heavily and dribbled off after two years when we both began to realize I hated fashion as it was done in those days. And they hated my fashion photographs. They probably would go over a little bit

more today. I just can't stand that whole kind of atmosphere, no more than I can understand advertising photography, or the people that go with it for the most part, though not everybody is bad. Stravinsky was in New York, staying in a hotel, and we had absolutely nothing to do with him. I had an idea. It dawned on me that I'd been going to concerts and looking at various instruments. I had already photographed musical instruments, in part and in whole. And I realized that I had been admiring the shape of the piano. Suddenly it hit me, the piano shape was strong, hard, sharp, linear, and beautiful, and it was really the echo of Stravinsky's work, of his own music. When I thought about that, I asked, "Where can I get a piano? I'd like to use a piano, I have an idea. And it's got to be a very simple background." An editor had a grand in her home, with a very simple wall, and a very simple background. I was able to manipulate the light on the background by simply taking a one thousand watt light and moving it around till I got the light exactly the way I wanted it. If you look at the photograph, you will see that it could have been taken in a studio with a north light. It's that beautiful, wonderful, round, delineating light. And it just happened. As a matter of fact, I did quite a number of photographs that afternoon of Stravinsky, and began a long association with him which culminated in a book many years later.

D: *Bravo Stravinsky.*

N: *Bravo Stravinsky.*

D: But *Harper's Bazaar* didn't say "Bravo Newman" when they first got that photograph.

N: They rejected the photograph. To this day, nobody believes that it's a reject. The real problem is people say, "Well he goes around photographing famous people." Actually I don't photograph only famous people. But so often, when I lecture, students and people ask me about them. They see more of the people I photograph who are famous; they don't see the other photographs. They do, but they don't recognize them, or if they do, they pass by them. They like them as photographs. Thing is, it is more difficult to photograph and to show your photographs of somebody famous than of somebody unknown, either in print or in an exhibition. The average person has a very definite idea about somebody who's in the news or in history. Therefore, you are putting your opinion up against theirs. Obviously, they're going to be much more critical. If you do somebody unknown, they have no way of judging whether you've caught that particular person, whether you've made an honest judgment of him, whether you have really understood what he or she is all about. They really cannot judge your photograph from that point of view. They can judge it from aesthetics, but that is all. So it's become a habit to show my photographs of well known

people.

D: One set of photographs of well known people I don't think has been widely seen. Tell us about that unusual duo of Carl Sandburg and Marilyn Monroe.

N: Well, those *are* famous people. One of my early books—which was not published; actually it was published in a different form, *One Mind's Eye*—was being put together by Simon & Schuster. Carl Sandburg agreed to do the words—you might almost say the words and music. He was working on the West Coast. He said, "Come out and let's start work." I went on out there, and stayed with a friend, the producer of a film called, "Something's Got to Give." And that of course was the film that Marilyn didn't finish; the thing that "gave" was Marilyn. To make this quartet—it's not a triangle—more complete, Carl and Marilyn had had very strong feelings about each other. He was helping her with her poetry. Here I was staying with this friend of mine. He was working with Marilyn, I was working with Carl, and they were friends. So it meant a few evenings together. But I never saw the glamorous creature. Oh, I saw flashes of her in public and things like that. But in the privacy of several homes, and later at my home, I saw nothing but a very sad, sick girl. It's very easy to say that in retrospect, but I even said it then. As a matter of fact, Henry Weinstein, the producer friend I was staying with, said sadly—after he took her home and I took Carl home after dinner that particular evening I took those pictures with Carl and Marilyn—"I give her five years. She'll either do away with herself, or she'll be put away." And it took five months. You could see that this was a girl who just couldn't come to grips with life anymore. She didn't know who she was. And I think that photograph shows it.

D: You had the opportunity to photograph John Kennedy when he was a senator, and when he was President. You have an interesting anecdote about one of the photographs you made of him in New York en route to the convention.

N: Oh, well there were quite a number of anecdotes. I first met him as the unknown junior Senator from Massachusetts. I was taking pictures in the capital, of the Senate. We walked around. The only person who said hello to us was somebody I knew. Nobody recognized him. Imagine. Then, when he thought that he might possibly get the vice-presidential nomination, he asked if I could photograph him.

D: What year are we in now?

N: Oh, it was about 1956. He was on his way to Chicago for the Democratic convention. And a lot of writers said afterwards, "How come Kennedy seemed to be so surprised by almost getting the vice-presidential nomination?" Four years later, they made him President of the United States, or helped make him president. When he stopped off the day before

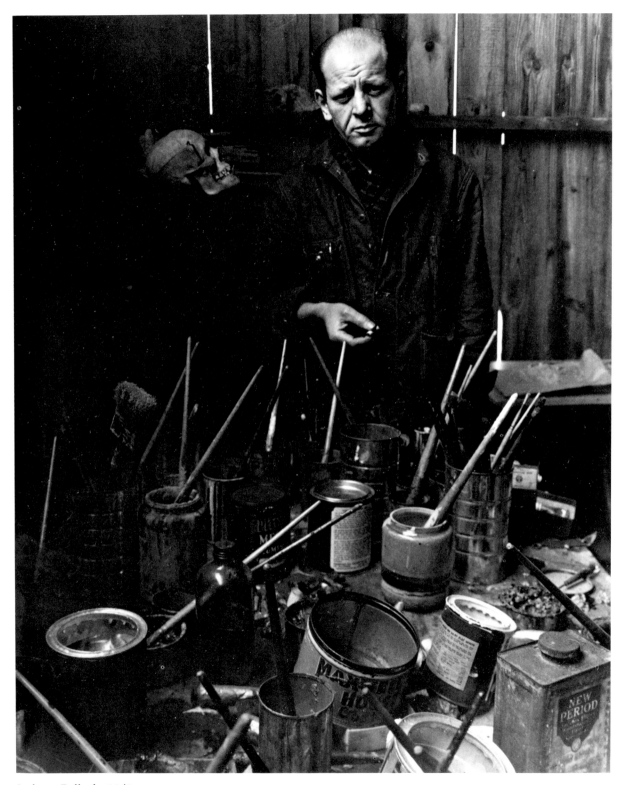

Jackson Pollock, 1949

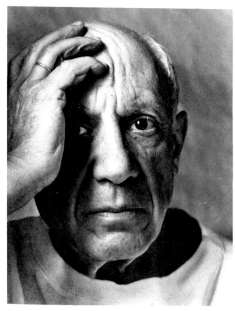

Pablo Picasso, 1954

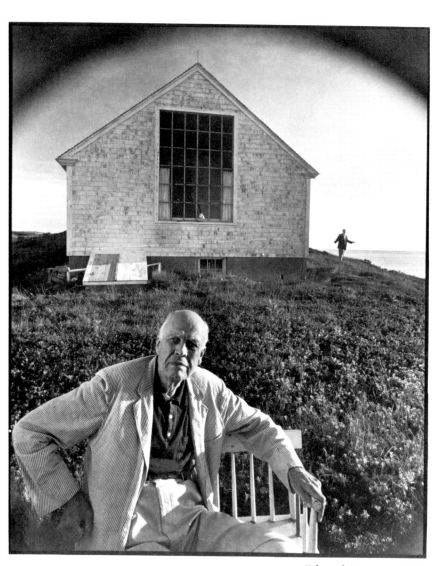

Edward Hopper, 1960

going to the 1956 convention, he spent the afternoon in the studio with Arnold Newman. Obviously, he knew that he might need some more political portraits, and he asked me to make one for him.

D: Is that the reason you were making them at the time?

N: Well, some things you just don't talk about. He said, "I need them for myself, Arnold." And I said, "Okay, Senator. Come on up and I'll do them."

That was the funniest anecdote, the first time I photographed Kennedy, and nobody knew who we were. It was for a story on the Senate. Actually, we were doing photographs of typical senators, ranging from the very famous—the most famous was the Majority leader, who was Johnson—down all the way through the Republicans and Democrats, to an unknown junior senator from Massachusetts. We did fifteen of them. And later, when I was photographing the President of the United States on the lawn of theWhite House, using the White House as a symbol of the presidency, he turned to me when we were all finished, and said, "Arnold, whatever happened to that first photograph you took?" I did about eight or nine or ten of them over the years. He had a great memory and sense of humor. So I replied, "You know, Mr. President, we did fiteen portraits for the senate story when I first photographed you as junior senator, and when we got them together, there was not quite enough room; they dropped the one least likely to succeed." So I thought I'd get a nice big "yuk" out of him, but instead, his face went rigid. Have you ever wanted to crawl under the grass, wished to hell you could take your words back? The only thing I could think to say was, "Well thank you very much, Mr. President," which was a way of saying, "I'm finished"; I was afraid he was going to walk out on me. As a matter of fact, he just said, "All right, Arnold," and just turned around and walked back toward his office across the Great South Lawn. And Pierre Salinger, who was there, turned to me and gave me one of those looks, you know, "How could you be so stupid?" And all the Secret Service men looked at me like, "Gee, you really put your foot in your mouth this time." I went back to Pierre's office afterwards and tried to explain how sorry I was, and I said, "Pierre, I apologize, I thought he was going to get a laugh out of it." I started going on, and he looked at me, and burst out laughing. I said, "What the heck's so funny?" He says, "Don't you know?" I said no. He said, "The last thirty minutes, the President's been walking all over the White House telling the story on himself. He's been pulling your leg." That's the kind of sense of humor that he had. But Kennedy made me squirm for a while.

D: You kept notebooks for your ideas even when you were a very young photographer. And you still take pride in your elaborate ledger book and your negative filing and calendar system. It really is very impressive. I assume it is not only your own invention. Your first and long-term assistant, Gus, is a part of that.

N: You should explain that Gus stands for Augusta.

D: We should. Mrs. Augusta Newman. How did that system evolve? You pride yourself on the fact that when someone calls you for a negative, rather than rummaging through some old shoebox and coming up with a negative, you can go back thirty years into the right drawer or the right cabinet, and find what you're looking for. How did you know so early on to keep those records, and how important is it for a photographer to be well organized?

N: I tell students, "Now is the time to organize your file." This is just a way of working. Some people are capable of doing it; some people are not. If you're not, you're going to be forever disorganized. If somebody asks for a print years later, and you can't find the negative, you can't find any prints, where are you? That is not the most important thing in photography, but it is a system of working. Some of the best artists I know are always very careful with their records. If they want to use my photographs, they'll call me up and say, "What date was that? What year was that? What were the circumstances?" Sometimes you make notes. I wasn't thinking of history so much. It was just simply a matter of keeping my work and my studio organized. By the way, the basis came from those inexpensive studios I worked for. They were dealing with thousands of negatives in several different studios. They had to be able to retrieve any one almost immediately. It's very simple; you just go to the card index filing system that we grew up with in the public libraries.

D: Are you so disciplined in all aspects of your work?

N: Hell, no. Ask Augusta, she'll tell you. Certain things you have to do, that's all. I think that I seek discipline in my work because personally I'm a terribly disorganized, haphazard guy. I am known for working very hard; I just do that to make up for my lack of discipline.

D: How much time do you spend in the darkroom, Arnold?

N: Oh, it comes in spurts. A lot of us today are lucky enough to have a studio where we can afford one or two assistants, depending. If I train them properly, they're able to set up, get things ready, and even get the first few test prints started. There's nothing wrong with this, because every artist in history who had a lot of work to do always had apprentices and assistants. I remember one who worked with us for a while, who used to do some of the fairly technical work—mixing things, getting things ready, dusting off the negatives. Later, he went around telling everybody at a show of mine, "I made those prints." Well, in point of fact, he worked with them the same way any apprentice or helper would do. But most of

the time I go in and finish them off. I've watched Henry Moore at work. He has people pointing up his stones. At the last minute he goes in there and completes it as he originally planned it. Why should he sit there and worry about taking X number of square feet off this tremendous marble? He no longer has to do that. It's carefully worked out by skilled workmen, see, but it is he who truly makes the sculpture. He drew those lines where they are to work in the first place.

D: There is an expression that seems to be unique among photographers. They talk with great pleasure about their personal work, and are often disdainful when they refer to their commercial work. How do you feel about that? And how do you keep the delicate balance going?

N: I'm not disdainful of my commercial work. Many of the things I did commercially, the things that people like and use, I think of as my so-called personal work. The Stravinsky was an assignment, and what differences does it make if it was handed to me by *Harper's Bazaar,* or the magazine who asked me to do Krupp, or the advertising executive at the *The New York Times* who asked me to do their executives? I was told that these were if not the first, among the first photographs taken for ads that wound up in places like the Modern, the Met and so on—accepted by others as works of art. I hate that expression, ''works of art,'' because now it's become a pompous kind of phrase. Even if I know that under the circumstances I can't create a so-called work of art; I take great professional pride in doing the best job I can. Otherwise, I would suffer, my personal work would suffer, my income eventually would suffer. Besides, why hate yourself for doing something that you might enjoy doing? I've had a lot of fun doing ads. I've had art directors say to me, ''Okay, we've got a problem, let's see the best way we can solve it.'' Once in a while, you can sort of go over the top; it's as good as your so-called personal work. Personal work is described as those things which you decide to do for yourself. You can cut it or do whatever you want with it; forget it, or use it as you please.

D: There are so many variables in terms of methods of printing and mounting and using paper that influence photography. I've often wondered how much of photography is dependent upon external forces like commercial manufacturers, and how much photographers are at the mercy of technology other than their own.

N: We must use technology. But I've heard painters complain about paint. I don't do much in the way of color photography for my personal work, because I can't control the colors exactly the way I want to. The manufacturers even confess, privately if not publicly, that they can't make an all-purpose film to satisfy everybody. Because they try to make it all-purpose, it doesn't satisfy the really critical, creative person. When we used our old cameras, we adjusted to the particular techniques of those periods. Don't forget that when photography was in its infancy, when it was really so primitive you wonder how they did it, great photographs were made. Great photographs are not made with the camera, they're made by a human being with a mind. He uses the tool. If the tool can't make a work of art, then he discards the tool and goes to something else. So long as the tools are available to us, enable us to make something that satisfies us, we'll use them, no matter how imperfect they are. They're not that imperfect yet.

D: What are the tools that you use?

N: All kinds of cameras. They are tools, that's exactly what they are. I use them to express the idea that I'm trying to get across. I use small cameras, I use large cameras, mostly I use a 4 x 5 view camera.

D: In your early work, you were very heavily influenced by Walker Evans and the Farm Security Administration—all sorts of social democracy issues. Those are lifelong personal concerns of yours. Are you returning to that kind of work, which is not as widely known as your photographs of people?

N: Actually, what influenced me about Evans and the Farm Security Administration was not so much their social beliefs, which I believed in whole-heartedly and still do, but how they went about doing their work. It was *how* they saw things, their eye, their vision, that influenced me. In the Thirties there was a group of students, a lot of whom became very well known. We all knew each other—Ben Rose, Sol Mednick, Penn. We were also influenced by painters such as Mondrian, Braque, Matisse—as well as by surrealism, by dadaism and so on. All these factors came together. You might say the same kind of mind creates a single image on a painting, or on a piece of film. I approach my photographs in that way. Therefore, I am not a social realist or a photojournalist, although I've done quite a bit of it. I am much more comfortable doing the single image sort of thing, even when I do several in one day. They may be related, but they're related by subject and not tied together by imagery. I got very upset. I was in the South, and I wandered with my camera over to the West Palm Beach slums, where the blacks were living at that time. I was trying to photograph dirty toilets, the terrible living conditions. I soon realized that that was not what I was really trying to say with my camera. What I was trying to say, in a more subtle manner, was how was it put together structurally? How do they look? What do they say? I think I'm much more related to Edward Hopper than I am to Walker Evans. The man who put it so beautifully was Eugene Smith, a very dear friend of mine, probably the greatest photojournalist who ever lived. Cartier-Bresson was not a photojournalist; he takes individual images,

if you really look at them. When Smith came back from Japan, he had a crowd of younger photographers around him at the International Center of Photography, where they were discussing his Minimata story. He began to realize, as a lot of us did in that room, that they were thinking that if they only had a subject like Minimata, they too could become great photojournalists. And he said, "Wait a minute, first I have to be a good artist before I can be a good photojournalist." That is the essence of our art. We must make it an art form and then use our ability to make it say what we want to say, whether it's about terrible conditions, or about people, or anything.

D: Do you photograph every day?

N: No. Photography comes in spurts, at least for me. First of all, there is so much work in the dark rooms, and that unfortunate and unhappily necessary business of business. And I find I spend too much time at my desk answering telephone calls I can't avoid, and getting involved. I'm beginning to be like a lot of friends of mine, a lot of painters and people working in the creative fields. I'm going to have to move to the country and get away from it all.

D: And leave Augusta behind to take care of everything?

N: Oh, no. After all these years, I don't want to say how many, I won't go where Augusta doesn't go. She's my life, as well as my work. We're very fortunate. And she has enabled me to work, by the way, by agreeing right at the beginning that we had a certain amount of things that we had to do. Therefore, we did only a certain amount of commercial work necessary to bring in the income. The rest of the time we did the work that a lot of people call "my personal work." She made it completely possible by working very hard with me over the years. Now I'm screened a great deal, because there's just too much, too many requests. But I have noticed the same thing about everybody who has become successful in any field. I used to resent their secretaries or their personal assistants, and I realize now they're absolutely necessary. A lot of people criticize artists' widows, particularly dealers. I decided a long time ago that the only thing that is difficult about the artists' widows is the fact that they say no when they should say no. They're only considered nice people when they say yes.

D: Let's come back to some of your sittings and your subjects. What makes for a successful portrait?

N: A good photograph, which says something about that person. No one photograph can say everything. No one photograph is a complete portrait, or a good image of that person, you know. I'd love to be able to use the word "portrait" without all the other connotations and barnacles attached to it. If it's a good photograph, and says something about that person, then I think it's a good portrait. That's all, it's very simple. Let's put it this way. How many times have you sat down to talk to somebody whom you've just met, and within just a few moments, or minutes, you've made a rough decision about what you think about that person? So often, that really is the case. You can almost tell when they've got their Sunday clothes expression on, so to speak, and they're being nice to you because they want something from you, or they just simply want your approval. And uncomfortably, you know darn right well they're not that way, because there's something false. This is something a photographer of people must understand and try to get behind. A lot of people are defensive; they're not being nasty or hiding something. Very often, particularly if they're having their photograph made, even the President of the United States is nervous and self-conscious. I'm terribly self-conscious.

D: Is that why almost none of your subjects are depicted smiling?

N: Oh, a lot of them are depicted smiling. The point is that I hate grinning pictures. I hate pictures that sit there forever on the piano or on the wall. If somebody went around that way all the time in life, I would say yes, that's the way to photograph them. But no one does that. The only thing you should do is to go around looking at people when they're not looking or thinking that you're looking at them, and observe them. They are never grinning, they are never always smiling. Sometimes people have a natural smile on their face, and I will photograph them that way. It's what I call the "common denominator" of that particular person. I try to get them to be what they are most of the time, what is typical of that particular person. That's what it's all about. We all weep at one time or another, but you don't take a photograph of a person weeping and say, that is a typical picture of that person. That is only something that happens in a moment of grief or what have you. A lot of people have great humor, and you can see it, and they're full of warmth. That's what you try to get. A lot of people are dour and always terribly serious, and you let it drift over to that direction. You rarely find that they're unhappy about that, except for those people who can't decide who they really are . . .

Aaron Siskind

Aaron Siskind is a key figure in the development of modern photography. Born in 1903, he has been actively involved in photography for almost 50 years now. An outstanding teacher, he taught at the photography department at Chicago's Institute of Design from 1951 to 1971. To the present he continues to develop his art.

Barbaralee Diamonstein: How did you first become interested in photography?

Aaron Siskind: I was given a small camera as a wedding gift from a very dear friend. My first pictures were taken on my honeymoon. As soon as I became familiar with the camera, I was intrigued with the possibilities of expression it offered. It was like a discovery for me.

D: Years before you started doing photography, you were a student at City College, where you appear to have been interested in everything, including the writing of poetry.

S: That's right. While I was in college, and directly after college, I was very interested in poetry and literature and also in music. I would spend hours at a time with friends, discussing great works of music and literature. They were marvelous years. For a long time I thought I would become a writer. I still love to read and to listen to music.

D: Soon after your discovery of photography in about 1930, you joined the Photo League in New York City. What was the Photo League and what attracted you to it?

S: Early in the 1930s I bought myself a little view camera, a Voigtlander Avis, and started making pictures around New York. One day I was walking down Lexington Avenue and I noticed a sign in a window identifying the headquarters of the Film and Photo League. I walked in to see what it was all about. Hanging on the walls in the front rooms was an exhibition of pictures about New York—mostly street photography. I was very stirred by these pictures. They reminded me that I still

Bucks County, 1935 (Courtesy: Light Gallery, New York)

had a great deal of interest in social problems. So I just decided to join the League. I knew what I was getting into. Dance, theater, and professional organizations had all been infiltrated by the Communist Party. The Photo League was one of the cultural organizations of the Party at the time. I was interested in the kinds of pictures the Photo League was making and in many of the things it stood for. What I didn't like, however, and what I resisted being drawn into throughout my years of involvement in the League, was the Communist Party's direction and domination of the League's point of view. My purpose in joining was to make pictures and to learn more about photography.

D: What were the kind of pictures that the Photo League was making, that you refer to?

S: Social document pictures. All the pictures were angled to make a point, to deliver some message, to show that this society of ours needed repair. The Communist Party dictated what the message was to be. As the Party line shifted, so did the work of the Photo League.

D: Somehow you managed to make pictures there and to thrive, apparently without becoming entangled in the political scene. What sustained your involvement in the League, despite this ideological emphasis?

S: I was already a mature person, particularly aesthetically, when I joined the League. Many things intrigued me. I had been involved in literature and music for many years. It was a very interesting period. I was especially curious to observe how the political mind acted in an aesthetic situation.

D: And what did you observe?

S: The main thing I observed was the effect of political involvement and political ideas on the kind of pictures that were being made. The photographers at the League felt an obligation to promote certain ideas in their work, and that affected their judgment as to what a good picture was and what a good picture was not. It also affected their choice of subject matter. I was very interested in this kind of picture-making. After some years of apprenticeship in the League I formed a group of photographers—young photographers, all beginners, called The Feature Group. The Feature Group studied the aesthetics of documentary photography through a series of exercises and group projects.

D: You've made a substantial contribution to modern art. Of equal importance to your work as a photographer is your contribution as a teacher of three generations of American photographers.

S: Oh God! You've probably interviewed some of my students.

D: I have, and they've acknowledged your influence on them. There is probably no figure other than Stieglitz who has been as influential as you have been through your teaching of modern photography.

S: No, I don't think that is a fair statement. I don't think we should be compared. Stieglitz has had a broader, wider influence on photography, in general. And, of course, enough time has passed to assess and observe that influence. The influence I have had so far has been more personal. More on a direct, one-to-one level. My influence has been more in line with my role as a teacher.

D: In fact your work as a teacher has gone on for almost fifty years.

S: That's right, although I've only been teaching photography since 1949.

D: Yes, but you started teaching in the public school system in New York City in 1926, first elementary school and then junior high school English.

S: That's right. I taught from 1926 to 1949—to earn a living.

D: Where did you teach?

S: Most of the time I was at P.S. 87 on the west side of Manhattan, 77th and Amsterdam. One of the curious good fortunes of my years of teaching is that a number of the students I had in my classes as children—even before I became actively involved in photography—have somehow or other reappeared in my life over the years. The most interesting students who have come back into my life are Richard and Robert Menschel. Both brothers were students of mine at P.S. 87 in the 1940s, during my last years of teaching in the public schools. Now they are important collectors, and marvellous people. We've all become close friends.

D: Since the 1940s you've used a formal approach to define your subjects. You have said that you share with the work of Franz Kline an ambiguous quality of color—a quality that interested both of you. Some people have suggested that you are interested not only in the ambiguous, but are dedicated to the allusive, and the extended metaphor.

S: Well, it shouldn't be surprising that someone of my background would be interested in metaphor. I have brought to my picture-making, qualities of expression that came out of my experience of music and literature. My belief in the meaning of abstract expression came from my love of music. And my use of metaphor comes out of my experience of poetry and literature.

D: What about Franz Kline? You and he were very close friends.

S: Yes, he was a wonderful man.

D: You said that the two of you had much in common artistically, that you shared an understanding of the use of sub-

ject matter. In your series, "Homage to Franz Kline," the similarities between your photographs and his paintings are striking. What was it that both of you saw?

S: I think that the greatest relationship between the work of Franz and the "Homage" pictures can be seen in the gestural quality of the pictures. I would find something on a wall that I could just "cut out," isolate, and it looked as if Franz had painted it. It was so close. Of course I could recognize and see these things because Franz was close to me as a person and because his art was close to me. It wasn't a question of being influenced by Franz. I had been working with gesture long

before I ever saw his work. What you get from viewing Franz's work and the "Homage" pictures is not so much a feeling of sameness but of companionship in a very deep sense—of fundamental relationship which gave me some assurance, some strength, sometimes the courage to go on.

D: You make a number of allusions to painters and painting, including the most traditional as well as the most contemporary. There seems to be a reflection of this in your work, which in many instances is a collaboration of both photography and painting.

S: I wouldn't say that. It's not a question of the collaboration

Fish in Hand, 1939
(Courtesy: Light Gallery, New York)

North Carolina 30, 1947
(Courtesy: Light Gallery, New York)

Jerome Arizona, 1949 (Courtesy: Light Gallery, New York)

Aaron Siskind

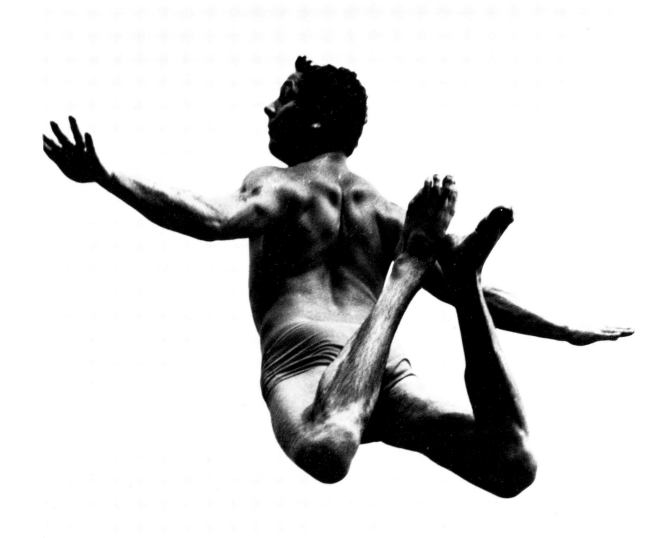

Pleasures and Terrors of Levitation, 1953 (Courtesy: Light Gallery, New York)

of photography and painting. But certainly I've been strongly influenced by painting over the years. For instance, when I first began making pictures on a flat plane because it worked for me, I found tremendous reassurance in what the painters were doing. They knew how to work with the flat plane. They'd been working with it for years and they understood it. When I studied the works of these artists—artists of enormous skill and with a great tradition—I observed the great variety of ways with which the flat plane could be handled. The painters and painting were a tremendous source of information for me.

D: New York in the period of the Fifties has been described by the critic Tom Hess as a time of dazzle and honky tonk and garbage. What were you doing during that period? What was your relationship to the city, and what were your involvements? Were you still living in New York?

S: Actually I wasn't in New York during the Fifties. I left in 1951.

D: What was your life like before you left?

S: In 1949 and 1950? Well, I had resigned from teaching. I was trying to make a living as a photographer, but I wasn't succeeding.

D: What gave you the courage to do that?

S: I didn't have any children. My wife—my first wife—was permanently hospitalized in 1938. I was living in New York and having a wonderful time with a lot of girlfriends. More and more I wanted to do only photography. I thought I'd try my hand at free-lancing to earn money. I spent a lot of time, and enjoyed wonderful associations with the painters. I didn't know many photographers at the time, just a few like Eliot Elisofon. Once he came up to my studio and, looking at some new work, he remarked, ''Aaron, this is wonderful, but where do you go from here?''

D: How did you answer him?

S: I didn't. I didn't know how I would develop. How would anybody know that? I was just interested in making pictures, I had no specific purpose.

D: Eventually what you did do, was to go to Chicago.

S: Right. It was Callahan who got me to go to Chicago.

D: How did that come about?

S: Well, it just came about because Callahan wanted me at the Institute of Design.

D: How did you know Callahan?

S: I met him in Chicago through a mutual friend during a trip out West. When he was made head of the photography department at the Institute he decided that I was the guy he wanted to have come out there to help him and to work with him. And I was. It was just right!

D: The combination and collaboration between you and Harry Callahan at the Institute was an extraordinary one.

S: We worked together as teachers, and with our differences, we complemented each other very well. I had a lot of teaching experience and that helped a great deal. With the undergraduates, I directed some documentary projects. The work on Louis Sullivan, that we're still completing, began as a project at the Institute. With the graduate students, Harry and I worked together, each contributing his own talents.

D: Was that a satisfying period?

S: Oh, in many ways it was a satisfying period. In terms of my own photography it was a very satisfying period.

D: Was it at this time that you started a long association with Harry Callahan and Mies van der Rohe?

S: Mies was running the school of Architecture at IIT ((Illinois Institute of Technology). There were many people who taught there that I knew—Callahan and Hugo Weber, the painter, were there. Eventually I got to know Mies. Over the years I took some pictures for him, and occasionally Harry and I would go up to visit him. I was never close friends with Mies, but I knew him well.

D: Did he influence you in terms of either a general or an architectural aesthetic?

S: His work interested me. In 1949 I took a trip out West and did a couple of assignments for a magazine called *Portfolio*. The publisher only did two or three issues—it was a very slick, plush magazine. Alexi Brodovitch, the editor, was familiar with my work. He was especially interested in the geometric-like approach I sometimes used, so he asked me to do a study of Mies van der Rohe's campus at IIT. I spent the whole day there shooting. That was my first real involvement with Mies's work. I didn't meet him until much later, when I moved to Chicago. The study was never published. I also drove all the way out to Arizona in a Model A Ford and met Fred Sommer, who later came to visit me in Chicago, and to teach at the Institute. He was there for a year.

D: What was that period like?

S: That's a little hard to say.

D: Well, give us a hint. Fred lived with you in Chicago. How did the two of you come to have this kind of ''odd couple'' arrangement? He says he did a lot for your eating habits, and that he was the cook. Did he do anything for your photography?

S: Well, I was living alone at the time. Callahan got a grant to go to Europe in 1958 and Fred came to Chicago to take his place. During that period, he shared my apartment and he did the cooking whenever we ate at home—which was most of the time. He is really a wonderful cook.

D: How is he as a photographer?

S: Oh, he's one of the great photographers of all time. He had all kinds of skills, skills that I wasn't even interested in. It

was marvelous. We always talked about aesthetics, about making pictures. He would look at my pictures, I would look at his, and we would discuss them.

D: Do you think a good picture speaks for itself, or do viewers need understanding, context, references, historical information, knowledge of the history of photography or the history of art to know what they're looking at in general, and, in particular, in your work?

S: Oh, of course it's necessary to have information. A picture is a social object. It is the result not only of the work of a person, but it has a history within it, and endless history. It has other people's personalities in it as well as the artist's, and it has other people's art in it, too. Any picture also will have other art of the same artist in it. It's a social phenomenon. Like any social phenomenon, it is very complex. How much you get out of the picture depends upon what you bring to it. The main thing about the meaning of anything, about getting the meaning out of anything—especially a work of art—is that it depends upon your experience with other works of art. All works of art are derived from each other—they come from each other. You can't just take a person who has never seen a picture—any kind of a picture—and expect him to look at a picture and understand what it is all about.

D: It has been said that your work is, in a sense, better to look at than many paintings. What I mean is that most people see modern paintings in books, and the effects of the paintings are diminished by the reproduction process. Your work deals with the same concerns as the painters', and it doesn't lose in reproduction.

S: Well, I think reproductions of black and white photographs are a little closer to a photograph than a black and white reproduction of a color photograph or of a painting. . . or even of a . . .

D: . . . a black and white painting? If you take a photograph of a Franz Kline painting . . .

S: Oh sure, they're closer, that's all. There are people who experience photographs in a very special and precious way. There's a quality in the actual photograph that does not seem to come out in a reproduction. Of course, I have a wonderful time, because sometimes I find that a reproduction of a photograph interests me more, or for a completely different reason. I find it very interesting if a photograph is reproduced in some other way. It becomes something entirely new.

D: For example?

S: If you have a certain photograph and you reproduce it on a certain kind of paper, sometimes you end up with very different effects that are more interesting than the original, or interesting in a different way. And then, of course, you have people like Irving Penn. Until recently we knew his work only from reproduction. There are people like Scott Hyde, too, who determine what a picture is going to look like when it is printed. There is no original. Hyde just gives instructions to the printer. That is how far you can go with photography.

D: How far do *you* think it is all going to go? Did you ever expect the interest in photography to unfold the way it has?

S: No, I never did, and I'm sort of curious to see how far it will go, but I'm also a bit apprehensive.

D: Why?

S: It seems that a lot of interest—a lot of critical interest—in photography stems not from an interest in the picture, but from an interest in all sorts of intellectual things. The intense analysis of a picture in some cases has no relationship with what the artist feels or felt. The conceptualization of a photograph can strip the picture of its meaning. And at times that seems to be happening.

D: And what do you see as the future direction of photography?

S: I don't see. My glasses broke. . .

D: What do you see as the state of photographic criticism now?

S: I think it is getting better and better all the time. There are a number of young people coming up who are very good. We are finally getting a tradition. The writings of Henry Smith are being collected and are going to be published. I think he is one of the best writers we have. There are also some art critics who have become interested in photography and who show promise, but who still need to learn a lot before they are truly at ease with the medium.

D: Do you still enjoy talking to the students?

S: I enjoy talking. I know how to do it.

D: Did you ever expect your life to unfold the way it has?

S: I never expected to be able to earn a living as a photographer. I did not know there would ever be so much interest. Harry Callahan and I always had a sense we were doing something wonderful and maybe important—always. But we never knew where we would end up.

D: If you had it to do over again, what would you do otherwise?

S: Well, being the person I am, I would probably do the same thing over again. I feel I've been lucky in many ways. I've had wonderful friends, and I always was able to have a job to support me that also gave me enough time to make pictures.

Frederick Sommer

Frederick Sommer is now seventy-five, and for a long while he has been far from photography's marketplace in New York. And yet he is at the heart of photography. Born in Italy, raised in Brazil, he received his training as a landscape architect at Cornell University in Ithaca, New York. For more than forty-five years now, he has made his home in Prescott, Arizona, where he has devoted himself to photography, painting and drawing, musical composition and self-discovery.

Barbaralee Diamonstein: For you, the world of art is the world of ideas. You've sought meaning in every aspect of your life. Besides photography your eclectic interests include landscape architecture, painting, music, science, and philosophy. How have you managed to forge such a unified sensibility out of such diverse subject matter and media?

Frederick Sommer: What I do is really the much easier way to do things. The hard way to go through life is to choose one path and to stick to it, and it might be the wrong choice. But you see, I never made the choice, I never had the risk of having made the wrong choice. I go from one thing to another as it interests me.

D: How and where did you become interested in the natural environment?

S: Well, that wasn't so very hard. I was living in Rio, in Brazil, which is literally at the edge of the jungle. The beautiful rain forest is all around it. I got interested in these things; it was easy. The exotic is easy to come by, you see. It is the discipline to understand the exotic that is difficult to come by.

D: By the time you were twelve years old, you could speak Italian and German and Portuguese and Spanish and French. How was your English?

S: Well, I'm trying, still trying!

D: It must have been quite a cultural transition to come to the United States at an early age. How did that come about?

S: Let's go back to languages. You know what languages mean? Languages are not difficult to come by. Languages are logical thought systems. If you're a reasonably thoughtful, organized person, and you don't have too much trouble with yourself, you can take this condition into another language without much difficulty, because a language is simply another way of stating logical propositions.

D: About fifty years ago, you suffered a physical collapse that you learned to deal with, at least philosophically. You began a new phase of your life and your education, the study of philosophy and art. When was the first time that you considered photography and what the artist as photographer might do?

S: I had been interested in photography because of the uses to which it can so easily be put. Everyone has done this at one point very early in life. Young people of fourteen or sixteen get hold of a camera, and so did I. Eventually I found that I could put some information together in a photograph. I wasn't saying it that way in those days. Photography was helping my architectural concerns at the time. It would be a long story to trace, the path of all this. But if you learn the basics of any discipline early, you find that you can take them into other areas. In the sciences there are certain procedures that apply to a lot of sciences. In the arts, there is a fundamental design, visual logic and reason. I found that I could do this very nicely in architecture. And one day I was in a big museum by myself, looking at important work. And I thought, "Well, this is no problem." I couldn't paint like that, but I could see how these artists had put these things together with the same type of logic with which one orders spaces.

D: When did you decide to actively pursue art as your central occupation?

S: I never made that decision. If anybody ever makes that decision it's a mistake. It has to happen. You have to become proficient at art. The burden of learning is very great if you realize that you're learning. But if you don't realize that you're learning, it's amazing what can happen.

D: Perhaps that's what happened to you in the mid 1930's in Los Angeles. You were walking through a museum or library, and you came across some musical compositions, and came up with a rather unusual notion that the best music has the best design. Can you explain that?

S: That was the first time I had had the chance to see a large selection of musical scores, and also facsimiles of original work. I had often thought that it might be interesting to have a chance like that, so I made good use of it. In a very short time, I was convinced, as I am today, that the best musicians have the best looking scores. Well now, somebody who is not too lazy and not too uninterested in things would be alerted by this state of affairs and would try to find out about it. And I did. There's no question now; it's been looked into extensively by myself and others. This is an idea that's going to catch on much more.

D: You're saying that the graphic design, the visual coherence of a musical composition, would give one a clue, without even playing a note, as to the quality of that composition.

S: Yes. If you take, for instance, a painting as visual design or architecture as visual design, some of the ideas may be involved with linguistic logic, and it would be possible to look at very complicated things in terms of interrelationships. If you wanted to think about music, without becoming esoteric, it's space, time. There are all sorts of other ways of describing what a musician finally does get on the page, and what finally is heard. It's visual logic that is heard, you see.

D: If the best musicians have the best looking scores, is the corollary that the best photographers have the best looking negatives?

S: I still don't think that it is possible to say what a good negative should look like. A really good negative is something that produces something different that never quite happened before. Consequently it'll have a complexion that you cannot possibly imagine. And that is its sense of reality.

D: Most photographers number their works in the thousands. You, of course, count your photographs in the hundreds. You've made only two or three copies of some of your pictures from a single negative, and sometimes the copies are not the same. Do you think that all prints from the same negative should not look alike?

S: It's actually difficult to make them alike. And the pursuit of this difficulty is what gets a lot of people in trouble. Let's put it in a rather nasty way. Suppose you hunt down a deer. And you shoot the animal, after it's exhausted. What then have you done? So the important thing is not to get involved in that way.

D: What are the advantages in working the way you do? In having the limited output that you have chosen?

S: Any time that you take to repeat is the time taken from something else. It isn't that I'm trying to be so parsimonious in the way I apportion time, because I am actually a very lazy person. And I don't intend to become efficient, because efficiency is the undoing of all possible pleasure.

Paracelsus (Paint on Cellophane), 1958

D: What makes a well-made photograph?

S: Well, it certainly has to bring something that no other photograph has brought before. The magnitude of the gain or the advantages of how much newness occurs, is not a question of quantity. It's just a tiny step, on the plus side. In other words, it's not getting up in the morning and saying, ''Today I'm going to do less well than I did yesterday.''

D: Of what is it the product?

S: It's the product of being on the plus side. You do it a little bit better.

D: Those are encouraging words. I wonder if early on in your career you received encouragement or support from other artists or photographers?

S: I wouldn't try to limit this to any particular application in the trade or in techniques or in learning some thing. This is what it boils down to: it's impossible to do anything with any other attitude. The only attitude that will give anything is not to withhold.

D: Early on you met Steiglitz and O'Keeffe and Weston. Were they supportive of you and of your work and ideas?

S: Well, when I met some of these people, we weren't all that well acquainted to start with. But they were people basically supportive of anything which was brought to them that had some understanding, and that was not making a certain sort of foolishness.

D: After you met Edward Weston, in the mid 1930's, he became a close friend of yours. Actually, he was one of the people who, after you first met and visited with him, caused you to become more interested and involved in photography.

S: That's accurate. But not necessarily for the reasons that people will think.

D: Well, for what reasons?

S: I was simply for an expansion of the possibilities of design displayed in his work. It was unavoidable to have great respect for what Weston had. But to have great respect for something does not mean you want to go and multiply what somebody has already laid, beautifully, like an egg somewhere in the corner. Even a good hen does not lay the same egg over again. So the question really is to appreciate the quality of not withholding in a person's work.

D: From its earliest beginnings, your work is filled with experimentation and new techniques. Along about 1939, for a period of ten years or so, you made paintings and photographs that were quite independent of each other. At the mid-point of that period there was an important stylistic change, a break, when you started working on what have been called ''horizonless landscapes,'' in which it was not easy, or even possible, to identify a site or a place. What was your intent with those horizonless landscape photographs?

S: I'll tell you the truth, I got onto it very simply. For one thing, there's very little in the Arizona sky. Usually not a trace of cloud, and in those days there wasn't a trace of smog. And so what could I do, have a rocky landscape and then have a strip of sky over it? Well, I tried to accommodate myself, and thought that maybe something could be done that way. But then I found that these very plain skies showed streaks. And these streaks were problems that Eastman film had, and it's not just Eastman film. What people don't realize is that generally speaking, film is made in enormous rolls, enormous sheets. The way the emulsion is floated on makes for little differences in its thickness. So it's like a set of waves; it varies a little bit. All films have this problem. The interesting point is that it's a surprise to the people working in 35 millimeter. They don't have any problem, because usually the film falls within one of these irregularities, or maybe overlaps part of it, so you wouldn't see it. But if you have a large-sized film, and you have several areas of unevenness it in, you have problems. Well, I tried to solve this problem, thinking all the time that maybe I wasn't doing the right thing. So I got help from the manufacturers.

D: Eastman Kodak?

S: Yes, and you know what they did? They sent me back worse looking prints than I had made from these defective negatives, and said that they were perfectly passable.

D: And how did you build on that experience?

S: I never photographed a plain sky again. Obviously I couldn't deal with these companies, but I could deal with the sky.

D: There are many interpretations of those horizonless landscapes. All sorts of people have ideas about what you had in mind; that you view the desert as being hostile to man, as an expression of the eternal presence of death. Tell us what your intent was, and what the meaning was?

S: The desert is a completely alive area just like any other area in the world. If you walk through a desert as a newcomer, you tend to see things that time has left there: a few bones, a few remains. The only reason that the bones are still there is because the climate's very good, which means that it is really a friendly climate. In a friendly climate the bones will survive longer. Around these parts, around New York, nothing will survive very long. In those days, very few people knew or used the word ecology. But if you realize that this is a very complex system unto itself, you start working with what's there, and don't wish to make it look like the countryside of France or Great Britain, or the tropics. It was just the opposite from where I had been.

D: Along about that time, you also went to California and met both Man Ray and Max Ernst. At least one became another

Untitled, circa 1965

Frederick Sommer

Venus, Jupiter and Mars, 1949

Circumnavigation of the Blood, 1950

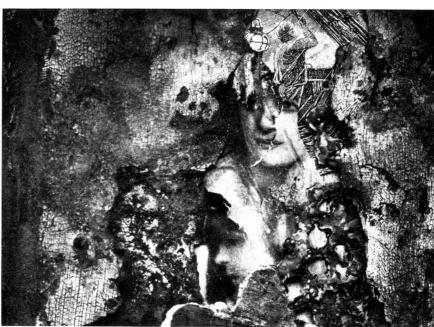

very close friend of yours. When you met this important group of surrealists in California, how did they respond to the work that you were doing? In what way, if at all, did they influence what you were doing?

S: Well, I wouldn't group them all together. There were no American surrealists. There may be some people who take some exception to that. But surrealism is something that happened once, and it's not going to happen like that again. You could do some things that might be in a surrealistic context. But in their own right, they will represent something completely different. Fortunately, things take care so that there will not be too much repetition. But yes, I met Man Ray on a few occasions, and I found him very nice.

D: In California?

S: Yes. He actually lived there for a short time. By the time I met him, he had been there perhaps a year. And one night some time after that, I met Max Ernst and several other surrealists at another place. Man Ray happened to be there that night, but it was just a coincidence. They were very friendly. He knew all of these people, but don't put them together in a group. They had a great influence on my work long before I had met them. But after they saw my work, I influenced them. This is the thing that people are not aware of yet. They keep thinking, ''What did surrealism do for you?''

D: I think some people are aware of the fact that a decade later, Yves Tanguy's work was very closely allied with yours, and that your photographs of the desert were an important influence on his later work. Is that the sort of thing you mean?

S: Well, that would be an example, but it's much more complex. In a sense the explanation can only be presented in pictorial logic, not linguistic logic. In fairness, I cannot claim that they were influenced by seeing some of my things. They were influenced by seeing the Arizona desert and the West and the United States. Max Ernst possibly was helped by seeing some of the things I had done. He was encouraged further in his exploration of the West. He was a natural explorer, anyway.

D: Is that how you would describe yourself, as well?

S: Yes, an unnatural explorer.

D: In that same period, around 1939 or 1940, you began a series of photographs of unusual things, of chicken heads and entrails and the contents of a package brought to you by a surgeon friend. Much of that material has been described as macabre, or difficult for many people to either comprehend or deal with. I wonder what about that subject matter captivated you and caused you to photograph it in the first place?

S: Things like that are not made as decisions. Things become available, and so you make a few moves. But this could be related back to a characterization of the desert and the things I did in the desert. We've been describing the desert as a dry place where things are disappearing. Biology exists there in terms of bones. If I come along and something still looks interesting, no matter what stage it is in, I will consider it.

D: But parts of chickens are one of the few things that are always available. Why did you choose to do that series, at that point in time?

S: People have not done them, and so apparently they were not available. What has been done a great deal is that people have photographed sequences in interiors of butcher shops, in the old-fashioned sense of abattoirs, where animals are killed. I have never been interested in the disposing of life.

D: Some of those photos had a shocking effect and created a sense of unease in some of the viewers. Is that what you intended?

S: No, on the contrary; there's much more sense of life. We can't say that in the Middle Ages or the Renaissance, people became interested in biological structure, in order to shock anyone. You don't have to go to a lot of trouble looking to shock. There are people who are naturally shocked by themselves every day. All they have to do is turn on the lights and look at themselves and they're shocked. Things are done for very sound reasons that don't involve any pranks.

D: You feel, perhaps, that one phase of the creation of art is to depict nature and sometimes it is unpleasant.

S: To speak of nature and to consider it in any sense whatsoever, means that we are considering a long order of relationships. And that is biological in every sense. And this is terribly important. I think I will be considered a pioneer in many respects, which we can't discuss now. This has to do with the awareness of biology within aesthetics. Every time you pick up a weekly magazine now, you see another report on some development in biology. And more and more they are discussing biology. As for what is really in question and is gradually arising, I had an early concern for it. I have looked at this as bio-aesthetic physics. Bio: biological in the sense of life. Now, as biological creatures we practice sense perception. Our life is put together by what we make of our sense perception, so bio-aesthetics is a modern definition for perception. And it is physics because we're using the word in the sense of the gross world of physics, that houses the biological world. So it's bio-aesthetic physics.

D: What are some of the other areas in which you were indeed a pioneer? We have talked about surrealism. And we have talked about the larger philosophical order of things in which photography is really a vehicle to express ideas about life in the universe.

S: Photography is a very wonderful discipline, because it does not permit you to just forget, at your convenience, something that you considered yesterday. This is the notebook that is not

Frederick Sommer

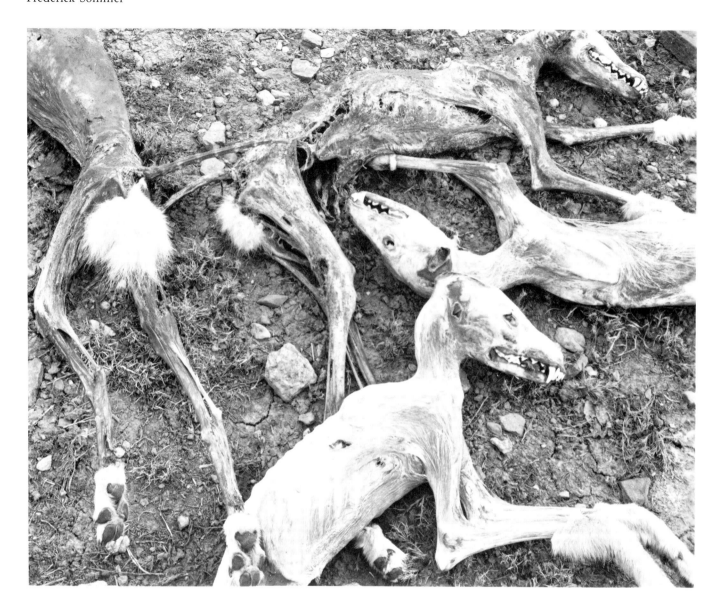

Coyotes, 1945

erasable. For instance, everyone has had some experience in skipping through a text, just leafing through it, and trying to find out a little bit of what's on a page, without reading it.

D: You've done some skip-reading experiments?

S: Yes, I've gradually worked my way into this. And of course, I realized that this was really an easy way, not necessarily a great way, but an easy way to make poetry.

D: How did you do that? Did you reorder the words of the text?

S: Yes, you've got to reorder the words of the text. You'll find that the combinations that can be made are quite extraordinary. You can take a very good poem and make a better one. Let's get to some of the things that really interest me about this. The better the text is, the greater the writer, the more you can rearrange the order of the words and change their interrelatedness. The important part is where this connects with surrealism. Obviously the surrealists had done this day and night, in all sorts of ways. There was hardly anything they hadn't done. But the surrealists did not accept the serious consequences of their findings. They were anti-aesthetic by intent. They did not want something to work out too elegantly. They did not realize that you are not taking the text apart, you are taking your own thoughts apart.

D: And what did you do with the findings of your skip-reading experiments? Did you apply any of them to photography?

S: You become much looser about how you do things, and after a while you perceive more elegantly in terrains where you know nothing.

D: One of your pursuits led you to invent synthetic cameraless negatives, where you had camera-free prints. Did you do that by applying paint or pencil to sheets of glass?

S: Well, there are many ways of doing it. I got interested in cameraless negatives for a number of reasons. Once in a while you see things on a piece of film or on a piece of glass, like roofing or a few sheets on a greenhouse. And you know you could print that on a piece of paper, and maybe it would be interesting. After a little bit of experimenting along that line I found that it was really uninteresting to do these things in the way nature had done them. Nature gives these things a certain scale, certain marks and textures and so on. What I began to see was the possibility of doing things in a way so that you could get very tight, small negatives that would open up. These began to show the possibilities of having much finer definition than silver emulsions. Very, very gradually I was led to realize that there are very unpredictable ways, or so it seemed at first, to make these chancey things. But after a while, I realized that you always walk some sort of path between all kinds of chances that you are taking, and not taking.

You develop a rationale, and the rationale is simply to work with what happens and to accept a much wider range than we are accustomed to seeing in the world around us.

D: What's the specific process that you used, and how do you modify the negative in your darkroom?

S: I think the first thing I did was to work with black pigment of some sort, and I got some fingerprints on a piece of plaster. And I realized how unbelievably fine the image of this fingerprint was. So I started playing with it and that led to some things. You can make emulsions or thin coats of paint that you can apply to glass, cellophane, or various other transparent materials. Then there were things that could be done that are much more mysterious in a way, like making drawings with pencil on aluminum foil. You put aluminum foil on a slight cushion of cellophane, so there isn't just a hard piece of glass next to it, and you draw with a pencil on it, and the pencil embeds itself in it. So you have an embedded drawing. If you smoke this over a candle, and then transfer it to a piece of glass, you get a varied deposit of soot.

D: But it must be very small . . .

S: All of this is very small. Then you begin to realize that if you do this with a certain care, then the enlarging possibilities of these very small structures are absolutely fantastic.

D: So you use an enlarger to create yet another transformation?

S: Yes. This has been rather interesting in that one thing photography has taught me, and I'm sure has taught a lot of other people, is that the problem is how to size a thing. Any photograph or drawing has a size which is most effective. If you make it a littler larger or a little smaller, it's not right, because its logic is not displayed sufficiently, in terms of our perceptions. So you learn to make things to suit the size in which the objects want to reveal their state of affairs, want to reveal their structure.

D: I'd like to talk about your own transformations and constructions. You started photographing objects, some of which you had possessed for a very long time. Why did you do that, particularly since there is in photography what is considered a near sacred distinction between the arranged and the spontaneous?

S: Well, that's why people need to take up logic. Then they wouldn't give credence to such statements lightly. Suppose you do rearrange something. Aren't we daily rearranging all of our affairs? But very few people accept the consequences of the moves that they have made. You must respect those moves. It's as if you are dealing with nature directly in the first place. That's what the statement, ''to respect what is in nature'', is about. If nature did not accept the consequences of her moves, there would be no biology.

D: Are you saying that there is an imaginative reality, and that the fantastic is a part of every reality?

S: The fantastic is only the state during which we get acquainted with the thing. It soon enough ceases to be fantastic and becomes quite lively and real.

D: How would you describe your work? Would you call yourself a symbolist, a surrealist?

S: In our affairs we deal daily with two logics: the logic of those things we see, which is pictorial logic, and the logic of how we operate, which is transactional logic or linguistic logic. But the things that we put together that we really enjoy, that appeal to our taste buds, are produced by the coming together of linguistic and pictorial logic. And when pictorial and linguistic logic truly come together, that is poetic logic.

D: Is that how you would describe your work?

S: Yes. I hope it's going in that direction.

D: At one time, you described yourself as, 'the most disposable' kind of photographer. You said that among certain photographers and historians, your work was not considered of an appropriate style. That's why I referred earlier to the sacred and the profane in photography. Your work was not considered appropriate for photography particularly when photography was an emerging art form, looking for its own kind of legitimacy. How did you react? To anyone other than the informed and those who were committed to your work, you were one of the best kept secrets in photography during that period.

S: The answer is surprisingly simple. It is the difference between people. An educated person understands a slightly longer sentence, that's all. That's the only difference that education makes. And I happen to like these longer sentences at times. Why hold this against me? Just because I practice being an educated person. Why blame everything on the camera?

D: You've also said that images are always about images. That's a word that's used very loosely. What do you mean when you talk about images?

S: Pictorial logic is about pictorial logic, which is about the display of the world. It's simple. Let us consider the really basic question that is underneath all of what you're asking. And that is, why photography is somehow still in ascendance when it's been quite a busy thing on the scene for many, many years? And right now, we feel still another surge of interest in it coming.

D: How do you explain it?

S: The answer does not seem to lie in photography itself, but in the fact that pictorial logic is in the ascendancy, against linguistic logic.

D: Another word that you use very often is "linkages." You see the world as a world of bonds, you seem to be inspired by connections. Is that accurate?

S: I am interested in connections that work.

D: How does that manifest itself in your extraordinarily diverse techniques? What are the linkages, the connections there among the various fields in which you work? Perhaps you might give an idea of what underlies your preoccupation with structural relationships.

S: I'm no different from a scientist. A scientist is very deeply interested in structural relationships. The old game, about what is subjective or objective or not objective enough, is disappearing. The scientists are asking for more clarifications in pictorial logic. That is the difference between the science of today and the science of about fifteen years ago. I knew this was a coming thing. But now it's literally stated.

D: How important is structure to what we do? You've talked about discipline, but now we're talking about another kind of structure.

S: There isn't anything without structure. There are many things in this world, but there are two simple ways in which we approach the fact of existence. They are "position" and "occupier". There's position. Everything is underpinned by a multiplicity of positions. But then there's the occupier that signifies what those positions represent. At that point the mathematicians can help. This is exactly the way mathematics is put together on certain levels.

D: How relevant is your early training to your recurring vocabulary; your own self-described obsession with position, linkages, structures, fulcrums and levers?

S: Without that there isn't anything. You can't make a print. If you want to help somebody and show him why he did a photograph, why he photographed this thing at all, you let him make a proof. He shows you this proof, and on this proof you show him how the levers are working, how these things weigh and pull, how all of it functions.

D: Is the same thing true of your painting and drawing?

S: This is exactly what design is about. Years ago, unfortunately, people lost the sense of how to talk about design, and so design lost its interest for people. People thought, "Oh my god, this guy's still talking about design." Yet design is the structure. It's what underpins things; it's how things are hung together.

D: If that is the case, how expected is the unexpected in your work?

S: On good days, very high. Something unexpected will come. The unexpected is everywhere around us. We tend to think in terms of how we have done it yesterday. Maybe we did something that worked a little bit better yesterday, and so we attack another state of affairs with this order. And in attacking

one set of affairs with another set of affairs, we inflict non-related orders on each other.

D: At the risk of introducing a non-related order—when you were talking earlier about taste buds, I was thinking just how wide ranging your palette really is. And then I went from palette to palate, and realized that among other things, you are a notable chef. At one point, you made a rather "odd couple" with Aaron Siskind when you lived with him in Chicago—and you did the cooking. What were the circumstances of that arrangement?

S: Well, it was fine for me. But it also was very good for Aaron. He got to eat much better food than he had been eating!!

D: How was it for his photography—or yours?

S: Eventually it did both of us some good. At that time, he was not so interested in some of the things I was saying.

D: For example?

S: I am referring to certain ways of treating a print, certain ways of handling densities, reducing, and taking care of edges and margins—things like that. One can do without these things, but I notice he does them carefully now.

D: Do you remind him of that?

S: All I say to him is, "Aaron, you know, your prints these days look so nice."

D: How does he reply?

S: Oh, he grins.

D: How did you become a chef?

S: Well, that is a curious story. I really learned it all from my wife. But I say it's a curious story because of a very recent experience. I had the chance to visit some people out in the country in the vicinity of Florence. This was a large household, and towards the end of the dinner they came up with three truffles. Somebody had brought three truffles. I saw someone holding them at the end of the table, and there was all this excitement about these truffles. And I thought, how marvellous it would be to find out what these things really smell like. I pride myself on remembering odors and tastes, and generally the people who know me know this to be the case. It turned out that in that whole house, among all those people, I was the only one who could not smell the truffle. Now this is a real problem. And I am investigating. I begin to see the possibility that no one can smell truffles, that truffles really don't exist, that they're simply a fiction. And I'm going to pursue this very seriously.

D: How do you plan to do that?

S: Oh, this is going to be difficult, because I'm not going to get much help. I know damn well, people will say, "Well, there's just something wrong with your sense of smell."

D: I know that you believe that confusion is enriching. But perhaps you might unravel some mysteries now. The titles of your pictures are rich and literary and allusive; and many of them are enigmatic, too. Help us solve some of the more perplexing ones. Tell me how "Venus, Jupiter, and Mars" got its name.

S: If you look at that picture, pretty soon you realize that there is this fabulous triangle in it. And it's a problem of very ancient standing. The Greeks had these problems. The gods fought among themselves over the tidbits and morsels going around. So here obviously, Jupiter is the stronger one, already more in the possession of Venus. But there was this other guy moving in. So obviously his name was War, Mars.

D: And how about "Livia?"

S: Well, that happens to be her name.

D: And she was a young child whom you knew?

S: Yes.

D: And "Coyotes?" Did you discover or did you arrange that?

S: Things come to our awareness in ways that are much more complex than we could arrange. Let me give you an example. We could take five pebbles, just a little bit larger than dice, of a somewhat regular shape. We would find that we could continue throwing them endlessly, and still get interesting arrangements. Every throw of these stones would bring us a combination of relationships that we could not even approach by arranging them ourselves. In other words, the forces in nature are constantly at work for us.

D: Other than the pursuit of the nonexistence of truffles, what are you working on now? There must be some new experiments that you are pursuing.

S: I think I would like to explore further the technique of cutting and photographing paper.

D: How do you do that?

S: I take large sheets of wrapping paper, laid on a board. And with a knife, I cut shapes into it, freely. You have to watch not to cut your shapes out completely, or they will fall out when you suspend the paper. I want to figure out more ways of doing this, to extend the complexity of the images.

D: Did you ever expect your life to unfold the way it has?

S: I don't even quite understand how it has unfolded up to now. If there is another day it's very likely it'll be a little different. I'm going to help it to be a little different.

D: Is there anything you would have done otherwise? What do you think would have happened if you had stayed with painting rather than photography?

S: My comprehension of, and interest in, visual logic would have been much weaker than it is now. Photography is just a tremendous teacher. You really find things. When you photograph and you learn to photograph well, you really spend

a lifetime. You may get what you wanted, and then you may get something that you didn't know you were going to get. So you have to work to teach yourself to do what you want to do. Of course, this turns out to be an illusion, because the only thing that's really worthwhile is what you didn't expect. To go back to the dice: it is always possible to find a better order. The only thing is, you cannot say that today you want a certain set of relationships. You have to give your attention to the things that do occur. You have to accept what happens, and that means to accept the consequences of your moves. Some people think that they have been unfairly dealt with by circumstances.

This is very likely to be their own problem, not having accepted the consequences of their own moves. Suppose someone is an upper story man. Now this is not a good thing to be. In some societies the police will get you sooner or later. But if you are a creative person, then you develop the idea of how to be an upper story man so that it's really worthwhile. The idea is simply to accept the consequences of what you do, beyond good or bad, because that has nothing to do with anything. What is good in one area is bad in another. It's the appropriateness, it's "position" and "occupier"—territories.

Garry Winogrand

Garry Winogrand is one of the most important photographers at work in America today. His sophisticated snapshot-aesthetic pictures celebrate ordinary events, and transform them with precise timing and framing into astute visual commentaries on modern life.

Barbaralee Diamonstein: Garry, the New School is not unfamiliar ground to you. As I recall, you studied here for a short time in the early part of your career.

Garry Winogrand: Yes. It might have been 1949.

D: You began to photograph just at that period when you were less then twenty years old. How did it all begin?

W: Cameras intrigued me.

D: You started out studying painting, though, didn't you?

W: Yeah, well, cameras always were seductive. And then a darkroom became available, and that's when I stopped doing anything else.

D: How does a darkroom "become available"?

W: There was a camera club at Columbia, where I was taking a painting course. And when I went down, somebody showed me how to use the stuff. That's all. I haven't done anything else since then. It was as simple as that. I fell into the business.

D: You started out supporting yourself with commercial work—advertising photography and such things.

W: Yes, and magazine work, industrial work. I was a hired gun, more or less.

D: Why did you decide to give all that up?

W: I enjoyed it until I stopped. You could travel and get around. I can't really explain why, I just didn't want to do it anymore.

D: That wasn't very long ago. . .

W: Well, it was 1969 when I got out of it, more or less.

D: And then you turned to teaching, as well as your own work?

W: Well, it was strange, because the phone rang and a teaching job turned up that sounded interesting. And I always did my own work. *The Animals* and a lot of *Public Relations* were done while I was doing commercial work.

D: When you refer to *Public Relations,* you're really talking about the title of a book that describes a very extensive body of material you started in 1969 on a Guggenheim Fellowship. During that period, you decided to photograph the effect of the media on events. And you studied ritual public events that very often were planned for the benefit of those who were recording them. What did you find out about that period, and what were you trying to tell us in your photographs?

W: I don't think anything happens without the press, one way or the other. I think it's all done for it. You saw it start, really, with Martin Luther King in Birmingham. He did the bus thing. And I don't think anything that followed would have happened if the press hadn't paid attention. As far as my end of it, photographing, goes, all I'm interested in is pictures, frankly. I went to events, and it would have been very easy to just illustrate that idea about the relationships between the press and the event, you know. But I felt that from my end, I should deal with the thing itself, which is the event. I pretty much functioned like the media itself.

D: But weren't you the media then?

W: I was one of them, yeah, absolutely. But maybe I was a little slyer, sometimes.

D: How so?

W: Well, at times people in the press were also useful to me, you know.

D: As subjects?

W: Oh, yeah, absolutely.

D: I'm reminded of a picture of Murray Kempton and Norman Mailer in that series at Mailer's 50th birthday party, that has been widely reproduced and discussed in critical essays. Are any of those events ever held just for fun or for the sheer relief of the participants? Are they always done to promote an idea, a cause, a person, or a product?

W: In my experience, I think it's the latter. I mean, people are going to have a good time, you know. One can go have a good time at these big openings in museums. And people go to have a good time. But the thing has another purpose.

D: What is the larger purpose?

W: In the case of museums, it's always got to do with money, people who donate and things like that. And I believe a certain kind of interest has to be demonstrated. The museums want

large crowds coming to the shows—it's the same thing. It's hype. Absolutely. But there's nothing evil about it.

D: Are you really saying that it's marketing?

W: A lot of it is. And then, of course, you have politics, the Vietnam war and all that monkey business. There are all kinds of reasons. At every one of those demonstrations in the late Sixties about the Vietnam war, you could guarantee there'd be a series of speeches. The ostensible purpose was to protest the war. But then somebody came up and gave a black power speech, usually Black Muslims, then. And then you'd have a women's rights speech. It was terrible to listen to these things.

D: How was it to look at?

W: Well, it was interesting; it's an interesting photographic problem. But if I was doing it as a job, I think I'd have to get paid extra. If I ever hear "Power to the people" again, I'll . . . I just found out that John Lennon wrote that song, "All we are saying is give peace a chance." I couldn't believe it. I thought it was terrible; I hated that song. They used to bring out the Pete Seeger wind-up toy to sing it. Tiresome.

D: I hope that what I'm going to bring up won't be tiresome for you, too . . . The term "street photography" and your name have been synonymous for quite some time. But the streets are not the only place where you've worked over the last twenty-five years or so. You've worked in zoos and aquaria, Metropolitan Museum of Art openings, Texas rodeos. There must be some common thread that runs through all of your work. How would you describe it?

W: Well, I'm not going to get into that. I think that those kind of distinctions and lists of titles like "street photographer" are so stupid.

D: How would you prefer to describe yourself?

W: I'm a photographer, a still photographer. That's it.

D: If you don't like "street photographer," how do you respond to that other 'tiresome phrase', "snapshot aesthetic"?

W: .I knew that was coming. That's another stupidity. The people who use the term don't even know the meaning. They use it to refer to photographs they believe are loosely organized, or casually made, whatever you want to call it. Whatever terms you like. The fact is, when they're talking about snapshots they're talking about the family album picture, which is one of the most precisely made photographs. Everybody's fifteen feet away and smiling. The sun is over the viewer's shoulder. That's when the picture is taken, always. It's one of the most carefully made photographs that ever happened. People are just dumb. They misunderstand.

D: That's an interesting point, particularly coming from someone who takes—or rather, composes and then snaps—lightning-fast shots.

W: I'll say this, I'm pretty fast with a camera when I have to

be. However, I think it's irrelevant. I mean, what if I said that every photograph I made was set up? From the photograph, you can't prove otherwise. You don't know anything from the photograph about how it was made, really. But every photograph could be set up. If one could imagine it, one could set it up. The whole discussion is a way of not talking about photographs.

D: Well, what would be a better way to describe that?

W: See, I don't think time is involved in how the thing is made. It's like, "There I was 40,000 feet in the air," whatever. You've got to deal with how photographs look, what's there, not how they're made. Even with what camera.

D: So what is really important . . .

W: Is the photograph.

D: . . . is how you organize complex situations or material to make a picture.

W: The picture, right. Not how I do anything. In the end, maybe the correct language would be how the fact of putting four edges around a collection of information or facts transforms it. A photograph is not what was photographed, it's something else.

D: Does it really not matter what kind of equipment you use?

W: Oh, I know what I like to use myself. I use Leicas, but when I look at the photograph, I don't ask the photograph questions. Mine or anybody else's. The only time I've ever dealt with that kind of thing is when I'm teaching. You talk about people who are interested in "how." But when I look at photographs, I couldn't care less "how." You see?

D: What *do* you look for?

W: I look at a photograph. What's going on? What's happening, photographically? If it's interesting, I try to understand why.

D: And how do you expect the viewer to respond to your photographs?

W: I have no expectations. None at all.

D: Well, what do you want to evoke?

W: I have no ideas on that subject. Two people could look at the same flowers and feel differently about them. Why not? I'm not making ads. I couldn't care less. Everybody's entitled to their own experience.

D: You describe very complex relationships photographically, in a very sympathetic way, but a very humorous one. Often you do that with juxtaposition, whether in zoos or rodeos or museum celebrations. Let's talk about your animal project. There, as in so much of your work, juxtapositions and gestures that usually pass unnoticed are very significant. You find them worth recording. Here you were, a city boy, how did you come to do a project that involved spending so much time in zoos? Do animals interest you that much?

W: Well, zoos are always in cities. Where else can they afford them, you know? When I was a kid in New York I used to go to the zoo. I always liked the zoo. I grew up within walking distance of the Bronx Zoo. And then when my first two children were young, I used to take them to the zoo. Zoos are always interesting. And I make pictures. Actually, the animal pictures came about in a funny way. I made a few shots. If you could see those contact sheets, they're mostly of the kids and maybe a few shots where I'm just playing. And at some point I realized something was going on in some of those pictures, so then I worked at it.

D: Consciously?

W: Yes. Then at some point I realized it made sense as a book. So that's what happened.

D: How important are humor and irony in your work?

W: I don't know. See, I don't get involved, frankly, in that way. When I see something, I know why something's funny or seems to be funny. But in the end it's just another picture as far as I'm concerned.

D: When you looked at those contact sheets, you noticed that something was going on. I've often wondered how a photographer who takes tens of thousands of photographs—and by now it may even be hundreds of thousands of photographs—keeps track of the material. How do you know what you have, and how do you find it?

W: Badly. That's all I can say. There've been times it's been just impossible to find a negative or whatever. But I'm basically just a one man operation, and so things get messed up. I don't have a filing system that's worth very much.

D: But don't you think that's important to your work?

W: I'm sure it is, but I can't do anything about it. It's hopeless. I've given up. You just go through a certain kind of drudgery every time you have to look for something. I've got certain things grouped by now, but there's a drudgery in finding them. There's always stuff missing.

D: You sold your very first work to the Museum of Modern Art. How did Edward Steichen come to know your work?

W: I had an agent. When Steichen was doing "The Family of Man", I went up to the office one day. I think Wayne Miller, who assisted Steichen with "The Family of Man," was up there and pulled out a bunch of pictures. So I got a message: "Take these pictures, call Steichen, make an appointment and take these pictures up there." And that's how I met him.

D: Did the museum buy any?

W: Yes, they bought some for that show.

D: How many did they buy? That was about 1960.

W: I don't remember.

D: Do you remember how much they paid for them?

W: Ten bucks each. Nobody sold prints then and prices didn't mean anything. In terms of earning your living, it was a joke.

D: Did you ever expect the public to celebrate the works of photographers either aesthetically or economically?

W: No. First of all, I don't know if they're celebrating. But yeah, I'm shocked that I can live pretty well, or reasonably, or make a certain amount of my living, anyway, off of prints. I guess it's nuts. I don't believe in it. I never anticipated it; I still don't believe it.

D: How do you explain the current rise of interest in photography?

W: Oh, I'm sure some of it has to do with taxes, tax shelter things. There are all kinds of reasons. There are people who like photography; there are people who are worrying about what's going to happen with the dollar. They want to get anything that seems hard. I don't know, but I think it's got to do with economics. Now and then you get somebody who buys a picture because he likes it.

D: What about all those young people who are so interested in photography?

W: They don't *buy* pictures. Young people don't have money to buy pictures. I don't really have any faith in anybody enjoying photographs in a large enough sense to matter. I think it's all about finances, on one side. And then there are people who are socially ambitious. If you go back aways, the Sculls, for instance, had a lot of money and they were socially ambitious. If you get an old master, it's not going to do you any good socially.

D: Besides, you can't get enough of them.

W: And likewise even French impressionists. So the Sculls bought pop. It was politics, and they moved with it. And I think that could be happening, to some degree, with photography, too. It doesn't cost as much to do it, either.

D: Then you don't have much faith in the longevity of the surge of interest, either economic or aesthetic, in photography. Do you see it as something typical of this moment?

W: I don't know what you mean by aesthetic.

D: Well, we're assigning the surge of interest to economic reasons, rather than the fact that more and more people think of photography as a legitimate art form.

W: I don't care how they think of it. Some of these people are acquiring some very good pictures by a lot of different photographers.

D: For whatever motivation . . .

W: Right. Who cares?

D: But if their interest is economically engendered, then photography could be a short term pursuit.

W: Possibly. I'll take one day at a time; that's enough! I have no idea what's going to happen. Who knows—if they can't afford to buy a boat, maybe they buy a print. Who knows what happens with their buck?

D: When I was taking your photograph earlier today, with well-intended whimsy I tilted my camera in an attempt to make my own Winogrand. From what I understand, that's not how it's done. What is the meaning of the horizontal tilted frame that you often use? And is your camera tilted when you make the picture?

W: It isn't tilted, no.

D: What are you doing?

W: Well, look, there's an arbitrary idea that the horizontal edge in a frame has to be the point of reference. And if you study those pictures, you'll see I use the vertical often enough. I use either edge. If it's as good as the vertical edge, it's as good as the horizontal edge. I never do it without a reason. The only ones you'll see are the ones that work. There's various reasons for doing it. But they're not tilted, you see.

D: How do you create that angle, then?

W: You use the vertical edge as the point of reference, instead of the horizontal edge. I have a picture of a beggar, where there's an arm coming into the frame from the side. And the arm is parallel to the horizontal edge and it makes it work. It's all games, you know. But it keeps it interesting to do, to play.

D: There is another photograph that has an arm coming in from that edge, in almost Sistine Chapel fashion. That arm and the hand on the end of it are feeding the trunk of an elephant.

W: Oh, you mean the cover of the animal book. That has nothing to do with what I'm talking about now. It's just that I carry an arm around with me, you know. I wouldn't be caught dead without that arm!

D: Has teaching affected the way you take photographs?

W: I really don't know.

D: Do you learn a great deal from your students? Do you have any new ideas, any reactions to their reactions?

W: No, the only thing that happens when I'm teaching is that I hope there are some students out there in the class who will ask questions. Teaching is only interesting because you struggle with trying to talk about photographs, photographs that work, you see. Teaching doesn't relate to photographing, at least not for me. But now and then I'll get a student who asks a question that puts me up against the wall and maybe by the end of the semester I can begin to deal with the question. You know what I mean. It's not easy.

D: Several years ago a student did ask you which qualities in a picture make it interesting instead of dead. And you replied

From *Stock Photographs,*
1980

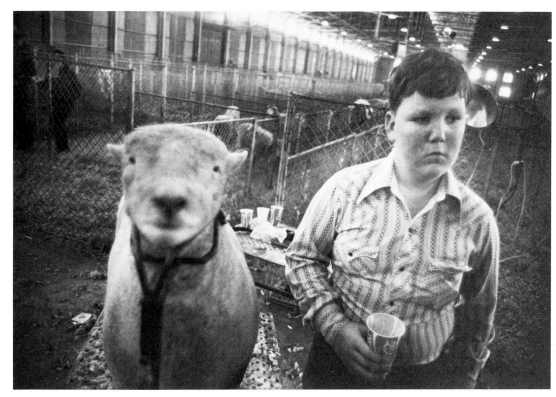

Ft. Worth, Texas, 1975,
from *Stock Photographs,*
1980

Garry Winogrand

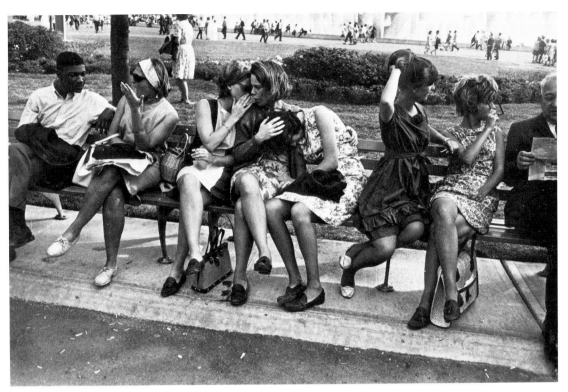

From *Public Relations*,
1964

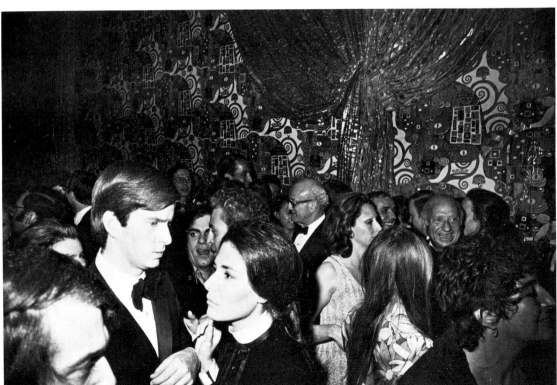

World's Fair,
New York City,
1964

with a telling statement describing what photography is all about. You said you didn't know what something would look like in a photograph until it had been photographed. A rather simple sentence that you used has been widely identified with you, and that sentence is: "I photograph to find out what something will look like photographed." That was about five or six years ago. And I know there are few things that displease you more than being bored. So I would hope that you have since amended or extended that idea. How would you express it now?

W: Well, I don't think it was that simple then, either. There are things I photograph because I'm interested in those things. But in the end, you know what I'm saying there. Earlier tonight, I said the photograph isn't what was photographed, it's something else. It's about transformation. And that's what it is. That hasn't changed, largely. But it's not that simple. Let's put it this way—I photograph what interests me all the time. I live with the pictures to see what that thing looks like photographed. I'm saying the same thing; I'm not changing it. I photograph what interests me. I'm not saying anything different, you see.

D: Well, what is it about a photograph that makes it alive or dead?

W: How problematic it is. It's got to do with the contention between content and form. Invariably that's what's responsible for its energies, its tensions, its being interesting or not. There are photographs that function just to give you information. I never saw a pyramid, but I've seen photographs; I know what a pyramid or a sphinx looks like. There are pictures that do that, but they satisfy a different kind of interest. Most photographs are of life, what goes on in the world. And that's boring, generally. Life is banal, you know. Let's say that an artist deals with banality. I don't care what the discipline is.

D: And how do you find the mystery in the banal?

W: Well, that's what's interesting. There is a transformation, you see, when you just put four edges around it. That changes it. A new world is created.

D: Does that discreet context make it more descriptive, and by transforming it give it a whole new layer of meaning?

W: You're asking me why that happens. Aside from the fact of just taking things out of context, I don't know why. That's part of a mystery. In a way, a transformation is a mystery to me. But there is a transformation, and that's fascinating. Just think how minimal somebody's family album is. But you start looking at one of them, and the word everybody will use is "charming." Something just happened. It's automatic, just operating a camera intelligently. You've got a lot going for you, you see. By just describing well with it, something happens.

D: There are a number of photographers who have things happen in their work that you have responded to over an extended period of time. Whose work have you found was of importance to, or influenced, yours?

W: Well, we could talk about hope, that's all. I hope I learned something from Evans and Frank and . . . I could make a big list . . .

D: In what way did they inform your work, your vision, or your life?

W: I'll just talk about Evans' and Frank's work. I don't know how to say easily what I learned. One thing I can say I learned is how amazing photography could be. I think it was the first time I was really moved by photographs.

D: Did you know Walker Evans?

W: No, not really. We weren't friends.

D: Cartier-Bresson and Kertész?

W: I met Bresson once in Paris. Kertész I probably know a little better. But I'm not friends with those people. I'm not friends with Robert. I've known Robert for a long time.

D: But you are closely associated with a number of contemporary photographers, your contemporaries.

W: Oh sure. Lee Friedlander, Tod Papageorge.

D: Tod Papageorge, a first rate photographer in his own right, was the curator of an exhibition of yours called "Public Relations." How did that come about, that one photographer not only is the curator of another's exhibition, but also writes the introduction to his work?

W: Ask John Szarkowski. It wasn't my idea. I mean, he did ask me if it was okay with me, and I was delighted.

D: Did you all stalk the streets together?

W: No, we don't work together. We might meet for lunch or something, and maybe happen to saunter around a bit in the process. But we don't do expeditions.

D: Just exhibitions. In 1967 your work was exhibited at the Museum of Modern Art, with Lee Friedlander's and Diane Arbus'. Do you feel that the three of you were a likely combination? Or were there important differences? Were you part of the same school?

W: Oh, we're all radically different. John gave the show a title, "New Documents", and there was a little bit of written explanation. I would go by that. I don't remember what was written, though.

D: Has the Museum of Modern Art been very influential in your own career?

W: I don't know. I mean, it doesn't have anything to do with what I do. Probably has made some differences in my sales, I wouldn't be surprised. Again, you have to ask other people, because I don't have a measuring device. There are photographers whose shows I try to make it my business to

see, if I'm in the city. There are photographers I have no interest in at all.

D: Tell me about the ones that interest you.

W: Tod or Hank Wessel, Bill Dane, Paul McConough, Steve Shore. Robert Adams, for sure. I'm ready to see what they do. Nicholas Nixon, also, I would make it my business to see. There's a lot of people working reasonably intelligently.

D: How important is that much criticized aspect of photography—the mechanical, duplicatable printing aspect—to the quality of the work? How much time do you spend in your darkroom? Do you develop your own work?

W: I develop my own film. And I work in spurts. I pile it up.

D: How far behind are you?

W: There's two ways I'm behind, in developing and in printing. It's not easily measurable. I'm a joke. That's the way I am; I mean, that's just the way I work. I've never felt overwhelmed. I know it gets done.

D: Do you have any assistants who work with you?

W: Well, I have a good friend who's a very good printer. And he does a certain amount of printing for me. I do all the developing. If somebody's going to goof my film, I'd better do it. I don't want to get that mad at anybody else.

D: How often does the unexpected or the goof happen when you work? And how often does it turn out to be a happy surprise?

W: I'm talking about technical goofs. I'm pretty much on top of it. The kind of picture you're referring to would have to be more about the effects of technical things, technical phenomena. And I'm just not interested in that kind of work at all. I've goofed, and there's been something interesting, but I haven't made use of it. It just doesn't interest me.

D: Are there any of your photographs that you would describe as being key in the development and evolution of your work?

W: No, I don't deal with them that way either.

D: How do you deal with them?

W: I don't know. I don't go around looking at my pictures. I sometimes think I'm a mechanic. I just take pictures. When the time comes, for whatever reason, I get involved in editing and getting some prints made and stuff. There are things that interest me. But I don't really mull over them a lot.

D: Well, what interests you the most? What's the most important thing to know about your work?

W: I think there's some stuff that's at least photographically interesting. There are things I back off from trying to talk about, you know. Particularly my own work. Also, there may be things better left unsaid. At times I'd much rather talk about other work.

D: Your work, particularly in *Public Relations*, has often

been compared to the work of that master press photographer, Weegee. Do you see any comparisons or similarities?

W: No, I think we're different. First of all, he dealt with very different things. I don't know who makes that comparison. It doesn't make sense to me at all.

D: Tell us about your new book.

W: It's called *Stock Photographs*. It was done at the Fort Worth livestock show and rodeo. I was commissioned to shoot there by the Fort Worth Art Museum for a show. You shoot one year and the show is the next year, when the rodeo is in town. It was a big group show. I was the only photographer. There was a videotape guy and some sculptors: Red Grooms, Rauschenberg, Terry Allen. And I think I hung some, I forget, sixty or so pictures in the show. And at the opening, somebody asked me if I was going to make a book out of it. And I knew I wouldn't. I mean, if I was going to make a book, I'd want to shoot more. You know, you do a book, and you want it to be a crackerjack of a book. Anyway, this person gave me the idea, the next year I went and did some shooting, and then the following year I did some more. And that was it. I probably shot a total of fourteen days, give or take.

D: You were teaching in Texas then, so you had some familiarity with cowboys and the West. It's been said that those rodeo pictures don't tell very pleasant truths. The image of the cowboy hero is somewhat deflated. Was that your intent?

W: My intention is to make interesting photographs. That's it, in the end. I don't make it up. Let's say it's a world I never made. That's what was there to deal with.

D: But one does select what one photographs, and what one doesn't. . .

W: Well, if you take a good look at the book, it's largely a portrait gallery of faces. Faces that I found dramatic. And some of those turned out to be reasonably dramatic photographs. But that's all it is, I think. They're in action; there's people dancing. Plus some actual rodeo action and some other animal pictures, livestock stuff. That's the way we're living. It's one world in this world. But it's not coverage; it's a record of my subjective interests.

D: There is another record that you made of one of your interests, at least at the time! I'm referring to the book on women. How did you assemble that collection?

W: It's the same thing, you know. I'm still compulsively interested in women. It's funny, I've always compulsively photographed women. I still do. I may very well do *"Son of Women are Beautiful."* I certainly have the work. I mean, I have the pictures if I wanted to try to get something like that published. It would be a joke.

D: Do you intend to?

W: No. That's all we need, another book like that! The thing that was interesting about doing that book was my difficulty in dealing with the pictures. When the woman is attractive, is it an interesting picture, or is it the woman? I had a lot of headaches with that, which was why it was interesting. I don't think I always got it straight. I don't think it was that straight, either. I think it's an interesting book, but I don't think it's as good as the other books I've done.

D: Which book did you enjoy most? Are there any projects that were more satisfying to you, while you were putting them together or when they became public, in books or exhibitions?

W: No. I enjoy photographing. It's always interesting, so I can't say one thing is more fun than another. Everything has it's own difficulties.

D: When Tod Papageorge was the curator of one of your exhibitions at the Museum of Modern Art, he observed that you do not create pictures of significant form, but rather of signifying form. What does that phrase mean?

W: I think that's what photographic description is about. That's how a camera describes things.

D: Throughout your work, there is a narrative voice, and an active one at that. Do you agree?

W: I generally deal with something happening. So let's say that what's out there is a narrative. Often enough, the picture plays with the question of what actually is happening. Almost the way puns function. They call the meaning of things into question. You know, why do you laugh at a pun? Language is basic to all of our existences in this world. We depend on it. So a pun calls the meaning of a word into question, and it upsets us tremendously. We laugh because suddenly we find out we're not going to get killed. I think a lot of things work that way with photographs.

D: In much of your work you've described contemporary America. Do you find any recurring themes, or any iconography that either engages your attention or should engage ours?

W: Well, you said it before, women in pictures. Aside from women, I don't know. My work doesn't function the way Robert Frank's did.

D: What are you working on now?

W: I've been living in Los Angeles and photographing there. That's it.

D: Any particular subject matter?

W: No. I'm all over the place. Literally.

D: And then you're going to look at those contact sheets and realize once again that the work comes together—as a book, or something else. . .

W: I really try to divorce myself from any thought of possible use of this stuff. That's part of the discipline. My only purpose while I'm working is to try to make interesting photographs, and what to do with them is another act—a later consideration. Certainly while I'm working, I want them to be as useless as possible.

D: What made you move to Los Angeles?

W: I wanted to photograph there. But I'll come back to New York. I think I'll start focusing in more on the entertainment business. I have been doing some of that already, all kinds of monkey business. But I'm all over the place, literally.

D: When you say the entertainment business, do you mean things that relate to movies?

W: Yes, movies. You know, the lots, et cetera.

D: Rather than the ''stars''?

W: Whatever. I may very well move in. I just don't know. I can't sit here and know what pictures I'm going to take.

D: Is environment—location—a very important influence on your photographs?

W: Well, Los Angeles has interested me for a long time. I was in Texas for five years, for the same reason. I wanted to photograph there. And the only way you can do it is to live there. So I'm living in Los Angeles for a couple of years. I've been a gypsy for quite a while. It'll come to an end. I'm going to come back to New York. I'm a New Yorker. Matter of fact, the more I'm in places like Texas and California, the more I know I'm a New Yorker. I have no confusions. About that.

D: We've talked about the influence of people like Walker Evans and Cartier-Bresson and Robert Frank, of course, on your work. How would you contrast your work to theirs?

W: I wouldn't. We're different, I think. With Evans, if nothing else, it's just in terms of the time we photograph. And my attitude to a lot of things is different from Evans'. Let's say I have a different kind of respect for the things in the world than he does. I have a different kind of seriousness. This might be misunderstood, but I certainly think that my attitude is different. And generally the cameras I use, and how I use them, are different. The things that he photographs describe a certain kind of exquisite taste. And let's say the things I photograph may describe a lack of that. You know what I mean? He was like a very good shopper.

D: And you?

W: I think the problem is different. I was thinking about him and Atget. The things they photographed were often beautiful, and that's a hell of a problem, to photograph something that's beautiful to start with, you see. The photograph should be more interesting or more beautiful than what was photographed. I deal with much more mundane objects, at least. I don't really; actually, I deal with it all. I can't keep away from the other things, but I don't avoid garbage.

Garry Winogrand

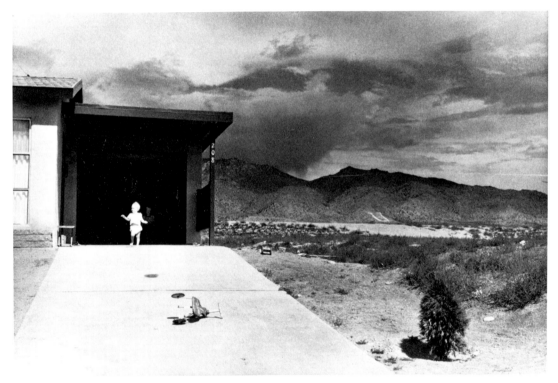

Baby in Garage, 1958

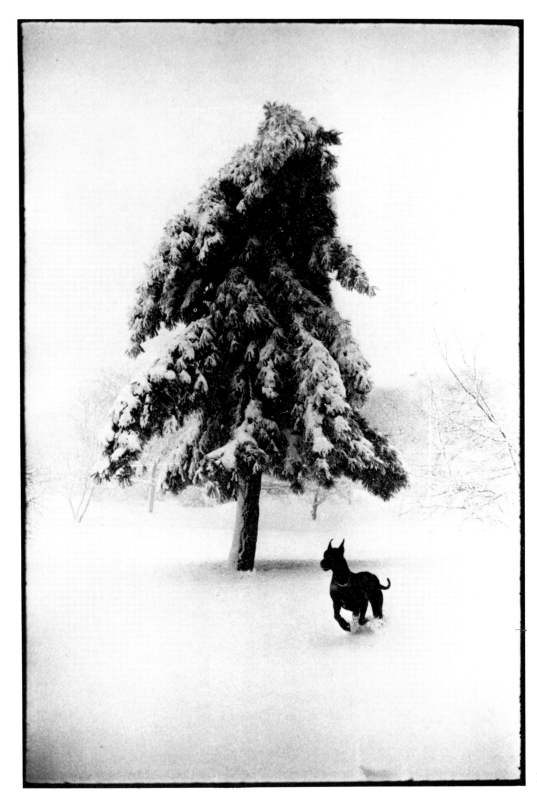

New York City, 1968

Garry Winograd

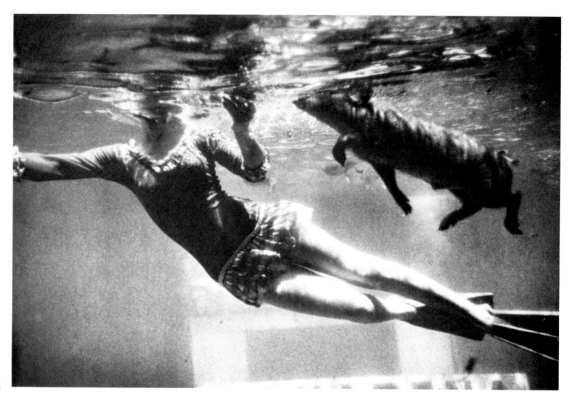

Untitled 1964
from *The Animals*, 1969

D: Do you think that some of those mundane objects are a holdover from your early commercial work?

W: No, no, I don't.

D: You worked in advertising for a long while. Did that influence your work?

W: I doubt it. I mean, I was able to work with two heads. If anything, doing ads and other commercial work were at least exercises in discipline.

D: Would you advise a young photographer who had to earn a living to turn to teaching or to commercial work like advertising?

W: You'd have to deal with a specific person. There's all kinds of people teaching who don't do anything worth a nickel. Likewise in advertising. Then there are some people who do get it together, so I wouldn't make any generalizations. You know if a specific person was asking me such questions, I might think I could tell well enough to say. Or I might say nothing. I don't know.

D: What general advice would you give to young photographers? What should they be doing?

W: The primary problem is to learn to be your own toughest critic. You have to pay attention to intelligent work, and to work at the same time. You see. I mean, you've got to bounce off better work. It's a matter of working.

D: Do you photograph every day?

W: Just about, yes.

D: But you don't develop every day?

W: Hell no! No way.

D: John Szarkowski called you the central photographer of your generation. That's very high praise.

W: Right. It is.

D: But it's also an enormous burden.

W: No, no problem at all. What has it got to do with working? When I'm photographing, I don't have that kind of nonsense running around in my head. I'm photographing. It's irrelevant in the end, so it doesn't mean a thing. It's not going to make me do better work or worse work as I can see it now.

D: Did you ever expect your life to unfold the way it has?

W: No, of course not. I mean, it's ridiculous. I had no idea. How can you know?

D: What did you have in mind?

W: Surviving, that's all. That's all I have in mind right now.

D: Flourishing, too?

W: That's unexpected. But I'm surviving. I'm a survivor. That's the way I understand it.

D: What are you going to do next? Do you have any exhibitions or books planned?

W: No, nothing cooking, not at the moment. Just shooting, that's enough. It's a lot of work organizing something, whether it's a show or a book, and I don't want to do it every day.

D: You have enormous curiosity that propels you from one project to the other.

W: I don't think of them as projects. All I'm doing is photographing. When I was working on *The Animals,* I was working on a lot of other things too. I kept going to the zoo because things were going on in certain pictures. It wasn't a project.

D: Do you think that's the way most photographers work?

W: I don't know. I know what happens. I have boxes of pictures that nothing is ever going to happen to. Even *Public Relations.* I mean, I was going to events long before, and I still am.

D: Have you ever had any particularly difficult assignments or photographic moments?

W: No, the only thing that's difficult is reloading when things are happening. Can you get it done fast enough?

D: You obviously have some secret because you are known as the fastest camera around. . .

W: Well, I don't know if I'm really the fastest. It doesn't matter. I don't think of it as difficult. It would be difficult if I were carrying something heavy, but I carry Leicas. You can't talk about it that way. I'm not operating a shovel and getting tired.

D: You said earlier that you sometimes think of yourself as a mechanic. Do you also think of yourself as an artist?

W: I probably am. I don't think about it, either. But, if I have to think, yeah, I guess so.